STYLE
AND THE
MAN

STYLE
AND THE
MAN

ALAN FLUSSER

PHOTOGRAPHS BY ROBERTO DUTESCO

ILLUSTRATIONS BY ANDERS WENNGREN

HarperStyle

An Imprint of HarperCollins*Publishers*

HarperCollins books may be purchased for educational, business, or sales promotional use. For information please write: Special Markets Department, HarperCollins Publishers, Inc., 10 East 53rd Street, New York, NY 10022.

FIRST EDITION

Designed by Joel Avirom

Typesetting and layouts by Laura Lindgren

ISBN 0-06-270155-X

96 97 98 99 00 ❖/RRD 10 9 8 7 6 5 4 3

*To my girls, Marilise, Piper, and Skye,
who had to share their husband and dad
for more time than they should have. I could never have
persevered without your loving support
and giggly "whatevers"*

ACKNOWLEDGMENTS

RICHARD LALLY
My new lifetime amigo for his consummate
professionalism and unselfish dedication
to the script at hand

ROBERTO DUTESCO
A photographer of prodigious talent
and a man of uncommon charm

ANDERS WENNGREN
For his museum-quality illustrations

Special mention:
JOSEPH MONTEBELLO, editor extraordinaire
A sartorial angel cloaked in substance and style
whose wisdom shaped our collaboration, so
I could realize my dreams

Sincere thanks to:
Paul Adler, Luciano Barbera, Michel Barnes, Tom Beebe,
G. Bruce Boyer, Bill Brandt, Cameron Buchanan,
John Butcher, John Carnera, Nino Cerruti, Jill Cohen,
Skip Cuddy, Angus Cundley, Martin Flusser, Santo Gallo,
Fred Gates, Ralph Di Gennaro, Robert Gieves,
Robert Gilotte, George Glasgow, Jay Greenfield,
Martin Greenfield, Clifford Grodd, Norman Halsey,
Woody Hochswender, Alexander Kabbaz, Richard Merkin,
Jim Moore, Derrill Osborn, Till Reiter, Andrew Rowley,
Adam Sahmanian, Mark Sahmanian, Ken Spink,
Bobby Taylor, Gaspare Tirone, Stanley Tucker, John Tudor,
Marco Wachter, Ken Williams,
and especially Joel Avirom

CONTENTS

INTRODUCTION
XI

1. HOW TO BUY AND WEAR...

TAILORED CLOTHING
5

THE DRESS SHIRT
25

SHOES
36

NECKWEAR:
ICON OF WESTERN CULTURE
47

ACCESSORIES:
BELTS AND BRACES, JEWELRY, HANDKERCHIEFS
58

FORMAL WEAR
70

SPORTSWEAR
87

CUSTOM-MADE CLOTHES
93

TRAVELING WITH YOUR WARDROBE:
PACKING AND CARE
105

2. Where to Shop

Boston
115

Milan
216

Chicago
124

Montreal
244

Dallas
134

New York
250

Florence
143

Paris
306

Hamburg
154

Rome
344

Houston
160

San Francisco
357

London
165

Tokyo
369

Los Angeles
202

Toronto
379

Vienna
386

INTRODUCTION

With this, my third book, I hope to take another step toward helping the style-conscious man to help himself. Much of what I have gleaned about sartorial matters is wisdom that was shared with me, so acting as its source for others gives me genuine pleasure. My father's interest in clothes planted the seed when I was very young. Much of what I have learned in traveling the globe to learn the verities of true style is contained within these pages.

Contrary to the opinons held by many of my colleagues, I believe that dressing well, or in this case, buying clothes wisely, is much less instinctual and arcane than often portrayed. During my thirty years of designing and selling clothes to men, I have found them to be quick studies if given dressing advice that is both demonstrable and rational. And I've yet to meet a man who, in the privacy of the fitting room, will not express an interest in learning how to look better.

Since the most expensive clothes a man will ever buy are those that he rarely wears, this guide tries to offer some insight into how to discern the stylishly classic from the provisionally fashionable. Although this is not a book about dressing as such, the information and illustrations describing how to buy and wear clothes are intended to clarify those issues that must be understood if one is to shop more wisely. Pictures of selected merchandise from around the world have been included to help the reader visualize the principles espoused here.

"Who are the well-dressed men of today?" That is the question I am asked more frequently than any other. I usually respond that there are few in the public eye, though I do cite several television newsmen who show some aptitude. This absence of stylish exemplars constitutes a paradox in modern men's fashion. Given this generation's heightened fashion consciousness and the explosive growth of international menswear, how do we explain this dearth of truly well-dressed men?

Many fashion historians consider the 1930s as the epoch of unparalleled elegance in men's clothing. It was certainly a stylish time. Though the world's economies were depressed, men's fashion took its lead from the custom clothes worn by the upper classes, Europe's titled

aristocracy, and Hollywood's cinematic royalty. However, the lesson of this era lies not in how extraordinarily well turned-out the privileged few were, but that the average man's level of dressing sophistication was not far behind. This clearly reflected his access to sound fashion advice and exposure to stylish role models. *Esquire* and *Apparel Arts* magazines, newsreels, films, newspaper and magazine ads, and the window displays and salespeople in fine stores all helped to set dressing standards for a generation.

Despite the commonly held myth that stylish men are born, not made, dressing well is an acquired skill. Becoming proficient in matters of self-attire is much like honing the talents needed to become a great golfer. While playing frequently can improve your game, until you start practicing the correct technique, your potential will always remain unfulfilled. All issues of proportion or design, as they relate to a man's individual style, should have a logical explanation. Unfortunately, much of what passes for expertise today is little more than opinion. Since there are no courses on how to dress well, nor anywhere to go for guidance that is unprejudiced by the prospect of a sale, it is no wonder the modern fashion firmament has produced so few paragons of men's style.

It also hasn't produced the highest caliber of sales help. As retailers' profits are squeezed by increased overheads, training and service are the first to suffer. The exceptional salesperson who manifests any real talent is often promoted to management or hired away. And since most trainees have never experienced fine service themselves, it's hard for them to know how to give it. As the price of fine wearables continues to rise, it behooves a man to become more self-sufficient in his pursuit of individual style.

This book attempts to inform the shopper by celebrating the exceptional retailer. Selling quality is a craft; doing it well requires an artist's passion and pride. Many of the visionaries whose stores are profiled here came to the menswear business in search of creative fulfillment rather than wealth. In carving out a niche and name for themselves in the quality end of their business, many had to create their own exclusive products, oversee their manufacture, choreograph their display, and participate in their sale. These doyens act as teachers, buyers, employers, salespersons, and designers.

Most of these merchants have seen their businesses endure some difficult times recently. Longtime suppliers have disappeared and the competition for the upscale male has become fierce. With the world growing ever smaller, the international ramifications of foreign wars, politics, and finance can wreak havoc with local trade. Unfortunately, more retailers have shuttered their doors over the last decade than during the thirty years preceding it. However, others have persevered, becoming even better at what they do despite having fewer resources with which to do it. Within their portals, much of the world's most distinguished menswear is to be found. It is my privilege to introduce you to them.

As one well-known store's advertising copy reads, "The educated consumer is our best customer." The dynamic between a knowledgeable audience and a performer raises the standards for both. My goal is that this book initiates a new kind of dialogue between reader and retailer, one that elevates their relationship to that of a collaboration. With each better able to inform and thus empower the other, both will be inspired to new heights.

STYLE
AND THE
MAN

HOW TO
BUY AND WEAR...

TAILORED CLOTHING

Since the price of a suit constitutes most men's single largest clothing outlay, unless you are confident of your ability to select the best one, I recommend that you prepare accordingly. Wearing something that is reasonably representative of what you are shopping for provides the salesman with a starting point and the fitter with a tailoring guide. If you are considering a different take on your usual habiliments, this same garment can also provide a basis for comparison.

Should you go to the store intending to make a purchase, you should bring a dress shirt whose fit satisfies you. The dress shirt is a key element in the suit-fitting process; its collar height and sleeve length inform the tailor how you expect those components of the jacket to fit. You should also bring along all the items you normally pack into your suit. If you wear a pocket square or an eyeglass case in your jacket, or keep a wallet in your back trouser pocket, your suit should be fitted to accommodate these items. The time invested in this preparation will minimize the probability that you will have to return to the store for an additional fitting after discovering that your bulging billfold makes your coat's chest gap.

If shopping in a large store that offers a variety of suit styles—such as London's Harrods or New York City's Saks Fifth Avenue—and you do not have a relationship with any of its salespeople, spend a few minutes looking for one whose dressing style impresses you. Do not automatically accept the first sales associate to engage you unless you know exactly what you want and need him to act merely as an expediter. If you are looking for a high-fashion designer suit, the classically attired salesperson would not be my first choice to explain the nuances that distinguish an Armani three-button crepe suit from the latest Vestimenta confection.

Conversely, if you like to accessorize your more English-style suits with high-class furnishings, you might want to be attended to by someone whose taste demonstrates firsthand experience in such matters. The salesman who dresses as if he is interested in clothes usually

regards his profession as something more than just an opportunity to bring home a regular paycheck. He prides himself in his taste and enjoys taking the extra effort to find something special. Ideally, in the course of your dialogue, he should be able to teach you something about how to dress better while assisting you with your decision making.

FIT AND FABRIC

Compared to a decade ago, most men wear their clothes fuller in scale and lighter in weight. This means that today's average suit jacket has slightly broader shoulders and a bit more length. Its pleated trousers are worn up on the natural waist with its fuller thighs tapering down to cuffed bottoms that break on the shoe. Much of this reproportionment is attributable to the high-fashion men's design community's search for a more modern yet comfortable vessel to replace the stuffy, boxlike structure of the conventional male business suit.

In the early stages of its latest reconfiguration, the suit jacket's dimensions were pushed outward to allow its softer and less padded shell to drape more fluidly from the wearer's shoulders and around his torso. Textured, crepe-weave fabrics were introduced to enhance the sweaterlike cushiness of the more advanced designer suitings. However, as the contemporary men's suit started looking less like its old self and more like a piece of sportswear, men who required the articulation and dressiness of the more classically tailored ensemble began to make their preferences known.

The classic suit is returning, but like any garment caught up in the maelstrom of high fashion, it's just not returning in quite the same form as when it left. While swinging back to its military roots, with enough shape and padding to recall its former prestige and purpose, men's tailored clothing is now lighter and more comfortable than ever. As fashion has eased up even the traditional suit's scale, so too have its conventional fabrics been influenced by the more modern, drapey cloths. Previously, the only fabrics able to maintain such defined line and proper creases were the typical four-harness worsteds from England and Italy. This is still the case. However, their tighter weaves and more substantial construction have now been made to feel soft and pliable. After you squeeze the fabric, the better cloths spring back without wrin-

kling. At the end of the day, a top-quality worsted wool suit still only needs to be hung out for a short time to regain its pressed look.

This is not to suggest that all crepelike textured woolens or other soft high-twist cloths are inferior in quality or wearability to the finer worsteds. Italy has created many exceptional fabrics that look sturdy but are light as feathers and fall as if tailored by gravity. It is true, however, that some less expensive, textured cloths will pull easier than the smoother worsteds and, if not tailored skillfully, will also not perform up to their potential. But the better, high-performance ones can be tailored by hand or by machine and still make you feel like a prince. However, if longevity is the objective, there is no substitute for the time-honored harder-finished worsteds. While they may not make you feel as languidly swathed, they will help a man convey a stature both confidently masculine and quietly measured.

ASSESSING A SUIT'S LONGEVITY

No other garment in the history of fashion better connotes an image of formal continuity and authority than the man's tailored suit jacket. The permanence of its form relies on a set of design relationships whose formal composition accommodates a surprising variety of improvisations without compromising its aesthetic integrity. During the past thirty years, fashion has remolded the jacket's envelope into temporal configurations ranging from boxy and short to fitted and long, each with different dispositions of button and trim. At the same time, its components have varied in shape, texture, and behavior. In spite of all these provisional arrangements, as the century draws to a close, the suit jacket continues to set the universal standard for civility in masculine attire.

While fabrics and patterns usually attract the eye first, the most important thing to consider in a suit is its silhouette. Most suits are made to last at least several years; however, more often than not, a suit's proportions determine its useful lifetime. A suit that is extreme in silhouette is more likely to go out of style before it falls apart. The right choice can give you years of pleasure; the wrong one will haunt your closet. However, once chosen, the suit's fit, not its design, should be the focus of one's attention.

In assessing a jacket's potential life span, four elements of its design should be considered. These are the garment's "bones." When in accordance with the wearer's architecture, they should flatter and enhance his stature. If the coat's geometry conflicts with the wearer's or deviates too far from the archetype's acknowledged grace notes of style, the coat's staying power will be significantly weakened.

THE SHOULDERS

SHOULDERS CUT TOO WIDE DIMINISH THE HEAD.

SHOULDERS CUT TOO NARROW MAKE THE HEAD APPEAR LARGER THAN IT IS.

THE JACKET'S SHOULDERS FRAME THE HEAD—A BALANCED PRESENTATION.

As the widest part of the jacket, the shoulders' expression sets the mood for the entire garment. The assertive eighties saw jacket shoulders attain aircraft carrier dimensions, while the introspective nineties returned the shoulders to a less obtrusive, more classic positioning. Most of history's best-dressed men had their shoulders tailored to look natural yet smart. Unless a man is extremely slope-shouldered or self-consciously short and needs the illusion of height, padded shoulders should be avoided.

The square, high shoulder became internationally fashionable with the emergence of Rome's "Continental look" in the late fifties. Then, in the late sixties, Pierre Cardin's hourglass suit reinforced the notion that strong shoulders were a criterion for high style. Today, given the priority placed on understated comfort, even in the sculpted shoulder's birthplace, the sophisticated Italian wears his hand-tailored shoulders soft, sloped, and less studied.

Close attention need also be paid to the shoulders' width. Since they frame the head, if the shoulders are cut too narrow, the head will appear larger than it actually is; if they are cut too wide, the head will appear disproportionately small.

Their width should be generous enough to permit the jacket's fabric to fall from the shoulder in a smooth, unbroken line all the way down the sleeve. If the width hugs too narrowly, the man's shoulder muscle will bulge out from under the top of the sleeve head, that point at which the jacket sleeve is attached to the shoulder.

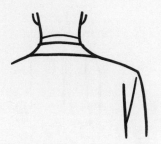

FULLNESS OVER THE BLADES ALLOWS THE JACKET TO DRAPE COMFORTABLY AND RELEASES THE ARMS TO MOVE FREELY.

The jacket also needs enough fullness across the front and back to lie flat on a man's chest without pulling open. A man with a strong chest requires a larger sized jacket just to accommodate this prominence. Fullness over the shoulder blades with breaks extending upward on the back from below the armholes allows ample room for free action. This extra fabric also causes the jacket to drape properly. A tight fit over the shoulder blades can make you feel as if you are in a straitjacket.

Sharp angles formed on either side of the head create an artificial formality. Stylish dressing is distinguished by its naturalness and unconscious ease. The more aggressive shoulder line is the mark of someone who is trying to look more important than he actually feels.

JACKET LENGTH

The correct length of an average man's jacket can vary up to ½" without diminishing its longevity. Altering its length can play havoc with the hip pockets, moving them out of balance with the whole. Your appropriate jacket length can be established using several methods. Regardless of which is chosen, one principle must be kept in mind: the coat has to be long enough to cover the curvature of a man's buttocks.

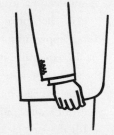

METHOD 1: JACKET LENGTH IN RELATION TO THE ARM. RULE OF THUMB: JACKET'S BOTTOM SHOULD LINE UP WITH THUMB KNUCKLE.

The first approach utilizes the arm as a guide, the other the torso. With the first method, a man uses the knuckle of his thumb to line up the bottom of his jacket. Though generally reliable, this formula has one draw-

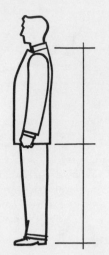

METHOD 2: JACKET LENGTH
IN RELATION TO THE TORSO.
DIVIDE THE DISTANCE FROM
THE COLLAR'S SEAM TO THE
FLOOR IN HALF.

back. A man with a short or average torso but long arms can end up with too long a coat. While its hip pockets may be more accessible, its excess length will swallow up his legs.

Employing the second method, the tailor measures from under the jacket's back collar, where the collar is joined to the coat's body, down to the floor and divides by two.

In the absence of a jacket, a buttoned shirt collar may be substituted as a starting point. This is the procedure taught in all formal tailoring schools. Both guidelines originated with America's introduction of ready-made tailored clothing for men, which needed to establish generalities upon which to base its standards of fit. However, since either of these can be influenced by dimensions unique to the wearer's physique, a top custom tailor will trust his learned eye to take in the whole picture before deciding on the jacket's ideal length.

THE WAIST BUTTON

The waist button is to a suit jacket what the fulcrum is to a seesaw. If it's off center, a delicate balance is lost. When the waist button is fastened, the entire body should be in proportion, with both legs and torso appearing at their maximum length. Since the button functions as an axis, raise it and you abbreviate the torso, lower it and the torso becomes elongated but the leg line is shortened. The correct placement of this critical element occurs ½" below the natural waist. To find your natural waist, put your hands around the smallest part of your torso. With the suit jacket's final fitting, most custom tailors will pull on the fastened waist button to confirm that there is enough fullness in the jacket's waist while observing how the coat moves on the body. An incorrectly positioned waist button calls the garment's pedigree into immediate question.

THE GORGE

The gorge is that point where the collar and lapel meet. The coat's design determines its positioning. While there is some flexibility in its placement on the upper chest, move it outside of this area to where it becomes a focal point and you court instant obsolescence. One American designer used to cut his lapels so high, his coats looked as if they would take flight. Conversely, in the late 1980s Giorgio Armani dropped his so low, they are now decorating the backs of their owners' closets. The lapel needs to have enough sweep to produce a graceful upswing without finishing so high on the collarbone as to make the coat appear as if it were moving backward.

JACKET COLLAR NEEDS TO BE LOWERED.

Twenty years ago, this design element was never an issue. Today if the jacket's gorge is out of sync it is usually because its placement is too low. Done initially to loosen up the coat's starchiness, dropping the gorge too low also loosens up the coat's longevity. Like all elements of classic design, the placement of the gorge should follow geometric logic, not the arbitrariness of fashion.

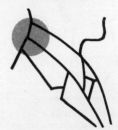

JACKET COLLAR NEEDS TO BE RAISED.

INTO THE FITTING ROOM

Proper fitting can do much for a less costly suit, while a poor fit can scuttle the most expensively hand-tailored creation. If a $3,000 suit's collar is bouncing off your neck as you walk, the suit's value will be severely compromised. The jacket collar that creeps up or stands away from your neck is the fault of the tailor, unless he fit it while you assumed a posture other than your normal one. When

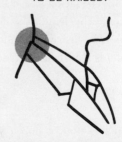

CORRECT RELATIONSHIP: AS ¹/₂" OF THE SHIRTSLEEVE SHOULD SHOW BELOW THE JACKET CUFF, ¹/₂" OF THE SHIRT COLLAR SHOULD APPEAR ABOVE THE JACKET COLLAR.

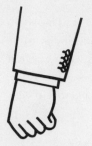

DRESSING THE HAND:
A $\frac{1}{2}$" BAND OF LINEN
SHOULD SHOW BELOW
THE JACKET CUFF.

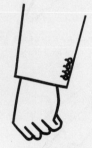

MOST MEN WEAR
THEIR COAT SLEEVES
TOO LONG.

standing in front of the tailor's mirror, relax. Do not stand at attention unless that is your natural stance. Standing overly erect can affect the way the tailor fits the jacket collar to your neck. Collar alterations will be even more accurate if you wear a dress shirt, whose collar height can be used by the fitter as a guide. There should be ½" of the shirt's collar showing above the jacket; ¾" should be exposed when wearing a wing collar.

Since there should be the same amount of linen rising above the jacket's collar as that which peeks out from under its sleeve, let's move on to sleeve length. Ninety percent of all men wear their coat sleeves too long and therefore are unable to show that ½" of shirt cuff that dresses the hand of any well-attired gentleman. Since most dress shirt sleeves either shrink or are bought too short, they cannot be seen even if the jacket's sleeves have been correctly fitted. Most tailors, in an effort to cover the wrist, finish the coat sleeve where the shirt sleeve is supposed to end. (For an explanation of the dress shirt sleeve's proper fit, see page 27.) The jacket sleeve should extend to where the wrist breaks with the hand. This length should reveal ½" of the shirt cuff. The band of linen between sleeve and hand, like that above the jacket collar, is one of the details that defines the sophisticated dresser.

VENTS

In less than a dozen years, ventless jackets have gone from avant-garde to mainstream. This design gives the hip a cleaner, more slimming line while lending the suit a dressier stature. Though aesthetically pleasing, ventless backs lack function, as they prevent easy access to the trouser pockets in addition to wrinkling more easily

from sitting. However, as this back gives a man's torso a leaner, sexier shape, most men ignore its inconvenience.

The center vent, an American predilection, is the least aesthetic venting option, though it offers more utility than having no vent at all. While perfectly designed for spreading the two sides of a rider's jacket across the saddle of a horse, its original intention, the single vent looks awful when a man, having put his hand in his trouser or jacket pocket, pulls it open to reveal his derriere and, if the vent is cut high enough, a fringe of disordered shirt. Savile Row custom tailors avoid the center vent like the plague unless it is imposed upon them by a visitor from the Colonies. The single vent's only saving grace is that it can be altered to better conceal a prominent hip than either the ready-made ventless or double-vented jacket.

The double vent or side slit offers the best combination of function and form. When you put your hands in your trouser pockets, the side vent's flap stays down, covering the buttocks. If you are seated, the flap moves away, thereby minimizing creasing. Most men shy away from side vents because getting them to fall correctly requires more attention. When fit properly, however, the jacket's two slits trace the outside lines of the body. An illusion of height is also created, because the side vent moves the observer's eye up from the bottom of the jacket. Since double-vented coats are costlier to manufacture and more difficult to fit than other models, you see them less frequently. However, the well-designed side-vented jacket gives its wearer a dash of style that bespeaks its English pedigree and custom-tailored tradition.

VESTS

Most men's suits come two-piece, since adding a third element increases their price. However, the vest has always been favored by those style-conscious men who appreciate the quiet resplendence of a third layer of wool. The businessman in his three-piece suit who removes his jacket in the office can rely on the dressiness of his waistcoat to retain some decorum while enjoying the freedom of shirtsleeved attire. A vest also augments a suit's versatility, as its exclusion from a three-piece ensemble creates a different look.

The properly fitted vest should be long enough for its fifth button from the top to cover the trouser waistband, yet not so long that its points extend below the hip. A well-made vest has its own definite waistline, which is where the trouser waistband should hit. Men who prefer low-rise trousers that rest on the hips should avoid vests. Belts and vests should also choose other dance partners, since belts not only add further bulk to the already layered waistline, but tend to poke out from under the vest. When the suit's trousers are supported by braces, with their pleats spilling out from under the waistcoat, the single-breasted ensemble achieves a tailored swank afforded only by the addition of this third layer.

A waistcoat should not have a skintight fit. It should be cut full enough to allow its wearer to sit comfortably with its back belt done up to keep it from riding up the trouser waistline. The top of the vest should be high enough to peek out above the waist-buttoned coat. A classic suit vest has four welt pockets, with a six-button front designed to leave the bottom button undone. Better-designed vests have their fronts slightly curved to conform to the single-breasted jacket's rounded fronts. A waistcoat's back should be longer than its front. This length is needed to cover the waistband should a man choose to bend forward. The vest's back lining usually matches the jacket's sleeve lining. Vests without adjustable rear belts or whose fronts and backs are of equal length are usually poorly designed and cheaply made.

Right down to its unbuttoned, cutaway bottom, the man's tailored vest is a legacy of upper-class fashion. Even the way it is worn is a tribute to royal style. Having unbuttoned his waistcoat to relieve the pressure on his royal ampleness, Edward VII neglected to do up the bottom vest button at dinner's end. Instead of a sartorial faux pas, an eccentric fashion ensued which survives to this day.

TROUSERS

The cut of today's tailored suit trouser is much more classic in shape than its predecessor from the fitted era. Pants have recovered from the hip-hugging jeans mentality of the sixties and the tight, plain-front Continental pant of the seventies. In the nineties, most men's trousers have a longer rise, deeper pleats, and full-cut thighs that taper down

to the ankles—exactly the way the great tailors
originally designed them—to give comfort and
follow the lines of the body.

During the Second World War, when the
U.S. government required manufacturers to con-
serve fabric, plain-front trousers became standard
issue, retaining their popularity throughout the
gray-flannel, Ivy League era. However, all suit
trousers should have pleats, just as most custom
trousers did prior to the war. Pleated pants look
dressier and their fuller fronts provide greater
comfort than plain-front trousers: hips widen
when the wearer is seated, and pleats can facilitate
this shift more easily and with less wear to the
trouser. Objects placed in a front pants pocket are
better concealed within a pleated trouser than a pleatless one.

THE TROUSER CREASE
SHOULD INTERSECT
THE MIDDLE OF THE
KNEE AND BISECT THE
MIDDLE OF THE SHOE.

The classically designed pleated trouser has two pleats on either
side of its fly—a deep one near the fly and a shallower one near the
pocket to help keep the main pleat closed. This arrangement main-
tains the working relationship between the two pleats. The current
trend for multiple pleats or some other gimmick of fancified fullness
reminds me of the recent gilding of the necktie with overwrought
prints, a fad that was as fleeting as it was excessive.

While having your trousers fitted, make sure the pleats are not
opening. Look down to see if each leg's front crease intersects the
middle of each kneecap and finishes in the middle of each shoe. If it is
off at all, the crease should err toward the inside of the trouser. A
crease that falls outside the knee creates the illusion of breadth, some-
thing most men prefer to avoid.

The trouser bottom should rest with a slight break on the top of
the shoe. It should be long enough to cover the hose when a man is in
stride. Its width should cover about two-thirds of the shoe's length.
Cuffs give the trouser bottom weight, helping to define the pleat's
crease while maintaining the trouser's contact with the shoe. Like any
detail of classic tailoring, cuff width should be neither so narrow nor
so wide that it calls attention to itself. To provide the proper balance,
the cuffs should be 1⅝" for a person under five feet ten, 1¾" if he is

THE WEIGHT OF THE
CUFF HELPS KEEP THE
TROUSER ON THE SHOE.
THE TROUSER BOTTOM
SHOULD COVER TWO-
THIRDS OF THE WEARER'S
SHOE AND BE LONG
ENOUGH TO REMAIN IN
CONTACT WITH THE SHOE
WHEN WALKING.

taller. Cuffs of 1¼" or 2" reflect the erraticness of their master: fashion.

QUALITY

With the transformation of the men's suit business into a world of designer fashion and the almost complete mechanization of its manufacturing process, determining the contemporary suit's quality and intrinsic value is the most elusive challenge facing today's shopper. Like women's ready-to-wear, the majority of men's tailored clothing today is sold on its name recognition, fit, and aura of fashionability. The era when men's suits were expected to carry a man from one decade to another and were purveyed based on the relative merits of their quality and hand tailoring is as dated as sized hosiery, exact-sleeved dress shirts, and the three-piece suit.

Except for a handful of factories left in the world that continue to tailor suits primarily by hand, most clothing manufacturers have either incorporated the latest technology into their production process or closed shop. The cost of skilled labor and the time required to create a garment in the old-world manner has limited this wearable's market to those retailers and consumers who appreciate the quality and work behind the hand-stitched garment's higher price. In his hallowed fitting rooms, the specialty retailer must be able to explain the nuances of this handcrafted creation from its silk thread and hand-made buttonholes to the superiority of its worsted fabric.

Beginning in the 1920s, before machines started replacing tailors, suits were graded from 1 to 6 in a system that specified the number of hand operations used to create the final product. For instance, a number 1, the lowest grade of suit, was almost entirely machine-made. A number 2 coat could use some handwork to finish the cuffs, collar, and buttons. A number 3 had to have these three components finished by hand. A number 6, the highest grade on the scale, was made almost entirely by hand. Of course, some manufac-

turers would misrepresent these numbers in an attempt to sell their product at a higher quality rating than it deserved, but at least the system gave the retailer and consumer some sort of uniform standard.

As technical improvements in machine-made clothes blurred the advantages of more costly hand crafting, tailored clothes have become creations of refined engineering and industrialized production. With the tailor's shears and hand-sewn stitches being replaced by computers, laser knives, conveyor belts, fusing, and high-speed pressing machinery, the modern men's suit has become a marvel of tailoring science and technological genius. And as with any automated creation, the measure of its quality is time, in this case minutes.

The modern suit that sells for $395 takes approximately 80 minutes of uninterrupted labor, while the higher-profile designer garment retailing for $1,495 requires approximately 150 minutes of continuous construction. In other words, little more than an hour of actual labor and quality control separate the least costly from the most expensive machine-made suit. While the higher-priced suit's shell fabric, linings, facings, and fusibles are more costly and produce a softer, more flexible garment, they do not account for the entire difference in retail price. A good part of the disparity represents the expenses involved in operating a high-profile designer fashion business: publicity, advertising, fashion shows, and the overhead of a design studio.

Today, most men's suits are constructed in the same manner as a dress shirt's collars and cuffs, whose outside layers are top-fused for permanent smoothness. First developed during the 1950s, the process of bonding or gluing a layer to an outside shell fabric has evolved to a level where it can nearly simulate the softness and flexibility of the hand-sewn canvas used in tailored men's clothes. Formerly, this layer of reinforcement placed between the coat's outer cloth and inner lining consisted of one or more ply of horsehair and regular canvas secured by numerous hand stitches. When suspended by the elasticity of its handmade silk stitches, its free-floating dynamic gave the jacket's front a lasting shapeliness and drape while lending pliancy and spring to the roll of its lapel. The scientific advances seen in the development and performance of the new fusibles have enabled mechanized tailoring to supplant the more traditional artisan methods. With the consumer requesting lighter, softer tailored clothing, these fusibles allow a

coat to mold to the wearer, though they sacrifice fit and longevity in the process.

So, how does a man cut through all this industry mumbo jumbo to determine his prospective suit's level of quality? The answer is complex and difficult to translate into the written word, since these automated garments lack the visible handwork of top quality tailoring to act as benchmarks. The cost efficiency of the new technology encourages manufacturers to incorporate many of the details associated with more expensive tailored clothes into less costly products, rendering the ranking of quality even less clear. Crotch pieces and lined knees are no longer the exclusive province of the most expensively tailored suit trousers, while underarm sweat shields and machine stitching that appears hand-sewn grace jackets with less than lofty pedigrees.

I will break down the subject into price brackets that represent various generic methods of manufacture so our investigation will have some boundaries and focus. Please remember that this is a discussion about the quality of the product's construction, not the beauty of its design. As you will learn later, a wearable's longevity is predicated more on its design than its quality. A well-designed $350 suit can provide more years of wear than an expensive hand-tailored worsted cashmere suit whose shoulders look as though the hanger is still holding them up.

The finest ready-made suits are constructed like those that are custom-made, except the workplace has been organized into a miniature factory. This means each garment is individually hand-cut with scissors; the chest, lapels, collar, armholes, buttonholes, lining, pockets, and sleeves have all been sewn by hand; and everything is hand-pressed. At this level of quality, the construction or padding of the jacket's lapels and collar is stitched totally by hand. There could be two thousand stitches or more in a single-breasted jacket's lapel; these will hold the garment's shape intact through all weathers, fair or foul. For this rarefied ready-made suit, one must expect to pay at least $2,000.

The next ministep below this level of quality can boast the same level of workmanship, but the time-consuming lapel hand-basting is done by a special machine. Those parts of the coat that need flexibility

and movement continue to be sewn by hand—armholes, shoulders, collar. At a minimum, you should be able to look at the inside of the jacket and confirm that the felling of its linings in these areas is hand-done. Next, you should take the coat's bottom front, three inches from its bottom and two inches from its edge. Rub it between your finger and thumb to feel if there are three distinct layers. You should be able to detect a floating canvas piece sandwiched between the coat's outer shell and inner lining. This confirms the coat has a canvas front rather than a fused one. It is the work of a tailor and the garment's shape will remain intact as long as it is well cared for. Selling for between $1,500 and $2,000, it will endure the ravages of extended wear.

Moving down to the next level of quality, you find the semitraditional or semi-canvas-front coat whose bottom front is fused but not its lapels, collar, and chest. Its canvas inner lining floats, held in place by hand stitches so it moves more naturally with the coat. The beauty of this hybrid is that its lapels roll and stay on the coat's chest more naturally than fused lapels will. The canvas inner lining gives the lapels more spring so that their edges remain in contact with the jacket's chest. One can always tell a fused lapel because its edges tend to curl away from the jacket. The semitraditional make has its shoulders, armholes, and collar hand-stitched so that the presentation around the man's face and upper torso appears supple and rich. The cost for such a suit usually falls between $850 and $1,200.

The majority of today's tailored clothing is sewn completely by machine and constructed through fusing. One version is made "open" or in what we call the American system. Parts such as the sleeves and collars are assembled separately first, then put together. In the "two-shell" or German system, the entire inside lining shell is assembled separately from the outside fabric shell. Then the one is sewn inside the other. The two-shell calls for less labor and prides itself on its consistency. While requiring additional manufacturing steps, the American system utilizes more basting stitches, elements of make that in the end come out of the coat but help build in its enduring shape. The price of this type of garment can range wildly, from $395 up to $1,495 depending on whose label is inside.

The only thing one needs to consider when making a choice between the two least expensive methods of tailoring is alterability.

Most men would never even consider this factor, but they must. Since the two-shell garment only has ⅜" outlet left in its seams, the man who gains ten pounds or more will find it impossible to have the coat let out. Imagine spending $750 on a suit only to find out it cannot be altered to accommodate a change in your physique. I would lean toward the garment made in the traditional open way because its shape comes from building in curves while the engineered coat's shape, due to its flat, straight-lined approach to make, will lose its shapeliness faster.

In conclusion, I would like to remind you that the aforementioned has been written as a general guide. Within each of these categories, you will encounter garments that resist easy classification. I hope the information passed on here will enable you to ask the correct questions when trying to get a grip on this difficult subject.

SHOPPING AND THE BODY TYPE

Whether short or tall, portly or slim, a man needs to shop for his clothing with his individual physique in mind. Since most people aspire to look like some idealized version of themselves, selecting clothes based on a particular body type is as old as fashion itself. Whereas I believe that familiarity with the geometric principles that downplay girth or emphasize height or breadth is helpful, such information should be viewed as a guide rather than dogma.

I have seen the most well-dressed men wear clothes in stark contradiction to the accepted dictates of fashionable physiognomy. I can recall one portly, older gentleman looking so debonair in his large, plaid, hefty tweed sports suit simply because it was cut to perfection. I am told that no other group of men would parade down Savile Row in the thirties with more panache than the contingent of Brazilian diplomats, most of whom were under five feet seven and all of whom wore their soft-shouldered, double-breasted suits with cuffed trousers. Proportion in dress is the foundation of all classic dressing. The truly stylish man knows enough about the rules to know how and when to break them.

To assist some of the basic body types in choosing their tailored clothing, I would like to make the following suggestions:

SHORT, SLIM MEN

Clothes should elongate and add shaped fullness.

Jackets
1. Shoulder can be higher and slightly broader.
2. Torso should broaden the chest and shoulders and have slight waist suppression.
3. Jacket length should be as short as possible, however, covering the buttocks without cutting the wearer in two.
4. Single-breasted, three-button coats promote a longer line.
5. Double-breasted coats should have a long roll and button below the natural waist.
6. Lapel notches should be in the chest's upper range. Peaked lapels offer more height.
7. Side vents or no vents.
8. Flap pockets add more width to the hip and balance better with the wider shoulder, but they are not as elongating as the simple besom pocket.
9. Long sleeves make a short man look overcoated.
10. Fabrics such as mill-finished worsteds and flannels; with patterning that emphasizes verticality such as: herringbones, medium-spaced chalk or pinstripes, and windowpanes longer in the woof (vertical) than the weft (horizontal).

Trousers
1. A matching trouser lengthens more than a contrasting one.
2. Should be worn high on the waist and fuller on the hip to promote a longer leg line and to smooth the transition of jacket to trouser.
3. Trouser should break on shoe to extend the view from top to bottom.
4. Cuffs (1⅝") help to smooth the transition of the fuller trouser with the larger scale shoe.

Accessories
1. Striped dress shirts with noncontrasting collars and cuffs.
2. Spread collars, tab collars, long pointed pinned collars.
3. Suspenders emphasize verticality.

4. Striped, solid, understated neckwear knotted in four-in-hand style.
5. Longer four-in-hand necktie can be tucked into trouser.
6. Tonal handkerchief folded with points leaning outward.
7. Welted-soled shoes add height and balance with the breadth of the shoulder.

SHORT, HEAVY MEN

Clothes should also elongate but work to deemphasize breadth.

Jackets
1. Straighter-cut coat.
2. Two-button single-breasted better than three-button or double-breasted.
3. Besom pockets over flap.
4. Side vents over no vents.
5. Sleeves need to taper down to cuff, cannot be too wide at hand.
6. Fabrics should be dark and smooth, such as fine worsteds.
7. Dark solids, medium-width stripings, and herringbones deemphasize bulk.

Trousers
1. Reverse pleat on trouser keeps front flat while breaking the expanse of its width.
2. As long a rise as comfortable, fit on natural waist not below protruding stomach.
3. Cuffs assist the transition of the full-cut trouser to the larger-scaled shoe.

Accessories
1. Long straight point collars.
2. Solid ties; patterened ties; ties with stripes or prints with movement.
3. Welt-sole shoes for a more substantial platform; no lightweight, dainty footwear.

TALL MEN

The taller the tree, the broader its branches, so the tall man needs fuller cut clothes for balance and style. The selections should deemphasize length by breaking up the vertical lines.

Jackets
1. Sloping shoulders of generous width.
2. Coat should be cut on the longer side.
3. Double-breasted model that buttons on waist, not below it, such as the 6/2 placement.
4. Two-button single-breasted.
5. Broader lapels, finishing in lower area of upper chest.
6. Flap pockets and the additional ticket pocket help fragment verticality.
7. The fabrics can be heavier in look, such as flannels and cheviots, and of larger scale in pattern, such as broad stripes, houndstooth checks, glen plaids, or squared-off windowpanes.

Trousers
1. Long rise, full cut with deep pleats.
2. Legs with gentle taper.
3. Cuffs (1¾") with definite break on shoe.

Accessories
1. Full-cut shirts must show ½" of shirt cuff.
2. White contrast collars and cuffs break up length.
3. Amply proportioned spread collars.
4. Broadly spaced, fine-lined stripes, tattersall checks, windowpanes, and horizontal stripes.
5. Belts break up length.
6. Welt-soled shoes for more substantial foundation.

ATHLETIC BUILD

For the man of average height whose chest size is at least eight inches more than his waist size, the principle is to reproportion the oversized shoulder with the smaller bottom.

Jackets

1. Shoulders should be as unpadded and natural-looking as possible.
2. Jackets need length to balance the strong shoulder without shortening the leg line.
3. Minimal waist suppression.
4. Two-button single-breasted over double-breasted—avoid three-button single-breasted.
5. Lapels should be full with slight belly.
6. Flaps on pockets.
7. Side vents or no vents.
8. Fabrics should deemphasize bulk: solid worsteds, herringbones, vertical windowpanes, subtle stripes with no less than ¾" spacing.

Trousers

1. To fill out the jacket, trousers must be worn as high on waist as comfortable.
2. Full cut through hip and thigh with taper to 1¾" cuff.
3. Trouser leg should have definite break on shoe.

Accessories

Assuming a broad face and thick neck:

1. Vertical shirt collars such as tab or long points.
2. Solid, striped, or patterned neckwear.
3. Shirts with strong stripes.
4. Shoes with larger scale to balance shoulders.

THE DRESS SHIRT

THE DRESS SHIRT COLLAR

When purchasing a dress shirt—that is, one intended to be worn with a necktie—consider its collar first. Regardless of whether the shirt appears to go perfectly with your new suit, or is meticulously crafted with vast numbers of stitches to the inch, or even woven in the Caribbean's most lustrous sea island cotton, if its high-banded collar looks as if it might swallow up your neck or its diminutive collar makes your already prominent chin appear more so, move on. You need to focus on that portion of the dress shirt responsible for exhibiting to best advantage the body part that should receive the most attention—your face.

The triangle formed by the V opening of a buttoned tailored jacket and extending up to the area just below a person's chin is the cynosure of a man's costume. There are several dynamics working simultaneously to direct a viewer's focus toward this sector. First, it is situated directly under the face, the wearer's most expressive body part. Second, the area is usually accentuated by contrasts between the darker jacket and lighter shirt, the jacket and tie, and the tie and dress shirt. This triangular sector offers more visible layers of textural activity than any other part of a man's outfit, and the point at which all these elements converge is directly under one's chin, where the inverted V of the dress shirt collar comes to a point.

THE CYNOSURE OF THE TAILORED MAN'S PRESENTATION.

Think of your face as a portrait and your shirt collar as its frame. The collar's height on your neck as well as the length and spread of its points should compliment the shape and size of your face. Within the infinite permutations of angle, scale, and mass, no single article of apparel better enhances a man's countenance than the well-designed dress shirt collar. Since a person's bone

structure is fixed, although it will be affected by a weight gain or loss, the choice of collar should be guided by the individual's particular physical requirements rather than the vicissitudes of fashion. Unlike other less visible accoutrements such as hosiery or shirt cuffs, this focal point constitutes one of a man's most revealing gestures of personal style. All sophisticated dressers have arrived at one or more collar styles that best highlight their unique features while managing to add a bit of dash along the way.

STRAIGHT POINT
COLLARS OFFSET
FACIAL ROTUNDITY.

Choosing the appropriate shirt collar requires experimentation and common sense. A smallish man with delicate features would be lost in a high-set collar with points longer than 3¼". Conversely, a heavyset or big-boned man would loom even larger and overshadow a small collar. Collars should counterbalance the facial structure by either softening its strong lines or strengthening its soft ones. Long straight point collars—those 3" or more—will extend and narrow a wide face just as the broad-spaced points of spread collars will offset the line of a long or narrow one.

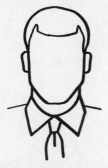

SPREAD COLLARS BEST
PRESENT THE LONG OR
NARROW FACE.

Tab collars or other pinned collars have the necessary height to shorten long necks. Strong-chinned men require fuller proportioned collars, just as large tabletops clamor for ample pedestals to achieve aesthetic balance. Though, admittedly, button-downs can look casually stylish, they are too often favored by exactly the kind of men who should avoid them—the double chinned set. Softer-chinned men need slightly higher and firmer collars to compensate for the lack of a strong line under their face.

Throughout the eighties and up through the mid-nineties, most dress shirts—no matter how expensive—generally had collars that were too small for the average wearer's face. In an effort to convey a more casual and less structured formality, men's fashion has explored many approaches to neutralizing the collar's conventional starched and

ordered format. Consequently, collars have been lowered, shortened, and softened to such degrees that the original precepts for their correct proportioning have either been distorted or lost completely. Button-downs have little or no roll, straight point collars are so short even the smallest tie knot prevents their points from touching the shirt's chest, while spread collars are so low on the neck they have been sapped of all their strength and flair. Except for those produced by a few high-end American, English, or Italian shirtmakers, most dress shirts give the impression they are apologizing for their collars. The explosive growth of the made-to-measure dress shirt business owes much of its prosperity to the scarcity of flatteringly scaled collars on ready-made dress shirts.

Fortunately, men's tailored clothing is segmenting into two distinct mind-sets—dress-up and dress-down. On the dressy side, men who require the services of a jacket and tie are beginning to return to those dress shirts that originally made this uniform so compelling by enabling it to dramatize a man's features. By the end of this decade, there will be more properly scaled collars on dress shirts than there were at its commencement.

I cannot help but wonder whether the long-understood sartorial contract between a man and the conventional format of a buttoned-up dress shirt and drawn-up necktie—which, in effect, exchanged superior stature for a measure of restriction—is no longer able to be negotiated. Since many of the contemporary, more diminutive collar styles fail to heighten the wearer's appearance, they offer little compensation for their inherent discomfort. As a result, many alternatives have been put forth in an effort to replace the classic dress shirt collar composition.

However, as Oscar Schoeffler, longtime fashion editor of *Esquire*, once warned, "Never underestimate the power of what you wear. After all, there is just a small bit of you sticking out at the collar and cuff. The rest of what the world sees is what you drape on your frame." Therefore, the most important factor to weigh when buying a dress shirt isn't its color, fit, or price. It is the collar and its smartness for the wearer's face.

FIT

Other than the Italians, who are almost fetishistically meticulous about the fit of their dress shirts, most men wear theirs too short in the sleeve,

too small in the collar, and too full around the wrist. The explanation for this is relatively straightforward: successive washings shrink collar size and sleeve length, while most shirting manufacturers allow enough breadth in a man's cuff to accommodate a large wrist girded by a Rolex-type watch.

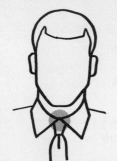

WELL-DESIGNED SPREAD COLLARS SHOULD HAVE NO TIE SPACE.

The best dress shirt is useless if its collar does not fit comfortably. With the top button closed, you should be able to slide two fingers between the neck and the collar of a new dress shirt. Most better dress shirt makers add an extra ½" to the stated collar size to allow for shrinkage within the first several washings. I would never wear a new dress shirt unless it fit big in the collar prior to its first washing. If it fits perfectly around the neck in the store or when first tried on at home, return it or risk being strangled by a smaller collar before too very long.

THE EDGES OF A SPREAD-COLLAR DRESS SHIRT SHOULD BE COVERED BY THE JACKET FRONT.

The back of the shirt collar should be high enough to show ½" above the rear portion of the jacket's collar (see page 11). Its points should be able to touch the shirt's body and rest smoothly on its front. When a tie is fitted up into the collar, its points should be long enough to remain in contact with the shirt's body, regardless of how sharply the wearer turns his head. No part of the collar's band should be able to be seen peeking over the tie's knot. Semispread to cutaway collars should have no tie space above the tie's knot. In other words, both sides of the collar's inverted V should meet or touch each other while the edges of their points should be covered by the jacket's neck.

DRESSING THE HAND

The band of linen between coat sleeve and hand is another one of those stylistic gestures associated with the better-dressed man. It has been so ever since the first aristocrat wore his lace ruffles spilled out

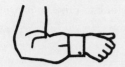

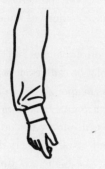

THE SLEEVE MUST HAVE
ENOUGH LENGTH FOR THE
ARM TO BEND WITHOUT
PULLING ON THE CUFF.

THE SHIRT CUFF MUST FIT
SNUGLY, SO THAT THE
ADDITIONAL SLEEVE
LENGTH WILL NOT FALL
OVER THE HAND.

from beneath his jacket cuffs. Some fashion historians mark the decline in modern men's style from the point at which ready-made buttoned cuffs replaced cuff-linked ones and men found their wrists swathed in excess fabric which either fell down their wrists or pulled up too short.

Whether you choose a button cuff or a French cuff, the shirt cuff should fit snugly around the wrist so that the additional length required to keep it from moving as the arm stretches does not fall down over the hand. If you can slide your hand through the cuff opening without first unfastening it, it is too large. If the sleeve is long enough and the cuff fits correctly, you should be able to move your arm in any direction without influencing how the cuff sits on top of your hand. The shirt cuff and hand should be able to move as a unit.

THE BODY

During the 1960s peacock era, when dress shirts had the fit of a second skin and were worn to flaunt the chest and arm muscles, the wearer had to pay particular attention to gaping shirtfronts if he inhaled too deeply or sat down. Today, with comfort driving the fit of men's clothes, issues such as these are no longer of much concern.

The shirt should certainly be full enough to allow its wearer to sit without concern. Normal shrinkage or a slight weight gain should not render it uncomfortable across the chest or waist. Since shirts with blousier fits tend to have lower arm holes, one should pay attention that the jacket's armhole does not pull up the shirtsleeve, making it too short to rest on the top of the hand. A shirt's armhole should fit comfortably up into the armpit for easier movement and consistent length.

The shirt's overall length should be such that you can raise your arms without pulling the garment out of the trouser top.

IN CONSIDERATION OF QUALITY

The most expensive component of any dress shirt is its fabric. As the layer in closest contact with the wearer's skin, the most comfortable and luxurious fiber to wear is unquestionably 100 percent cotton. Anyone doubting this need only examine the fiber content of almost all men's undergarments.

Better dress shirts are made in two-ply cotton or two-fold yarns, less expensive ones in single-ply. Cotton-poly blends are never two-ply, therefore these fabrics tend to be found only in cheaper shirts. In a true two-ply fabric, the yarns used in the vertical warp and horizontal weft are made from two fibers long enough to twist around each other to produce the incremental strength, silkiness, and luster associated with the two-fold luxury fabric. The finer the yarn, the higher its threads-per-inch count. Two-ply fabrics start at 80/2 (the 2 representing two-ply) and progress to as fine as 220/2 (which feels more like silk than cotton and is so expensive it is used only in custom-made shirts). Since two-ply dress shirts are costlier, most manufacturers will include this designation on the label. If it is not so designated, it usually means the shirt is of a single-ply fabric and its cost should reflect this.

Most two-ply dress shirts begin retailing at $75 for those privately labeled in large department stores and go to well over $200 for those more highly crafted with finer-count two-ply fabrics. This is not to suggest that single-ply dress shirts are necessarily inferior to or automatically less desirable than two-ply versions. Since we know how a poorly designed collar can scuttle the most expensive dress shirt, the two-ply designation reflects a garment's intrinsic quality and not its relative value.

The better dress shirt is one of the few products whose craft has been relatively uncompromised by modern manufacturing technology. Due to the many pieces that must be put together and the exacting sewing procedures required, there is no substitute for the skilled, highly trained labor needed to produce a fine dress shirt. As it is not covered over by linings and such, a dress shirt's construction, with the

exception of collar and cuff, can be more easily evaluated than that of tailored clothing or neckties. All of its stitching, seams, and finishing are plainly exposed to the inquiring eye, especially if one knows what to look for and why.

There can be some details of workmanship that, should even one be found present, signal your investigation is at an end and the shirt's dearer price has been confirmed. Most of these benchmarks are holdovers from a less mechanized age when the standards for deluxe quality were set by bespoke shirtmakers. No manufacturer would willingly invest in the labor required to make such a shirt without ensuring the fabric was of a quality that justified the product's retail price. He would be hard-pressed to recoup the cost of such craftsmanship if it was wasted on a shirt composed of inferior cloth.

The handmade buttonhole is a detail rarely found in shirts made outside of France or Italy. If you have a shirt with handmade buttonholes it represents a piece of workmanship that literally comes from the old country. Now, some custom shirtmakers will argue in favor of a fine machine-made buttonhole over a handmade one, but handmade buttonholes are a mark of top-drawer threads. Ironically, they can only be identified by their imperfect stitches and the difference in appearance between its underside and visible portion. As with legitimate custom-tailored clothes, buttonholes are to be handmade, nothing less.

When dress shirts were worn closely fitted to the torso, their side seams were much in evidence and their width and finishing were considered two of the most important criteria for judging their shirtmaking craft. I can recall visiting Italy during the sixties and observing the Romans wrapped in their skintight, darted blue voile shirts with side seams that seemed to disappear into minute lines that traced the body. These side seams were of a single-needle construction. If the shirt you are considering has this feature, you are no doubt holding a garment that will command a better price.

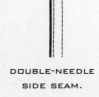

SINGLE-NEEDLE
SIDE SEAM.

DOUBLE-NEEDLE
SIDE SEAM.

Single-needle side seams are sewn twice, once up and once down the shirt's seam, using only one needle and leaving just a single row of stitches visible on the outside. This is time-consuming and requires greater

SYMBOL OF OLD-WORLD
WORKMANSHIP:
REINFORCING GUSSET
STRENGTHENS AND
CONCEALS THE POINT AT
WHICH THE SHIRT'S
FRONT, BACK, AND
SIDE SEAMS JOIN.

skill on the part of the operator than other seams. Most shirts' side seams are sewn on a double-needle machine, which is much faster and produces two rows of visible stitching. Unfortunately, the double-needle side seam can, depending on the quality of its execution, pucker over time due to the thread and fabric's different reactions to washing. However, since most modern shoppers are not that informed, the single-needle side seam is rarely found on ready-made shirts, and is almost exclusively reserved for those dress shirts found in the world of the bespoke.

Another telltale sign of an expensively made dress shirt can be found in the bottom tail's design and finishing. Charvet, the famed French *chemisier,* designs its shirts with a square bottom and side slits or vents, which they feel produce less bulk under the trouser. They also believe their deeper sides keep the shirt better anchored. Turnbull and Asser, the Jermyn Street shirtmaker, prefers the rounded bottom but reinforces its side seam at the bottom with a small triangular gusset. Either of these

ALL FINE DRESS SHIRTS
SHOULD HAVE A
BUTTONING SLEEVE
PLACKET. EVIDENCE OF
METICULOUS CRAFTING IS
THE PRESENCE OF A
HORIZONTAL BUTTONHOLE.

designs demands greater labor and expertise than the typical hemmed bottom. Prior to World War II, the gusset was a common feature on better shirts, but production costs forced many manufacturers to abandon this old-fashioned finishing technique.

The next nuance of detail that signals a dress shirt's loftier pedigree is the direction of its sleeve placket's buttonhole. All better shirts come with a small placket button and button-hole to close the opening running up the inside sleeve from its cuff. However, a horizontally sewn buttonhole is evidence of meticulous crafting, since the button must be lined up perfectly with the buttonhole, unlike a vertical placement which allows a greater margin for

error. Since this detail is easily detectable, it can make any examination a short one.

The last sure giveaway of rarefied shirt-making can only be detected in a shirt made of a striped fabric. Should the stripe of its sleeve line up exactly with the horizontal line of the yoke's stripe when they meet at the shoulder seams, you are in the presence of shirtmaking art. Generally, this kind of work is reserved for the custom-made dress shirt, but should you find it in one ready-made, be prepared to pay at least $150.

A MATCHING PATTERNED YOKE TO SLEEVE IS FOUND ONLY IN A VERY EXPENSIVE DRESS SHIRT.

The next passel of workmanship details should be present on all deluxe-priced ($125 and up) dress shirts whether they are representing themselves as better ready-to-wear, made-to-measure, or even custom-made. While it is more difficult for the beginner to identify these details, once learned, less well-made dress shirts become much easier to spot.

The stitching on a shirt's collar and cuffs should be so fine as to be nearly invisible. If you can clearly see each individual stitch sitting on top of the fabric, its manufacture is less costly. All better dress shirt collars have removable stays. The shape or pattern on either side of a shirt's collar parts or cuffs should match exactly. Pockets should be lined up so that they virtually vanish from sight. Buttonholes should be finished so that it is difficult to see their individual stitches. Buttons should be cross-stitched for extra strength, an operation that cannot be performed by machine.

Real pearl buttons are to fine shirts what authentic horn buttons are to expensive sports jackets. If a sewing machine needle hits a plastic button, the button shatters; should that same needle strike a pearl button, the needle shatters. Authentic mother-of-pearl buttons, especially thicker ones, are incredibly sensual to the hand and eye, as well as costing ten times the price of the typical plastic button.

DRESS SHIRT AESTHETICS

While the dress shirt functions as a backdrop for necktie, braces, jacket, and pocket square, there are two options in furnishing this stage. The first and by far the more popularly practiced method

employs the dress shirt as a neutral foundation. As such, the elements are either harmonized upon it or one is emphasized over the others, such as the bold print tie against a solid white shirt. In this presentation, the shirt acts purely in a supporting role.

The alternative approach casts the dress shirt as leading man at center stage. This style emanated from England and is reasonably easy to execute if the principles governing its execution are well understood. In socially conscious London, an upper-class man would signal his membership in a particular club, regiment, or school through his choice of tie. Since these neckties' designs were fairly standard and limited in number (there being, after all, only so many organizations the wearer could claim as his own), he tended to punctuate his somber and predictable business ensembles with more strongly patterned dress shirts, the very reason London's Jermyn Street became so renowned for gentlemen's dress shirts. In this approach, the tie, shirt, and pocket square act as subordinate players to the shirt. A well-endowed collar was essential to convey the shirt's leading role and the wearer's loftier station, which is why English-bred dress shirts tend to have more prominent collars than their European or American counterparts.

As either of these approaches can project considerable sophistication, one last issue remains in guiding a man toward an informed dress shirt purchase. This concerns the stylistic consistency of the shirt's parts. For example, regardless of how beautiful its fabric or fit, a double-breasted jacket with a center vent remains a half-breed, a mixed metaphor, a sartorial mutt. A garment's detailing must be in character with its fabric, or else, like a pinstriped suit with patch pockets or flap pockets on a tuxedo, the wearable's integrity and classiness is compromised.

Here are some general guidelines specific to the styling of men's dress shirts:

The smoother and more lustrous the fabric, the dressier the shirt. On the scale of relative formality, blue broadcloth ranks above blue end-on-end broadcloth which, in turn, ranks above blue pinpoint oxford, which is finer and dressier than regular blue oxford. But royal or queen's oxford, which is made of a two-ply yarn that gives the oxford weave greater sheen and a finer texture, is comparable to end-

on-end broadcloth in its formality. The more white that shows in the ground of a check or stripe, the dressier the shirting.

Different collar styles also connote varying degrees of dress-up. Spread collars are generally dressier than straight point collars and become even more so with each degree of openness. White contrast collars dress up any shirt no matter its pattern or color, and should only be worn with a French cuff in either self fabric or contrasting white. However, a straight point contrast collar in white is as much a sartorial oxymoron as button cuffs on a dress shirt with a white contrast spread collar. Contrast-collar dress shirts look less authentically classy in collar models less open than a semi-spread, because their to-attach stiff progenitors could only accommodate a four-in-hand if there was enough width to the collar opening. Tab, pinned, or eyelet collars can also give a fabric a more decorous look. If you see a blue oxford shirt decorated with a white spread collar or a button-down collar loitering on a dressy white ground English striping, avoid these mongrel offerings, for their questionable propriety will do nothing for yours.

Most of the criteria for purchasing a classically styled dress shirt have little to do with price or even the quality of the fabric. If a relatively inexpensive shirt made with a mediocre fabric has a collar that is flattering to your face and affords you the right fit, it will render greater value to you than a more expensively made shirt with neither of these attributes. Value has to do with longevity of wear, as ultimately, the most expensive clothes a man can buy are those that rarely come out of the closet.

SHOES

No single article of clothing is so articulate as a shoe, and none is so revealing of the status and attitude of the wearer. For a man, buying business footwear is often an act requiring considerably more time and thought than that given to the selection of an accessory or, for some, even a suit. The result must satisfy not only the wearer's aesthetic needs, it must also provide long-lasting comfort. Particularly for dress-up, any decision concerning men's footwear pivots on something of a paradox: the more imagination and taste one tries to inject into the choice, the more subtle the outcome should be. In terms of fit, strict attention is required, since shoes that are found to be unsatisfactory after several wearings cannot be altered like a suit of clothes. Therefore, purchasing a pair of shoes is a deliberate, thought-provoking act. I guess that's why *Esquire*'s legendary fashion journalist George Frazier said, "Wanna know if a guy is well-dressed? Look down."

Before considering a new pair of shoes, a man must first decide which sensibility of footwear fashion best complements his own dressing style. Today, there are essentially three scales of expression from which to choose: Italian, English, or contemporary. As with tailored clothing, no matter how well made or costly the shoe, its longevity will be ultimately determined by its shape. The finest crocodile slip-on will be less desirable if, as your tastes change, you feel it makes your foot look too Cinderellaesque in contrast to your fuller-cut, pleated trousers.

THE CLASSIC ITALIAN SHOE

In reaction to the shapeless, Ivy League gray-flannel bags of the 1950s and their accompanying gunboat-shaped lace-ups, the style-conscious American became enamored of the body-hugging silhouette worn by the Continental sophisticate. Accordingly, slim-fitting Italian footwear, with its leaner lines and light construction, gained popularity. Its slightly

pointier, slipper-shaped toe and close-trimmed soles attached to its small-pored, shiny-soft calfskin upper made the wearer's foot appear smaller than it actually was. The shoe's diminutive platform was the proper conclusion for the era's tapering, narrow-legged trousers.

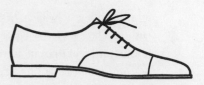

THE CLASSIC ITALIAN SHOE: ITS LOWER LINES MAKE THE FOOT APPEAR SMALLER.

The fuller-cut clothing of the designer-driven 1990s, however, demands a larger-scaled shoe. Today's trousers, with their full, deep pleats in drapier fabrics and proper cuffs resting in a pronounced break at the shoe tops, often swallow up thin, low-cut footwear. This style of shodding is still popular around the world with men who expect a sharp finish from their footwear. It's part of a conservative Euro-classicism that still equates style with clothing that makes you look trim.

THE ENGLISH BENCH-MADE SHOE

The father of the post-boot, ready-made gentleman's town shoe is the bench-made English oxford. Once the straps were removed from men's breeches and the low-cut shoe replaced the boot, men's footwear was freed to pursue new expressions of design. Just as Savile Row artisans posted the benchmark for tailored fashion, West End cobblers set the international standards for high-class foot fashion. Most of today's British ready-made shoes were originally designed during the period between the world wars for individual customers. Although the British models and shapes have changed minimally since their introduction some seventy-five years ago, this footwear's upper-class lineage makes them the choice of the wellborn and well-bred to this day.

Since ready-made English shoes, like the boots and other military-style footwear from which they evolved, were created to endure cold, wet climates, their construction is stiffer and more durable than the lighter-weight footwear of the Mediterranean male. The English shoe uses a heavier leather

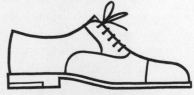

THE TRADITIONAL BRITISH SHOE: ITS WELT CONSTRUCTION GIVES IT A MORE SUBSTANTIAL PROPORTION.

on the upper, which is first stitched to a welt, a separate piece of leather. Then its leather sole is sewn to the welt of the upper. Heavier in look and feel than its Latin cousin, it offers superior support for the foot and body while providing considerable protection against the elements. Since its welted sole can be easily replaced without disturbing the shape of its upper, it will wear longer than the lightweight Italian product whose sole is either sewn or glued directly to the insole. When bench-made and hand-polished to an antique veneer, this article of English craftsmanship, like a fine set of luggage, looks and feels better with age.

THE CONTEMPORARY SHOE

This third, more modern fashion sensibility in footwear style evolved from two separate but parallel movements in men's fashion. In the early seventies the bohemian antifashion crowd plucked the cowboy

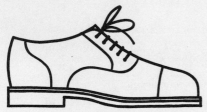

THE CONTEMPORARY SHOE:
ITS LARGER SCALE BALANCES
THE FULLER CUT OF
MODERN CLOTHES.

boot from its working environment and taught it a new rhetoric. Having then seen it usurped and cosmeticized by the hipper urban bourgeois, they switched to the more aggressive semiotics of worker-style footwear, adopting either the construction boot, the black high-laced American combat boot or, the epitome of downtown chic, the Doc Martens mechanic's boot. Along with athletic shoes, which were beginning to be worn as much for leisure as for sport, these shoes all shared a street fashion insouciance as well as a new, larger scale of proportion.

At the same time, the world of high fashion witnessed the emergence of the Japanese kimono-inspired minimalist fashion along with Giorgio Armani's broad-shouldered slouch. Both expressions were fuller on top and required something different on the bottom extremities. Black space shoes such as Doc Martens addressed these requirements, as did any shoe from the past whose scale refused to be overwhelmed underneath all this sartorial largesse. The American CIA-issue black wingtips of the fifties, with their gunboat proportions, as well as some

older European walking and country shoes, were adopted and became the precursors to this newest category of footwear design.

Today, every shoe designer or manufacturer has some of these more contemporary-scaled shoddings as part of their collection. With their cushiony insides and weather-resistant exteriors, these reconfigured classics offer greater versatility than either the classic Italian or English shoe, allowing an easy transition from uptown formality to downtown casualness. Mating a shoe of this proportion to even the most conservative of clothes magically transforms everything above the ankle into a more contemporary-looking ensemble.

FITTING THE SHOE

The greatest challenge to a proper shoe fit rests in the very nature of the foot. Though it might not be immediately obvious, your foot's shape and size are not static. They change depending on the time of day or season, the prevailing climate, and whether your foot is at rest or bearing the weight of your body. Adapting a somewhat fixed object (the shoe last) to one in constant flux (the foot) requires fine design and skilled technology. All of the factors that theoretically govern proper fit can be present, but in the final analysis, it's the customer who determines whether the shoe does or does not fit, and this is a wholly subjective decision.

Size alone is not a determining factor. Five different pairs of feet may possess identical measurements, but when fitted in the same shoe style and size each may react differently. Toe shape can have an impact on size and fit; materials—such as cordovan, which has little yield, or calfskin, which has greater stretch—are another important consideration. However, the first thing you must determine when trying on a shoe is whether its last is appropriate to your foot.

The last is the wooden form around which the shoe is constructed and the form the leather adopts once it is on your foot. John Lobb, the famous London bootmaker, titled his book *The Last Comes First*, and that's as true today as it ever was. Shoes of the same size but made on different lasts will offer dissimilar fits. All shoes, from custom-made to mass-produced, must start with a sculpted wooden last. Any discomfort from the heel, the instep, the ball of the shoe, or

its toe are determined by this wood carving. This ready-made form must approximate the shape and character of your feet so that the shoe becomes like a second skin after several wearings.

Shoes should feel comfortable from the moment you try them on. Certainly, they will feel better with wear, but comfort should not be deferred if the fit feels wrong within your first few steps. If shopping for a dress shoe, make sure socks you are wearing are the same weight as those you would normally wear with this shoe; fitting a lace-up shoe over athletic socks could prove counterproductive. Shop in the afternoon rather than in the morning, as your feet tend to swell during the course of a day's activity.

Take the time to have your feet measured properly. Most people believe their feet are smaller than they actually are. A well-trained shoe salesman should always want to measure your feet first rather than ask you your size. Never buy expensive shoes from a salesman who does not know how to take a proper measurement. And since studies show that only 15 percent of all men have a right and left foot of exactly equal size, you should insist on having both feet measured. After trying on both shoes and putting them through some paces, sit down for a minute before walking in them again. Let your feet settle. Two pairs of feet can have similar measurements while at rest but register distinctly different numbers after bearing weight.

If the shoe in question is a lace-up, you should be able to tie the laces so that there is no more than a quarter-inch gap between the opposing edges at the top. Slip-ons can occasionally be bought one half size smaller than a lace-up, which means only a 3/16" difference in length and mass. A lace-up is cut higher up the instep so it stays on the foot more easily, while a slip-on is cut lower and needs to stretch and collapse more. Boots, athletic shoes, and casual shoes are better bought a half size larger than your other shoes, since they are usually worn with thicker socks and your feet tend to perspire more due to their encasement. Also, since they usually must endure harder wear, your feet will need greater room to expand.

It is difficult to identify all the criteria that justify the price of expensive shoes, but one of these is certainly the construction of the shoe's interior, which should be finished as meticulously as its outside.

It should be fully leather-lined with leather insoles, since no material is better suited to absorb all the moisture produced by the foot while making a substantial contribution to the shoe's continuing shapeliness and comfort.

Better shoes also have leather heels, sometimes tipped with rubber for better wear. Leather heels retain their shape when exposed to the elements. The heels of most less-expensive shoes are made with a resinlike hardboard which will splay out when wet, losing their shape and support. The stitching that attaches the sole to the upper on top-quality shoes is buried in a groove that cannot be seen by the naked eye. On less expensive shoes, the stitching is exposed and erodes quickly with wear.

FOOTWEAR DECORUM

While black shoes are predictably correct for dark navy suits and formal wear, brown actually offers a man more stylish flexibility. Notice how any article placed on a polished mahogany tabletop immediately acquires an expensive aura. Based on a similar dynamic, top-quality brown leather shoes confer a richness and character to any type or color of fabric worn in close proximity.

Boston Brahmins have long appreciated the eccentric classiness of mating brown lace-ups with navy or charcoal suits. Today's best-dressed group of men, the Milanese, are almost religious in their preference for brown footwear over black. Their saddle-tanned business shoes are bone-polished to a deep, dark patina while their rubber-soled brown suede weekend shoes are reserved for less postured leisure wear. Murray Pearlstein, proprietor and dean of America's most enlightened men's fashion store, Louis, Boston, spent most of the 1980s spreading the brown shoe gospel.

While the English may shudder at what they consider to be a perversion of their established form for town wear, I seem to recall one of their own, the future Edward VIII, donning his brown suedes with a gray chalk-stripe lounge suit back in the 1920s, setting a sartorial precedent and a new tradition all in the same Long Island afternoon. Though it's been some time since Edward VIII set his crowd abuzz, dark brown suede tie shoes are finally coming into their own as an

alternative business shoe for men desiring to step out with a little more chic. Long misconstrued as a foppish affectation of the "look *anglais*," the brown suede shoe is now being worn and appreciated by the younger tie-and-jacket-wearing denizens.

Like a hand-rolled white linen handkerchief peeking out of the breast pocket of a tailored jacket, this footwear makes anything worn with it appear more expensive and smart. These shoes look good with clothing of any type or color and, owing to their break with traditional shiny-surfaced footwear, represent something of a departure for the arriviste fashion consumer. But, once familiar with its aristocratic heritage, you will find that no shoe adds a more cultured swagger to a man's tailored ensemble than the dark brown, reverse-calf suede lace-up in its most town-elegant model—the semibrogue with perforated cap toe.

It's difficult to explain why other colors such as burgundy, navy, or dark gray have never connoted much class or taste in masculine footwear. Perhaps it's because shiny, dyed colors appear artificial next to the more natural saddle-leather colors of brown and black. The only time color in male footwear escapes being viewed as stylishly sophomoric is in the nonreflective, napped surfaces of suede or velvet found in such status-conferring classics as the Gucci buckled slip-on, Belgian loafer, or Prince Albert dress slipper. In these models and fabrics, dark colors such as bottle green, burgundy, navy, or chocolate brown come off as refined, not contrived.

A similar principle applies to white as a color for summer shoes. The red-soled English white buck has a definite blue-blooded American cachet, as do the two-tone correspondent shoes that made their debut in this country as leisure wear during the 1920s. But if the white suede of the correspondence shoe has been replaced with shiny white leather, as it is in most of today's commercial versions, it's a horse, *ahem*, of a different color. Representing an era when the care of high-maintenance attire was left to those employed to look after the privileged, authentic two-toned shoes are as difficult to maintain as they are to polish. However, substituting leather for white suede renounces the shoe's wellborn origins and reduces its taste from the patrician to the parvenu.

HOSIERY

Most men consider hosiery a necessary staple, but one hardly worth the expenditure of much thought or money. Completely concealed when standing, mostly obscured when walking or sitting, no part of a man's ensemble is likely to elicit less notice. Those men who pay more than just casual attention to this stepchild of an accessory do so primarily for their own private enjoyment.

However, at the risk of boring the socks off you by making the first of many references to those legendary toffs of yesteryear swank, Fred, the Duke & Co., these men selected their ankle adornments with the same care and eye for personal expression they brought to the rest of their attire. Hosiery is yet another element that a man can use to enrich his ensemble. Doing something interesting with your hosiery is just one more opportunity to cultivate your own taste and, in this case, should you fail, few will be the wiser.

Socks are chosen by the clothing and shoe company they will keep. As a general principle, the dressier the outfit, the finer the hose. The choices range from sheer silk for formal wear to fine-gauge wool or cotton lisle for business attire to wool argyles, cotton cables, or ragg socks for casual wear. Just as a navy cotton cable sock would appear too sportive under a dressy pinstripe worsted business suit, one would not mate a pair of semisheer lisle hose with a rough tweed jacket and flannel trousers.

The most egregious breach of hosiery etiquette that a man can commit is to allow a patch of skin to show between trouser and hose while seated, because his socks are too short. The chances of such a faux pas occurring today have been significantly minimized with the introduction of over-the-calf dress hosiery. Garters have gone the way of separate collars, and ankle-height hose is now only available in sport socks. Although garters (or suspenders, as the English call them) sound Victorian, when made well and worn correctly, they are comfortable and do not require the corseting of the entire leg up to the knee, as over-the-calf hose does.

Since the foot is almost completely encased by some form of covering, natural-fiber hosiery has always been the choice of those who are willing to invest the time required for its proper care. Nothing makes a man feel more sure-footed and confident than the feel of fine-

gauge 100 percent natural wool, cotton, or linen hose caressing his foot as it is massaged by the supple leather lining of a well-crafted dress shoe. And since the shoe is subject to constant moisture, heat, and friction, nothing contributes more to better foot health than absorbent, air-circulating, natural-fiber hose.

ANKLE DECOR

The function of ankle outfitting somewhat parallels the role of the belt in relation to the shirt above it and the trouser below it. When chosen well, a waist wrapping should meld the two while embellishing the visual transition. As with the dress belt, the darker the sock, the dressier the effect. Conversely, the lighter or brighter the stripe of expanse between trouser and shoe, the more casual the look.

A sock should match the trouser rather than the shoe. Footwear and hosiery that work as a unit ultimately appear to separate themselves from the whole, instead of functioning as an extension of it. With a navy suit and black shoes, navy socks look richer than black. With a dark gray suit and brown shoes, charcoal gray hose is the more elegant choice. While de rigueur for formal wear and obligatory for the downtown folk swathed in regulation black, solid black hose should be avoided for business wear; it transforms the ankle into a black hole and diminishes that which it could beautify.

The next step up in trouser cuff decor is the adoption of a third color that echoes one found in any of the accessories above the waist-line. With a dark gray suit, medium blue dress shirt, and navy and wine tie, one might consider burgundy hose, whose dark coloring aids the transition from trouser to shoe while subtly incorporating this area of the ensemble into the whole. The prize for the most soigné of modern ankle veneer must go to the Milanese, who will anoint their charcoal suit trouser and dark brown brogues with bottle green hose, reminding the observer that their choice of a dark green necktie was no accident.

Socks sporting a two- or three-color design or decorated with a clock bring you to the playing field of the hall of famers. This is where hosiery acquisition becomes considerably more focused, as only ankle knitwear of real character can make the team. Scoring here imparts

the same sense of freedom one feels once he becomes comfortable wearing a patterned necktie with a patterned dress shirt. If you start your exploration with such time-honored combinations as two-toned houndstooth hose with glen plaid flannels, fine herringbones with striped suitings, or spaced polka dots with windowpane worsteds, donning your socks in the morning will no longer be routine.

Acquiring truly handsome hosiery poses a serious challenge for those who cannot afford to spend at least twenty dollars for a pair of socks. While technology has extended the life of this once perishable accessory, it has also homogenized the designs found in the mass market. Pre–World War II hosiery was not made to last more than a dozen wearings, so it was inexpensive and designed to encourage impulse buying, like neckwear. Once nylon and other synthetic fibers were introduced, resulting in the one-size-fits-all dress sock, the days of sized hosiery with creative designs were numbered. The new high-speed knitting machinery must produce megavolumes to pay for itself and has changed hosiery from a specialized commodity into a mass-produced wearable. Japan manufactures most of the world's fine-gauge, one-size patterned dress hose, while Italy and France can still turn out sized hosiery with some real character.

With most retailers preferring to carry only stretch socks and most men not even knowing their true size, other than the more expensive European sized hose, it is one predictable world of dress ankle fashion. Brooks Brothers, for decades the hosiery capital of the tie-wearing world, now has but one sock worth considering, its ultra-conservative sized wool or cotton ribbed dress sock. In the States, Paul Stuart, Barneys, and Sulka carry the best imports, while each major city has the odd specialty store carrying a smattering of imported sized European hose. Of the designer hosiery currently being offered, Ralph Lauren's is by far the most elegant of the commercially made one-size.

However, with dress-down fashion gaining wider acceptance around the world, casual hosiery is flourishing and, with it, many appealing, chunkier foot cushionings. As this area allows for greater texture and fiber combinations, the hose have a much greater range of design possibilities. Here, the one-size-fits-all sock provides comfort, function, and fashion when worn under the larger, less-than-exact-fitting athletic shoe or walking boot. Since such footwear usually

covers the entire ankle, this hosiery can be provocative and colorful—only you and a select few will ever see them.

Unless the economies of producing elegant hose change in the near future, sized hosiery will go the way of the exact-sleeved dress shirt. It will virtually disappear for those who cannot afford to pay its higher price. If you do come across some sized vestiges of a previous time like hand-clocked lisle hose, patterned wool hose, hand-knitted cables, or real Scottish argyles or bird's-eyes, like a collectible, buy as many of them as you can afford and squirrel them away for some special future occasions.

NECKWEAR:
ICON OF WESTERN CULTURE

This adjunct to male elegance once carried more information about its wearer than any other item in his wardrobe. Whereas a man's suit told you something of his present position, the necktie—be it of the club, old school, regimental, or wedding variety—was usually a reliable chronicler of his past. It could speak volumes about his breeding, education, or social station. The go-go fashions of the eighties transformed the tie's traditional role as harmonizer into a ornament of surfeit. However, with the tailored-clothing market reflecting the current decade's increasingly sober and less grandiloquent mood, the neckwear aesthetic is once again in transition—searching for a more mannered yet modern expression.

The eighties were not the first time America subverted the conformist nature of the necktie with a riot of fantasy. The bold, brassy ties that became so popular in the States after World War II tore down the barriers of both good and bad taste. Yet they were an anomaly in what was still a stylish nation. It is common today to see an otherwise reasonably well-dressed man mar his entire presentation by donning some banner of a necktie as overwrought in design as it is self-conscious in taste. Relearning, or learning for the first time, the necktie's eloquent metaphorical language will not be easy, because its former poetry has been buried under an avalanche of excess. Whether a generation conditioned to wearing ties as manifestos of liberation will use this otherwise functionless strip to project an air of sophistication rather than a rush of libido is the question of the day.

Advising a man on how to choose a stylish necktie is like helping him to pick one that makes him feel handsome—the final decision is that subjective and personal. Ideally, the necktie should be a strong indicator of the taste and style of its wearer. Yet despite its potential for conveying the wearer's individuality, it's no longer clear who the modern necktie speaks for. Sixty percent of all men's neckties are purchased by women. Not too long ago Bill Blass, one of America's preem-

inent taste makers, observed, "A woman should not play too large of a role in the clothes a man wears. Men who have learned to mix patterns have mastered something very important. Since a tie is one of the best forms of self-expression a man has, why should his wife pick it?"

I not only endorse that sentiment, I would go even further: it is virtually impossible for a man to dress well if he does not select his own clothing. With few exceptions, sophisticated dressers—be they men or women—rarely trust their wardrobe choices to a second party, no matter how respected or beloved that person might be. The man who aspires to cultivate a feel for stylish neckwear must be willing to immerse himself in the trial-and-error process of its screening selection. One can learn as much from a failed purchase—the tie that looked so smart in the shop but now rarely escapes his closet—as he can from one he cannot stop wearing. Confidence comes from being able to make the right decision, not having it made for you.

PERMANENT NECKWEAR FASHION

Some neckwear designs transcend the caprices of fashion. Like a well-cut gray flannel suit, these ties retain their stylishness by virtue of their incontestable good taste. With the four-in-hand reclaiming its rightful role as the refiner of its surroundings, sumptuousness will again be the order of the day, and that means a revival of the woven necktie with its unparalleled richness of hand. Solid ties of all woven textures from satin to faille to grenadine will return, renewing interest in patterned dress shirts. Small Macclesfield wovens such as black-and-white shepherd's checks or silver wedding ties and simple two- or three-color geometrics will continue as the classiest neckwear known to spread-collared gents.

DIAGONAL GEOMETRY OF STRIPED NECKWEAR CHISELS AWAY BOTH BREADTH AND SOFTNESS FROM THE FACE.

Woven stripes will also find their place under the well-furnished chin. The smarter dresser will notice how their diagonal composition magically chisels away breadth and softness from the face. While their settings

will be less regimentally British, the direction of their stripes should indicate their English heritage. Following the jacket's left over right fastening, they should run from the left shoulder down toward the right pocket. Seventy-five years ago, when Brooks Brothers first introduced English repp ties to America, they cut them in the other direction (running from high right to lower left) to distinguish them from the stripes of the British club ties, which, technically, were to be worn by members only. This violation of sartorial dogma remains a point of contention between "striped blades" from either side of the herring pond.

Print ties will finally become less jazzy and therefore more refined. The lightweight jacquard cloths that lent the bolder print ties their sheen and bogus image of superior quality will now defer to heavier print cloths that feel more substantial in the hand. In contrast to those overrendered prints that almost insist on a neutral solid shirt as a backdrop, designs such as the impeccably civilized polka dot or two-color abstract, appropriately modernized in scale and setting, will also afford men a much wider range of shirting and suiting options. As cloths with greater surface interest become more acceptable in tailored clothing, neckwear will respond in kind by bringing back the textured neckties of old such as cashmere and silk for fall tweed wear and spongy, linenlike silks for the nubbier jacketings and high-twist suitings of summer.

JUDGING A NECKTIE'S VALUE

The price of a fine necktie today can range wildly from $50 to $150. Many of the criteria formerly relied on to identify the quality and degree of a necktie's handcrafting can no longer be discerned by the average consumer. Establishing the tie's relative value used to be a straightforward affair. However, modern technology has produced machines capable of simulating hand-stitching with such verisimilitude that they can deceive even the trained eye. Additionally, the designer business has dramatically altered the relationship between value and price. Under its standard, the article's visual composition—rather than the inherent quality of the tie's shell's fabric or craftsmanship—becomes the primary benchmark for valuation.

Today, the perceived status conferred by the tie's label, as well as the design of its shell fabric, constitute the major factors governing its purchase. Given how easily technology can feign a product's pedigree and that the allure of most neckties is grounded in their surface design, the average consumer must often rely on a store's reputation or the knowledge of a salesman to accurately judge its value. Frequently it is the individual shopkeeper who sets a particular standard of quality whether his customers demand it or not. Rhodes & Brousse in Paris still makes its ties as the firm always has—totally by hand on the premises. Tincati in Milan craft theirs with a costly hand-done loop keeper, allowing movement of the tie's front blade. Sulka's neckwear is lined in pure silk with a triangular stitch put in the neckband for reinforcement. Hermès uses more silk in its neckties than other printed foulard makers. If in doubt, ask someone from the store to explain the tie's higher price by pointing out its virtues, such as whether it is completely handmade, tipped in silk, and so on. If no one in the shop is able to do this, and such considerations are important to you, find a store that knows more about its product.

Thoughtful books on neckwear recommend a number of tests that can be performed by the prospective buyer to verify a tie's workmanship. You can hold the necktie suspended in front of you by its narrow blade to make sure it doesn't twist. This confirms it was made correctly and cut precisely on a forty-five-degree bias. Or you can verify a tie's resiliency by gently pulling it from both ends to see if it returns to its original shape. There are some other paces to put a tie through that years ago might have had some relevance to this discussion but needn't be mentioned here. I have subjected ties from high-quality stores or manufacturers to enough trials to conclude that for every tie that passed each of these inspections, I found another from the same source that did not. If, after knotting the tie, it was still to my liking, I would buy it anyway.

In my opinion, the only reliable gauge of a necktie's quality and value is the consumer's sense of feel. As you touch a tie's surface, your fingers must immediately respond to the sumptuousness of its outer fabric. Gently pressing down on it, you should detect the lush cushioning provided by its inner construction. Of these two main ingredients, the tie's most tangible asset, its outer shell, accounts for

two-thirds of its price. A costly tie should possess a rich and sensuous "hand." This term describes a fabric's tactile character—its weight, texture, and fall. All fine ties are made of 100 percent silk. No other fiber produces a fabric so densely soft or as capable of reflecting light so richly. The best silk for neckwear is woven or printed in Italy and England, though a few excellent examples can be also be found from France and Switzerland.

Ties must absorb a lot of pressure, especially in their knotting areas. Looking fresh and hanging straight when worn, uncreasing and returning to its original shape after wear, and resisting the ravages of continual knotting is the function not only of the tie's outer fabric but, more important, of its invisible interior. For the same reasons a tailored jacket's collar and armhole function better and last longer when hand-sewn, no wearable allows for more give than those sewn together by hand. Fine neckwear is either made completely by hand or by machine with hand-finishing. A skilled artisan can produce around ten hand-made ties per hour, while the hand-finished process can turn out several thousand in a day. In the 1970s, the Liba machine was invented to close the envelope of the tie. It has now been refined to such a degree that it can actually replicate the irregular slip stitches of the handmade tie. Even many seasoned manufacturers cannot spot the difference without taking apart the tie.

The one constant characteristic of a better-made tie is that it comes in three sections, while cheaper ones are composed of two. Many ties are tipped with a fancy acetate that is a dead ringer for silk. The resemblance is so close, asking the salesman is often the only way to tell the two fabrics apart. The best ties, of course, are tipped with real silk. However, there are two easily detected details of construction that, if either is present, immediately justify the tie's expense. Since both require costly labor, it is assumed that no maker would risk such an investment unless the necktie's shell fabric could also command a higher price. If you turn over the tie's apron or blades and find they are tipped with the same material as the shell rather than the customary lightweight

SELF-TIPPING: A TIE WHOSE BLADES ARE FINISHED WITH THE SAME FABRIC AS THE SHELL IS A COSTLY PRODUCT.

synthetic tipping, it is the product of a costly process. This self-tipping, or French tipping, as it was formerly termed, requires more of the outer shell's expensive silk.

On less expensive ties, the label is sewn on the back side of the front apron as a keeper of the narrower rear blade. Some better ties use the tie's own fabric for this self-loop, which certainly looks more refined and finished. However, the finest neckties go one step further by tucking the self-loop's ends into the blade's center seam, thereby anchoring it securely and insuring it will not pull out with wear. If the tie you are examining has either of these telltale ingredients, you are in the presence of neckwear art and should be prepared to pay accordingly.

SELF-LOOP: IF A TIE'S BACK LOOP IS TUCKED INTO THE CENTER SEAM OF THE TIE'S LARGER BLADE, IT IS AN EXPENSIVELY MADE NECKTIE.

The ultimate in neckwear craft is the seven-fold tie which, as its name indicates, is a silk square folded by skilled hands seven times to produce a cravat of matchless luxury. It has no lining other than its own silk. There are probably no more than four or five makers of this handiwork left in the entire world. This is distinctive haberdashery for true aficionados and you should expect to pay at least $125 for such an indulgence (see page 248, L'Uomo).

HOW TO WEAR A TIE

Whereas a tie's color or pattern represents the signature of its maker or designer, how it is worn says something only about its wearer. The only step in a man's daily dressing ritual usually performed with the aid of a mirror is the knotting of his cravat and its positioning up into the shirt collar. Over time, performing this male rite should become another manifestation of personal style. However, given the frequency and repetition of this daily habit, it's amazing how few men understand how a tie should appear when correctly set in a dress shirt collar.

Military officers are taught a dress line. This vertical line bisects the chin, continues down the middle of the collar and tie, passes through mid–belt buckle, and finishes at the tips of the shoes. This image offers

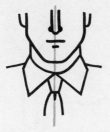

AUTHORITY IS CONFERRED IF
A VERTICAL LINE PASSES
THROUGH THE CHIN, THE
COLLARS' UPSIDE-DOWN V,
AND THE TIE KNOT'S DIMPLE.

a good guideline to follow when suiting up in a dress shirt and tie. When a dress shirt collar meets to form an upside-down V and is filled by a tight, purposely made knot whose dimple extends this imaginary downward line, the composition emanates subliminal authority. If the tie is not pulled up smartly into the collar and arched out a bit from the neck, the power of the entire arrangement becomes diluted. This is why serious practitioners of tie comportment often opt for tab or pin collars. The added support these collars afford keeps a tie standing at attention throughout the day with a minimum of periodic fixing.

KNOTTING THE TIE

The knots most men construct are usually hand-me-downs from their fathers. Although two knots—the Windsor and half Windsor—still enjoy limited usage, it is the four-in-hand that remains the knot of preference for most elegantly attired men. Not only is it the simplest knot to execute, it fits better into the average dress shirt collar than any other knot.

The larger, triangular Windsor knot was originally introduced to fill the opening created by the spread collar's horizontally angled points. Also, fuller-faced men felt this wider knot looked better under their large chins. Unfortunately, unless you wear a rather high-banded spread collar with longer points, the Windsor knot tends to lift the average collar points from the shirt's body. Sophisticated dressers also find its look much too self-conscious. The four-in-hand, with its conical and slightly asymmetrical shape, is infinitely more stylish. The half Windsor might be excused, if

THE NECKTIE SHOULD BE
PULLED UP INTO THE COLLAR
SO THAT IT IS TIGHT ENOUGH
TO ARCH OUT SLIGHTLY FROM
THE NECK.

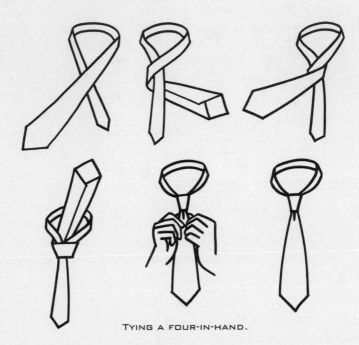

TYING A FOUR-IN-HAND.

only to give a thin tie a fuller knot. If your tie needs to have a larger knot, use the Prince Albert version, which basically loops over a second time. This produces a larger, cylindrical knot which can fit into more collars than the broader Windsors.

No matter which knot you prefer, never buy a tie whose bulk or texture will prevent it from being able to be smartly pulled up into the collar. Some knit ties or wool ties can make too large a knot if they are not designed properly. When in doubt, always knot them in the store to see how they sit in your collar. In fact, never purchase any brand of neckwear you are unfamiliar with, without knotting it up first.

A tie's proportions should relate to your jacket lapels and shirt collar. The width of its larger front blade should not exceed that of the jacket's lapels, although it can certainly be narrower. Choose a tie whose bottom width measures between three and a half and four inches, and you put to rest any fears that fashion may one day render it obsolete.

Though it may be acceptable in England, a tie's length should not be seen falling below the waistband of your trousers. If your tie is too long, tuck the offending excess into your pants in the style of Fred

Astaire or the Duke of Windsor. Its bottom will get wrinkled, but if it's always worn this way, it can only offend your closet. Tie bars are an excellent way to keep the tie from flying about and look better worn angled slightly downward. Wearing a necktie with a bar or tucked into the trousers will also keep it out of the soup while helping to maintain its arch in the shirt collar.

THE BOW TIE

Wearing a bow tie has never been an issue of fashion. Its adherents often wear them to signal their contempt for such a perceived insecurity. By implying that its wearer is a man of independent thought, the bow tie conspicuously separates him from the confor-mity of the necktied pack. However, the bow tie's identification as a formal accessory has done much to create mistrust in its use as everyday wear. Bow ties can be worn for all occasions and are appropriate with either single- or double-breasted jackets.

THE BOW'S WIDTH SHOULD FINISH WITHIN THE OUTER EDGES OF A MAN'S EYES AND THE OUTSIDE LINES OF HIS COLLAR.

A bow tie should not appear to over-whelm its shirt collar. As with other neck-wear, a bow tie needs to be framed by the collar. Reverse that perspective and you appear swathed. A slightly larger-scaled collar better offsets the bow's horizontal geometry. Collars such as Brooks Brothers' fuller-roll button-down, longer straight point collars, or semispreads with some degree of softness, all help frame the tie's irregular bow.

To wear a bow tie stylishly, two ele-ments must be considered. First, its width should not extend beyond the outer edge of a person's eyes or the breadth of his collar, whichever is wider. If it violates these borders, a man will appear festooned no matter how elegantly the bow is tied. And how it is tied is the second, more important issue.

BOW TIES THAT EXTEND BEYOND THE WIDTH OF THE WEARER'S FACE OR COLLAR MAKE HIM APPEAR GIFT-WRAPPED.

As with a four-in-hand, there is no reason to consider wearing a bow tie unless you plan on tying it yourself. Place a pretied model under your chin and you forsake any claim to individuality or style. It's like allowing someone to forge your signature. The lines may be exact, but where are the moody loops and unpredictable swirls that declare it completely yours? A bow tie's style, especially its unmanufactured imperfection, rests on its celebration of the individual. A too-perfectly-knotted bow tie looks prepackaged, measured, and ready to squirt.

Bow ties assume two basic shapes: the thistle and the narrower bat's wing. Though they can be worn interchangeably, the thistle end should not exceed 2¾" or be less than 2¼". And the bat's wing can range between 1½" and 2". Just as braces used to be sold in exact lengths, bow ties were formerly available in exact neck sizes. This made it nearly impossible to purchase one which finished in a bow whose width was too broad to fit the wearer's face, unless it was by choice.

Today, most bow ties come in adjustable sizes. Therefore, never buy a bow tie without first trying it on. You should always be certain how it looks tied and if its width can be altered by reducing the neck size. If your neck size is 16, you can always set your bow tie one half size smaller. This maintains the bow's width on the smaller size—the side to err on when in doubt. Some bow tie ends are so long, no amount of downsizing will render a proper fit.

With black-tie wear as the exception, avoid woven designs and concentrate on printed foulards when formulating your daytime bow tie collection. Like printed pocket squares, less formal bows need soft-ness and malleability if they are to come off looking unaffectedly nat-ural. However, striped bows should be of woven silk, otherwise they lose some of their schooled authenticity. In printed foulards, look for polka dots, newer geometrics, or any pattern that has some movement in its design. And remember, like a fine felt fedora, the bow will avoid looking like a point of exclamation only if its style resides within its manipulated imperfection.

KNOTTING THE BOW TIE

Learning to tie your bow tie is not the daunting task you might imagine; it requires the same skill most men had to master when they were taught to tie their shoes. First, sit down and cross your legs. Wrap

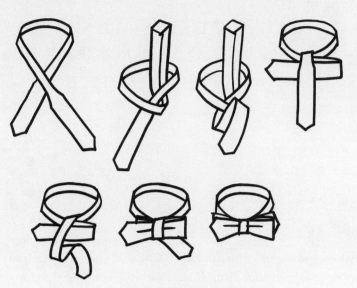

KNOTTING THE BOW TIE.

the tie around your thigh just above the knee. Hold one end of the tie in each hand. Close your eyes and tie the bow as you would your shoe laces. Opening your eyes, you should find that, though it may lack a certain aesthetic, you have tied the bow into a recognizable knot.

With the tie still wrapped about your knee, you can begin to fine-tune the bow. Hold its left loop in your left hand and its right loop in your right. Pulling the two sides in opposite directions will tighten the knot while pulling the tab ends will reshape and straighten the loops. Even though the bow tie may look delicate, you will learn how solid its knot becomes and find it will remain so until it is untied. After familiarizing yourself with this process, replicate it in front of a mirror while still shirtless. A shirt collar only complicates the learning process for a novice (see diagram). You may have to repeat this exercise several times, but don't be frustrated. Once learned, tying a bow tie is like riding a bike.

ACCESSORIES:
BELTS AND BRACES,
JEWELRY, HANDKERCHIEFS

BELTS AND BRACES

At the start of this century, suit trousers rarely came with belt loops. Now, as the year 2000 approaches, few are made without them. During the 1920s, the height of male elegance, most gentlemen sported braces (an English invention and term), since most suits were worn with vests, and belts added yet another unnecessary layer of bulk around the waist. During the Victorian era suspenders were held in the same regard as underwear. With the emergence of the two-piece suit, they became exposed to public view—a sign of poor breeding. As a result, belts gained acceptance for business wear and found an unqualified reception by the burgeoning sportswear market.

Braces fell further into disuse as men accustomed themselves to belts during World War II and continued to wear them in ever increasing numbers throughout the gray-flannel era of the 1950s. As the waistline slipped to the hips during the peacock era of the sixties and mid-seventies, the fortunes of suspenders experienced a similar descent. Tight-fitting low-rise trousers and hip-hugging jeans kept suspenders as the private province of the Savile Row dresser and East Coast WASP. It was not until the early 1980s, when fuller-cut clothes returned to favor and the trouser returned to the waistline where it started, that braces began to win back a little of their own. However, with the ascendance of the slouchier, Armani-inspired dress, their popularity again waned. Today, braces continue as the choice of suspension by men who like their clothes to feel and drape in the old-fashioned, time-honored way.

Originally a brace, like a belt, was
made in exact sizes so that its back fork
and adjustable front levers could be appro-
priately positioned according to the
wearer's height. Its levers were supposed to
rest in the hollow created by the protuber-
ance of the chest and the taper of the
waistline. If set above the bottom half of
the chest, not only would the levers' double
layer of ribbon bulk up the chest, but their
gilded buckles would be distractingly close
to the wearer's face. Today, most braces are
sold in only one size, so the majority of
them are cut to accommodate taller men,
leaving shorter men with buckles up
around their necks. If your braces are so
cut, ask the store if they can shorten them.
If they are unable to, take them to a shoe
repair shop that has the machinery to do
the job properly.

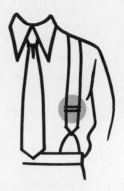

THE BRASS LEVERS SHOULD
REST IN THE HOLLOW BETWEEN
THE PROTUBERANCE OF THE
CHEST AND THE TAPER OF
THE WAISTLINE.

The front buttons inside the sus-
pended trouser's waistband should be
directly in line with the main pleat closest
to the fly. This not only helps the pleat to
lie smoothly when standing, it also defines
the trouser's crease and anchors its depth.
Buttons set too far to the side of the trouser
reduce the pressure on the shoulder strap,
making it likely to slip from the shoulder.

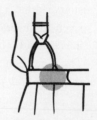

THE POSITIONING OF THE
SUSPENDER TAB DIRECTLY
OVER THE FIRST PLEAT IS
ESSENTIAL TO CONTROL ITS
OPENING AND MAINTAIN
TENSION ON THE TROUSER'S
FRONT CREASE.

For the record, few clothing or brace manufacturers use properly
shaped brace buttons. Ideally, when attached to the waistband, they
should permit enough space for the brace's leather loop to move freely
from side to side. Originally, during the era of vested suits, braces
attached to domed buttons on the outside of the trouser waistband.
Most brace buttons of today are so flat that attaching the suspender's
loop to the trouser becomes more difficult than necessary as well as
limiting the loop's freedom of movement.

BRACES OVER BELTS

1. The waist expands when you sit and returns to its smaller circumference on standing. The looser-fitting suspended trousers accommodate these changes in stomach dimensions. Belted trousers can only fit comfortably in one position or the other.

2. Braces encourage better posture. You can suck in that gut and jut out that chest without fear of losing your trousers.

3. With braces, you can set the desired length of the trouser in the morning, then never have to bother with them for the rest of the day. Belted trousers, fitted as they are to one precise length, tend to slip to the hip and require more attention.

4. Pleated trousers drape better suspended rather than belted. Set on the natural waist and above the horizontal tug of the hips, their pleats remain defined and move gracefully in concert with the leg.

5. Unless a man's front is washboard flat, belts tend to push the stomach out, spreading the pleat unnecessarily.

6. Even more than a necktie, braces allow the wearer the option of injecting a bit of his own personality into the visual fray.

7. The extension waistband of a braced trouser is more simple and thus more refined than that punctuated by a belt buckle.

BELTS OVER BRACES

1. Many men regard the wearing of braces as too much of a cultural cliché, too readily assigning them to a particular social background or business path. Belts are stylistically neutral and leave more of the wearer to be revealed at his own discretion.

2. Men who wear their trousers on their hips or under their stomachs cannot do so comfortably while wearing suspenders.

3. Brace straps can easily slip off men with sloped shoulders.

4. Many men believe that the belt and buckle appear sexier to women.

5. In summer, when the body perspires more, one becomes increasingly conscious of the straps lying on his torso, even though the space between the body and the suspended trouser permits more air to circulate. Historically, it was during those warmer months that men started experimenting with belts.

BUYING THE SUSPENDER

Today, the finest suspenders are made of rayon, replacing yesteryear's silk. The straps are cut in 1¼" or 1½" strips. Any smaller and they will bind; any wider and they will feel cumbersome and unnatural. Never buy braces with clip ends or in an elastic fabric unless you are also planning to purchase a farm. Avoid braces made with necktie silk that is backed for reinforcement, as they are neither authentically stylish nor durable. Any design on the braces' straps should be woven into them rather than printed on the surface. Only woven designs possess the structure and character to convey this appurtenance's utilitarian lineage.

Top-quality suspenders come with leather fittings and adjustable brass levers. England's Albert Thurston can still turn out the Rolls-Royce of brace construction, while America's Trafalgar makes a lighter-weight brace with top-quality fittings as well. The knitted ends seen frequently today were originally favored for evening wear, since their softer, pliable ends felt less bulky under a waistcoat or cummerbund. Their colored ends relieve one from adhering to the conventional protocol of matching this leather detail with the color of the shoe.

If the store is prepared to pay a premium, Thurston will still make hand-stitched white catgut ends that will eventually turn cream, imparting an aged patina. Since most Englishmen adhere to black for town footwear, the white catgut was always preferred for the brace's leather trim. However, in an effort to hold down prices, white, black, or brown machine-made ends have been introduced. But, like the working buttonholes on custom-made jacket sleeves, if you want to trump the hoi polloi, the old-fashioned white catgut earns the connoisseur's nod.

Since braces share the same vertical plane as the tie, their coordination is primarily guided by their relationship to each other and only secondarily to the dress shirt and trouser. The sophisticated dresser demonstrates his sartorial faculties by using the lines of the brace to frame the composition of the furnishings. Solid or striped braces achieve this objective with more versatility and ease than patterned ones. As most men's neckwear tends to be patterned, the solid or striped ribbon can pick up one of the colors without conflicting with the tie's design. Patterned braces, on the other hand, are easier to coordinate with a solid or striped necktie.

BUYING AND WEARING THE DRESS BELT

Not only should the dress belt's exterior be made of a fine-grain leather, its underside should also be leather-lined. When buckled, its end should be long enough to finish through the trouser's first belt loop, but not so long as to run past the second. Its width should vary between 1¼" and 1½". The dress belt's color should conform to the ensemble's other visible leather element, the shoe. This usually eliminates most hues except those that are shades of brown or black. Buckles should be sturdy but simple, in brass or silver, depending on the color of your jewelry.

Dress belts should be darker than the suits they are worn with. The darker and finer the leather, the dressier the belt. Lighter-hued leathers set against the backdrop of a darker trouser convey a sportier nuance, as does a rougher-grained or more textured leather. Crocodile and lizard constitute the luxury end of the dress belt spectrum. As the Boston Brahmins have long known and the Northern Italians have recently affirmed, mating brown shoes with any traditionally colored business suiting ranks a smidgen above the predictable black on the sophistication scale. As brown shoes are going to be more frequently seen in the company of dark suits, you would be well advised to consider investing in the finest brown crocodile belt affordable.

HANDKERCHIEFS

Since the close of the fourteenth century, when the English monarch Richard II declared it boorish to blow one's nose either on one's sleeve or the floor, the use of a handkerchief has been considered a symbol of gentility and social rank. The lineage of the navy blue blazer may in part be credited to this desire to impose a higher standard of propriety among those in service to the crown. As legend has it, the captain of the HMS *Blazer*—in anticipation of a visit from Her Majesty Queen Victoria—outfitted his crew in navy serge jackets to smarten their appearance and affixed rows of brass buttons on their sleeves to discourage them from wiping their noses on their all too visible sleeves.

Immediate availability has always been a requirement for any handkerchief; the user must have ready access to it if he is to head off

that unexpected sneeze before it becomes a source of embarrassment, mop up the spilled champagne before it flows into the lap of a guest, or other social niceties. During World War I, officers cached their handkerchiefs within their coat sleeves, in deference to their uniform's hard-to-open buttoned-down or flapped pockets. Soon after, the one for "blow" was tucked safely away in the unflapped rear trouser pocket, while the dress handkerchief, the one for "show," returned to its rightful place, the breast pocket. All properly designed tailored jackets have such a pocket, appropriately angled to better contain and set off the breast handkerchief. As no serious writer would want to compromise his prose by omitting the correct punctuation, no serious *élégant* leaves his chest pocket similarly unattended.

As with the adaptation of like artifacts of sartorial polish— French cuffs, collar bars, braces, and so forth—the donning of a chest handkerchief is an act of dressing up and finish. As such, it is an enterprise that most men avoid like some plague, fearing that they will do it incorrectly, badly, or both. To the less sophisticated it can smack of the effete and precious. This is unfortunate, since the inclusion of a simply folded white linen handkerchief into a suit jacket's chest pocket is the simplest and least expensive way to give a mediocre suit the aplomb and distinction of a more expensive one.

Complicating the question as to whether the omission of such an elitist trapping equates to a lack of stylish propriety is its philosophical conflict with today's ethic of minimalism as it equates to dressing. The pared-back simplicity and monotone rigor favored by current fashion thinking is undermined by the inclusion of such a high-contrast embellishment. The problem could be sidestepped by lowering and angling the chest pocket's position and filling it with dark-toned, less high-contrast pocket squares, thus bringing it more into the whole. But for now, since that thought represents a fashion that may never materialize, I will confine this discussion to the guidelines as set down in the heyday of breast pocket fashion—the 1920s and 1930s— when no man could consider himself a practitioner of fine dress having not yet come to terms with the minor art of rigging out the breast pocket.

One would be hard-pressed to find a picture of the Duke of Windsor, Fred Astaire, or Gary Cooper in which some form of pocket

square is not in evidence. For each of these Promethean dressers, the breast pocket afforded yet another opportunity to express his own style. While the Duke of Windsor's linen hanks were always neatly folded, they were worn at odd angles and in unconventional positions in the pocket opening. Gary Cooper's were less self-consciously folded, looking as if he had only just stuffed it in a few seconds before greeting you and possessing the same unstudiedness as his curled-up dress shirt collars. Fred Astaire liked to wear his silk squares in a puff fold he allegedly invented. Wearing a handkerchief that looks neither affected nor sloppy is akin to developing a discerning palate for good wine or food; it takes some practice. Douglas Fairbanks Jr. often reminded me that if you want to dress well, it takes time to look as if it took no time at all.

DRESSING THE BREAST POCKET

In order to purchase a pocket handkerchief wisely, you should know beforehand how you plan to wear it and what colors you expect it to meld with. Pocket decor is but one element of an entire composition. It should not be used as an exclamation point or function as one end of a parenthetical bracket (with the other end being the tie). The observing eye should never be encouraged to travel horizontally across the wearer's body. Overtly coordinating, or even worse, matching the tie and handkerchief, is a sure sign of an unsure dresser.

Pocket handkerchiefs are harmonized on two bases: color and texture. If a solid handkerchief is chosen, its color should echo one color in the tie's design, provided it is a multicolored pattern. If the pocket square is patterned, one color of its design should match or, at a minimum, complement the dominant color in the solid or two-color tie. When wearing a multicolored pocket square, it is simplest to keep to a solid tie or simple two-color stripe with more ground than stripe. Use one of the hank's colors to reflect the primary color of the tie. If particularly skilled, you can use the remaining hues to pull in the shirt and suit.

To play down any contrivance, the textures of the tie and pocket square should also differ. Once you accept this

A FINE HANDKERCHIEF'S
EDGES ARE ALWAYS
HAND-ROLLED.

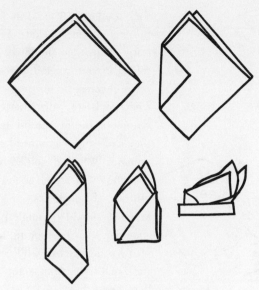

FOLDING A LINEN POCKET SQUARE.

dictum, the too-common practice of wearing a tie with matching pocket square becomes a nonoption. If the tie has a silken luster, the pocket square should be of a dry material such as linen. If the tie is of a dulled fabric such as wool, linen, or cotton, the pocket square can be shiny, such as a printed solid or foulard.

Only in certain cases would it be considered in good taste to make the pocket square your ensemble's focal point. Dressy high-contrast ensembles such as navy and white for daytime or black and white for dinner wear can support the exclamation point of a brightly colored silk pocket square. This style works well so long as it is not forced to compete with another component for center stage, thereby breaking up the ensemble's symmetry into too many pieces.

Like the subtle hand-stitched edge of a finely tailored jacket lapel, a fine-quality handkerchief always has its edges rolled by hand. Since the linen handkerchief is folded to reveal its points, the edges need the graceful roll and stitch of handiwork to properly convey its refinement. The starchier linen hank produces a dressier look than the jauntier, printed foulard. The best size for a pocket handkerchief is the sixteen-to-eighteen-inch square, with the printed silk foulard light-

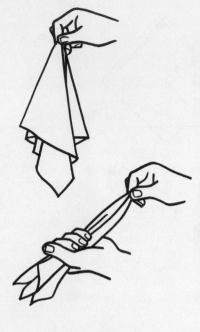

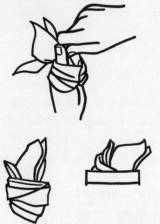

FOLDING A PRINTED
SILK SQUARE.

weight enough to hold its fold without bulking up the pocket. When considering a printed foulard, first try it folded in your pocket to see if it either bulges excessively or drops out of sight from lack of substance. The silks require a bit of careful technique so they can project a natural and unfussy aplomb. Whether folded with points showing or in some version of the puff fold for silk pocket squares, the handkerchief should be angled toward the shoulder. This positioning helps in fostering a dégagé air, while emphasizing the lapel's diagonal slant and shoulders' breadth.

JEWELRY

Some wearables cannot be classified as clothes, but without them many men would not feel completely dressed. In pre–World War II days, a hip flask and cigarette case were considered essential accessories for a generation that believed a drink before and a cigarette after were two of the three best things in life. The demonization of tobacco has stigmatized even the most stylish of smoking implements, while the flask has gone the way of the swizzle stick. For the moment, sex is still in fashion.

Since Victorian times, men have tended to avoid all but the most discreet and functional of decorative accessories. The 1980s—that decade of "affluent fashion"—revived those few sanctioned items of male self-embellishment that could succinctly communicate the

wearer's business and social status. With the return of cuff links, suspenders, the collector's watch, and select writing instruments came a proliferation of shops specializing in such paraphernalia. The eighties saw more men become collectors of vintage jewelry and watches than in any other period of this century.

The golden age of jewelry workmanship spanned the mid-nineteenth century to the outbreak of the First World War, with the Art Nouveau and Art Deco periods also producing some extraordinary design and craftsmanship. Today, sporting a pair of Edwardian cuff links or an early Cartier tank watch affords men one of the few opportunities to actually wear an ornament of beauty and antiquity without incurring the suspicion of his confreres. Being able to recount some fanciful but true anecdote explaining the item's origin, or recalling its first (and, ideally, celebrated) owner only enhances this collectible's secondhand mystique.

It's been said that watching a man undo his cuff links is every bit as sensual as hearing the zipper slide down the back of a woman's dress. While I cannot comment on the first part of that observation, one thing that I can state unequivocally is that no form of shirtsleeve closure dresses a man's hand better than a well-fitted French cuff punctuated by the subtle glamour of its buttonhole-covering link.

The most prized examples of antique cuff art have always relied on all four faces to convey their craftsmanship and lineage. To fully exploit the cuff link's decorative potential, each side should bear a design and be conjoined by a link or chain—the reason it is so named. Wearing a set that clips on one side not only exposes its superstructure, but suggests you could only afford to pay for the gold or gemstone on the outside. Though it is a bit easier to link your French cuffs with a bar that pushes through its four buttonholes, you end up dressing only half of each hand.

Cuff links with stones, even colored ones such as rubies, emeralds, or sapphires, were traditionally frowned upon as daywear and usually reserved for black tie as part of a set of studs with matching links. In the light of day, such a display would still be considered somewhat ostentatious, although they can certainly be worn after dark to accompany a dressy business suit. An antique set of studs is another acquisition to consider seriously. Like owning a fine pocket

or dress watch, having something different for formal occasions endows the ensemble with its own specialness and creates an heirloom that can be passed down to a son or beloved nephew in a rite of passage.

Another implement of elegance adopted by many knowledgeably dressed men is the gold safety pin, used to pull up a soft straight point or rounded collar into a dressier pose. Like the tab collar arrangement, this joining of the collar keeps the necktie arched and in place all day long. If the shirt is a better one made with cotton linings, the pinholes will disappear with washing. The gold pin should never be worn with a shirt whose collar has eyelet holes. This type of collar requires a bar with two balls (or some other shape) on either side, one of which unscrews to permit proper fastening. I've seen a few of the more swanky embellish their collar tackle by adding cabochon sapphires or small rubies to either end of the bar or pin. Avoid modern collar slides; most of them do not have sufficient spring in their mechanisms to hold the collar without slipping during the course of an active day and, as they generally tend to be too long, fail to pull in the collar sufficiently. However, if you come across one from a previous age when they were better constructed, test it with a tie done up in the collar. If it holds, snatch it up, as they are very rare.

Tie clasps, an American invention, can add a touch of controlled flourish. They should be bars of understated design neither large nor gaudy, although should you come across a whimsical one this is not a bad place to affect a little highbrow humor. The bars keep your tie from substituting as a napkin while helping the tie remain arched in the neckband. They also add a measure of panache for those shorter men who choose to tuck their ties into their belt lines à la Fred Astaire, who loved tie bars and high-waisted trousers. The aficionados angle theirs downward to affect a less posed air.

As for finger regalia, the simpler the better. More ornate nonmarital finger decorations are associated with men who make a living by commission. Signet rings are an elegant alternative to the simple wedding band or jeweler's ring. When engraved with the wearer's initials, they suggest one hails from the gentrified side of the tracks with forbears who might have used theirs to seal correspondence or parcel out land.

Fortunately, we have gone beyond the Victorian notion that deemed the public display of a timepiece vulgar, since a true gentleman's concerns were not supposed to include the passage of time. On the other hand (pun definitely intended), the actor Peter O'Toole may be carrying things too far when he wears watches on both arms simultaneously. When queried on an American talk show why the double dip, he replied, "Life is too short to risk wasting precious seconds glancing at the wrong wrist."

Early decorum required the pocket watch to accompany the tailcoat, while a slim dress watch was acceptable for dinner clothes or dressy day wear. Wearing a Dick Tracy–scaled timepiece with a business suit not only discloses the wearer's aesthetic insensitivity, it will also fray the shirtsleeve in no time flat. Gianni Agnelli, chairman of Fiat and Italy's own Duke of Windsor, resolved this problem in his own maverick manner by wearing it over the cuff. On him it looks aristocratically idiosyncratic; on most others, it looks contrived. Watches should be chosen to smarten the hand, not encumber it. When it comes to keeping time fashionably, especially during the low-key nineties, less is usually more.

FORMAL WEAR

If a man's suit ranks as the most articulate garment in the language of clothes, then his formal wear should guarantee sartorial eloquence. Due to the ritual surrounding the way it is worn and what accompanies it, formal wear's original spirit has been relatively well preserved. The simple combination of richly textured black accented by fresh white contrasts bespeaks refinement. And so it is that this last vestige of upper-class attire continues to live on in the dinner jacket, with its comforting certainty that all men look good in it.

Acquiring high-pedigree dinner clothes represents one of the more difficult challenges facing today's male consumer. That is not because, as with neckwear or sportswear, its variety can overwhelm one; rather it is because truly classic dinner clothes are difficult to find. Much of what is represented today as "black-tie" is the result of a store or manufacturer's judgment on how much of a difference from his normal business attire the average man is prepared to accept in his dinner clothes. This not only applies to commercially produced tuxedos, but to the majority of expensively hand-tailored ones offered in fine specialty stores as well. In some cases, straying from the archetype is motivated by cost. Tailoring the properly detailed tuxedo requires particular trimmings and therefore more labor. Often, however, its lack of pedigree is a function of simple ignorance resulting from not having been sufficiently exposed to the genuine article.

In spite of male evening clothes being highly formulaic and regimented by their very nature, opportunities to observe this particular masculine attire being worn correctly today are surprisingly rare. Menswear designers offer their alternative buttoned-up and casual versions each season, while the Hollywood crowd turns out its renditions for each year's televised awards ceremonies. Most of the innovations they concoct are motivated by the desire for individuality and comfort, and the resulting confections usually turn out to be less than

classic. The fact is that many men go to considerable effort to look special in a tuxedo when to do so is simply a matter of having the right information.

I feel that before one attempts to improvise in the ceremonial world of men's evening attire, it's important to understand the original design's intention and aesthetic logic. Trying to improve upon its ordered predictability in an effort to achieve a more personal expression is to be encouraged. But to create something unique and stylish, one should base such decisions on practical knowledge, rather than personal opinion or ephemeral fashion.

Since the culmination of the dinner jacket's final format in the late 1930s, nothing has improved upon the genius of its line or the refined aesthetics of its component furnishings. This does not mean that to own a fine tuxedo, one must have it cut or even tailored like those from the tuxedo's heyday. It does mean that its modeling and detailing must respect the exquisite relationship of form and function that were worked out through the collaboration of English tailors and shirtmakers with their fastidiously dressed customers of that stylish era. No other period could have produced such a success, because each step of the new form's evolution was being compared to and measured by the perfection of the outfit it was intended to replace, the grand-daddy of male refinement, the evening tailcoat and white tie. Not only did the tuxedo's final form end up projecting the same level of stature and class as its starched progenitor, it did so while providing considerably more comfort.

I will introduce briefly the dinner jacket's unusual history and its relationship to the tailcoat-and-white-tie ensemble, so that we may apply its rationale to selecting proper dinner clothes today. As W. Fowler said in his 1902 book, *Matter of Manners*, "The man who knows what to avoid is already the owner of style."

THE HISTORY OF THE DINNER JACKET
BLACK TIE, TUXEDO

As the name suggests, the original dinner jacket was to be exactly that, a less formal dining ensemble for use exclusively in the privacy of one's home or club. The original design was created during the mid-nine-

teenth century for the English prince who later became Edward VII. He decided there should be a comfortable alternative to the constricting swallowtail evening coat and bone-hard white-tie getup worn at the dinner table. The consensus is that the very first model of this shortened jacket must have been a rolled collar (shawl) double-breasted lounge suit in black worsted with grosgrain facings. The same design in velvet was worn as a smoking jacket by gentlemen at home, its grosgrain facings lifted from that of the tailcoat's lapels. Victorian ladies did not smoke and insisted any husband who did should confine this activity to his den. The smoking jacket could then be left there, in situ, so as not to radiate the noxious fumes around the rest of the house.

Edward's dinner jacket was admired by the husband of an American houseguest visiting him at Sandringham, his country estate, and the man asked the prince if he could copy it. Edward consented and the American brought the innovation back to his millionaires' club in Tuxedo Park, New York. In 1886, one Griswald Lorillard, sporting his version to the club's autumn ball, scandalized his hostess and hastened his departure, but forever established the jacket's place alongside the tailcoat-and-white-tie ensemble.

From that point in the late nineteenth century up through the early days of the 1920s known as the golden age of the British gentleman, black-tie attire continued as an option at home or in a men's club. However, for an evening in public, white-tie remained the dress of choice by polite society. The 1920s produced menswear's first unofficial designer, the new arbiter of fashion, David, the Prince of Wales, who was later crowned as Edward VIII but is better known by the title he took after his 1936 abdication, the Duke of Windsor. Clothes-conscious and a bit of a maverick, he was determined to throw off the stuffy formality of his father's generation of court-ruled attire and make clothes more comfortable for himself and his fellow aristocrats.

The prince often arrived for dinner in dinner coat and black tie when everyone else was decked out in full tails. Sometimes he would wear a lounge-coat-like double-breasted dinner jacket with silk facings on the lapels or he would take the piqué dress vest from the tailcoat outfit and wear it with a single-breasted dinner jacket. Before giving up the throne, he abdicated the boiled-front evening shirt and its separate stiff wing collar, replacing them with a soft, pleated-front dinner shirt

and its attached soft turndown collar. He devised a backless waistcoat with lapels to wear in warmer climes. Although he was not the first to wear it, he helped popularize midnight blue for dinner clothes, which by artificial light looked richer than black. By the end of the 1930s, with his international coterie of friends adopting such elegant comfort in public, the dinner jacket, an amalgam of the tailcoat and lounge suit, began to replace the swallowtail dress coat and white tie.

WHITE TIE AND TAILS

The king of all male civilian garments is the evening tailcoat. Its long tails confer dignity while its starched white expanse of piqué waistcoat, shirt, and tie flatters even the most rubicund of faces. The evening tailcoat has changed very little in the two hundred years since it was a riding coat. Its major alteration occurred when its double-breasted model was altered so it no longer buttoned in front. The single-breasted cutaway retained the button stance from the double-breasted model, as it does today. The outfit was, and still is, pretty straightforward, entailing very little choice in either color or detail. All that was needed was to tailor its established proportions to the wearer's frame, and presto: its debonair magic turned average men into movie stars.

THE PIQUÉ WAISTCOAT'S POINTS SHOULD NEVER EXTEND BELOW THOSE OF THE TAILCOAT.

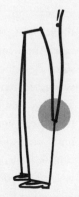

The outfit consisted of white piqué bow tie and matching stiff white piqué-front evening shirt with attachable wing collar, worn with a single- or double-breasted piqué vest, black worsted swallowtail coat, and matching trousers trimmed with two rows of braids on the outside of each leg. Black silk hose worn under patent leather oxfords or opera pumps with grosgrain bows completed the uniform. A white linen handkerchief with hand-rolled

THE CORRECT BACK LENGTH OF A TAILCOAT SHOULD LINE UP WITH THE BACK OF A MAN'S KNEE.

edges graced the breast pocket, while a colored carnation as boutonniere was optional. The only dressing errors egregious enough to

scuttle its perfection were if the waistcoat's points extended below those of the tailcoat's front (a common occurrence today) or if the length of the coat's tails were not resting exactly in line with the back of the man's knees.

THE WHITE-TIE EVENING SHIRT

The piqué-front evening shirt had a separate stiff wing collar whose shape evolved from turning down the corners of a stiff stock that was worn with a starched cravat, a nineteenth-century Beau Brummell fashion. The white piqué bow tie was made to exact neck sizes, so that in addition to covering the exposed metal head of the front and back collar studs, the bow's intended width was fixed.

The wing collar sat high under the chin, giving extraordinary stature and definition to the face and chin. Its high back was to show 3/4" above the jacket's collar, or 1/4" higher than the black-tie's more comfortable turndown collar. The collar's wings helped to keep the piqué bow in place by pressing it forward. The angle of the opening and height of the collar determined the style and size of the bow tie. The outer edges of the bow never finished outside the edges of the wing collar (see page 193, Poulsen & Skone). This boilerplate guide for all bow-tie wear was established during that time and is respected even today.

Complementing the wing collar, the evening shirt's sleeves took single, stiff cuffs that, like the collar's height, were intended to show more than the softer French-style double cuffs of the black-tie dress shirt. The "boiled" shirtfront look took one or two studs, and the type of stud fastener determined the size and shape of the opening through which it connected with the stud's head, thus covering any evidence of the shirt's construction. The shirt's bosom, a biblike design in stiff linen or piqué, was to fit so that its width did not extend under the trouser's suspenders, and its length was to stop short of the trouser's waistband. Because of its stiff front, if you sat down without it being secured to the trouser, it would billow out like a sail in full wind. A tab with buttonhole affixed the shirt to a special button in the trouser's waistband, keeping it in place and worry-free.

For all of this arithmetic to add up, the dress trouser needed to fit on the natural waist and not below it. This was accomplished with the help of suspenders (termed "braces" in the King's English). Without a

high-waisted fit, the vest would not cover the bottom part of the shirt's bib and have its points finish above those of the tailcoat. With all of these studs, straps, and buttons needing to be in their proper place, putting on the white-tie ensemble might appear to be a form of Victorian bondage. In fact, when the clothes were tailored correctly, they were both comfortable to wear and moved in graceful concert with the wearer.

Most of these designs were transformed and worked into the classic tuxedo's final composition. Thus the stiff white-tie and "boiled" shirtfront gave way to the black-tie's softer lines without compromising its formal look, and so on. Keeping in mind the design heritage one searches for when selecting a tuxedo, let's move on and consider this information as it applies to today's black-tie dressing.

DINNER JACKET DOGMA—THE DETAILS
WEIGHT

Most formal affairs are held indoors, where central heating and air conditioning insure comfortable temperatures. So most men prefer a fabric weight that provides comfort for more than a single season. Unfortunately, contrary to popular opinion, there is no such thing as a year-round weight; no cloth can both warm you in the frost of winter and cool you in the heat of summer. However, a fine worsted cloth of nine to ten ounces will get one through most climate-controlled environments rather handsomely. Since most affairs include dancing and dining, when in doubt, err on the lighter side. While your dinner jacket may never drape like the gravity-prone, fourteen-ounce ones worn in the old movies, you should not have to suffer in pursuit of elegance either. If you wear a dinner jacket frequently enough to justify owning more than one, a choice of weights will certainly expand your style and comfort quotient. You could drop to a lighter, seven-and-a-half- or eight-ounce fabric for summer wear and move up to a fuller eleven- or twelve-ounce weight for fall and winter.

MODEL

A man of any size, shape, or weight can look stylish in a double-breasted tuxedo; it just depends on how it is cut. Both single- and double-breasted models are equally authentic and correct. The single-

breasted model is worn unbuttoned, requiring its exposed waistband to be covered by a cummerbund or dress vest, and providing more opportunities for accessories and thus versatility. The double-breasted model relieves you of this additional layer around the waist, but the jacket looks better buttoned when the wearer is standing. Men tend to unbutton it when seated, so this model ends up being fussed with more than its single-breasted counterpart. A double-breasted dinner coat is never worn with a vest or cummerbund underneath.

COLOR

Black is the norm, while midnight blue with black trimmings is also worn. Midnight blue comes across less green and more rich in artificial light than black; however, such a garment is rarely offered in the ready-to-wear world. In America, between the beginning of the summer season, June 1, and the end of August, an off-white or tan-colored dinner jacket may be worn. On trips to the South or warmer climates, these light-colored jackets are perfectly acceptable throughout the year.

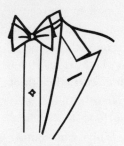

THE PEAKED LAPEL IS THE MOST DRESSY DESIGN FOR DINNER JACKETS.

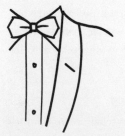

THE SHAWL LAPEL IS ALSO CORRECT AND DEBONAIR.

LAPELS

Only shawl or peaked lapels are used for dinner clothes. Peaked derives its heritage from the tailcoat, shawl from the smoking jacket. The shawl lapel produces a softer, old-world image and tends to be used on alternative tuxedo jackets such as the white summer dinner jacket, velvet smoking coat, or more idiosyncratic ones in wool tartan or cotton madras. Men with round faces or less muscular physiques generally look smarter in the uplifting, sharper-angled, pointed-end peaked lapel. Both lapels possess the sweep and self-importance that helps differentiate the black-tie coat from the less formal suit jacket.

A dinner jacket with notch lapels is a sartorial oxymoron, like sporting a dinner shirt with a button-down collar. (Actually, I've seen this done as a kind of tongue-in-

cheek old-boy eccentricity.) Not only does this sportier coat lapel design lack the aesthetic logic and refinement required of formal wear, its casualness makes the rest of the ensemble look common and less dignified.

All dinner jacket lapels require a working buttonhole on the breast pocket side for a boutonnière. Many times, one finds himself in a wedding party or other official circumstances as an usher where he is asked to wear a flower. There is nothing more sophomoric-looking than having to pin one on the lapel. It makes this one flourish of tail-coat élan appear clownlike.

Custom-made dinner clothes pay even more attention to the buttonhole area by sewing a loop as a stem keeper under the lapel. You could ask the store if they could cut a buttonhole in the dinner jacket's lapel, although they will probably discourage you. It takes a qualified tailor to correctly determine its proper location and to execute a well-finished buttonhole through the silk-faced lapel. It is done all the time in custom clothes, however, and even if the buttonhole is machine-made, the boutonniere will cover it up. The buttonhole should be no less than one inch in length.

POCKETS

The tuxedo pocket must be dressy, yet simple. There is really only one type that should appear on the dinner jacket and that is the jetted or double besom pocket. Besom pockets can be of self fabric, as on a dressy day suit, or trimmed in the lapel's silk facing. Flap pockets belong with notch lapels; neither were ever intended for formal clothes. While flap pockets are cheaper to make (as are notch lapels), they also add a layer

THE JETTED OR DOUBLE-BESOM DESIGN IS THE ONLY POCKET STYLE APPROPRIATE FOR A DINNER JACKET.

of cloth to the hip, and are thus neither slimming nor simple enough for such elegant apparel. Just as you would not expect to find peaked lapels on a tweed sports jacket or cuffs on dinner trousers, you should not see pocket flaps on a dinner jacket.

VENTS

The original dinner clothes were made ventless and then later offered with side vents. Ventless jackets are more slimming while side vents provide easier access to trouser pockets and are more comfortable to

sit in, something one does a lot at formal occasions. Single vents are fine for horseback riding, as they open up, providing comfort while in the saddle. Unfortunately, they also open up when a man puts his hand in his coat or trouser pocket, exposing his back side as well as a patch of dress shirt. Single vents are acceptable on single-breasted coats, never on double-breasted ones, and with their sporting heritage, they compromise the intended formality of the tuxedo.

TRIMMINGS

Because grosgrain or ribbed silk was originally used on tailcoats, this style of trimming has always been considered a bit more refined than the shinier, more theatrical satin. In the early days of off-the-peg English tuxedos, many carried satin facings, so the ribbed silk came to be identified with the Savile Row–made tuxedo. The best facings are made of pure silk, while less expensive ones contain a synthetic component. Shawl lapels look fine in satin or grosgrain. Grosgrain facings permit some contrast in textures for the bow tie, while satin facings demand the bow tie to match which, especially if not hand-tied, will produce a more contrived effect.

The dinner jacket's buttons can be plain or covered in the lapel's facings. Some of the more old-world custom tailors cover their dress buttons in a fine, woven silk design, which at first may look a bit fancy, but can be quite subtle and distinguished. Like the tailcoat and better lounge suit, the jacket sleeves are to be finished with four buttons, their edges touching. Fewer buttons is not dressy enough, more is frivolous.

THE DINNER TROUSER

Pleated trousers are compatible with a cummerbund or waistcoat. Sitting is certainly a lot easier and more comfortable in pleated trousers than plain front. Their waistband must be covered, so they need to fit as high on the waist as is comfortable. Suspenders help to maintain their correct height, and keep their pleats lying flat under the waist covering. The side seams are trimmed with one band of facing (as opposed to white-tie, with two rows), which should conform in texture to the lapel facings—satin for satin, braided for grosgrain.

 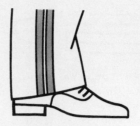

THE BLACK-TIE THE TAILCOAT
DINNER TROUSER TROUSER REQUIRES
CARRIES ONE STRIPE. TWO STRIPES.

Dinner trouser pockets are usually cut on the side seam. Vertical pockets are dressier and easier to get to, especially if their top section is partially covered by a weskit or cummerbund. Better dress vests have side slits to facilitate pocket access. Dress trousers never take cuffs. How could they with their side-seam decoration? A wonderful depiction of this tradition can be enjoyed watching the Fred Astaire classic *Shall We Dance*. (For fit, see page 14.)

THE BLACK-TIE WAIST

Hardy Amies, the English tailor, would term it "naf or off," while the legendary English fashion journalist George Frazier would certainly sigh and complain it lacked any *duende* (style) at all. A trimmed waistband, as a substitute for a waistcoat or cummerbund, is thoroughly "bush league," to borrow a phrase from the days when this novelty was first introduced. Formal dress is ultimately about good form, and sometimes quick fixes that compromise such form need to be recognized as such and be avoided. The tailoring or finishing in high-class evening wear should be invisible, starting with the dress shirt's stud hole and extending to the trouser's waistband and side seam.

While shawl-lapel dinner jackets look elegant with either form of waistband covering, the cummerbund's curved design harmonizes particularly well with this shape of lapel. A fine-quality cummerbund has a little pocket stitched behind its deepest pleat on the wearer's right side. This was to provide a handy and dignified place to keep theater or opera tickets at the ready, which explains why the cummer-

A CUMMERBUND'S FOLDS ALWAYS FACE UP
TO HOLD THE EVENING'S TICKETS.

bund is always worn with its folds pointing upward. The single-breasted peaked-lapel jacket, like its sartorial antecedent, the evening tailcoat, synchronizes better with the dress waistcoat, as the vest's points below the waist echo those of the coat lapels worn above the waist.

THE BLACK-TIE DRESS SHIRT
The Collar

Two collar styles qualify as dignified enough to support the more formal design of the dinner jacket. The original, appropriated from the tailcoat ensemble, is the stiff wing collar. The second, introduced by the Duke of Windsor as a more comfortable alternative, is the attached semispread, turndown model.

Both collars do justice to any of the classic dinner jacket models, but of all the possible permutations, the one combination that tends to look better balanced is the wing collar with the single-breasted peaked-lapel dinner jacket. Again, its dramatic points are in perfect harmony with the coat's lapel design. Other than that particular combination, both collar styles are correct with either jacket or lapel style.

However, one of the more unfortunate casualties of the modernization of black-tie attire was the wing collar evening shirt. Its separate collar succeeded uniquely in framing and refining a man's face because of its stiff, high, wing design presentation of the bow tie. Once attached to the shirt, it began to be lowered and softened to fit a broader range of necks, and lost not only its stature but also its function. In spite of its resurgent popularity, today's wing-collar evening shirts make most men look like mad scientists, as with one twist of the neck, their collar points crumble and roll over the bow tie. They have little height, no snap, miniature wings, and, not surprisingly, little presence. It's no wonder that ideas such as a banded collar evening shirt with a fancy button closure is being substituted. At least it offers a modicum of interest in an area where the drama of the wing collar would have formerly upstaged all the competition.

DINNER SHIRT DETAILS

The less dressy turndown-collar dinner shirts usually have a soft pleated front. Sometimes they are made with a piqué collar and matching front, called a Marcella dinner shirt (see page 173, Budd). Since the wing-collar dress shirt commanded a more severe formality, it took a stiff and simple front, either in piqué or starched cotton. Even though it is common to see today's wing collar mated with a soft, pleated front, it is yet another example of mixing sartorial metaphors— much like wearing a tassel loafer of patent leather. All fine dinner shirts should be made with a bib-type construction so their fronts do not billow out of the trouser tops when seated. Better dinner shirt fronts finish above the waistband and have a little tab that attaches to the trouser's inside waist button to keep it from pulling up. The width of the shirtfront should not extend under the wearer's

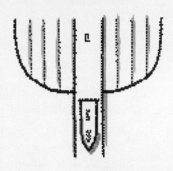

THE PROPER DINNER SHIRT IS CONSTRUCTED IN A BIB FRONT DESIGN SO AS NOT TO EXTEND UNDER THE TROUSER WAIST- BAND WITH A TAB TO SECURE IT TO THE TROUSER, SO THAT IT DOES NOT RIDE UP UNDER THE WAISTCOAT OR CUMMERBUND.

suspenders. Wing collar shirts take one or two studs, turndown collars take two or three. Black-tie dinner shirts require a double or French cuff.

THE TUXEDO BOW TIE

The bow's color and texture are governed strictly by the jacket's lapel facings—satin for satin trimmings and a ribbed or pebble weave variation for grosgrain facings. Its thistle or bat's-wing shape is a matter of personal preference. The bow's width should not extend beyond the outside edges of the collar's wings or spread collar's perimeter (see page 55). Bow ties are always worn in front of the wing collar (see page 193). The original collars were bone hard, and therefore it was impossible to place their parts over the bow.

Although the black-tie ensemble is a rather strict form of dress, its bow tie and pocket handkerchief offer some latitude for personal expression. They both look best done by hand, and a lack of perfection is desired, humanizing the ensemble and making it appear more indi-

vidual. Most men cringe at the very thought of having to knot their own bow, but it is rare to find a stylish man who has not overcome that fear. It is one element of formal wear that continues to separate the skilled dresser from those who are content to let the form wear them.

FORMAL FOOTWEAR

The most aristocratic and elegant of all evening footwear is the black calf opera pump with black grosgrain bow. The man's pump, a word believed to derive from "pomp," is the oldest surviving vestige of nineteenth-century court fashion still in popular use. Originally worn in concert with silk stockings and silk knee breeches, its somewhat effete image accounts for its being misunderstood by the more macho contemporary dresser. Today it can only be found at Polo Ralph Lauren or Paul Stuart in Japan. Still the favorite of the connoisseur, its slipperlike club elegance bespeaks the unique character and upper-class heritage of black-tie attire. A more conventional alternative used to be a lace-up patent leather oxford (also more difficult to find), and in the correct shape, this shoe is quite classy in its own right.

The ideal ankle wrapping to augment all this polished swellegance is the black silk, over-the-calf or garter length hose with a self or contrasting clock design down either side. The silk's dulled luster echoes the understated sheen of the trouser's side braid while enriching the dulled matte surface of the surrounding worsted trouser and black calf shoe. The silk's surface also repeats the texture of the opera pumps' grosgrain bow, adding the relief of illumination at the end of a long stretch of dark black worsted.

COLLECTIBLE TUXEDO ACCESSORIES

In aspiring to make your formal attire appear less penguinlike, it is very easy to end up gilding the lily rather than personalizing it. The idea is to accent the composition of black and white with a single flourish of spice, a pinch of dissonance. The safest strategy is to replace one element in the arrangement with either a third color or two-color pattern, leaving the rest to keep the structure pulled together.

The best colors are those rich enough to hold their own against the severity of black and white, such as bottle green, burgundy, Vatican purple, deep gold, or dark red. If a pattern is chosen, it should be a recognizable classic such as polka dot or houndstooth, or tattersall in two colors with black as one of them (that is, black and red, black and gold, or even just black and white). The ideal position for this dollop of panache is where it can be surrounded by black and thus integrated more into the whole. A vest, cummerbund, dress shirt, and pocket square all have enough dark color framing them to pull an alternative design into the composition. Some men choose patterned hose as their expression of personal badinage, but that is best left to the more assured dresser.

Less recommended, but by far the more practiced, is the contrast bow tie. However, if the ensemble's only discordant item is located directly under the chin, it ends up either distracting from or competing with the desired focal point, the wearer's face—something to be avoided at any level of formality.

Matched sets—such as bow ties and cummerbunds—should be shunned. The introduction of more than one contrasting accessory dilutes the form's symmetry, forcing the eye to move from one to another, thereby breaking down its whole into smaller, less important pieces. The black-tie ensemble is already regimented and predictable; adding coordinates that make you appear even more prepackaged not only suggests the wearer's lack of sophistication, but produces an effect of something more akin to gift wrapping. Proust said that elegance is never far away from simplicity, and that thought is especially applicable in accessorizing one's black-tie attire.

BLACK-TIE ALTERNATIVES
(TO BE USED ONE AT A TIME)
DINNER JACKETS

1. Single- or double-breasted velvet smoking jacket in bottle green, black, dark brown, or burgundy, with or without frog closings, with or without silk facings.
2. Black-watch tartan, printed silk foulard, madras, solid silk, in a single- or double-breasted shawl collar with self-facings.

3. For summer, off-white or Sahara tan, Panama weave, single- or double-breasted, self-faced shawl collar dinner jacket with midnight blue dress trousers.

Dinner Shirts

1. Spread-collar, pleated-front, high-count cotton or silk broadcloth in cream, medium blue, pink, or gold/yellow.
2. Any classically styled turndown-collar dinner shirt in black and white color scheme such as gingham check, tartan, black polka dot on white ground, or striped black-and-white horizontal front.

Footwear

1. Black velvet Prince Albert slipper with embroidery or wearer's initials.
2. Black crocodile or lizard opera pump with black bow.
3. Black velvet patent-leather-trimmed Belgian dress slipper.

ALTERNATIVE ACCESSORIES

Handkerchiefs

1. The finest hand-rolled white English, French, or Swiss linen handkerchief affordable.
2. Printed foulard in black ground with white motif in designs such as polka dot, tattersall, plaid, or other classic pattern. Its edges must be hand-rolled.
3. The above foulard in black/gold, black/dark green, black/red, or black/purple color combinations.
4. Hand-rolled linen or cotton in white ground with simple or fancy black border, black and white, check or plaid.

Waistcoats

1. The dress vest model should be single-breasted with shawl collar, three-button, full-back or backless construction. Better ones have an elastic loop for fastening to the trouser's front, and a longer back with vents on the sides.
2. Black ground silk foulard printed in paisley, polka dot, small plaid, or other elegant motif.

3. Small geometric Macclesfield woven design in black ground pattern. Fabric should have a slight sheen such as a dulled satin effect. Small figures, checks, paisley, repp stripe, or black moiré.

CUMMERBUNDS

1. The design should have a nice curve along its top line. Better ones come with an elastic loop for fastening to the trouser's front and a pocket for tickets.
2. Woven or printed designs in similar patterning to vest, with the folds worn up.

MODERN TUXEDO FASHION

If the invitation reads black-tie, and the desire is to effect a less traditional, more contemporary look, one must move to the softer and more chic side of the fashion spectrum. This means replacing the starched high contrast of black-and-white attire with something less buttoned-up and self-consciously stiff.

The popular fashion for wearing one dark color from head to toe quickly separates one from the well-scrubbed mix-and-match crowd. Introducing softness into formal wear automatically helps to make it more casual and less authoritarian. By combining the more feminine elements of shape and texture with the rich historical trimmings of male formal wear, tuxedo dressing can take on a modern mien. I will offer one example and elaborate on its potential applications.

The most important item around which to construct any ensemble is the jacket. If designed well, it affords more options to dressing up or dressing down an outfit than any other kind of garment. The most versatile model for the man is the double-breasted peaked-lapel with its six-on-two button stance. If the model is to function as the centerpiece around which touches are to be added, its silhouette can be made more contemporary, but its styling must be kept simple and classic. Its proportions should be enlarged, with a slightly wider but sloped shoulder, slight taper in the waist, no vents in the back. Its trimmings should be similar to those of its more traditional brother: grosgrain-faced lapels, properly trimmed dress trousers, and so on. For example, if the jacket is made from a black high-twist, semitextured

wool, its chameleonlike character will meld the swagger of today's fashion with the authenticity of the past.

When the jacket is worn separately, like a secondhand vintage tuxedo with blue jeans, dinner shirt, black tie, and opera pumps, it becomes hip enough for a downtown artist's black-tie opening. With matching trousers and black silk banded-collar shirt, the ensemble's monotone swank can be transported uptown, still keeping considerably to the left of the stereotypical black-and-white ensemble. Worn with matching trousers and more genteel accessories, it now becomes a chic version of the tuxedo, taking you anywhere button-down convention beckons.

Because of its slightly old but new, classy but drapey aesthetic, the modern dinner jacket can accommodate a wide range of accessories. A simple black T-shirt or vintage H Bar C western shirt, or black jeans, or black cowboy boots (pointed-toe and angled-heel only) can be played off against its classic but modern flavor.

The American fashion designer Geoffrey Beene has adapted the Corbusier smock jacket, in various seasonal black fabrics, for his own formal outings. Its Mao-jacket lines are as timeless as the aforementioned men's tailored dinner jacket, and it functions as a neutral foundation to which personal elements can be added.

To dress in a modern way is to buy clothes that permit a maximum of accessorizing, clothes that convert from day to evening, dress to sport, inside to outside with the addition of one or two accessories. Develop an eye for the beyond-fashion classic. One man's oversized black cashmere cardigan sweater can be another's winter tuxedo jacket.

JEWELRY

This would be the right time to invest in an antique dress set, as it can be used for the rest of your life. The dress set should include shirt studs (two or three), cuff links, and three vest buttons. Though colored stones such as rubies, sapphires, or emeralds are discouraged for day wear, they can be worn in the evening. Black-and-white designs or simple gold always looks refined. The perfect timepiece to accompany all this finery is a slim pocket watch, with an elegant cover and gold chain.

SPORTSWEAR

The availability of well-designed, affordable, and stylish sportswear is at an all-time high. As the fastest-growing segment of the men's apparel business, it nearly monopolizes the shelves of most of the world's retailers. It also reflects society's drift toward more casual dressing. Even the corporate community has begun to embrace dress-down wear for the office. Sartorial standards for the new, informal workplace are still being worked out, with much of what is worn there looking as if its wearer has already left for the weekend. As casual attire for the office gains popularity and acceptance, sportswear will continue to drive the menswear business and play an even larger role in shaping its future.

While the American businessman's approach to non-tie urban attire is still less formal than his European counterpart's, the two are moving closer together than ever before. The American traveler, in combining his navy blazer with jeans, sneakers, and the odd home team cap or T-shirt, still thinks of sportswear in terms of athletics. The continental traveler continues to rely on his sports jacket as a centerpiece, around which he coordinates his dressier tailored sportswear. However, if you caught the European male relaxing at home, you would probably find him decked out in casual clothes that were American in spirit, if not origin.

During the late sixties and early seventies, when modern sportswear was still in its infancy, men's weekend garb took its fashion cues from the weekday business ensemble. Sport shirts fit like dress shirts, casual slacks like suit trousers. The outfit had to look pressed and coordinated from top to bottom. By the nineties, having realized that tight-fitting clothes made them look old-fashioned, men finally became comfortable with easier-fitting attire. The cuts of today's khakis from Italy's Giorgio Armani, America's Ralph Lauren, and even the Gap are all reasonably similar in scale and feel. Chambray or denim work shirts tend to have the same prewashed fabric, generosity of fit, and workwear detailing whether you find them in Tokyo or Dallas.

Anyone wanting evidence of the dramatic reproportionment that has taken place in men's fashion should watch a present-day American basketball game and then look at a tape of a hoops contest circa 1970. The uniforms of Jerry West or Oscar Robertson bear little resemblance to the playground threads of Michael Jordan, Reggie Miller, and company. Their fuller-cut uniforms demonstrate how the new fuller proportions have pervaded all aspects of menswear.

These days, clothes refuse to stay locked within the category for which they were originally designed. The street's free-form interpretations of today's sportswear has opened up the market for work wear, high-performance gear, and hiking apparel. People are using these garments as mixed metaphors, pulling together the counterpoints of country and city, fitted and loose, high-tech and hand-tailored, all in one outfit.

Instead of trying to construct a road map of sportswear style, I have listed by store in each category some of the world's sportswear standbys and updated classics. These can form the foundation of any man's leisure wardrobe. This compilation is not intended to be all-encompassing; it merely represents a point of departure. One reason men have difficulty developing a better feel for stylish clothes is that they are bombarded by a plethora of undistinguished merchandise whose sheer mass distracts attention from the fewer examples of subtle good taste. It is my hope that, by examining the items found in these compendiums, the reader will develop a more discriminating and sophisticated eye.

Individual style, especially as it relates to the ruleless world of sportswear dressing, hinges on a wardrobe composed of casual components possessing a high degree of versatility. Sportswear needs to be simultaneously classic and fashionable. Its classicism is defined by the simplicity of its design, the quality and suppleness of its fabric, and the timelessness of its silhouette. Its fashionableness is based on whether it can easily convert from casual to dressy as well as function as a different layer within different ensembles. The following examples of sportswear are those that you can grow into or grow old with. As a man's taste matures, it becomes more personal. And it is the well-chosen wardrobe that shouldn't have to be replaced to accommodate this evolution.

SPORT JACKETS

1. Caraceni—custom-made navy blue cashmere single-breasted blazer
2. Arnys—Corbusier coat in corduroy, flannel, or linen
3. Honest—unconstructed three-button single-breasted in navy or black wool or natural linen
4. Saks Fifth Avenue—Donna Karan tailored shirt jacket in wool gabardine
5. Façonnable—6-on-2 side-vented blue blazer with gilded buttons
6. Giorgio Armani—black crepe Mao-style jacket
7. Bergdorf Goodman—Luciano Barbera tweed sweater jacket
8. Louis, Boston—handmade, unpadded worsted cashmere three-button jacket by Kiton.
9. Wilkes Bashford—Biella Collection unconstructed sport jacket
10. Red and Blue—six-ply cashmere sweater jacket

TROUSERS

1. Neiman Marcus—Zegna wide-wale pleated corduroys
2. Louis, Boston—Luciano Barbera moleskin cottons in olive or khaki
3. Camouflage—Levi's 501s
4. Ralph Lauren—G.I. washed chino in plain front with button fly
5. Ralph Lauren—linen Bermudas
6. Bergdorf Goodman—Luciano Barbera pleated gray flannels
7. Alan Flusser—hand-tailored dak top cotton sueded gabardines with lap seam
8. Saks Fifth Avenue—Giorgio Armani pleated velvet cottons
9. Tinkers' Catalog—pull-on printed brushed cotton flannel bottoms
10. Paragon—Cotton Inc.'s washed cotton knit jersey full-cut shorts

OUTERWEAR

1. W. & H. Gidden—English Husky riding jacket
2. Cordings—Barbour fisherman's coat
3. Principe—Casentino coat
4. Au Petit Matelot—Gloverall duffel coat
5. Connolly—Mille Miglia suede blouson

6. Old England—boiled wool Tyrolean jacket
7. Mettez—Ivy League Tyrolean coat
8. Ralph Lauren—Mohawk jacket
9. Façonnable—Avirex bomber jacket
10. Gastine Renette—double-length hunting shell
11. Paul Stuart—alpaca bear coat
12. Bardelli—shearling coat
13. Holland & Holland—suede hunting vest

SPORT SHIRTS
KNITS

1. Louis, Boston—Luciano Barbera fine cotton piqué knit polo shirt with open sleeve
2. Honest—Zanone long-sleeve cotton polo collar in dark colors for winter
3. Loft—T-shirt or mock turtle knit with pocket, short- or long-sleeve
4. Bergdorf Goodman—John Smedley cotton lisle or fine wool polo shirts
5. Ermenegildo Zegna—washed linen T-shirts
6. Mark Shale—worsted wool or combed cotton long-sleeve cardigan with knit collar and pocket
7. Charvet—cashmere and silk long-sleeve polo shirts
8. Sulka—printed cotton polo shirts
9. Barneys New York—Zanone short- or long-sleeve cotton or linen fashion polo shirts
10. Red and Blue—polo shirts in cashmere long-sleeve, Egyptian cotton or linen in short sleeve
11. Hermès—any non-logo, striped T-shirt with pocket and open sleeve
12. Chalarini—Johnny Lamb's printed piqué polo shirts

WOVEN

1. Buttondown—Luigi Borelli chambray shirt
2. Wilkes Bashford—Mariano Rubinacci white linen short-sleeve camp collar shirt
3. Barneys New York—long-sleeve muted rayon plaids in straight point collars

4. Victoire Hommes—long-sleeve sport shirts in pinwale corduroy or antique stripes
5. Island—long-sleeve cotton flannels, short-sleeve linen plaids
6. Oliver—dark-patterned or solid long-sleeve sport shirts, banded or in other new collar styles
7. Arnys—washed cotton button-downs

SWEATERS

1. Buttondown—single-ply cashmere crewneck with sweatshirt modeling
2. Crimson—two-ply Scottish cashmere cardigan
3. Arnys—suede vest with knitted back
4. Louis, Boston—hand-knit fisherman's alpaca turtlenecks
5. Giorgio Armani—argyle pullover
6. Braun—Malo cashmere two-ply cable crewneck
7. Paul Stuart—Scottish Fair Isle vests
8. Old England—shetland crewneck in fashion colors
9. Hobbs—pop art cashmere sweater
10. Hobbs—cashmere jogging suit
11. Joseph Abboud—bulky wool or cotton hand-knit in earth tones
12. Barneys New York—various pullovers in wool or cotton
13. Arnys—seamless cashmere pullover

ACCESSORIES

1. Hermès—mahogany brown alligator belt
2. Sulka—yellow alligator-trimmed polo belt
3. Ralph Lauren Sport Shop—hand-knit patterned hose
4. Paul Stuart—gentleman's argyles
5. Arnys—Bird's-eye and other dressier patterned hose
6. Old England—offbeat wool headgear
7. Paragon—athletic hats and team logo tops
8. Charles Bosquet—cashmere and silk neckerchiefs

STREET SHOES

1. Hermès—John Lobb Lopez penny loafer
2. Weston—Demi-Chasse lace-up
3. Diego Della Valle—J. P. Tod's suede slip-on
4. Giorgio Armani—suede buck
5. Hackett—suede tassel loafer
6. Gucci—lug sole slip-on
7. Gucci—classic slip-on
8. C.P. Company—Paraboot Avignon split-toe
9. Poulsen & Skone—tobacco suede apron-front casual
10. Poulsen & Skone—two-eyelet suede chukka boot
11. Billy Martin's—western boot with point-toe and underslung heel

SPORT SHOES

1. L.L. Bean—six-inch-height Maine hunting boot
2. Polo Sport—Polo sport shoe
3. Paragon—Timberland work boot
4. Camouflage—Doc Martens
5. Hermès—John Lobb espadrille
6. Diego Della Valle—J. P. Tod's chukka boot
7. Diego Della Valle—J. P. Tod's driving shoe

EVENING SHOES

1. Edward Green—green velvet Albert slipper
2. Ralph Lauren—black calf opera pump
3. Belgian Shoes—black velvet dinner slipper
4. Belgian Shoes—black, navy, or brown suede slip-on
5. Belgian Shoes—leopard slip-on
6. George Cleverley—custom-made velvet slipper with monogram

CUSTOM-MADE CLOTHES

Wearing something created expressly for one's body and mind is an intoxicating luxury particularly for men accustomed to buying off the rack. After realizing what such personalized raiment can do for him both physically and psychologically, it is the rare man who doesn't become a convert for life. Even in today's culture of instant gratification, a large majority of the world's best-dressed men still go to the effort and expense of having their clothes custom made. Bespoke fashion allows its wearer to act, in concert with whatever skilled craftsmen he has chosen, as the architect of his own look. This collaboration usually produces a dressing style that is individual and worldly.

Custom-made apparel is the product of exact measurements taken on a known individual. It's the difference between designing a garment on a real person and designing one for an imaginary figure. No ready-to-wear garment, no matter how well it is altered, can ever be as accurately fitted as one made by a skilled craftsman who constructs it right over the bones and bumps of his client. The maker must be an artist who can compensate for whatever nature has withheld. In cases where a considerable remolding of the client's form is required, the end result can become a glorified abstraction of the subject's better self.

The advantages of well-designed custom-made wearables over off-the-peg are significant and self-evident. With proper rotation and care, handmade apparel will outlast any item produced in a factory. A custom-made suit will yield at least ten years of good service, while a handcrafted shoe can easily last over twenty years. Amortized over the life of the product, the cost per annum favors the custom-made quality.

However, value is not the primary reason many men prefer custom tailoring. In the bespoke world, everything revolves around the pampered customer—his build, posture, coloring, and personal taste dictate all. Buying custom clothes represents the sort of focused and

efficient use of time that top executives try to cultivate throughout their business day. Additionally, the relationship forged over time between maker and client can provide pleasure above and beyond the work produced by this alliance. Given the privacy and intimate attention afforded each customer by this process, a man can relax during his fitting and then return to the rigors of daily life refreshed.

Having described the real upside to the bespoke experience, we must now consider its potential downside. One of the inherent disadvantages of custom making is that the finished product cannot be judged until it is too far along to be substantially changed. Therefore, much depends on the taste and aesthetic sensibilities of the maker. If he adheres to the time-tested steps of the custom-tailoring tradition, the materials and workmanship that normally accompany such a process usually ensure the garment's superior quality. However, the quality of its design is another matter.

The highest-caliber workmanship or carriage-trade service will not undo the unsightliness of a poorly designed peaked lapel, an unflatteringly shaped dress shirt collar, or an inelegantly formed toe box. Whereas most men operating as custom makers are terrific mechanics and skilled craftsmen, their tastes tend to reflect their own working-class backgrounds. Many well-established firms are now owned by an employee who stepped out of the workroom to take over the business after the founder retired or passed on. Years of laboring over his craft hardly give him the appropriate social frame of reference to act as arbiter of taste and style in this collaboration.

Examples of this can be found in most Hong Kong tailored clothes. Compared to the average ready-to-wear suit, the Hong Kong creation, which generally features better fabrics and workmanship, offers a good value. However, most are poorly designed, inexpensively finished, and, therefore, unsophisticated in appearance.

Choosing a custom maker is difficult for the man traveling in this rarefied world for the first time. Some protection is assumed if the choice is based on a friend's recommendation. However, you remove considerable risk from the selection process by employing an artisan who has a definable "house style." The finest bespoke firms are still thriving because their signature approach to design has transcended the vagaries of fashion as well as the tastes of their employees. Most of

the top firms have their own long-considered ideas on what style shows off a man to his best advantage, and you should listen carefully to see if their beliefs reflect your own. Establishments that claim they will make "anything you want" are to be avoided, unless you yourself are a designer and are prepared to take responsibility for the garment's final form.

If you desire a look all your own, find a craftsman who already makes something recognizably close to what you want and is comfortable adapting it to your needs. I would not go to Bill Fioravanti in New York City for a soft-shouldered, drapey suit, just as I would not ask London's Anderson & Sheppard to make me a fitted, built-up, English-style hacking jacket. Such judgments are easier to reach, since these makers have a clear-cut point of view. While you cannot totally eliminate the risk factor from the custom-made product, choosing a craftsman with a "house look" minimizes the margin of surprise. However, in the hands of a craftsman with a strong sense of style, the outcome's unpredictability becomes part of the experience's attraction.

Equally important is understanding just how custom-made the article actually is. Today, the term "custom-made" has come to represent a wide range of different manufacturing processes and qualities, so caveat emptor. Legitimately bespoke products involve a specific series of steps with commensurate degrees of quality and thus price. If a customer is going to order something represented as custom-made, and he is going to receive something made by a different process, he should know this beforehand.

CUSTOM TAILORING

With retailers cutting back their slower-turning stocks of tailored clothing to bolster their cash flow, more stores than ever before are offering made-to-order clothes. And given the reduced selections and available sizes, more men are testing these waters. Because the price of a better designer or European hand-tailored, off-the-peg suit has, in some instances, surpassed that of one custom-made, the interest in bespoke clothing has increased. However, the first thing you must establish is to what degree the clothing you are about to order is genuinely custom-made.

The term "custom-made," when referring to tailored clothing, is used so loosely today—particularly by those who have something to gain by its obfuscation—that it is now applied to almost any garment that has not been purchased off the rack. However, the criteria for judging whether a man's tailored garment is authentically custom-made have changed little since the early part of this century. Three procedures must be observed if the product is to earn such a designation.

First, the individual parts must be cut from a paper pattern that has been created specifically for the wearer. In the old days, the tailor who measured the suit would cut the pattern immediately upon the client's departure. This meant the wearer's unique carriage and manner, elements that inform the garment's character, were kept fresh in his mind's eye. Second, all the work required to create the suit was to be executed on the premises where the measurements were taken. This insured authenticity and aesthetic consistency, and acted as a quality control. Finally, except for the straight seams of the trouser, all work was to be executed completely by hand.

The terminology presupposes that the material is of the highest caliber, the sewing thread of silk, the linings of fine silk or rayon bemberg, and the buttons of genuine horn or a vegetable derivative. The entire process required at least two or three fittings to take the garment from its first to final stage. Any suit that went through these rigors was recognized for the Savile Row tailors who invented and refined this production process. The long-term advantage of having a suit made in this manner revolves around its original paper template. Once created, it can be adjusted to further perfect the next garment. Nothing controls the consistency of each subsequent suit's fit and look more precisely than this finite individual pattern.

One step below custom-made is made-to-measure. Instead of a paper pattern being made expressly for the client, the manufacturer's stock pattern becomes the starting point. Various adjustments for fit and posture are incorporated into it to individualize the final garment. The coat is delivered to the store without buttonholes, allowing the shop's fitter to position them correctly while the customer is wearing it. This technique for capturing a person's fit works well for most men unless their posture or bone formation requires something more particular. How well it replicates the custom-made suit's fit depends on the

extent to which its base pattern can be manipulated to resemble an original pattern.

Since made-to-measure defines a process rather than the degree of craft, this product can vary widely in quality and cost. It can be made from a superior cloth or an inferior one, by hand or by machine. However, how closely it comes to matching the bespoke coat's quality will depend on its ingredients and workmanship.

Last on the scale of individually cut clothing is something called a stock single. Too many suits represented today as custom-made are usually from this group. Though it doesn't afford the same degree of customized fit as the made-to-measure, this creation is certainly a step up from ready-to-wear. Since a stock single is cut one at a time, it offers the wearer an opportunity to personalize a factory-produced suit. If you have an athletic build, say a forty-inch chest with a thirty-one-inch waist, the suit can be ordered with a smaller trouser and its jacket's waist will be tapered accordingly. Or if your measurements indicate your jacket should be longer than a regular but shorter than a long, and, additionally, your trouser requires a longer rise, these adjustments can be made. However, under no circumstance should this be mistaken for anything other than what it is, and it is clearly not a custom-made suit.

The differences between the made-to-measure and stock single vary according to the manufacturer. Some makers permit various fitting adjustments on a stock single while others permit none at all. Today, a computer generates individual cutting instructions and a customer's pattern is created and retained to record subsequent alterations. If the customer's body reasonably approximates the stock pattern, the computer will provide a fit approaching the bespoke blueprint. However, if the customer requires significant adjustments, the computer-generated stock pattern will not measure up.

Most of the nuances that distinguish one top custom tailor from another are too esoteric to describe in mere words. Before engaging any tailor, you should ask to see a recent sample of his work, preferably something that is about to be collected by its owner. Unfortunately, inspecting the jacket's cut or fit when it is not being worn by the body it was designed for won't be of much benefit unless you are a tailor or bring a learned eye to such matters. Though its fabric, mod-

eling, and detailing reflect the patron's wishes and most of its tailoring craft is concealed beneath its linings or shell fabric, you can learn much by examining the buttonholes. The sensibility and execution of the buttonholes reflect the creator's training and taste in a way that can be illuminating.

Examine the lapel buttonhole first. As the detail closest to the wearer's face, it offers the most visible evidence of the tailor's artistry. It is the last element of needlework to go into the garment before its final pressing. If its color, size, or placement is off, it can undo the forty or so hours of painstaking work invested in your garment. As founders of the woolen tailoring world, Savile Row tailors established the standards for high-class buttonhole decorum many years ago. Depending on where he apprenticed, each tailor on the Row may favor a different silhouette or style, but each jacket's buttonholes are a consistent part of this legendary culture's pedigree.

Creating a proper buttonhole is a dying art usually performed by trained women with exceptional finger dexterity. The lapel buttonhole should be long enough (1" to 1⅛") to comfortably accommodate a flower, though you may never choose to wear one. There should be a keeper for the flower stem on the lapel's underside. The buttonhole should be precisely angled on the same line as the slope of the lapel's notch. If the coat has a peaked lapel, it should line up on the same angle as the peaked portion. If a flower were placed in it, it would be framed by the lapel's outer edges.

The buttonholes on the lapels and sleeves should be hand-sewn so skillfully that their individual stitches become hard to discern. Although there are sewing machines that try to simulate the look of a handmade buttonhole, legitimately custom-made clothes require that they be hand-sewn. Many tailors choose a machine-made buttonhole because their own hand-sewn buttonholes end up looking ragged, as if a dog had gnawed on them. A handmade buttonhole is clean on the outside and rough on the underside. A machine-made hole is clean on both sides. When finished, the buttonhole should be supple to the touch.

Quite important is its color, which should disappear into the cloth. For example, a buttonhole on a black-and-white glen plaid suit should have an inconspicuous, medium gray tint. If I saw a color such

as charcoal gray or even black, contrasting upon such a cloth, as is found in most middlebrow custom-tailored clothes, I would note the tailor's lack of taste.

The jacket sleeve's buttonholes should be aligned straight and close enough to one another so that the buttons appear to kiss. The distance from the edge of the jacket's cuff to the middle of the first button should not exceed 1⅛". More than that, and they look as if they are floating on the sleeve and have abandoned their historical relationship to the cuff as its fastener.

THE SYMBOLS OF CUSTOM TAILORING: HANDMADE, FUNCTIONAL JACKET SLEEVE BUTTONHOLES.

If a tailor seems knowing about buttonholes, I would defer to his judgment in other matters. This is critical, since no matter how specifically you instruct any tailor, many aesthetic judgments concerning taste are going to be made by him in the course of his work with little input from you, and these are the ones that will ultimately infuse the clothing with a sense of class and character.

THE BUTTONHOLES' PLACEMENT INDICATES THE PEDIGREE OF THEIR TAILOR: THE BUTTON'S EDGES SHOULD KISS AND NOT REST TOO HIGH UP THE SLEEVE AS IN READY-TO-WEAR GARMENTS.

CUSTOM SHIRTING

Besides the individualization of its styling, the advantages of the custom-made dress shirt over one that is ready-to-wear can be found in its precise fit as well as the superior quality and taste of its fabrics. The most visible and important component of the dress shirt is its collar (see pages 25–27), and the bespoke process allows for one that is designed to best present the wearer's face. The fit of the dress shirt's cuff to the wearer's hand, its second most noticeable detail, is another area where the custom route is decidedly the higher of the two roads.

In choosing a shirtmaker, you must inquire about what process he will use to produce your shirt. The maker should begin by creating

an individual pattern from which he makes a sample shirt. Having been worn and washed several times at home, the shirt should be examined on your body for final approval or further altering. After those washings, the collar should fit comfortably while still allowing for some shrinkage. The shirtsleeve should still be long enough to show ½" of cuff from under the jacket sleeve and also have enough length to offset further shrinkage.

If cut from a stock pattern rather than an individual pattern, the shirt is not custom-made. In some cases, if you are a standard fit, the shirt might require little adjustment, but it would be inaccurate to call it bespoke. Shirts deserving to be called custom-made cost $150 and up and should be made from thirty-six-inch-width, 100 percent cotton, two-ply cloth. This is easy enough to determine. Ask the salesman to show you a bolt of the fabric and ask him to measure its width. Since fabric woven in this old-world width is always two-ply, this is a fail-safe checkpoint. Thirty-six-inch narrow-width shirting fabrics are made on Europe's older, slower looms, which produce a luxurious cloth of richer colors and hand than the more up-to-date high-speed looms. The two-ply yarns insure that the fabric will feel even silkier with wear. As long as the shirt's fabric is woven in either Switzerland or Italy, you are assured of a finished product of deluxe caliber.

To confirm a shirt's pedigree, you must establish the shirt's level of sewing artistry and manufacturing skill. The entire shirt, including its side seams, should be sewn with a single needle. This construction allows for the smallest stitches, the narrowest seams, and the most meticulous finishing. The shirt's side seams should be precisely narrow and the individual stitches on its collar so small as to be almost invisible. The collar and cuff linings should be cotton (not fused) and from Europe. Switzerland makes the best. The yoke on the back of a custom shirt should be made of two separate pieces joined in the center

A TWO-PIECE (SPLIT) YOKE INDICATES THE POSSIBILITY THAT ONE SHOULDER IS HIGHER THAN THE OTHER AND HAS BEEN ACCOUNTED FOR IN THE SHIRT'S INDIVIDUAL DESIGN.

and the buttons should be genuine mother-of-pearl and attached by hand. If there is a monogram, it too should be hand-embroidered as opposed to machine-made.

If the answers to these areas of investigation are satisfactory, you can be assured of receiving a top-quality product and should be prepared to pay $150 to $300, depending on the country where it is bought and any extras it might feature. Some makers include monograms or extra cuffs and collars. Choose to have the shirt's excess fabric set aside rather than made into a finished collar. If you lose or put on weight, it's better to have the fabric on hand. The costs can also vary according to the quality of two-ply cotton fabric used, which can range from 100s up to the very expensive, silklike 220s.

Of course, all things being equal, the cost of a bespoke dress shirt ultimately rests on the genius of its pattern and the nuances of its fit. However, there are some aspects of shirtmaking that do separate the masters from the top makers. These details include special gussets to reinforce the shirt's side seams where they meet at the hem bottom, pattern matching on the back yoke to the sleeve, hand-sewn buttonholes (found only in Europe), horizontal sleeve placket buttonholes, and extra-thick mother-of-pearl buttons (see "The Dress Shirt,"page 32).

All of the above qualify the product as custom-made. Below this, there are a variety of methods of individualized shirtmaking that are often called custom-made. Obviously, this term stands for a specific process of creating a particular shirt with an attendant quality of shirting fabric and shirtmaking. Made-to-order, individually cut, and made-to-measure are all terms that indicate something less than custom-made, and that is why they need to be understood if one is to compare apples with apples. If you pay less than $150 for a dress shirt and it is represented as being comparable to the top-of-the-heap bespoke ones, something is amiss. That is not to say that a custom-made shirt will always look better than a less expensive garment. A well-designed ready-to-wear shirt can look more flattering than a bespoke one with a poorly designed collar. As with all wearing apparel, design, not quality, is the ultimate arbiter of stylish longevity.

CUSTOM-MADE SHOES

The custom-made shoe represents the best return on investment of any article of male *habillement*. If you can afford the initial outlay of $1,200 or more, you can amortize their cost over a ten-to-thirty-year period. My own first pair of monogrammed velvet slippers is still going strong after twenty years of wear inside and outside the house.

Cobblers are distinguished from one another by their design sensibility. Any argument over the merits of a particular maker is usually a debate about taste rather than quality. The process of custom shoemaking is so particular and time-consuming that the handful of old-line firms still practicing the art do it pretty much as their forebears taught them. Once you have established that the creation procedure begins with your own carved wooden last, the tradition of bespoke footwear virtually guarantees the proven, time-honored sequence of handcrafting operations that will follow.

This means, to quote again the British cobbler John Lobb, "the last comes first." As a true representation of the client's foot, bunions and all, sculpted in wood, the last is everything in custom shoemaking. It determines the precise shape of the shoe that will eventually fit it. As long as the individual or firm crafting your shoe is prepared to invest the ten to twenty hours needed to properly sculpt this wooden form, the product's pedigree is assured. Some European cobblers make a temporary shoe to test out the last before going to a finished shoe. This is even more exacting and time-consuming and increases the expense and the odds of receiving a perfect fit—but the most important ingredient is still the artistry of the last.

Custom-made shoes enjoy three advantages over ready-to-wear—fit, quality, and style. Factory-made shoes require the wearer's foot to fit the shoe, a hit-or-miss proposition given the nuances of the individual foot. Custom-made shoes are constructed around such idiosyncrasies as bunions, calcifications, unusual toe joints, bone spurs, and crooked toes. The arch of a handmade shoe can be fitted up under the foot's instep, bolstering the arch while supporting the body's weight. The real art of a good handmade shoe can be found in its lightness and springiness to the step. Its weightlessness can be deceiving, since it is probably solid enough to outlast its owner.

No machine yet invented can construct a shoe as fine as one made and stitched by hand. The thread used to stitch the leather on custom-made shoes is hemp. In some operations, eight to twelve pieces of it are rolled and waxed into a single twine, producing a stronger thread than that used in factory-made products. Machine stitching is just punched in and will never hold as long as those made by hand and individually locked in.

Handmade shoes employ costlier, higher quality leathers than factory-made ones and, when polished, produce a richer, deeper luster. Over time, the surface of brown handmade shoes will develop a patina, much like the wood of some fine antique. The individual leather pieces that constitute the custom shoe's design are also more carefully matched than in the ready-made.

As for style, rest a handmade shoe next to one made by machine, and the custom's bevelled waist and closer-cut welts will graphically underscore its neighbor's bootlike clunkiness. The sculpting of the bespoke shoe's waist can make even the most ungainly foot appear sleek and smart. No machine-made toe box can ever be as elegantly crafted as one individually built by hand.

The difference between handmade and machine-made shoes becomes obvious when you examine their respective back quarters and heels. On a custom-made shoe, the instep side is cut higher on the foot than its outside back quarter. On the ready-made, the two sides are the same height. Top-quality heels are built from layers of leather held together by brass pins and have rubber tips to prevent slippage in bad

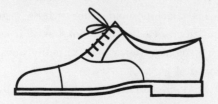

THE INSIDE BACK QUARTER OF A
HANDMADE SHOE IS CUT HIGHER ON
THE FOOT THAN THE OUTSIDE BACK
QUARTER. THIS SUPPORTS THE
INSIDE OF THE FOOT WHILE MAKING
THE FOOT APPEAR LIGHTER AND
MORE ELEGANT TO THE EYE.

A HANDMADE SHOE'S
SHAPE REFLECTS THE
NATURAL LINES OF THE
FOOT MORE CLOSELY
THAN THE MASS-
PRODUCED SHOE.

A MACHINE-MADE
SHOE'S SHAPE
REQUIRES THE FOOT
TO CONFORM TO IT.

weather. They are made to taper just so, while most ready-made heels resemble solid blocks. The curved pitch of the handmade shoe's back, when compared to the machine-made's regulation ninety-degree angle, conveys a gracefulness only seen in cobbled footwear.

But perhaps the most significant distinction between individual and factory-produced shodding is the manner in which the custom-made shoe's shape follows the foot's natural line. Much like the foot, the inside and outside lines of the handmade shoe have contrasting symmetries. The handmade's outside line is curved, while the inside line is straight. The machine-made shoe, whose inside and outside lines almost approximate each other, looks as if it could have been stamped out with a cookie cutter, which, in many ways, is exactly how it has been produced.

The shoemakers discussed in the shopping section of this book are the top custom designers in the world. While each firm has its own house shape, it is the client's foot that will ultimately determine the product's final silhouette. However, no matter what shoe style the patron desires, these masters can design any model that will delight the foot as much as it will capture the eye.

TRAVELING WITH YOUR WARDROBE: PACKING AND CARE

THE SECRETS OF WRINKLE-FREE TRAVEL

The basic objective of packing a suitcase is to get as much in as small a space as possible, while managing to arrive at your destination relatively wrinkle-free. An underpacked suitcase leaves too much room for clothes to shift and crunch. Conversely, an overpacked one produces hard-to-remove creases. When carefully folded and arranged, the contents of a suitcase should snugly fill its interior with its weight distributed equally throughout the bag for easier carrying.

Before making any other packing decisions, you must first choose the sort of luggage, hard or soft, that best fits your traveling requirements. While a hard suitcase offers your clothes greater protection and can be a terrific makeshift seat if there is nothing else available, its inflexibility can be a hindrance if you are forced to squeeze it into a tight, awkward storage area. If it is bulky as well as heavy, transporting the hard suitcase can also bang your shins to a fare-thee-well. Luggage made along the lines of the old-world-elegant Vuitton or Asprey's steamer trunks look exceptionally stylish, but they will also soon look exceptionally battered after being pummelled about in today's taxi trunks or airport conveyances. Of course, if you travel by limousine to the Concorde or *Queen Elizabeth II*, such problems will be of little concern. But for those whose mode of transportation to the airport, dock, or train depot usually has a meter in the front seat, the luggage's vulnerability is an issue.

Softer cases give you greater flexibility around their sides; should you acquire anything during your travels, they can accommodate the additions more easily than harder luggage. They are also more man-

ageable in difficult-to-fit spaces, a fact you'll appreciate if one ends up jammed beneath your legs. And your shins are in little danger if you have to carry one across a crowded airport. The softer bags range from the ballistic nylon—lightweight, slashproof, and Prada chic if well-designed and black—to the printed canvas and leather-trimmed bags by Etro, Gucci, or Fendi, which last a lot longer than their soft appearance might suggest.

If you opt for the semistructured luggage, you should consider whether you will travel with a suitcase large enough to accommodate a single-folded coat or a garment bag. The idea that your clothing, especially your suits, should hang in your luggage just as they hang in your closet has made the garment bag a popular choice for many travelers.

Since packing and unpacking the garment bag are easy matters, overpacking the garment bag is always a temptation. So, when faced with a choice between the three- or four-suiter, give serious thought to the smaller of the two. Garment bags come with several zippered compartments, designed to hold specific items such as shoes or toiletries. The better ones come with a "wet" bag for damp exercise clothes or laundry and have compartments that are accessible from the inside as well as the outside. Choose one with mesh or clear vinyl compartments, so you can see whatever you are looking for without having to completely unpack. Also, be sure to find a bag that can utilize different types of hangers, so that you are not stuck if you lose or damage one. Garment bags can be heavy and unwieldy, so make sure yours has a wide, padded shoulder strap. Finally, whether you choose the suitcase or the garment bag, there is a technique to packing both.

PACKING

PACKING THE SUITCASE

As a first order of business, you must decide which articles will be packed at the bottom of your bag. Many experts recommend putting trousers in first, leaving the legs out until everything else is in, and then folding them over the top of the pile. I disagree with this on two counts. First, since the trouser would rest against the top and bottom sides of the suitcase, you risk exposing it to any number of hazards, including moisture, that could not only ruin the trouser but effectively

the entire suit. Second, travelers often arrive at their destination without enough time to fully unpack before having to keep some business appointment or social engagement. Therefore, the last thing to pack is a suit, since it is the first item that you will want to hang up to air out and dewrinkle. The first thing you pack will have to absorb the full weight of the clothes placed on top of it. So the garment to place at the bottom of your bag should be some item like a sweater, jogging clothes, jeans, or bulky trousers, anything that can wrinkle or get wet without causing you anxiety.

While packing, place tissue paper or plastic between each layer of clothing. Acid-free, crinkly tissue paper is the butler-approved device, while plastic, which allows your clothes to slide rather than settle and crease, is a close second. As you pack these items, a small moat should form around your island of clothing. This is the place for your footwear. Since packing and unpacking exposes fine leather shoes to scratching, your shoes should be protected by bags. The best shoe bags are made of brushed felt, which shields the shoe's uppers while maintaining their polish. They also prevent the shoes from leaving polish marks on your suitcase or clothes. Plastic bags will not prevent scratches and scuffs and, if the climate is humid, can stick to the shoe, diminishing its luster. Face the soles of the bagged shoes against the walls of the case so that they are provided with the maximum protection while lending structure to the other packed garments.

Besides being covered, your shoes should be treed. Without travel shoe trees, your footwear may become deformed. Wooden trees are preferable, since they absorb moisture; shoe repair shops sell light plastic ones that will do in a pinch but should otherwise be avoided. If trees, plastic or otherwise, are unavailable, you can provide your shoes with temporary support by stuffing them with socks or underwear. Never separate a pair of shoes; if you pack a left and a right in different containers, you double the chances that the pair will not arrive intact. Once the shoes are positioned, soft items such as linen, hosiery, and handkerchiefs should be stuffed in the spaces between them to provide additional cushioning.

Dress shirts can now be added with their collars alternating at each end. A professionally folded dress shirt with collar support in the cleaner's plastic bag is going to emerge from its casing more wearable

than the ones you folded yourself. Shirts folded off hangers always need more touching up than shirts folded by the cleaner. However, if you insist on folding them yourself, choose the "long" fold, with the shirt folded below the waistline, ensuring a crease-free belly. Rolled-up socks or underwear can be stuffed within the collar for additional support.

Everything that is now in your case should be firmly set in place. If the moat between the outside wall and your clothing island is well fortified, the contents should move as a unit while the surrounding items can move independently as the weight of the parcel is redistributed during travel. Your trousers, folded in two with each waistband alternating with the other, should be packed next. In between each trouser, place four or five neckties folded once in half. The trousers will keep them flat and any resulting crease in the tie will come at the back of the neck where it is concealed by your collar. A traveling tie case offers an even safer mode of travel for your neckwear, and it can easily be hung in your closet.

THE SUIT COAT SHOULD BE FOLDED IN HALF, INSIDE OUT, TAKING CARE TO PUSH THE SHOULDERS THROUGH AS SHOWN.

THE SECOND FOLD OF THE JACKET SHOULD BE BETWEEN WAIST BUTTON AND TOP OF INSIDE POCKET—WRINKLES SHOW LESS HERE AND HANG OUT MORE EASILY.

Your jacket is the next article to go in. Experienced travelers pack the night before, leaving their tailored clothing out until the very last moment to save unnecessary creasing. Fold your jacket lengthwise in half, inside out, taking care to push the shoulders through while making sure the sleeves meet each other inside and hang down without wrinkling. Place plastic inside the coat's vertical fold. If your case is not long enough to accommodate single folding, put a layer of plastic or tissue over the folded jacket and fold it a second time between the button nearest the waistline and the top of the inside pocket. This is one place where a recalcitrant fold will easily come out.

One of the final items for packing is the leakproof dopp kit, which allows for any last-minute additions. This can be used to plug up any gaps on the perimeter created by the stacking of the trousers and jackets. Just as with your first layer, the last thing to be placed over your suit jacket should be a robe, second coat, or even some plastic, anything that will prevent moisture from reaching the garments below.

Packing the Garment Bag

Experienced travelers who favor garment bags use their compartmentalized arrangement to their advantage. They lay out each outfit beforehand with a dress shirt placed under each jacket and several ties hung on top of the slacks. Tissue is placed in the jacket sleeves and between the jacket and trouser. Each ensemble is encased by a plastic dry cleaning bag before it is hung in the garment bag. Folded dress shirts are never left at the bag's bottom where they can be crushed if a hanger falls.

PERMANENT PACKING FOR FREQUENT TRAVELERS
Accoutrements

1. Small travel jewelry box for spare cuff links, collar bar pin, collar stays
2. Extra shoelaces in black or brown
3. Sewing kit with two different-sized needles; black, beige, and white thread; and several extra shirt buttons
4. Safety pins, small Swiss Army knife, and tape in case a cuff comes undone and emergency surgery is required
5. Travel alarm clock to back up the hotel wake-up call
6. Extra pair of reading glasses
7. Suede brush and whisk brush
8. Six to twelve plastic shirt bags to aid your packing

A word of warning: if you include any bottles in your bag, make sure they are unbreakable. Never place a breakable bottle in your bag unless it is packed in a leakproof container.

CARE FOR THE TRAVELER'S WARDROBE
TAILORED CLOTHING

As soon as you reach your destination, unpack and hang up your tailored clothes. Jackets should always be hung on wooden, wishbone-style hangers. Wire hangers are the bane of good clothes, so avoid hanging your jackets from them. Ordinary wooden hangers are an acceptable alternative if the heavier wishbone hangers are unavailable. The trousers can be folded over the center bar. However, it is always better to suspend them by their cuffs from a clip hanger, or, if your hotel is really classy and provides them, small wood trouser hangers with felt pads to prevent the trouser cuffs from wrinkling. When suspended by the cuffs, the full weight of the trouser is brought to bear, retaining the unbroken crease down the leg. If there is no time to have your clothes professionally pressed, hanging a suit in a steamy bathroom and then letting it dry in a cool room is a good way to remove its wrinkles. A good-quality travel press can also work the wrinkles out.

Try to arrange your schedule so your clothes can be properly pressed after unpacking. A freshly pressed suit will always look better than one that was pressed just prior to packing. If you have your suit pressed at the hotel, find out what quality of work it provides. Too often, either dry cleaning chemicals or an inexperienced presser can take the life and bounce out of a fine suit. Fine tailors prefer to do their own pressing when possible, because a bad press can ruin a well-made suit, while a good one can totally rejuvenate one. Ask the hotel's concierge or valet service to have your garments soft-pressed by hand. Tell them you want the jacket's lapels soft-rolled and the trousers steamed, brushed, and hand finished.

Avoid dry-cleaning a suit unless it is absolutely necessary, for instance if perspiration has seeped completely through it. Other than a light-colored summer suit, if the suit becomes stained, have it spot-cleaned first, then pressed. It is important to attach a note to the garment, telling the cleaner what caused the blemish. Technology has developed specific chemicals to combat specific stains. If the spot were red and the cleaner suspected raspberries were the culprit, he might try a fruit cleaning agent, whereas if it were blood, a protein-based solvent would be in order. Allow the cleaner as much time as he needs

to deal with the stain. Some stains never get properly removed because the job was rushed to meet the traveler's schedule.

If you spill something, blot it up immediately. The more you get out of the fabric, the less there will be to eradicate later. Putting seltzer or water on oil-based stains such as salad dressing, mayonnaise, and the like only spreads the surface of the stain, making it ten times harder to remove. For water-soluble spills such as wine, the soiled garment should be placed on top of a dry, flat surface where it can be daubed with a warm, wet cloth. If it needs further attention, the spot can be dispatched with proper dry cleaning. Some food stains are harder to remove than others, therefore the more time you allow the cleaner, the better the chance of receiving a spotless garment.

DRESS SHIRT CARE

Nothing more discourages a man from investing in an expensive dress shirt than the prospect of having it professionally cleaned. Few places know how to press one properly. However, armed with some specific instructions, you can contain the damage and even be pleasantly surprised by the results. First, do not dry-clean dress shirts. Cotton dress shirts surrender their fresh, linenlike crispness and eventually turn gray if regularly dry-cleaned. Some men mistakenly believe this is the only way to prevent the garment from shrinking. Far better to buy a shirt in a size that allows for shrinkage.

Never allow a partially soiled dress shirt to be pressed; the heat from the iron can permanently "cook" the dirt into the fabric. Ask the laundry to wash the shirt separately without machine drying. Most shirts are washed en masse, which just spreads the dirt from one garment to another. Request that the shirt be hand-pressed—never allow it to be machine pressed—with as little starch in the collar and cuffs as you can bear. Heavy starch reduces the life of the collars and cuffs and accelerates their shrinkage.

SHOE CARE

The only thing profligate about owning expensive shoes is scrimping on their care. Plastic shoe trees do to shoes what wire hangers do to jackets—avoid them if at all possible. Wooden shoe trees are the best protection your investment can have and should be inserted as soon as

the shoe is removed from the foot. The shoe's interior is subject to some astonishing conditions including continual moisture, heat, friction, and bacterial growth. Its exterior is exposed to heat, cold, precipitation, chemicals, abrasions, and good old-fashioned grime. Shoes must be rotated and allowed time to dry out. Wooden trees speed the drying process, deodorize, and prevent wet shoes from curling at the toe. If the shoes have been soaked, keep them away from heat, which can crack the leather. Stuffing them with newspaper will draw the moisture from the leather. Once they have dried, buff them with a soft cloth.

Leather is a skin, so treat it with the same care as you would your own. Shoes must be polished for protection and appearance. The first step I would take with a new pair of shoes is to treat them to the best shine available. There is nothing worse than getting a scuff mark on some unprotected portion of a new shoe; it will be with you in some form for the remainder of the shoe's life. Wax, which shields the leather against the elements, should be the first layer applied to the shoe. Polish is used only to achieve surface luster and should not be used as a substitute. Do not take your shoes out into the rain without first making sure they are protected by a good coat of polish. You should also polish the stitches of the shoe's welts; this helps to waterproof them.

CARING FOR YOUR NECKTIES

No stain is more difficult to remove than the one that lands on your silk necktie. However, if cleaned properly, most stains can be removed, provided the soiled tie has not sat for months in the back of your closet. This task should be performed by a professional service, such as New York City's Tiecrafters, Inc. (212-629-5800), which has the special equipment to press and roll the tie back into its original shape. Avoid cleaners who claim they can do this, because most will not invest money in such expensive machinery for the few neckties they clean each month.

WHERE TO SHOP

BOSTON

AN INTRODUCTION

I asked America's best-known literary dandy, the writer Tom Wolfe, what he thought was Boston's contribution to the lexicon of American male style. His immediate response was, "The Boston Crackling Look—you know, those creased but boned cap-toe lace-ups that confirmed the wearer had social standing to burn!" Boston is this country's most renowned outpost of patrician dressing and, as such, offers one last glimpse into a society where well-worn and cared-for fine clothing continues as a symbol of breeding, not fashion.

The legendary New England propensity for thrift and frugality provided the ideal atmosphere for this Beacon Hill sartorial puritanism to flourish. Even before the sixties generation's infatuation with vintage clothes, old was better in Boston. Frayed button-downs, bespoke hand-me-down tweed jackets that still looked prepared to go another fifty years before they rotted away, balled and shapeless crew-neck shetlands, and let-down khakis hovering ankle-length above worn but polished tassel loafers were as much a school uniform for upper-class preppies as the tailcoats and bow ties worn by their English counterparts at Eton.

Boston was a founding city of that part of the American landscape often referred to as "the Effete East." Its hallowed grounds extended down through New York City to Philadelphia, forming an old-boy network of privileged connections forged at the prep schools, ivied universities, and social clubs contained within. Membership carried its own unspoken signs of recognition. Inclusion assumed a certain genealogy and bank account, with little status accorded to those whose clothes looked too recently acquired. It was just not the clothes themselves but how they were worn that separated the landed from the merely loaded. For example, in those days, the Boston penchant for pairing polished tan, as opposed to black, Brooks Brothers Peal lace-ups with the firm's navy number one sack suits was usually a dead giveaway to one's Brahmin origins. Unlike the fitted cloaks donned by the English aristocracy, America's elite was more comfortable in Brooks's casually tailored camouflage.

BOSTON

Boston produced this century's last stylishly clad president, John F. Kennedy. Few in public office since have known how to wear a white linen pocket handkerchief or even why. It was also home to menswear's most educated fashion journalist, George Frazier. Frazier, who was habitually attired in a black grenadine necktie, reptilian-thin custom-made tan cap-toes, carnation, and rapier pen, wrote the seminal treatise on dressing, "The Art of Wearing Clothes," for *Esquire* magazine in the late 1960s. Witness to the slide of the American male's taste into the anarchy of the peacock revolution, he inveighed eloquently against what he perceived as the culture's loss of good fashion sense.

Many of today's style makers are disciples of the Boston aesthetic: musician Bobby Short, artist and writer Richard Merkin, custom tailor Morty Sills, and fashion designer Joseph Abboud, not to mention the country's most fashionable men's store, Louis, Boston. And one should remember that America's only homegrown global men's designer business, Polo by Ralph Lauren, was based on the idea of selling this same WASP lifestyle to the aspiring masses.

Fred Astaire used to throw a new suit or hat up against the wall just to knock the newness out of it. Sergio Loro Piana, one of Italy's high-swank dressers, holds up his custom-tailored Caraceni suit pants with a shabby high school belt. But neither's eccentricity would have pleased Lady Clare Rendleshaw as much as the Duke of Devonshire's proclivities as she related them in the London *Times*. "He's my pin-up man. He has lovely frayed cuffs and collars, as if he lent his wardrobe to the gardener to wear-in for six months. Now there's style for you!" George Frazier would surely have agreed.

ANDOVER SHOP
22 HOLYOKE STREET
CAMBRIDGE
TELEPHONE: (617) 876-4900
HOURS: 9–5:30 MON.–SAT.

Tucked away on Holyoke Street in a space not much larger than a cubbyhole, this store has collected an impressive list of patrons that belies its unassuming appearance. The reason behind this patronage is

Charles Davidson, one of Cambridge's most fascinating personalities and one of the last retailers in the natural-shoulder vein to know the subtleties of English and American custom tailoring.

I remember walking in one day with a friend. Charlie, as he is known to everyone, says nothing. He walks up to him, never having met him, holds up a jacket, and says, "Try this." My friend slides it on and falls in love. He looks inside. No label. Charlie tells him, "Look inside the pocket." A tag reads "J.F.K. 1961." A Kennedy had brought it in for Charlie to copy.

Charlie founded the Andover Shop in 1949 in Andover, Massa-chusetts. Four years later, he opened a branch in Cambridge, and there he continues to reside. A diminutive man, rarely without a cigar or a provocative opinion, he is friend and adviser to an endless list of critics, writers, and musicians who keep in constant touch by mail or phone, sending him their books or records as well as their orders for clothes. His students have included George Frazier, Bobby Short, Richard Merkin, Miles Davis, and yours truly.

Recently, Charlie had to replace the storefront. He used the same architect, same materials, and same colors, and the store appears brand-old. Inside, it looks the way I imagine Pat Moynihan's closet might: chock full of colorful "trad" threads, a typical selection of Ivy League shirts, trousers, and jackets. Where it excels is in its made-to-measure suits, jackets, and topcoats, which comprise fifty percent of its business. However, it shines because of Charlie, who has great

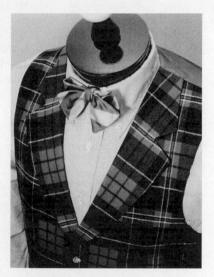

THE ALUMNI OF IVY LEAGUE AESTHETICS: REPP TO-TIE, TARTAN WAISTCOAT, OXFORD BUTTON-DOWN.

taste in selecting fabrics and has as much knowledge about making a suit as any of the masters of Savile Row. But like some top chefs, he needs to be inspired to do his best. If a customer shows real interest, Charlie will respond in kind. He may pull out his special English buttons and linings or some select vesting fabrics he has hidden away.

Otherwise he is liable to seem no more knowledgeable or involved than the guy down the block.

With typical dry wit, Charlie quips that he actually knew more when he opened the shop than he does now, because his taste had not yet been compromised. The Andover Shop is an esteemed institution, a museum and a place of learning in a town devoted to academia. And Charlie is its Ivy League proctor.

J. PRESS
82 MT. AUBURN STREET
CAMBRIDGE
TELEPHONE: (617) 547-9886
HOURS: 10–6 MON.–SAT.

Only by the standards of J. Press could today's Brooks Brothers be termed fashionable. Founded in New Haven in 1902, then expanding to New York, then Cambridge in 1932 (Press also went to Princeton, but didn't do well there and was suspended), this is the last citadel of the Ivy League look—uncompromised, unchanged, and unpleated. The concept here is that the classics should continue to have a place in the contemporary wardrobe, just as surely as they do in a college curriculum.

Although the New York City store represents 50 percent of the firm's business, the Cambridge store is the genuine article, ivy and all. It's so authentic in every odd detail that after seeing its preppy spin-offs around the world, it appears almost a parody of itself. The store reeks of pipes and porkpies, bow ties and fraternities, repp ties and raccoon coats.

One of the ironies of international business is that it took the Japanese to preserve this museum of American menswear fashion. After World War II, when the vanquished wanted to dress like their conquerors, the Japanese turned to tweeds and button-downs—a look that later came to be called "trad." In 1986, after a thirty-year licensing relationship, Kashiyama, a Japanese manufacturer, bought J. Press, thereby ensuring its survival.

Although the New York store has moved into plainer quarters, the crimson-and-white awning of the Cambridge shop and the blue and white of New Haven are as familiar as a pair of worn-out tassel

loafers. It's intriguing that Brooks Brothers, now owned by a British company, is trying to move into the modern age, while J. Press's business is still bustling with all those trads and grads of the George Will School of Haute Collegiate Couture yearning for the real three-button, natural-shoulder sacks with the straight-legged, nonpleated trousers. They're here, along with the grasshoppers on chinos, rhinos on ties, cable shetlands in pink, yellow, and orange, and the cashmere-mohair-and-wool Magee-striped shetland ($495) in a pattern that has been the shop's signature for over fifty years. Some items from yesteryear still have application outside of the prep world, such as their striped ribbon belts in repp tie colors like navy and yellow or green and pink, or different designs such as a flag pattern ($15) that, with its D-ring brass slides, looks great holding up a pair of today's pleated linen Bermudas or summer khakis. This style of dressing still employs punches of strong color to idealize the spirit of buoyancy and optimism of the American traditionalist.

One of the original college-town tweedmongers, Press is the last holdout of American fashion as a symbol of class identity. It's what remains of white-shoe dressing for those blue bloods who never had to buy their own furniture. And it will probably never change. I was reassured about this the last time I was there upon learning that everyone in the place was off to the Hasty Pudding on Friday night to see Mort Sahl kick up one of his classic satires on the moral majority.

JOSEPH ABBOUD
37 NEWBURY STREET
BOSTON
TELEPHONE: (617) 266-4200
FAX: (617) 266-6006
HOURS: 10–6 MON.–SAT.

When opening his first retail store in 1990, Joe Abboud decided on Boston, "because it felt like good luck to start in the city where I was born." Situated in the Gwathmey Siegel Building, one of the two modern structures on Boston's elegant but somewhat staid Newbury Street, the store is much like Abboud's clothing: a little old, a little new, classical motifs done in a contemporary style.

BOSTON

There are no mannequins. All the merchandise is out within reach, nothing behind counters. The play between the texture of his clothes and the curved lines of the architectural surroundings gives the interior a feeling of movement and sensuousness. The woods used throughout the store are environmentally responsible choices, just as Joe's stationery and publicity materials are printed on recycled paper.

Joe apprenticed at Louis, Boston for twelve years, eventually becoming one of its chief buyers and merchandisers. Then, in 1981, he left to join Ralph Lauren as associate director of menswear design. In 1986, he began his own business and quickly established a signature design imprint. Joe prefers his fabrics in earth tones, assembling them in an unusual mix of patterns. His sportswear collection—hand-knit sweaters, vests, and leather outerwear—is always handsome. His woven sport shirts always have four or five designs that are familiar yet new for the season.

Because of his training, both at school and at the side of two of America's great architects of style, Murray Pearlstein and Ralph Lauren, Joe was quickly able to express his own vision with clarity and taste. As the only graduate of the Ralph Lauren School of Design who has been able to forge his own path without going back to the well, Joseph Abboud is one of America's design talents who has modernized traditional clothes through his unique combination of modern fabrics and contemporary silhouettes, thereby adding a new dimension to the world of American menswear design.

KEEZER'S
140 RIVER STREET
CENTRAL SQUARE
CAMBRIDGE
TELEPHONE: (617) 547-2455
HOURS: 10–6 MON.–SAT.

One could say with a fairly straight face that Keezer's is really about the past. Founded in 1895 by Max Keezer, this is the oldest used clothing store in America. There is nothing hip or fashionable about the place. Its atmosphere is more Salvation Army than *Esquire* magazine.

For years, Keezer's dressed Harvard students and graduates, including John F. Kennedy, who used to buy chesterfield coats here. In turn, these same students filled Keezer's racks, bringing in their suits and coats for ready cash. People used to joke that Harvard was the college across from Keezer's. Not anymore. Nine years ago, it moved a couple of miles from Harvard Square.

The new store makes the original look chic. It's lost everything but the secondhand clothes. Its still a good place for tuxes in an emergency; secondhand tails are $85 and tux jackets are $40 to $60. You can occasionally find an old black Chesterfield or odd tweed jacket from a tailor's hand that's seen better days. People who need money can turn in their Saks Fifth Avenue and Neiman Marcus castoffs, which today tend to be more Ferre and Armani than Southwick or Hickey-Freeman.

In the old days, a particularly opportune moment to make finds was the week immediately following the Harvard-Yale football game. Lost bets had to be paid, and the easiest way to raise capital was a trip to Keezer's. Often, wealthy students would bring suits made by their fathers' tailors directly to the owner, who could always be counted on to cover their drinking bills.

Keezer's is a trip down memory lane, provided you have a good memory. The name is part of Ivy League Americana, but the store is no longer stylish, convenient, or even kitsch. As a matter of fact, it's probably the ugliest store mentioned in these pages. But who knows? You just might run across a pair of tartan dress trousers left by one of the older tweeds whose weight graduated him out of them and who felt no compunction trading them in for some ready money.

LOUIS, BOSTON
234 BERKELEY STREET
BOSTON
TELEPHONE: (800) 224-5135
FAX: (617) 266-4586
HOURS: 10–6 MON.–SAT.; TILL 7 WED., THURS.;
CAFE OPEN AT 8 A.M., WED.–FRI. FOR DINNER

Louis is the finest fashion store for men in this country and, perhaps, the world. If this judgment were based solely on the sophistication of

BOSTON

its merchandise, the store would win hands down. When you add its knowledgeable sales staff and the quality of its visual presentations, it's clearly in a class all its own.

What loyalists come here for is the vision and fashion wisdom of its courageous proprietor, Murray Pearlstein. Opinionated and impassioned are not the only words that have been used to describe Murray, but he is the reason Louis offers such a definite and thus different point of view. Whether the customer is ready or not, if Murray believes in a fashion's legitimacy, he will stock it in the store in spades. Murray and his seasoned staff helped pioneer most of what today's worldly dresser takes for granted. Twenty years ago, they were dispensing ventless jackets, pleated trousers, and broader-shouldered suits, while arguing in favor of brown and olive suitings for business as well as the more sophisticated taste of brown business shoes over black.

CEDAR APPURTENANCES TO PRESERVE THE PRIVILEGED: LUXURY CAN TURN TO EXTRAVAGANCE IF NOT DILIGENTLY MAINTAINED.

What is now "Murray's Mecca" was once Boston's Museum of Natural History. It took two years to bring this landmark from the age of the dinosaurs to the age of Mariano Rubinacci, Brioni, Zegna, and Kiton. Luciano Barbera, perhaps Italy's finest taste maker, was introduced to America by Murray. On hand are always several exquisite examples from one of these heroes of Italian tailoring. For example, on my last visit, an unlined, handmade cashmere sports jacket was just waiting to light on some initiate's shoulders—and "light" is the operative word.

Half of Louis's customers come from outside Massachusetts. That would not be surprising if the store were located in a hub of international travel and business or even in a destination stop for vacationers, but Boston? It's the right store in the wrong city. In a town renowned for its ivy walls and hallowed halls, Murray has established his own institution of higher learning. Despite the Brahmin predilection for threadbare clothes and New England thrift, Louis sells

some of the country's most expensive and progressive fashion. Aware that many men are moving away from a fixed dress code into more interchangeable, functional attire, the store has begun to provide soft dressing options, sportswear from as yet undiscovered designers, and a jeans look without the denim. And, most important, they are taking responsibility for educating their customers with advice and attractive displays.

By closing its New York City and Chestnut Hill stores, Louis has come through the eighties slightly scathed, but the stronger and wiser for it. Focusing its talented team on one showplace has made Louis even more unique than before. The new store has twice the space of the old Boylston Street store, on-site valet parking, a European-style cafe, a grooming salon, and floors of stone, marble, wood, carpet, tile, and sisal to define each of the twelve shops within the store.

Today, Louis occupies the country's vanguard position in high-quality men's fashion retailing.

CHICAGO

An Introduction

People who love cities love Chicago. Not only is it Sinatra's kind of town, it's every man's kind of town. Chicago is Bulls, Bears, and business. It has survived the fire, Prohibition, the curse of the Cubs, and Capone; no wonder its motto is "I Will." Forever fighting an image as the Second City, it never ceases to try harder and is not shy about exhibiting its brash sense of self.

From its position at the juncture of Illinois, Wisconsin, Indiana, and Michigan, Chicago has played a monumental role in America's social history. It has its own music (the word "jazz" was coined here). It has its own food, from deep-dish pizza to red-hots to "chizbuggas." Its own literature: Sandburg and Hecht, Farrell and Bellow, Dreiser and Sinclair. Its own honor roll: the University of Chicago has produced more Nobel Prize winners than any other university in the world. And its own architecture.

"For sheer commercial splendor," wrote architectural historian Reyner Banham, "Chicago is the rival of Baroque Rome." The city gave birth to America's first skyscraper and the Chicago School: Louis Sullivan, Frank Lloyd Wright, Ludwig Mies van der Rohe, Helmut Jahn, John Root, and Daniel Burnham are gods of modern architecture. People come from all over the world to marvel at the physicality of Chicago, from its Wrigley Building to the towers of Hancock and Sears.

In his famous poem of 1916, Carl Sandburg called Chicago "City of the Big Shoulders." And that incisive appellation tells you much of what you need to know about Chicago style. This is the home of custom-made buildings and soaring suits. Given the city's structural blend of metal, marble, brick, and glass—seasoned with outdoor sculptures by Picasso, Chagall, and Calder—the Chicago suit, with its pure lines, is the inevitable result.

A man on these sweeping streets walks proud. In an environment of such magnitude, he wants a suit that calls attention to his importance: angled, broad, and sharp. Here, it's still a compliment to be

called sharp. Some of the credit must go to Capone and his boys, who popularized the *Guys and Dolls* image of underworld fashion. Certainly, mafioso Frank Nitti's double-breasted ensemble, whose pinstripes could be seen from across the Loop, must have been the original power suit.

The main shopping area can be found on Michigan Avenue, the Champs-Élysées of Chicago. The stretch dubbed the Magnificent Mile is bound by the Loop on the south and by Oak Street on the north. Here you will find such time-honored stores as Saks Fifth Avenue, Neiman Marcus, Ralph Lauren, Mark Shale, and Brooks Brothers. Oak Street, Chicago's Rodeo Drive, is home to Ultimo, with its Giorgio Armani shop, as well as New York City's Barneys and Sulka. Syd Jerome is still downtown, while Bigsby & Kruthers and Paul Stuart have recently opened new digs on Michigan Avenue.

Motivated by weather that can change from Siberian cold to tropical warmth, with the shrieking wind known almost affectionately as the Hawk sweeping in from Lake Michigan, the Chicagoan needs a diversified wardrobe. While the New Yorker may be able to get away with a nine-month suit, this gentleman cannot. And since the business of Chicago is business, a man will not be out of place in a dressy suit. This is a city that exalts line and space in every direction, up, down, and out. Chicago symbolizes American grandiosity: the West's open prairies, man's monuments of steel, nature's great lakes, and fashion's big shoulders.

BIGSBY & KRUTHERS
1750 NORTH CLARK STREET
CHICAGO
TELEPHONE: (312) 440-1750
HOURS: 10–9 MON., THURS.; 10–8 TUES.,
WED.; 10–6 FRI., SAT.; 12–5 SUN.

This is Chicago's edge, one they claim not to have invented, but one they're identified with sharpening. Bigsby's business is visible because they are after the visible guy.

Using a recipe from their early days back on chaotic Maxwell Street—one-third clothes, one-third price, and one-third theater—

CHICAGO

Gene and Joe Silverberg have grabbed everyone's attention. The pull begins on the drive in from O'Hare. About the same time you are presented with the extraordinary skyline of Chicago, you behold a three-sided painted panorama of a tuxedoed Michael Jordan and other local heroes who are Bigsby customers. At the valet parking lot near the stores, there's a conspicuous green digital clock proclaiming, "It's Time to Buy a Suit."

From the days when they sold surplus goods and no-label Cardin suits, then pooled their money in 1970 to open a shop in New Town, the Silverbergs have been on a roll. Their instincts are part show biz, part sales pitch, never losing their penchant for growth and exploration. They chose the name Bigsby & Kruthers because it sounded important and established. They keep moving, keep taking the next step, keep thrusting their names in front of the public—from the black-and-white T-shirts worn by their bootblacks and stock boys to their annual Suitbook, an oversize brochure populated with the black-and-white portraits of such name-droppable customers as Phil Jackson, Christie Hefner, and Ahmad Rashad. They also have Michael Jordan as a business partner in their basement steak house, Bigsby's Bar & Grill.

Carving out their niche in competitive Chicago, the Silverbergs moved their traditional customer forward by offering him conservatively cut suits in adventurous fabrics while selling their fashion customer the most advanced model suits in more conservative fabrics. By mixing European full-cut fashions with John Molloy's dress-for-success traditionalism, they've created an international business style, propelling Connecticut button-downers and Midwestern double-knit polyester types into something more interesting. They carry tailored clothing and sportswear from many of the leading designer names: Donna Karan, Calvin Klein, Joseph Abboud, Giorgio Armani, and Hugo Boss.

The Silverbergs' success is a chapter out of Horatio Alger and the American Dream. Theirs is a culture where the man purchasing a $350 suit can receive the same treatment as the man buying a $1,200 one. This on-the-go business for the on-the-go Chicago male has been fueled by the Silverbergs' promotional skills and their creative use of their high-profile clientele; Bigsby's ingenious marketing and merchan-

dising techniques have made them Chicago's most talked about merchants. Bigsby & Kruthers pioneered dressing for the Chicagoan who aspired to look sharp and cool rather than old-money and thus unnoticed. Not only is that this business's edge, it's Chicago's.

MARK SHALE
919 NORTH MICHIGAN AVENUE
CHICAGO
TELEPHONE: (312) 440-0720
HOURS: 10–7 MON.–FRI., 10–6 SAT., 12–5 SUN.

This is Chicago's soft-shoulder fashion store. The business dates back to 1905, when the Al Baskin Company was founded in Streator, Illinois, about eighty miles southwest of Chicago. In 1929, Al Baskin opened a bigger store in Joliet, and two months later the financial world collapsed. Baskin survived the depression because of his great relationship with his customers. Through fire and famine, he kept on going, moving to new stores, renovating, pioneering, and enlarging. In 1937, Baskin's was the first store in the Midwest to have air conditioning and indirect fluorescent lighting; in 1949, his next store was the first to have an adjacent parking lot; in 1959, he introduced the concept of the shop-within-a-shop.

Al had two sons, Mark and Shale. Upon his retirement in 1972, they opened the first Mark Shale store in Woodfield Mall, winning architectural awards for lighting and display. Now there are eight stores. This flagship store, which opened in 1981, is strategically positioned in the historic Palmolive Building, directly across from the Drake Hotel in the middle of Michigan Avenue's Magnificent Mile. The salespeople are very knowledgeable about

AN EXEMPLAR OF MODERN DRESSING: PART CARDIGAN, PART PULLOVER, PART T-SHIRT, THIS WOOL MERINO KNIT DESIGN OFFERS UNRIVALED LAYERING VERSATILITY.

CHICAGO

style and taste and are empowered to do just about anything for the customer.

This is a traditional store that's moved itself and its customers forward by inviting Italy to join them for dinner. Initially inspired by Brooks Brothers, Britches, and Ralph Lauren, until every other store fell under the same spell, Mark Shale Italianized its preppy look. It caters to the young, smart Chicago career professional who is not a fashion aficionado but likes to dress. Their clothes, in cut and fabric, lean to the more contemporary side. They still appeal to the traditionalist who wants to move into something European, but not so stylized that it forces him to abandon his traditional soft-shoulder roots. There are suits by Corneliani, Joseph Abboud, Hugo Boss, Calvin Klein, and Alan Flusser ($450–$995). Most dress shirts are in the $60 to $85 range.

They also offer, under their own label, probably the best urban sportswear of any multistore specialty group in the States. From cardigan-front knitted tops to hip trousers in Italy's latest weaves, their weekend clothes are tasteful, fashionable, and well priced.

The business remains family-owned, and is still based on an extraordinary customer-service credo. This cherished anecdote reveals to what degree they are committed to providing service: A man came in looking for a Joseph Abboud tuxedo, but the store didn't have one. The salesman checked with the manufacturer, as well as other stores in other towns, all to no avail—until he called Nordstrom in San Francisco. They had the tux. The salesman charged it to his own credit card and had it shipped. However, it was sent to the wrong address. Undaunted, the salesman straightened things out, got the tuxedo, and personally delivered it to the customer. Family-run retail businesses are always more inclined to treat a customer as a member of its extended family. It is how the business began, and three generations later, it's still how Mark Shale operates today.

Nike Town
669 North Michigan Avenue
Chicago
Telephone: (312) 642-6363
Fax: (312) 642-1974
Hours: 10–8 Mon.–Fri., 9:30–6 Sat., 10–6 Sun.

The original and a must. It's as if they asked Steven Spielberg to design a store dedicated to showing not only Nike wares but also extolling the lore of American sports culture. It's gigantic, awesome, a four-floor cathedral of rubber and bounce dedicated to our obsession with sports.

This is the New Museum. We used to go see dinosaurs. Now we come here and see Michael Jordan's basketball uniform. It's a grand presentation for kids and grown-ups, the ultimate souvenir shop for visiting Europeans.

Pucci
333 North Michigan Avenue
Chicago
Telephone: (312) 332-3759
Hours: 9–4 Mon.–Fri. by appointment only

Pucci is the oldest custom tailor establishment in the United States. Signor Pucci was the first tenant in this office building when he opened in 1928, helping establish Chicago as a shouldered society. He was not a tailor but a stylist. When he died in 1965, his son Lawrence and daughter Caryl took over. This did not mean making changes, however; it meant maintaining the status quo. Nothing— from its quirkily theatrical decor to their double-knit fabrics that probably pioneered the custom-made leisure suits of the early 1960s—has changed since his demise. There's no fax, no computer, no electronic input from the outside. This is the serious atelier of a classic tailor.

Pucci is a mini-museum of Midwest tailoring lore. The show-room is hushed and carpeted, with armchairs upholstered with

CHICAGO

embroidered *P*s fabric and a busily designed family crest on display. Their fitting room is a marble-and-mirror sanctum, while the cutting room is one of the most beautiful I've ever seen, with checkerboard floor, skylight, and huge windows. Photographs of Signor Pucci and some of his famed clients are framed on the wall. Bolts of differently designed Pucci linings in red with gold motifs—some of them over thirty years old—peek out from underneath the huge cutting tables. Looking out at the river, the Tribune and Wrigley buildings, and the University of Chicago—a dazzling expanse of raw power—can't help but instill in a man a sense of establishment.

I remember watching *The Ed Sullivan Show* and wondering where entertainers like Danny Kaye, Danny Thomas, and Martin and Lewis could find such enormous suits—creations that looked as if, like hot air balloons, they had descended from on high and simply come to rest on their shoulders. This is where. Pucci also swathed thirties big-band leaders like Paul Whiteman, Tommy Dorsey, and Benny Goodman; artists such as Dick Tracy's creator, Chester Gould; and maybe even Capone. Pavarotti and Victor Borge still come here.

The Pucci suit has every bit of tailoring knowledge, quality, and detail that you'd expect for $3,000 (or, as they prefer to say, $2,995). Like Chicago's famous Oxxford clothing, this garment is totally hand-made, with a resolute shoulder line that typifies its middle-American origins. The Pucci design is untouched by the high fashion of Giorgio Armani. It makes the conservative Hickey-Freeman suit appear down-right avant-garde.

That a Pucci suit has such little relationship to current fashion is reason enough to know about it. This shop and its products are vestiges of American custom tailoring—the kinds of period pieces that will soon disappear. And as a window into menswear's more grandiose past, it will be a loss for every student and aficionado of the craft's myth and culture.

SYD JEROME
2 NORTH LASALLE STREET
CHICAGO
TELEPHONE: (312) 346-0333, (312) 346-0337
HOURS: 8:30–6 MON.–FRI., 9–5:30 SAT.

"How're ya doin', babe?" So greets Syd Jerome, son of a tailor, who claims to have held a piece of chalk in his hand long before he held a baseball. Syd opened his first shop in 1958—south of the Magnificent Mile and deep in the heart of the business section—and filled it with shirts, ties, and salesmen's samples. Today's store, wrapped around a major corner of downtown, is another home to the Chicago power suit.

From established labels such as Zegna, Armani, and Hugo Boss to the latest European comers, there are three thousand ready-made Italian designer suits on the floor. Syd sells so much tailored clothing, he employs ten tailors on the premises to alter or recut as necessary, using the matching threads he requests the manufacturer to include for such eventualities. He mates Van Lack dress shirts to the suits and stocks Thierry Mugler, Romeo Gigli, Iceberg, and New Man for sportswear.

This is not the place for the button-down set, but for people who want to look anything other than American or conservative. Like Bigsby & Kruthers, Syd charted its alternative course a long time ago. He decided that the traditional look of Chicago—as epitomized by Brooks Brothers and the late Brittany Ltd.—was well represented, and if he was going to develop his own niche it should be European (at that time it was Cardin and Saint Laurent fitted clothing; today it's Armani and Boss). It was a good decision.

Syd is one of those shopkeepers who is always on hand, doing the fitting and the buying while teaching his son, Scott, the ropes. It is due to his passion for the business that he's been able to thrive and retain the surprising number of Fortune 500 loyalists who are made to feel comfortable by his attentions. Outsiders might be put off by the sizzle and tinsel of this aggressive business wear—the black suits, bold floral ties, leopard cummerbund-and-tie sets, black lizard belts trimmed in silver. It seems that this is an element in every Chicago emporium that positions itself as a contemporary clothier. But one shouldn't be confused about the business at hand.

CHICAGO

Like Bigsby & Kruthers, whose downtown shop sits directly across the street, Syd Jerome is a player in this arena of Chicago power dressing. And like Bigsby, he's helped define his customer's taste and edge.

ULTIMO
114 EAST OAK STREET
CHICAGO
TELEPHONE: (312) 787-0906
HOURS: 9:30-6 MON.-SAT.

Joan Weinstein and John Jones are the undisputed purveyors of Chicago chic, and Ultimo is chic by anyone's standards. For twenty-four years, it's been the destination of choice for those who can't get to either coast to buy European fashion edited with the same insider's insight as New York's Charivari, L.A.'s Maxfield, or San Francisco's Wilkes Bashford. This is a high-style emporium. By virtue of having women's clothes in close proximity to the men's, the store has always been able to expose its male customers to the latest designer developments. Like the handful of other internationally sophisticated fashion shops in the States, Ultimo, aided by longtime salesmen and merchandise bought with particular customers in mind, has attracted a loyal following from beyond Chicago's borders.

Their clothing is cleverly eclectic. You might see a great denim shirt for $85 hanging next to a Chrome Hearts leather jacket trimmed in sterling silver for $3,000. The atmosphere also pulls from a range of international decor, from its drapes in an African motif and rusty-wine walls to the kilim rugs on top of sisal matting, leopard-framed mirrors, Moroccan furniture, bamboo chairs, and huge baskets filled with enormous cacti.

Ultimo first brought Armani to the Midwest when he was still working for Nino Cerruti in a basement office in Milan. Later, they gave him a three-story shop in a brownstone across the street. They also introduced the Japanese designers Issey Miyake, Matsuda, and Comme des Garçons to the land of the Great Lakes. Today there's a Zegna shop, with clothes made exclusively for the store ($800-$1,800), and

an upstairs sportswear shop carrying highly edited pieces from the sophisticated collections of Europe. Elsewhere are Italian private-label dress shirts ($100–$350) and an interesting collection of neckwear ($75–$125).

Although Barneys has moved in to challenge them, Ultimo was here first, pioneering high fashion in the Midwest. Ultimo is recognized as the local hero, which continues to ensure their position as the hippest store in the heartland.

DALLAS

AN INTRODUCTION

The very first building in Dallas was, of all things, a store. In 1840, John Neely Bryan built a log cabin on the east bank of the Trinity River, and there he installed a trading post. Retailing escalated, the goods got better, and then on a summer Sunday in 1860, every store and hotel in town burned to the ground. Undaunted and true to their hearty heritage, the Dallas merchants picked themselves up and rebuilt their shelves. Today, things are looking downright healthy. Whatever retailing crisis has hit the rest of the country seems to have bypassed Dallas. Or maybe it's just pluck. Due to creative movers such as Stanley Korshak's aggressive Crawford Brock, Pockets' David Smith, and h.d.'s Henry DeMarco, some stores are not only flourishing, they're expanding.

Big D shoppers aren't bashful, and they're not thrifty. Dallas ranks third as headquarters for Fortune 500 companies, and there's lots of money here. The citizens have places to go and reasons to get dolled up. They love to shop, they love to eat, they love to be seen: at a concert at the I. M. Pei–designed Meyerson Symphony Center in the splashy new sixty-acre Arts District or a Cowboys game at the stadium, at the cause-of-the-month ball at the Mansion or the weekly Mesquite Championship Rodeo, during a night at the Civic Opera, or an afternoon at the Prairie Dog Chili Cookoff and Pickled-Quail-Egg-Eating World Championship.

They're driving their German cars downtown to the legendary Neiman Marcus, and they're driving farther down the road. Dallas has more shopping centers and more retail space per capita than any other city in the United States. Beautiful Highland Parks Village, Texas's first shopping center, built in 1931, is surrounded by posh homes, supported by old-money customers, and is much like New York's Southampton. The Galleria is a "supermall" that includes the Westin Hotel, four-star restaurants, a five-theater cinema, an ice rink, and 195 stores. The glamorous Crescent Court, built by the oil-slick Hunts, contains the Crescent

Hotel and Korshak's, among other tony holdings. NorthPark, the most centrally located of the malls, has Neiman Marcus. Hipper and more off-beat clothes can be found in the shops along suburban Greenville Avenue. The funky and secondhand are in Deep Ellum (formerly Deep Elm, and once the center of African-American culture), which is, like New York's SoHo, a jazzy hotbed of warehouses and artists' studios.

Dallas is less dressy than New York and Chicago. It's long been conservative in its politics and its dress, but things are changing. Its corporate citizens travel, they've become unquestionably more haber-dashing, they know quality, and they're beginning to bring it home.

DESPOS
500 CRESCENT COURT
SUITE 152
DALLAS
TELEPHONE: (214) 871-3707
HOURS: 9–6 MON.–FRI., 10–1 SAT.

Chris Despos did something unusual for these parts. Having learned the art of tailoring from his father and brother in his hometown of Fort Wayne, Indiana, he went on for further polish. Like a journeyman of the old world, he spent one vacation working in Italy with a Caraceni craftsman and another in New York City studying pattern-making with the late, legendary Henry Stewart of Savile Row. Then, in 1981, he opened his own establishment. This thirtysomething fellow is a serious student of fashion and, more to the point, a skilled practi-tioner. He does the patterns and cutting, then turns the work over to his seven tailors to sew.

Chris moved to the elegant Hunt complex called Crescent Court, in 1991. Sleek, modern, clubby, it has sisal rugs on its marble floors, walls of white and tan, high ceilings that give it the unlikely shape of a bandshell, and lots of books on menswear. Its elegant fitting room, decorated in dark wood with walls of Edwardian green, has such executive time-killers as a phone and mini-TV. These are pretty grand digs for a custom tailor.

The focus here is on suits ($2,200–$2,750), which require two or three fittings and take six weeks. The house style features a higher waistline, straight shoulder, and padded chest for a tall, rangy look.

DALLAS

His single-breasted jacket, with its perpendicular, closed front, has a particularly elongating shape; it's something like an English hacking jacket with a little less suppression to it. The jacket's breast welt pocket is a student's homage to the famous Caraceni boat-shaped original. Despos also carries Pantarella socks, Sunspel mesh undershorts ($26) and undershirts ($35–$50) from England, which are rarely seen in the United States, and a small complement of ties and dress shirts.

I admire Mr. Despos's enthusiasm, his dedication to accommodating the customer, and that he has his own identity about the fit of his clothes. Chris's design sense could benefit from more exposure to the higher climes of Savile Row or Italy, but his creations are legitimately well-made and should please the man who likes fine clothes and aspires to look individual in the world of Dallas fashion.

H.D.'S CLOTHING COMPANY
3018 GREENVILLE AVENUE
DALLAS
TELEPHONE: (214) 821-5255
HOURS: 11–7 MON.–FRI., 1–6 SAT., 12–5 SUN.

To encounter Harry DeMarco, hip and ponytailed, is to understand what's stacked on his industrial Metro racks. When the world was wrapped in faded denim, DeMarco was right in its epicenter, at the Britannia jeans company. After learning what he could, he opened his store in 1981 on Greenville Avenue, one of Dallas's smart little shopping areas. Then he studied his customers. Fifty percent of what he picks up during his five annual trips to Europe and seven to New York is chosen expressly for them. He pioneers many new, small sources, and knows what he's buying as well as for whom he's buying it. He sells a style that people want to relax in: jeans, alternative jeans, shorts in lots of styles and lengths, and great tops.

With black Pirelli rubber on the floor and neon on the walls, the place reminds me of Paris in the late sixties and early seventies, when the jeans phenomenon hit the Left Bank and the first $50 faded, washed jeans appeared at Lothar and the Bob Shop. The French had a way of making jeans glamorous. So does h.d.'s.

DALLAS

The look here is street rather than country club. It starts with a cotton T, Diesel jeans and sneaks that have just the right amount of rock 'n' roll. It's white hip-hop that has been snatched up by Texans who have outgrown fitted clothing and just want to be comfortable. For summer, h.d. offers all kinds of shorts in the latest cut; in winter, bottoms in the latest silhouette. There are cotton woven bottoms and cut-and-sewn woven shirts, fifties-style linen striped continuous-waist-band pants, stuff from Milan, stuff from France. Lots of cotton.

DeMarco has built a business and survived the great retailing crisis by doing his homework. He uses his space wisely and lets its limitations guide him. (Each August 1, everything goes on sale.) As a result, the fashion is focused and well edited. You're not likely to find someone else wearing any item you buy here, because DeMarco buys only four of everything. If you don't buy it when you see it, you've missed it.

NEIMAN MARCUS
400 NORTHPARK CENTER
DALLAS
TELEPHONE: (214) 363-8311
HOURS: 10–9 MON.–FRI., 10–8 SAT., 12–6 SUN.

Neiman Marcus invented the carriage-trade business in the Southwest and remains the area's preeminent retailer. It was established as a women's store in 1907 by Carrie Marcus Neiman with her husband and her brother. Menswear was added in 1928, under the supervision of her nephew, Stanley Marcus, whose first interest was to fill the space suddenly vacated by a tenant shopkeeper who went broke.

It wasn't easy breaking down the rough-hewn macho Texas male and bringing him into a "ladies' store," but Stanley persevered. Stanley took a lot of first steps in creating the firm's men's business. After deciding to carry Cavanaugh hats, he went to the New York

TAILORED SUPPLENESS BY ZEGNA: SOPHISTICATED SPORTSCLOTHES FOR THE MATURE IN TASTE.

DALLAS

hattery and invited its top salesman, Hans List, to Dallas. List's performance at Neiman Marcus was the first time a personal appearance on behalf of selling men's clothes was undertaken in this country. Hans and his hats were a hit.

From head to foot, Neiman's has always been in the forefront. Stanley Marcus was the first to sell French lisle socks for $7.50 when most cotton socks in Dallas went for a buck. After World War II, while traveling in Italy, he noticed that tailors there used Dupioni silk for ladies' clothes. It might work for men, too, he mused, but his buyer balked. Unfazed, Marcus had some silk suits tailored for himself. He planned to sport them around his customers and let them tell the buyer what to purchase. They did. The next year, the store took orders for over 2,000 silk suits, and Neiman's had a silk-suit exclusive in the United States for three or four years before other retailers finally caught on.

The store's first advertisement, which appeared in the *Dallas Morning News* in 1907, proclaimed, "As well as the Store of Fashion, we will be known as the Store of Quality and Superior Values. We shall be hypercritical in our selections." The store's world-famous Christmas Book, which was first printed in 1915 as a modest six-page brochure, has included doodads ranging from an $8.95 monogrammed hammer to an $11,500 Chinese junk, a life-size stuffed panda to a breathing Black Angus, a tube of martini-flavored toothpaste to a shahtoosh muffler made from the chin hairs of the ibex goat found in the Himalayan Mountains in Kashmir.

Stanley Marcus retired from the store in 1976 to become chairman emeritus. His prowess and philosophy remain dazzlingly fresh and eminently practicable. He believes, and has taught his disciples to believe, that customers are individuals, not numbers, and they must be treated as such. Their idiosyncrasies must be honored. No inconvenience is too much. Open the store on a Sunday, if a good customer can't come to town on any other day. If the wrong item has been sent to a customer in Puerto Vallarta, get on a plane with the right one. This is a far cry from the way most merchandisers are trained, with their focus on money management rather than on the management of the goods and the people who consume them.

"A store," Marcus remarked to me recently, "is like a newspaper. Everyone has access to the same material; it's what the editors decide

to put on the front page, the back page, or bury in a column that distinguishes it." Stanley's mission was to cultivate a certain level of taste, purvey that taste, and educate shoppers so they will crave it. Rather than offering them what they want, he sold them what they ought to want. "It's what you do not have that makes what you *do* so good," a customer once told him. Taste, he feels, is the merchant's responsibility, and sometimes he has to show courage and leadership even when it means deferring profits.

Today, Neiman's is doing just fine. Its men's team, headed by an alumnus from the Stanley Marcus school, Robert Ackerman, reports to its new president, Burton Tansky, former chairman of Bergdorf Goodman. Like Stanley Marcus, Mr. Tansky is a merchant who loves to inspect the merchandise on a floor. He constantly reminds his buyers of which segment of the country's population is responsible for Neiman Marcus's success. He has encouraged his merchandise team to stay the course and further expand the company's historic franchise of the affluent shopper.

No one appreciates this reaffirmation of the company's founding credo more than the man responsible for its enormous men's tailored clothing business, merchandise manager extraordinaire Derrill Osborn. As one of the country's most colorful and charismatic doyens of men's style, Mr. Osborn has been faithfully plying the lessons taught to him by his two famous mentors, the gurus of American specialty retailing, Neiman's Stanley Marcus and Saks Fifth Avenue's Adam Gimbel.

In his person, manner, and experience, Mr. Osborn personifies the menswear executive as his profession was practiced when the winter sale started after Christmas rather than before Thanksgiving. And to Neiman Marcus's credit, the store is probably one of the few large retailers with the sophistication to take advantage of his unique background. Perhaps that is why their annual $100,000,000 tailored clothing sales represents the world's most prestigious and prodigious menswear enterprise.

In Dallas, while the downtown store is the granddaddy of the chain and a historical showplace, NorthPark has the larger presentation of Neiman's menswear. Recently renovated, its rich spread of the top of the top covers eight thousand square feet and takes in a silken sea of fifteen thousand neckties and seven thousand suits. Italy's Kiton,

DALLAS

Brioni, and Luciano Barbera suitings retail at over $2,000, and Oxxford, Armani's Black Label, Donna Karan Couture, and Zegna sell for above $1,500, pushing the average price for a suit here to $1,400. Neiman's also does the country's largest special order business in better clothes. If you are looking for a fine quality, handmade or designer suiting and cannot find it here, you probably can't find it at all.

If anyone questions Neiman Marcus's commitment to servicing the wishes of the country's old and new rich, one perusal of its men's floors will end all doubt. With the legacy of the Marcus family intact and a retail culture accustomed to ministering to such privileged tastes and desires, Neiman Marcus is the retailer of choice for those who want to select from among the best.

POCKETS
9669 NORTH CENTRAL EXPRESSWAY
SUITE 100
DALLAS
TELEPHONE: (214) 368-1167
HOURS: 9–6 MON.–SAT.; TILL 8 THURS.

As a destination store, Pockets is almost a microcosm of what has happened to the traditional menswear retailer. In order to survive, the store gradually moved away from its natural shoulder roots and became more modern, upmarket, and fashion driven.

Owner David Smith originally opened across the road in 1974, moving here in 1987 because he needed the space. Up went the pine paneling, down went the dhurrie rugs, in came the goods from a number of unexpected vendors including Zegna, Canali, Nick Hilton, V2, Jhane Barnes, Barry Bricken, Luciano Barbera, Ike Behar, and Burberry. Smith expertly shops the European market, buying small quantities that mix well in his polyglot bazaar. His innovative medley of color and pattern gives the shop great appeal; he describes it as "a gigantic closet."

Smith, who's always on the premises in shirt and tie, knows his customer by name and what he likes to wear—in the office or on the golf course. He appreciates that Pockets customers must make an effort to visit him, so David tries to make the trip worthwhile. This is a

full-line store, from shoes to hats, from conservative to medium fashion. Sixty percent of the merchandise is business clothing—suits, dress shirts, and an array of two thousand ties ($55–$125), traditional or otherwise. The balance is composed of urban sportswear, selected with that same desk-bound Pockets customer in mind. He might find a soft, unconstructed jacket, hip vest, or banded-collar top, and at the same time, a plaid button-down shirt to wear under an interesting crewneck sweater that the Ralph Lauren set would appreciate.

Shopping here is serendipitous. Smith's taste is eclectic, not stuffy, helping to guide the traditional man into the contemporary world without scaring him. His store is wise, warm, safely fashionable, and an example of what one creative merchant did to survive in designer-driven America.

STANLEY KORSHAK
500 CRESCENT COURT
SUITE 100
DALLAS
TELEPHONE: (214) 871-3600
HOURS: 10–6 MON.–SAT.

Once upon a time, Stanley Korshak was considered the Stanley Marcus of Chicago. Mr. Korshak was a famous carriage-trade retailer in the Windy City. Then, in 1986, Korshak blew into Dallas as a high-end specialty store for men and women. It upscaled and upscaled, moving from traditional to high fashion, adding a cappuccino bar and cafe, and hiring the innovative Crawford Brock as president. Mr. Brock turned around and invited Stanley Marcus, the then eighty-nine-year-old doyen of specialty retailing and founding father of Neiman Marcus, to act as the firm's consigliere.

This is Dallas glamour with a big *G*. Korshak is a division of Rosewood Property Company, which is a part of the Caroline Hunt Trust Estate. Rosewood owns a half interest in the Shops at the Crescent (the chichi shopping sprawl in which this gem is situated) as well as the adjacent Hotel Crescent Court. In a field where others are downsizing, Korshak is looking up. Continuing to consolidate its upscale trade, the store has attracted a new, entrepreneurial breed of college-

DALLAS

educated salespeople. The buyers work alongside the salespeople, thereby keeping in touch with customers and maintaining an intimacy in buying.

Dallas is Polo-land in sportswear, but Crawford, once again forging his own way, went after the high fashion business. The store now sells more Armani than any other single specialty store and has the largest Donna Karan men's shop in the United States. The menswear presentation is all Texas space and theater, with its own separate entrance. The club-elegant rooms are done in stained rosewood, African burl elm, and mahogany, with rich rugs on the marble floors. Twin walls are blanketed in ties, another wall flaunts nothing but hosiery— all patterns, no solids. They have recently added the most extensive presentation of formal wear of any American specialty store. And now more: the Rosewood Collection, a private assemblage of top quality, traditional menswear recently premiered in a two-thousand-square-foot addition. It features dress shirts from the likes of Borelli and Sulka, and tailored clothes from Canali, Belvest, and Kiton.

Korshak is not intended for the baby-carriage, ice-cream-cone mall shopper. It's for the deep-pocketed customer who has a touch of the dramatic in him, a man who's interested in the broad sweep of high-end fashion from here to Europe and back; in fact, very much the Neiman Marcus customer. The store's exciting to shop, pricey, absolutely alluring, and a required stop on your next trip to Big D.

FLORENCE

AN INTRODUCTION

Florence is a country town, thirty miles from the Adriatic Sea and fifteen minutes from the Tuscan hills. Many who live there spend an equal amount of time outside it. As a result, the dressing style found in Florence is much less citified than that of the international business cities of Milan and Rome.

Milan is industrial, austere, and cold. It wears its three-button clothing buttoned to the top button. Florence is more villagey and open, buttoned on the middle button. While the business uniform of Milan is usually charcoal-gray worsted, the Florentine version might be a corduroy suit or a tweed jacket and flannels. These are not showy threads, because Florence is not a swaggering, movers-and-shakers kind of place. It's a small, charming town, especially for those who live here year-round.

The city's commercial district is a relatively small central area, so tourists and shoppers interact daily with the town's residents. Such exposure results in the Florentine man's inbred penchant for quality and conservatism being spiced with a surprising dose of eccentricity. He is not afraid to mix old with new, inexpensive with expensive, or country with city.

Florence offers more strata of fine specialty men's stores than any other city in Italy. Twice a year, the Pitti Uomo, the major Italian men's show, attracts the world's top retailers to the city, adding to its collective fashion consciousness. Most of the leading international men's designers are well represented here as well as some recently opened Ralph Lauren–esque shops. Numerous old-world, family-run stores abound, as well as several designer/retailers, who put collections together from local sources to create their own cosmopolitan fashion.

Dickens called Florence's medieval cobblestone streets, with their high walls and inadequate sidewalks, "magnificently stern and somber," a description that may capture their architecture but not their spirit. When you add the city's rich breadth of menswear to its Tuscan charm, art, and food, Florence becomes one of the requisite stops on Europe's fashion itinerary.

FLORENCE

ARMERIA CENTRALE
VIA PELLICCERIA 30R
FLORENCE
TELEPHONE: 210162
HOURS: 9–1:30, 3:30–7:30 MON.–SAT.

Armeria Centrale is the oldest gun shop in Florence. Its stone floors and metal cabinets are purely functional and not at all romantic. I'm always intrigued when I see a shop of this vintage that specializes in a particular sport. Usually, as in the case of Armeria Centrale, it will have several wearables created exclusively for the shop by its original owner. Sometimes they are uniquely authentic enough to be considered collectibles.

The trappings here are top-notch, as they have been since the door opened in 1920. Along with the guns, bows, and other weapons, there are sophisticated sports clothes that can be adapted to civilian use: Viyella-like shirts with printed hunting scenes, hunting jackets with beautiful details, unusual field boots, and poly-filled quilted hunting vests in bright blue ($80), which look wonderful over olive and loden green. All of it is worlds apart from the black-and-red buffalo-checked shirts and yellow hats seen on American hunters, who choose visibility over style. These are elegant stomping-around clothes, whether your venue is the Black Forest or the Champs-Élysées.

CASA DELLO SPORT
VIA TOSINGHI 8–10R
FLORENCE
TELEPHONE: 215696, 213373
HOURS: 9:30–7:30 MON.–FRI., 9–1 SAT.

Casa dello Sport has to be the most colorful shop in Florence. Stroll along for a visit after savoring ice cream at Vivoli, the gelateria where the Florentines claim this confection was born. On Saturday it's a meeting place for sports-minded hobnobbers and rubber-footed browsers shopping for athletic wear, and the place to buy distinctive apparel for golf, skiing, or soccer.

In the States, the emphasis is on the equipment. In Florence, where the fans do not swoon over lived-in-looking athletic wear the way the States' urbanites do, Casa dello Sport's selection remains status-driven. Labels count. I find the athletic wear here appealing on another level: Like this country's weekday togs, it has a slightly more refined, cleaned-up attitude. When shopping for sportswear in this city, I always look for something indigenous that won't be found on Madison Avenue. Casa dello Sport, which opened in 1919, is a veritable fount of such merchandise.

The shop is a field of team colors—but they are Italian team colors in classy combinations such as bottle green, navy, and bright yellow, rather than the pedestrian combinations Nike mass-produces for the street warriors in the States. In addition to all the color, the store is inviting because of how they've layered the presentation, like a grocery store. You walk in and you want to buy something—an Italian rugby jersey, Milan football shorts, special bike sweaters, and so on. It's interesting to compare what Nike, Reebok, and Adidas create for the Continent and see how they gentrify it for the sophisticated European palate.

EREDI CHIARINI ROYAL
VIA ROMA 18/20/22R
FLORENCE
TELEPHONE: 284478
HOURS: 9:30–7:30 MON.–SAT.

And another reproduction of Ralph Lauren's Rhinelander mansion is unveiled. This Florentine re-creation is a prop-enhanced enclave for the young professional whose parents patronize the older-world Principe or Neuber stores. It is tasteful, considered, with a level of quality higher than that of its American inspiration. After all, this is Italy. The store carries three stories of American classics with an Italian touch, playing somewhere between a dramatic palazzo and an unintended parody of its Madison Avenue forefather.

Of all the stores around the world that owe their image to Lauren, this is by far the most unabashedly reverential, even down to the Persian rugs of the same patterns and colors tossed on floors

FLORENCE

stained the same brown. There's even a sporty Polo presentation amidst a series of walnut-paneled rooms decorated with blue-and-white-striped wallpaper, swagged curtains, and tortoiseshell-framed scenes. It's a gentleman's club setting, Florentine style.

Eredi Chiarini Royal is an ambitious enterprise, remarkable since it has evolved over four generations from a little fabric shop that opened one hundred years ago in the Piazza Beccaria. Everything begins with the Polo concept and then goes off on an Italian tangent. The presentation of neckwear alone is compelling: 150 loosely knotted ties on horizontal bars, a gorgeous silk sea of pattern and color ($60–$80). The dress shirts are elegant ($80–$150), as are the suits. Their double-breasted model has a custom-made look and is one of the better ready-made versions available in Europe ($800–$1,200).

Like Ralph Lauren's Polo Sport shop across from his Madison Avenue manor, their weekend store is next door. Here you will find a collection of the most interesting urban sport and casual clothes produced in Europe for the "chino-and-Top-Sider set." Its offerings vary according to the season, but among their well-edited collections are Johnny Lamb's printed polo shirts, button-down shirts from Brooks Brothers, great European jeans, and Tod's sports shoes.

If you covet traditional American clothes but with a more sophisticated rendering, this is where you'll find them. It's always interesting to see how the Continentals do Ralph Lauren, because of all the countries in the world, no contingent better appreciates the classiness and classic-ness of his taste more than the Northern Italians.

GUCCI

VIA TORNABUONI 73R

FLORENCE

TELEPHONE: 26401 1

FAX: 212634

HOURS: 10–7 MON.–FRI., 9–1 SAT.

Twenty years after Gucci, Fendi, and Vuitton luggage became monikers of status and wealth, the famous Gucci shoe has lost little of its stylistic relevance. Today you can find it in its original model or with a thicker rubber sole, giving it the extra scale to mate with today's

fuller-cut clothing. The famous buckled suede slip-on with horse's bit ($200) is still one of the softest, most comfortable casual shoes a man can sport—brown leather for the classicist who favors his navy blazer accessorized with gold buttons and gray-flannel trousers, or black suede with a lug sole for the Versace set. Its signature design is accorded cosmopolitan cachet from Palm Beach's Worth Avenue to Milan's Via della Spiga.

The house of Gucci was established in 1904. The current shop opened in 1966. Inside, it is woodsy and leathery, a sensual evocation of the days when old Guccio Gucci (thus the famous interlocking G's) made saddles and harnesses for the nobility's horses. The interior is "tanned," with open shelves lined in beige leather. The walls and displays are finished in satinwood and walnut and trimmed in a tortoiseshell design inlaid with a black floral motif. Several levels of parquet floors escort you from the entrance back into the inner rooms. On every glass-topped showcase rests a brass-bound leather scroll that is unfurled by the salesman in the course of a smaller article's presentation. Larger leather products are displayed in a magnificent back room beneath a vaulted ceiling.

There are very few items of men's attire that have survived the vagaries of high fashion as gracefully as the Gucci slip-on. And I cannot imagine a more handsome or elegant environment in which to acquire this enduring symbol of Italian chic.

H. NEUBER
GALLERIA TORNABUONI
VIA TORNABUONI
FLORENCE
TELEPHONE: 215763
HOURS: 3:30–7:30 MON.; 9:30–1,
3:30–7:30 TUES.–SAT.

As the oldest retailer in Florence, Neuber has a well-entrenched commitment to the local gentry. A century ago, Neuber was located in the Via Tornabuoni. In 1920, it moved to the Via Strozzi, where it was conveniently located directly across from Florence's version of Brooks Brothers, Principe. Recently it moved back to Via Tornabuoni.

FLORENCE

Most of these gallant old shops still carry the English classics popularized by the aristocracy of Europe—and Neuber was the first in Florence to showcase Burberry and Aquascutum. Until three years ago, it was also the city's exclusive purveyor of Hermès. Today, the store is known for its Scottish-made sweaters of lambswool and cashmere by Peter Scott, Chester Barrie, and McGeorge. There are also beautiful alligator belts with simple gold buckles by Longi ($260), English Holiday & Brown ties, and leather products by Monza's famed Schiatte. A quilted long-sleeved riding jacket, which was the rage two years ago, comes from Husky in England ($120; the sleeveless version is $80). It's available in five colors: olive, loden green, black, dark pink, and a soft, dusty, cashmere yellow—exclusively Neuber colors.

Even in its new incarnation, with its diagonal light-wood floors, Persian rugs, vaulted ceilings, and tall gold-trimmed mahogany cases, Neuber remains a classicist's preserve.

LUISA VIA ROMA
VIA ROMA 19–21R
FLORENCE
TELEPHONE: 217826
HOURS: 3:30–7:30 MON., 9:30–7:30 TUES.–SAT.

In the unruffled days of 1930, Luisa sat on a stool making simple straw hats. That was then, this is now, and these nights the Via Roma—which runs from the Ponte Vecchio to the Duomo—becomes a throbbing thoroughfare. And Luisa is one of the main draws. The prime mover here is Luisa's grandson, Andrea Panconesi, forty-two, who traveled the world and decided to bring some of its treasures home to Florence. This high-tech hot spot, renovated in 1984, was the first store to bring non-Italian designers (especially the early-eighties Japanese) to Florence.

The shop occupies two floors, the second of which, up a spiral staircase, is for men. The intentionally spare white walls, stained floors, black lighting gear, and glass-and-black-metal display cases are designed to avoid competing with their well-edited collections from the world's fast-track designers such as Dries Van Noten, Donna Karan,

Dolce & Gabbana, and Yohji Yamamoto. This is the Charivari of Florence, and you might still find a man's straw topper provided it's been made hip by the likes of Jean-Paul Gaultier.

OLIVER

Via Vacchereccia 15R
Florence
Telephone: 2396327
Fax: 287266
Hours: 3:30–7:30 Mon.; 9:30–1,
3:30–7:30 Tues.–Sat.

Brown is the new black, and this kind of fashion direction is what you expect to find at Oliver. Twenty-four years of pioneering *l'uomo vogue*, Firenze style, has made this fashion depot one of Italy's most renowned. Were Giorgio, Calvin, and Donna to agree on one point, it would be that there's always something to learn from forty-four-year-old Roberto Ottanelli, its visionary proprietor. His shop, with its black floors and black tables, has been at the same location since its inception. Ottanelli wants the environment to stand still; it is the merchandise that moves.

Oliver's is the *cioppino*—an Italian bouillabaisse—approach to men's fashion. Ottanelli starts with a bit of Armani and Romeo Gigli, adds a pinch of Dries Van Noten, flavors it with some local wares from the fashion artisans found in the surrounding hills, blends well, and serves it up to be viewed in two large windows. He feels that his customer does not want to dress head to toe in one single collection, à la Armani, but prefers to mix high with low, inexpensive with expensive, designer fashion with that of the street.

He is proud that the store hasn't changed in twenty-four years, and likes being able to anchor the changes in fashion by having the environment be the constant. His lacquered floors, wood presen-

INFORMED FASHION FOR THOSE
ACOLYTES OF THE AVANT-GARDE.

FLORENCE

tation tables, and high-tech touches are the perfect backdrop for presenting the subtle sophistication for which he is known. You can find some of the best navy, charcoal, and dark brown sweaters, woven or knit shirts, vests and hip bottoms available in Europe, and at very reasonable prices. He carries a whole range of high-fashion clothing—thirty percent under the Oliver label, the balance a mixture of such names as Romeo Gigli and Fabrizio del Carlo. More important, better than anyone else, he demonstrates how dark you can dress and still look colorful.

———

PRINCIPE
PIAZZA STROZZI 1
FLORENCE
TELEPHONE: 292764
FAX: 293398
HOURS: 3:30–7:30 MON.; 9:30–1, 3:30–7:30 TUES.–SAT.

Principe is the Brooks Brothers of Florence. It's also as close as you'll get to a department store in this town. If you closed your eyes en route to the first floor and then opened them on arrival, you'd think you were somewhere in Connecticut circa 1965. English repp, challis, and paisley ties abound, as do other souvenirs of the Ivy League such as Alan Paine shetlands, tweed sports jackets, argyle hosiery, and Brooks-style boxer shorts.

You might even think the place was built around the turn of the century. Actually, it was built in 1930. After the Arno flooded the city in 1967, the store's ground floor was entirely reconstructed—although it's hard to believe its carved, hand-turned, Florentine-rustic banisters aren't a hundred years old. The decor is Italian country, with brick-colored stone floors and odd rugs thrown about, arched windows, interior wood porticos for displays, family crests framed on tartans, tarnished brass light fixtures, and chairs covered in warm saddle leather with plaid Viyella blankets tossed over the arm. Above the fake fireplace are crossed skis and flat, laced snowshoes. A pair of trappers' shoes rests on the hearth.

The third-generation of the Doni family is still making Principe's clothes, including its famous Casentino coat, a Florentine duffle made

of a specially treated wool from the Tuscan hills and offered in three particular colors that haven't changed since its introduction in the 1950s: a bright russet, a Lombardy green, and an unusually deep brown. The duffle is available every fall until sold out, which it usually is by late November. On my last visit, I saw a unique sheepskin-lined glove done in three colors of suede: loden green on the outside, rust on the palm, and bark-brown on the thumbs ($80).

Principe is a likable leftover from the period when English country clothes were the preferred garb of the aristocracy, and continues to function as an informal rendezvous for the old families of Florence. When you imagine the kind of clothes your father might hand down, this—as well as the seven other Principe stores from here to Cortina d'Ampezzo—is where you'll find them. Like Florence itself, this is not a dress-up place. Theirs are classic clothes to be worn on the way into town from the seashore or countryside and back again.

TIE YOUR TIE
VIA DELLA SPADA 8R
FLORENCE
TELEPHONE: 211015
HOURS: 3:30–7:30 MON.; 9–1:30, 3:30–7:30 TUES.–SAT.

They should have called this shop Dress Your Tie, a more literal translation of its Italian idiom. This tiny shop pushes that sentiment to the maximum by offering the most uncompromisingly high-quality men's wearables the country can produce: seven-fold ties, dress shirts with handmade buttonholes, hand-lasted shoes, and Neapolitan-tailored, bench-made clothes. Only in Italy would you find a shop whose entire raison d'être is to celebrate its country's preeminent craftsmanship. Like the space, its selection is limited, but what is found here is both handsome and totally satisfying to those in pursuit of the ultimate in quality.

Owner Franco Minucci, who unveiled his little outpost ten years ago, is more interested in matters of perfection than in the latest color combinations wafting down the Milanese runways. His cut is modern,

FLORENCE

but the making is old-world Italian. You'll find hand-sewn unlined suits by Kiton and Ettolini, dress shirts by Borelli and Bergamo ($180), footwear by Silvano Lattanzi and Mantellassi ($325), Fedeli knitwear, and cashmere sweaters with hand-finished buttonholes. The understated elegance of this tiny store's wares stands as testimony to Italy's superiority in producing factory-made wearables with the same level of care and artisanship as those fashioned by an individual craftsman.

<div align="center">

UGOLINI
VIA TORNABUONI 20–22
FLORENCE
TELEPHONE: 216664
HOURS: 3:30–7:30 MON.; 9–1, 3:30–7:30 TUES.–SAT.

</div>

Ugolini is the oldest store in Florence still in residence at its original address, in this case a stone's throw from the city's most famous bridge, the Ponte Vecchio. As the finest glove shop in town, very little about it has changed since it was founded a century ago. Its overall color scheme is a warm bronze, from the rugs to the walls to

the deep blond leather chairs. Built in 1906, the staircase is done in burnished parquetry, with polished herringbone wood-patterned floors and window recesses framed by its huge windows that open onto the street.

There are forty-five styles of gloves, all handmade in Italy and all washable ($60–$125). In addition, there are Briggs umbrellas, Church shoes, John Lang cashmere sweaters—over twenty-five styles in sixteen to eighteen colors, most in two-ply and some in four-ply. Ugolini also carries Nicky neckwear which is, in my opinion, the best-designed and -crafted tie in Italy. Cashmere and cashmere-blend

CASHMERE AND SILK FOUR-IN-HANDS BY NICKY, ITALY'S PREMIER NECKWEAR DESIGNER.

ties cost $75 and are designed to knot into a small four-in-hand while constructed to resist stretching with wear.

Shopping here is a decidedly European experience, a holdover from the age when retailing was more dependent on personal service. Opening its doors in an age when men of leisure would frequent such emporiums expecting a level of service commensurate with that found in their homes, Ugolini has not strayed far from its origins.

FLORENCE

HAMBURG

Hamburg is one of Germany's most elegant old burgs. The country's second largest city, it is also one of the most verdant, with numerous avenues lined with imposing oaks and surrounded by luscious parklands. Most of its landmarks are constructed in colorful, chessboardlike designs in brick that shimmer in the slanting rays of the late afternoon sun.

Water is this multicultural city's central theme. Before reaching Hamburg, the Elbe River separates into two arms that meet again on the west side of the city. One tributary, the Alster River, was dammed in 1235, creating two shallow lakes, the Inner and Outer Alster, which cover over four hundred acres and combine with the ports and canals to produce a city with more bridges than Venice, London, and Amsterdam combined. When the weather warms, the lakes are popular with rowers, canoers, and sailors, who enjoy navigating their vessels around the heart of the city. As Europe's second largest port, Hamburg has long been the hub for Northern European trade. The port celebrated its eight hundredth anniversary in 1989.

Hamburg is also a *ville* for strollers and window-shoppers. It has its charming historic center whose simple, family-run Hansel and Gretel shops rest in the shadows cast by the town's mixture of modern and medieval architecture. The city also features Europe's most extensive system of covered shopping arcades. With their glass domes, mirrored ceilings, and faux-deco marble arches, these enclaves of metropolitan merchanting bear little resemblance to your typical American mall. Wind and weather cannot diminish the pleasures of window-shopping, as no less than a dozen covered shopping arcades draw themselves like a pearl necklace from the Alster lakes to the city's port.

Hamburg is Germany's media capital, an international insurance and business center, with more consulates than any city in the world. As a result, the people of Hamburg have been exposed to diverse and

sophisticated perspectives on culture, politics, fashion, and philosophy. They tend to be a worldly lot, proud and independent-minded. It is said that when Kaiser Wilhelm II arrived for a visit, the mayor of Hamburg exemplified his fellow townsmen's republican spirit by refusing to address the sovereign as "Your Majesty." While they may have disdained royalty, the town's leaders and taste makers have always regarded themselves as part of an aristocracy more British than German. Its most renowned men's shop, Ladage & Oelke, is a 150-year-old institution that sells British lifestyle right off the peg.

Four out of five German equestrian competitions are staged here, with its annual championship called, in deference to England's most famous race, the Derby. A high percentage of Germany's millionaires, attracted by the unpretentiousness of Hamburg's life, reside in this city where style is defined by its restraint. As Gregor Rezzori, the famed *Meister* of German letters, has observed, "In Hamburg, they understate themselves so very, very much, because they want to be English. Out of understatement, they make a sense of pompousness, which is extraordinary."

BRAUN
BERGSTRASSE 17
20095 HAMBURG
TELEPHONE: 040 33 44 70
FAX: 040 32 29 25
HOURS: 9:30–6:30 MON.–SAT.

Perhaps it has something to do with the climate, but the northern portion of almost any industrialized nation tends to be less showy than its southern half. An example of this phenomenon can be found in Hamburg, whose taste mirrors that of Northern Italy's Milan. In this conservative and affluent German city, Italian fashion is represented more by the hand-tailoring of Kiton than the drapey cloaks of Armani. Braun, Hamburg's primary purveyor of Northern Italian chic, is, not coincidentally, the *ville*'s most upscale men's retailer.

Ensconced in a handsome, modern three-floor building, the store looks out on Hamburg's central lake, a beautiful, scenic waterway

HAMBURG

that permits visitors to sail directly into the heart of the city. Walking into this establishment, you are presented with a cache of silk neckwear and cotton shirtings from the top makers in Italy. Lorenzini dress shirts ($300–$350) are paired with Nicky and Etro handmade neckwear ($80–$125) as well as sumptuous seven-fold neckties by Kiton.

Ascending the stairs to the second level, you are greeted by Malo cashmere and other classic Milanese-styled sportswear. Braun's top floor, with its vast panorama of the entire lake, is where you will find this store's tailored clothing, most of it by Kiton ($2,000–$3,500). Though the modern German appetite for color can be heavy-handed, the Biella worsteds, Como fine silks, and mega-quality Italian shirtings carried here combine to dull that edge just enough to offer real taste and style. Hamburg, with its bridges and waterways, is often called the Venice of Germany, but this store, with its sophisticated fashion sensibility, represents a little slice of Milan.

FERD. SCHAFFNER
NEUER WALL 24
2000 HAMBURG 36
TELEPHONE: 040 36 77 06
HOURS: 9:30–6:30 MON.–SAT.

Wrapped around one of Hamburg's most elegant shopping corners is this city's oldest and most celebrated glove shop. As the climate here often calls for mittens of one sort or another, this store is usually crowded with customers. Men come to choose dress and sport gloves from among the hundreds of styles that comprise the Schaffner inventory.

But the main attraction here is the exceptional driving glove ($90), which is favored by most of this country's serious power drivers. Open at the knuckles and behind the palm, with plenty of strategically placed holes for proper ventilation, Schaffner stocks these in a wide variety of two-toned combinations—such as black on the outside and cream within—that are meant to correspond to your vehicle's exterior and interior color schemes. While this may be pushing the

aesthetics of autobahn attire past the normal limits—in a country where the driving speed on such roads knows no limits—these leather trappings will encourage any driver to keep his hand on the wheel when putting his BMW or Mercedes through its 120 mph paces.

LADAGE & OELKE
11 NEUER WALL U. ALSTERARKADEN 11
2 HAMBURG 36
TELEPHONE: 040 34 47 48
HOURS: 9:30–6:30 MON.–FRI.

No other store in Hamburg better represents its burghers' upper-crust traditions and aspirations than this off-the-peg purveyor of British fashion circa 1950; even rival shop owners point to it as proof of their city's sophistication. While exemplifying the affinity for Anglo style shared by most of this country's worldlings, Ladage & Oelke surrounds its English wares with some old-world Germanic class.

Founded in 1845, the store is so fuddy-duddy it's charming. Suits are hung in closets that pull out for your inspection, ties are presented under glass-topped tables, while slacks and outerwear are bunched together on metal rolling racks. One side of the store faces the Alster and affords a view of Hamburg's medieval architecture; the other side leads to the midtown shopping center. In 1989, a suspicious fire that started in a neighboring health food store drove Ladage & Oelke out of their celebrated premises for over a year to an address practically on the other side of the city. Such was the loyalty of their customers, business actually improved in their temporary home.

This was always thought to be an establishment untouched by time. Prior to the fire, you could breathe in the England of the 1840s the moment you passed through its portals. The renovations have somewhat altered it; today, it feels like a Cambridge retail shop and its merchandise reflects that: Briggs umbrellas, duffle coats, Husky riding macs, tweed hacking jackets, and real English paisley repps of the type knotted twenty years ago. There is an Edward Green shoe

HAMBURG

presentation on the second floor, and if you closed your eyes for a moment you would swear it was the Thames and not the Alster rushing by outside.

———

PFEIFEN TESCH
COLONNADEN 10
20354 HAMBURG
TELEPHONE: 040 34 25 84
HOURS: 8:30–6:30 MON.–FRI., 9–2 SAT.,
9–4 FRST SATURDAY OF THE MONTH (SUMMER), 9–6 SAT. (WINTER)

Colonnaden, an arch-covered, elegant old Hamburg street for strollers was once the city's prime retail boulevard. Unfortunately, greedy developers and landlords have forced out most of the long-established merchants who lent this thoroughfare no small amount of class and worldliness in favor of tenants who could afford higher rents. However, this still-posh street can claim one remnant from its glorious past—Pfeifen Tesch, Germany's most famous pipe shop.

Pipe enthusiasts, whether they favor a simple briar pipe or an antique meerschaum, will swear they have entered paradise when confronted with the mind-boggling five thousand different pipe styles carried by this firm. Stored in elegant wooden holders, the pipes come in every shape and size. You will find more styles of the prized Dunhill pipe here than anywhere else in the world. Their handmade pipes are produced just as they were when this shop first opened in 1880. Before it is considered worthy of being shaped into smoking art, a piece of wood must be properly veined and aged at least fifty years. For lovers of tobacco who prefer more exclamatory expressions of self than the passive pipe will permit, Pfeifen Tesch also stocks an impressive selection of world-class hand-rolled cigars, including Montecristos from Cuba.

Among the upper classes, the pipe has always been a symbol of leisure, camaraderie, and reflection. The smoking implements at Pfeifen Tesch possess a character that can transform even the most mundane room into an elegant den where men can arrive at their knottiest decisions in an atmosphere made calm by the aroma of a well-crafted pipe of vintage wood.

STABEN

RATHANSMARKT 5

HAMBURG

TELEPHONE: 40 37 73 53

HOURS: 9–6 MON.–FRI., 9–2 SAT.

(9–4 FIRST SATURDAY OF EVERY MONTH)

This is one of Hamburg's most well-respected family stores. Never grandiose, the firm goes about its business the old-fashioned way. Customers are greeted like beloved relations with service recalling a time when a salesman knew a client well enough to notice that he had put on a little weight and discreetly slipped him into a 42 instead of his customary 40.

Staben was founded in 1919 by the family patriarch, who happened to be one of Germany's most renowned tailors. In location and fashion sense, Staben exists somewhere between the Milanese élan of Braun and the Anglo-Saxon tradition of Ladage & Oelke. Its clothing is of an accessible, upper-middlebrow taste. Staben is where the Hamburg professional comes to purchase a fine-quality, conservative business suit that is neither too fashionable nor too traditional. Wearing its two-button, side-vented model ($1,000–$1,750), he can conduct business in any country confident that the garment's style will flatter him without calling undue attention to itself. The tailored clothing can be found upstairs amidst comfortable sitting rooms and fitting rooms as gracious in space as private parlors.

The ground floor carries furnishings and a smattering of sportswear. The collection of fine-gauge wool or cotton knitwear in turtlenecks or polo shirts is particularly handsome. Like Hamburg, Staben's setting, which is neither ostentatious in decor nor unimportant in scale, epitomizes the Northern German's proclivity to understated luxury.

HOUSTON

An Introduction

"This city has been an act of real estate, rather than an act of God or man," architecture critic Ada Louise Huxtable observed in the *New York Times* twenty years ago, and Houston's get-up-and-go has not gotten up and gone. Speed is of the essence here, as confirmed by the railroad train racing across the city's flag. Space is the theme—down here, in this sprawl of over five hundred square miles, and out there, where "Houston" was the first word spoken by man from the moon. In 1958, Houston contained fewer than a million people. Today, with over four million, it is the fourth largest city in America.

In Houston, towers soar, the population quadruples, freeways loop, and the Lyndon B. Johnson Space Center and Texas Medical Center pioneer stars and science. The city is in a rush, but its concern with style is less driven. The bankers and oilers, doctors and researchers who operate this city's preeminent industries are a conservative lot, and that's how they dress. Slow to change, overly dependent on designer labels to confer wardrobe credibility, Houston men are a bit self-conscious about fashion.

Dallas and Houston, like San Francisco and Los Angeles, are not merely miles apart. They share a state without sharing a state of mind. Dallas is old guard enlivened by new money and looks toward New York and Paris for sartorial inspiration. Far away from the shores of English style, Houston's fashion is Euro-modern with brassy neckwear and sculpted suits—rough-and-tumble with an up-to-the-moment edge.

HOUSTON

LESLIE & CO.
1749 SOUTH POST OAK ROAD, POST OAK PLAZA
HOUSTON
TELEPHONE: (713) 960-9113
FAX: (713) 960-1882
HOURS: 10–6 MON.–FRI., 10–8 THURS., 12–5 SUN.

When Les Ho opened this store in 1977, he characterized it as "liberated Brooks Brothers." He introduced Ralph Lauren to Houston and surrounded his offerings with other soft-shoulder clothes that further supported Ralph's contemporary take on traditional wear. Today, even Brooks Brothers has had its button-downs undone by its British owners in an effort to get in step with the modern man. But Les is a purist at heart and has resisted the shouldering of men's clothes with all his might.

With the explosion of European designer fashion and the deterioration of the traditional dress code, Les has moved into more casual sportswear and weekend wear. These days, there is more aggressively patterned neckwear than Les might have approved of in his earlier repp stripe days. You can, however, still buy a natty single-breasted business suit with all the historic haberdashery trimmings. And he has introduced the Alan Flusser collection to augment his tailored offerings. Les's is still the best place to learn about mating tie and tweed, Oxford cloth and pinstripes.

THE DIAGONALS OF ALAN FLUSSER: THE GEOMETRY OF STRIPED NECKWEAR SCULPTS AWAY EXCESS BREADTH FROM A MAN'S FACE WHILE FACILITATING STYLISH COORDINATION WITH CHECK OR PLAID JACKETING.

The shop still looks more like a Ralph Lauren outpost than most Polo stores do: dark floor, Persian area rugs, lots of wood and framed photos of polo players, and so on. It has the familiarity and time-honored aura of its wares. Les enjoys the challenge of teaching the subtleties of traditional taste to the newly graduated collegiate set. He was a pioneer of upper-class style for the Houston man, and he still is.

HOUSTON

M. PENNER
2950 KIRBY DRIVE
HOUSTON
TELEPHONE: (713) 527-8200
FAX: (713) 527-9648
HOURS: 10:30–6:30 MON.–FRI.,
10:30–8 THURS., 10–6 SAT.

When Morris Penner opened his business, you couldn't find a European suit in Houston. Today, men don't buy much else. Having lived in Europe and returned to Houston, Penner could not find clothes that gave him a sexy, Continental look. His family was in the retail business in San Antonio, but he wanted to do something on his own. When he opened this European outpost, his competitors gave him ninety days. Twenty years later, the competitors are gone and most of Houston knows "Sonny" Penner.

M. Penner started with Pierre Cardin suits and today carries Canali, Vestimenta, and Brioni—avoiding designers' names, when possible. He has Fumigali and Ferragamo neckwear and does an impressive made-to-measure business in Ermenegildo Zegna, which he introduced fifteen years ago, way before anyone else. His dressy, better-quality European sportswear featured upstairs includes tailored linen trousers ($145), fine-gauge knit T-shirts, and woven sport shirts ($145). This is sportswear for going out to dinner, not for playing golf or trimming sails.

Ten years ago, Sonny and son resituated themselves between Houston's posh Galleria and the tree-lined drive to wealthy River Oaks. Their store is modern, carpeted, and comfortable, with a balcony opening up to the sportswear level. More than any other shop in the city, M. Penner represents the Houston man's predilection for conservative clothing with European flair and accessories with punch.

Norton Ditto
2019 Post Oak Boulevard
Houston
Telephone: (713) 688-9800
Fax: (713) 621-3875
Hours: 10–6 Mon.–Sat., 10–8 Thurs.

This is the story of two brothers who made customers out of friends and friends out of customers. When Ben Ditto, the extroverted front man of the business, died, the entire community turned out to pay its respects. The store was sold to three employees, but without the charisma of its founder, its faults caught up with it. Eventually, the family bought it back in an effort to restore it to its former stature. Lanson and Sarah Ditto, its new-old owners, hired Dick Hite, a dynamic motivational seller and entrepreneur, to lead it back to glory. The entire community is rooting for it.

Norton Ditto is making its transition from a Windsor-knot store to a four-in-hand. It's a store of grand proportions—with twenty-foot ceilings, columns, and parquet floors—a holdover from the bygone era of grand retailing, when space was employed for effect and grace, not looked upon in terms of dollars per square foot. Oxxford and Hickey-Freeman will now rub shoulders with some of Europe's most stylish imports. Their dynamic salespeople will get a chance to stretch themselves. And the members of the River Oaks, Houston Country, and Lakeside clubs, who are the bedrock of the Norton Ditto business, will begin to look better in the boardroom as well as on the links.

A local once remarked that being poor is a long-term proposition, while being broke can be temporary. With the Houston country club clan deep of pocket and loyal in spirit, the future of Norton Ditto appears to be looking up.

HOUSTON

STELZIG'S
3123 SOUTH POST OAK BOULEVARD
HOUSTON
TELEPHONE: (713) 629-7779
HOURS: 9:30–6 MON.–SAT., 1–5 SUN.

John Wayne signed his name to their leather-bound guest book. Roy and Gene would drop in at rodeo time, and Red Skelton had a hankering for the place too. When they moved into this suburban location in 1987, after being in their downtown store for fifty years, Charlie Daniels pulled into the parking lot and threw a concert. Even "that nice Jackson boy" came through, says Leo Stelzig Jr., the third-generation proprietor of what just might be America's oldest privately owned store. With Houston holding the biggest rodeo in the country, is it any wonder that this 125-year-old outfitter to the real cowboy is an institution in Houston? And there's no charge for the aroma—that wonderful, leathery essence of cowpoke and Marlboro Man.

You can't miss Stelzig's. A gigantic white stallion is rearing up on its hind legs above the entrance. The store has a tin ceiling and wood floors just like the original depot did, and the same black marble sign out front. Horns and animal skins adorn the walls and balcony; hats and boots adorn the salespeople. For sale, there are ten-gallons galore at the saloon-style hat bar; boots of alligator, ostrich, lizard, and eel; custom belts ($75 for the plain, $250 for the intricately tooled), and chaps ($250). The leather shop, where they tool the belts, repair the tack, and custom-make the saddles, is windowed for all to see.

This spiffed-up trading post has as much character as any store in the world. Stelzig's western wear, like the Brooks Brothers button-down and the Levi's 501, is indigenous to America and positively intriguing to heritage-conscious Europeans. Other leather-bent imitators may pop up all over Texas, but they also tend to fade with the vicissitudes of western fashion. However, Stelzig's is for the cowboy in every man, whether real or imagined.

LONDON

An Introduction

Alot has changed in London since the days when Max Beerbohm declared that no man could make love with conviction unless his coat had been cut in Piccadilly. Gone are the times when an old boy dropping into his club could expect to find his newspaper ironed with yesterday's change boiled and waiting. Pax Britannica has vanished, and with it England's sartorial sovereignty over much of the globe. The monarchy's century-old position as the ideological bedrock and sole arbiter for gentlemen's attire has been shaken to its very royal foundations.

Preoccupied with defending its shores during World War II and then bombarded from within by its own Carnaby Street and peacock revolutions, London's insular Savile Row adopted a typical island siege mentality. It chose to ignore the sea changes occurring in men's dressing habits. Some years later, across town in Chelsea, another phenomenon of London street life was playing itself out. Products of the English class struggle, the punks were taking their turn challenging the status quo. Like the mods, rockers, and peacocks who preceded them, the punks were driven by the pent-up frustration common to most underprivileged youth. They lacked money, power, or influence. Shock was the only weapon in their arsenal, and they wielded it with abandon in their battle against an older generation's complacency.

Suddenly, a vacuum was left when a reluctant empire discovered it had no one who could step forward and lead in the same royal style as Edward VII or his star-crossed grandsons, George VI and Edward VIII, the dandified Duke of Windsor. All three had been paragons of fashion, but their like was not to be found. With no suitable role model to show the way, the anarchistic supermarket diversity of the London street scene commanded center stage. England lost hold of its sartorial compass. Unable to lead, unaccustomed to following, London became a spectator to men's fashion rather than its leading player.

LONDON

The irony of this is that Great Britain became the only industrial country unable to cash in on the commerciality of the English look. In a surprising reversal of history, other countries systematically purloined its vast archives of original textile and knitwear design as well as its trademark bespoke nomenclature. The British lion, once conqueror of whole nations, now watched as other countries usurped its aesthetic ideology for their own profit.

Across the Channel, the French, early practitioners of the *style anglais*, continued to exploit it as the basis for many of their famous Parisian retail stores as well as for some of their most successful international designer businesses. Since the sixties, Italy's retailers had been hard at work renovating the aged British dress codes that were byproducts of an outmoded class system. Together with the burgeoning designer textile community, they developed the technology to remake the authentic Savile Row look in lighter fabrics with more drape and softness than the older English or Scottish mills could deliver. Their democratic adaptation took the stuffiness out of the English look and made it more accessible and modern, allowing Italy to swipe the fashion scepter away from the Empire.

Japan, which was permeated by Western fashion influences in the years immediately following World War II, created a whole sector of modern Japanese fashion called "trad." J. Press, an American retailer and one of the original tweedmongers at Yale in the 1920s, licensed its name to a Japanese manufacturer, which in turn built a $250 million men's and women's business. During the mid-eighties, with the trad phenomenon at its height, two of Japan's national magazines exclusively devoted themselves to instructing the Western-looking locals in the precepts of English public school attire and American Ivy League dress. Even today, the Japanese continue to call a suit a *sebiro*, their phonetic pronunciation of London's street of tailors, Savile Row.

Great Britain's former colonies have also weighed in. The worldwide success of America's Ralph Lauren has not only introduced upper-class British style to non-English-speaking nations, he has given a rejuvenating shot of privileged taste to the home country as well. West of England flannels, Harris tweeds and Scottish tartans, shetland, Fair Isle, and argyle knitwear, Macclesfield and paisley neckwear, Ralph saw all of it languishing at Brooks Brothers and revived it at a

time when most people, including the Brits, felt the English look was old hat.

However, in spite of all this chipping away at the rock, the London of Windsor style, like the House of Windsor, is still standing. Unlike other countries whose newly rich are so mixed in origin, England has had a thousand years to produce an agreed-upon policy in clothes, and a succession of kings and princes to personify it. The tenets of the British bespoke tradition, from the shape of a man's hat in relation to his head down to the width of his trouser cuff as it relates to his shoe size, remain sacrosanct criteria of proper form. London still reigns supreme as history's custodian of these proverbial sartorial jewels without which no man can be crowned a true *élégant*. Entrée into this elite world of educated dress continues to be offered within the byways of London's glass-topped Victorian arcades and Georgian streets.

While London admittedly has its spots of international high fashion and designer ready-to-wear, this is not one of its "long suits." This city is the final frontier where rendering assistance is considered more a privilege than an obligation. In a world of begrudging and superficial service, the real aristocrats of British style are those men who first apprenticed and then devoted their lives to serving those gentlemen searching for the gospel according to the bespoke way. Theirs is the only generation still able to pass on the verities of English style as it was once practiced in menswear's golden age, that heady time bookended by the First and Second World Wars. It is the cherished dialogue between the client and his tailor, cobbler, shirtmaker, or gunsmith, where he bespeaks his requirements and the product is bespoke, that makes London shopping still so utopian.

So if you happen to be standing on a London street corner and suddenly notice the snappy gait of a pair of black polished bench-mades, advancing from beneath an enthusiastically striped ensemble, with bowler on head and brolly in hand, don't be taken aback. This is not some bewildered character out of Central Casting. It is the last of a type, an Englishman born, bred, and bespoke in all of his Bond Street glory. For those infatuates of the art of male adornment, this sight alone makes a visit to London worth every shilling.

LONDON

ANDERSON & SHEPPARD
30 SAVILE ROW
LONDON
TELEPHONE: 171 734 1420
HOURS: 8:30–5 MON.–FRI.

England's most famous royal male, Prince Charles, is a client. Three greats from a throng of many—Gary Cooper, Rudolph Valentino, and Douglas Fairbanks Jr.—were longtime devotees. And a host of today's American fashion leaders—Calvin Klein, Alexander Julian, Neiman Marcus's Derrill Osborn, Garrick Anderson, and yours truly—have been customers. No other postwar tailor has had such a profound and continuing influence on the design of tailored clothes. They combine the elegance of fine tailoring with the studied nonchalance of sportswear.

"Some people swear at our clothes, others swear by them. We are not everybody's cup of tea," declares former A & S chairman William Lowery. Norman Halsey, Anderson & Sheppard's impeccably tailored director, explains, "We don't build up bodies, we drape them. If you lined up one hundred people in front of me, I could tell you which man was wearing one of our suits from the front or back. We use a thin flax canvas with very little padding. Our suits are for people who know how to hold themselves." In other words, these clothes help to convey the wearer's style rather than conceal it.

Anderson & Sheppard's artisans carry on the tradition of the Duke of Windsor's legendary maverick tailor, Frederic Scholte. He created the London drape suit, which from 1920 to 1938—considered by most to be the heyday of Anglo elegance—was the only cut of clothes to be seen in. The shoulder is sloped and natural, the chest breaks on both sides in front and like a shirt on the

BESPOKE PREROGATIVE: GRAY FLANNELS HAND-TAILORED TO IDIOSYNCRATIC FANCY.

LONDON

blades in back, a high, small armhole with a large upper sleeve permits the jacket to hold around the neck while freeing the arms to move with the same comfort found in sweaters. While dancing around the fitting room, Fred Astaire would suddenly stop in midair and turn toward the mirror to see where his collar finished up—making sure it was on his back and not standing away from his neck. "He was a tough taskmaster," recalls former chairman Bill Lowery.

Founded in 1906, Anderson & Sheppard anchors a corner of the Row. As you pass through its angled portals, you cross into a world untouched by the rush of time. The store's interior is much as it was when it was built in 1927. Modern equipment would be out of place here. The floor is wood, the rugs are frayed. Passing by bolts of English worsteds and woolens stacked to waist level on the wooden tables, under the watchful eye of an antlered moosehead hung high on the back wall, you are ushered into one of their famous fitting rooms. "Through this way, sir," beckons Norman Halsey. And another convert joins the esteemed ranks.

Everything is particular about A & S, from the color, size, and placement of its buttonholes to the shape of its lapels, notches, pockets, vest fronts, and trouser details. These elements were all designed seventy years ago and have not been altered since. Suits start at $2,000, jackets at $1,300, and take six to eight weeks to complete. All clothes are made on the premises with separate makers for the coat, vest, and trouser—truly the old-fashioned way.

Given these garments' softness, such attentive tailoring invests each suit with its own singular character. Unlike classic English tailoring, which has an almost military rigidity, the Anderson & Sheppard style is achieved through its softness of line, not its severity. As Dennis Halbrey, the firm's former head cutter, once said, "If a man wears a suit out of the shop and is complimented by a friend, we have failed. It's sort of like a good haircut. Clothes should look casual, almost as if they are worn without care. What you want to see is the person, not the clothes."

LONDON

ASPREY LTD.
165–169 NEW BOND STREET
LONDON
TELEPHONE: 171 493 6767
TELEX: 25110 ASPREY G
FAX: 171 491 0384
HOURS: 9:30–5:30 MON.–FRI., 10–5 SAT.

No self-respecting, smart English officer went away to the First World War without his Asprey's slide-action, engine-turned, monogrammed silver cigarette case. This is probably one of the few shopping refuges where kings, queens, princes, maharajas, and heads of state prefer to do their own shopping. Once inside, you are cocooned in luxury, where all is serene and assured. Like Madame Tussaud's or the Tower of London, Asprey has become a required stop on the tourist's itinerary. Whether you come to spend thousands or just browse, no request is too great or too small for its highly trained staff.

Asprey is a London landmark, a rambling four-story slice of British tradition, standing on a half-acre of golden real estate in the heart of the West End. The Asprey dynasty began with William Asprey, the Huguenot calico-printer and metalworker who founded the firm in 1781. It was his grandson Charles—an enterprising young man with a taste for the lavish—who moved the establishment to Bond Street in 1841. Six monarchs have ruled over the British Empire since that time, many honoring the firm with royal warrants.

What Savile Row is to men's tailoring, Asprey is to men's accessories. For wallets (pocket or breast), business-card covers, jewelry boxes, traveling alarm

THE FOUNTAINHEAD FOR THOSE PORTABLE LUXURIES A MAN MIGHT FANCY—TO ORDER: A CROCODILE DAY-TIMER COVER AND MATCHING CARD CASE.

clocks, document cases, dopp kits, and memo pads, they have no peer.
A memo pad in ostrich with rolled gold corners and attached gold pen
is $300, and a simple sealskin wallet is $185. If you are looking for an
elegant black crocodile cover to mask that ugly but reliable Day-Timer
you've grown so dependent on, the price is a mere $1,750 if the
pockets are done in leather, more if they are crocodile. Pocket-size
computers are unattractive objects unless they can be appropriately
swathed in a custom-made alligator computer wallet ($750). How to
impress the next recipient of your business card? Remove it from your
embossed ostrich holder, if you are wearing a sports jacket; black
lizard for dress. Should you desire something personal, more one-of-a-
kind, made in a special size, skin, or requiring a particular detail,
upstairs are six craftsmen and two engravers who do nothing other
than minister to the whims and cravings of their privileged clientele.

Asprey also features an extensive range of tie clasps from the
simple to the elaborate. Many come in two widths and either nine- or
eighteen-karat gold and others in silver. These can be kept in your
Asprey pigskin jewelry box (with a green-velvet retainer pad to secure
everything in its proper place). For those gentlemen who want some-
thing more than just a safety pin for their soft-collar shirts, the
craftsmen here can place miniature cabochon rubies or sapphires on
either end for that subtle sparkle of jeweled finishing.

Whether the taste is aristocratic or parvenu, London's West End has
always been a preserve of craftsmen undaunted by the luxurious longings
of the world's most entitled gentlemen. And nowhere have they been
better served than at Asprey, whose motto is, of course, "It can be done."

BROWNS
23–27 SOUTH MOLTON STREET
LONDON
TELEPHONE: 171 491 7833
FAX: 171 408 1281
HOURS: 9:45–6 MON.–SAT., TILL 7 THURS.

When the Bursteins opened their town house doors in 1970, this was a
nondescript London street. It is doubtful they ever imagined that their
store would be responsible for the area's renaissance, with South

LONDON

Molton Street ultimately being paved over to become this city's smartest shopping stroll. During the eighties, with the openings of a Ralph Lauren shop on Bond Street, a separate Giorgio Armani boutique, and a host of other offshoots (including a hair salon and a restaurant), the Browns phenomenon attracted many retailers to London. Now considered a London fashion institution, Browns has held its own while Covent Garden supplanted Chelsea as the high style destination area and New Bond Street finally emerged from under the rug dealers' dominion to retake its rightful place as Mayfair's street of luxe.

Browns's menswear business started as an updated tweedy English shop and has evolved into a boutique for the international avant-garde. Its collections are extremely well edited and sparingly presented. You can always find special pieces here that you won't find elsewhere, such as a Chrome Hearts jacket, the offbeat vest or trouser, or the most provocative and trend-setting sweater or T-shirt by such designers as Dolce & Gabbana, Calvin Klein, Donna Karan, Romeo Gigli, Dries Van Noten, or Prada. The pace is fast, the merchandise ethereal.

Still one of the most well-respected high fashion stores in the world, Browns is quick to recognize and pioneer new design talents. It has probably introduced London to more important designers, men's and women's, than all the other English stores combined. Walter Albini and Giorgio Armani, two of Italy's best, were carried here long before they were recognized in Italy. Along with Paul Smith or the seasonal opening of a Joseph men's store, this is one of London's most enduring sanctuaries for the fashion-conscious male.

BUDD

1A & 3 PICCADILLY ARCADE
LONDON
TELEPHONE: 171 493 0139
HOURS: 9–5:30 MON.–THURS., 9–5 FRI., 9–12:30 SAT.

When the Piccadilly Arcade was flattened in the Great War, the only stand left intact was Budd. This cramped, three-floor haberdashery, founded in 1910, is still a survivor: It is one of the last authentic bespoke shirtmakers still operating in the West End. The man who

earned Budd its exalted reputation was its former head cutter, Mr. Chalmers, who apprenticed at Hawes & Curtis in the thirties cutting the royal collars for the Duke of Windsor. From 1936 until his retirement in 1988, Chalmers strictly maintained the country's shirtmaking standards established during the 1930s. He insisted that all the cutting and sewing take place on the premises and retained the firm's signature three-hole button as a guarantee that the buttons were only to be attached by hand.

Today, Budd offers more authentic ready-made accessories for black- or white-tie attire than any store in the world. They carry a silk pleated-front dinner shirt with spread collar ($200), also stocking it in a plain-front model ($185). Their sized (14½, 15, etc.) bat's-wing or thistle-shaped bows come in corded satin or silk barathea. You will also find adjustable satin bows in the two shapes. A Marcella dinner shirt (piqué front, collar, and cuffs with a voile body for $135) has been made for the shop since 1910, with the only difference today being that its collar is now attached to the body.

On the custom side, they still make celluloid collars in such shapes as wing, round, and spread, for wear as separate collars attached in the old way to a banded-collar body. These cost $30 each with a minimum order of six. And lastly, they still make a proper white-tie shirt for tails, the one that buttons up the back for a separate collar and—since the studs go into the shirt before you do—requires a valet or friend to do it up ($200). Their custom-made dress shirts cost $140 to $185 (sea island, $200; silk, $240). They take four to six weeks, with a sample made first to wash and test. Three is the minimum order.

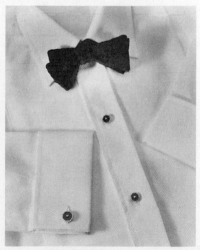

As a family-maintained business, Budd is one of the few West End firms that still makes remarkable products according to their own dictates without regard to current fashion. You will not find a better

THE MARCELLA OPTION: VINTAGE BOND STREET SWANK AS STAND-IN FOR THE PLEATED-FRONT DINNER SHIRT—VOILE BODY WITH PIQUÉ COLLAR, BIB, AND CUFFS.

place to stock up on high-class evening furnishings, black or white. The store offers another confirmation of London's penchant for reconnecting gentlemen to a time when male elegance was not exceptional, just expected.

G. J. CLEVERLEY & CO. LTD.
12 ROYAL ARCADE
28 OLD BOND STREET
LONDON
TELEPHONE: 171 493 0443
HOURS: 9–5:30 MON.–FRI., 10–2 SAT.

"The art of a good handmade shoe," George Cleverley once declared, "lies in its lightness and springiness, but it will also be a solid shoe and last a long, long time. The leather must be well worked, well hammered, so as to get the pores tight. And then everything depends on the last. If you don't get it right, it's a washout."

As his many celebrated clients have eagerly attested, Mr. Cleverley made his reputation getting it right. Among the high-voltage personalities who have been shod by the late doyen (who died at 92 in 1991) are Spencer Tracy, Edward G. Robinson, Humphrey Bogart, Laurence Olivier, John Gielgud, Ray Milland, Gary Cooper, Cary Grant, and Adolphe Menjou. After seeing Prime Minister Winston Churchill in a pair of Cleverley's monogrammed velvet slippers, Supreme Allied Commander Eisenhower rang up the shoemaker and asked him to "make me a pair just like Winnie's."

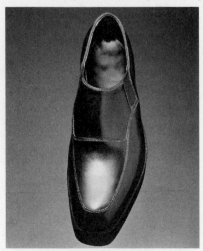

A LAST OF CHIPPENDALE ARTISTRY: GEORGE'S ELEGANTLY ELONGATING, CHISELED TOE AND SCULPTED WAIST SIDE-GUSSETED TOWN SHOE.

Cleverley began his career as a shoe designer in Edwardian London. He ended it at New & Lingwood, sharing his art for thirteen years with younger shoemakers such as John Carnera, to whom the master bequeathed his lasts and the right

LONDON

to use his name. An innovator, George created his own look—the chisel-toed sculpture that became known as the Cleverley Shape. "His shoes had that curious blend of club elegance and fireside comfort that is the mark of a great cobbler," wrote the Cleverley-shod Terence Stamp in a glowing tribute.

When New & Lingwood changed hands, the Cleverley legacy was reestablished by Carnera, who opened this shop in partnership with another Cleverley protégé, George Glasgow. It is dedicated to preserving the Cleverley standard of prewar craftsmanship. As one would expect, no London firm is better prepared to turn out footwear of the quality and taste with which the Cleverley name has become synonymous. There are thirty models of Cleverley-designed bespoke shoes available here. Prices start at $1,300 and the shoes require twelve weeks for delivery. The ready-to-wear shoes cost about $350 a pair and come in thirty-six styles, including oxfords, town brogues, semibrogues, slippers, a suede slip-on with a specially designed band across the front, not to mention the famous Cleverley side-gusset slip-on with its special V opening at the top. George liked to make side-gusset shoes, as he felt no other design afforded a better fit for a slip-on model.

George Cleverley's work was, in Kahlil Gibran's phrase, "love made visible." In the shop that proudly bears his name, cobbling is still a labor of love. The artisans who produce its current wonders appreciate the time they spent refining their craft under G.J.'s expert eye. As John Carnera and George Glasgow explain, "The least we can do is ensure that future generations can enjoy the master's shoes."

CONNOLLY LTD.
32 GROSVENOR CRESCENT MEWS
LONDON
TELEPHONE: 171 235 3883
FAX: 171 235 3838
HOURS: 10–6 MON.–SAT.

If you have ever ridden in a Rolls-Royce, Aston Martin, or Ferrari, or on the *Q.E. II* or Concorde, your posterior has been cushioned on Connolly-tanned leather. This family company established in 1878 supplies leather of the highest reputation to royalty, fourteen parlia-

LONDON

ments throughout the globe (the red benches in the House of Lords are from this firm), and the top end of the motor-coach industry. Now, it is making its prestigious hides available to the general public through its first retail venture, which offers a remarkable collection of contemporary luxury leather goods and a coordinated range of accessories.

As one would expect from a firm whose history includes upholstering the leather seat for Edward VII's coronation coach and holds the Royal Warrant as Tanners and Curriers to Her Majesty Queen Elizabeth II, everything about this fourth-generation company's initial retail enterprise is quintessentially English—from its landmarked building to the products contained within. When Connolly first discovered the old Belgravia Stables in a mews behind Hyde Park, they felt it had the proper lineage to serve as a showcase for their wares. The family's brief to Andrée Putman—the architect charged with renovating these premises—couldn't have been more direct: Create a strong, modern retail image for the shop while retaining this historic building's sense of tradition and place. Putman added little to the beautiful simplicity of the existing space. The basic structure, the mews doors, and the loose boxes of the original stables remain as an homage to the past, while the architect's treatment of the structural elements and finishes, such as the black distressed marble-tiled floor and the bleached wood, has created an uplifting, modern retail environment.

The mews's doors open to this former working stable to reveal the shop's luggage collection, designed by Ross Lovegrove. The luggage designs, combining burled-walnut frames and polished aluminum fittings, emit the same resonance as the classic automobiles of the fifties and sixties with their masculine yet elegant lines. The pieces come, of course, in British racing green as well as other natural leather colors, all with a signature pale cream leather interior. Their sizing is designed to take "on board," such as their suit carrier at $4,000 or weekend case at $3,750.

Interspersed around the main floor, shoppers will discover all that they could possibly need to tour in style and luxury. From the touring espresso coffee set which plugs into the car's lighter to an English pewter tank for that emergency gallon of petrol, it's as thoroughly British as David Niven setting off around the world in a hot air balloon stocked with champagne and ice. There are racing hats, gog-

gles, and the original driving shoe in twenty colors ($250). Popularized by such car buffs as Gianni Agnelli, this extremely comfortable slip-on, with rubber studs on its bottom and heel for protection, represents just one of the authentic wearables assembled here. The original "Mille Miglia" reindeer-skin jacket, complete with underarm vents to handle that hairpin bend, as worn by the "Boy-Racers" of the famous Italian classic car race, can be purchased here for $1,500. Want to throw a gossamer layer of cashmere over your shoulders to keep the chill from circling you in your one open-sided tonneau cover? It's here, designed like a robe with a belt, in a below-the-knee length for $2,000.

Upstairs, in the craftsman's workshop, one can examine the firm's complete range of upholstery and automotive hides, then arrange an appointment with a member of the renovation team so that your aging Ferrari's interior can be restored. Or he can avail himself of the Connolly leather-wrapping service and have the portable phone on his yacht swathed in this coveted material. The company craftsmen are famed for their skill at wrapping anything from the smallest desk accessory to a stretch limousine.

Some might allege that such products represent nothing more than a short catalog of gift-wrapped, imperialistic snobbery. However, to those who can still appreciate the character of a well-worn, bespoke leather shoe, these are the kind of goods that raise the particular English exercise of privilege to an art form. As the latest entry into London's upscale retail world, Connolly is committed to dealing only in merchandise that improves with age, a perception that has long defined the very essence of what it means to "buy British."

CORDINGS
19 PICCADILLY
LONDON
TELEPHONE: 171 734 0830
FAX: 171 494 2349
HOURS: 9:30–6 MON.–FRI., 10–6 SAT.

Since the nineteenth century, Cordings has been recognized in England and abroad as a purveyor of top-quality raincoats, riding mackintoshes, shooting clothes, and outdoor footwear. Established in 1839 at

LONDON

the Old Temple Bar in the Strand, this historic firm carries almost everything for the outdoor activist. It was to Cordings that Sir Henry Morton Stanley came in 1871 to be "kitted out" in preparation for his famous journey in quest of Dr. Livingstone.

The three-story shop, located just a scone's throw away from Piccadilly Circus, is a pleasure to browse through, filled with classic and unusual merchandise from shooting stockings to inverness capes, from exclusive Scottish tweed breeches to Norfolk jackets and field coats made of handsome Yorkshire tweed. Three-button tweed jackets with vests start at $595.

Tweed plus fours are $225, plus twos in moleskin and corduroy are $100. Fabulous hand-knit shooting hose for tweeds are $80, with hand-knit tasseled tie-ups to go under the cuff. A waisted and skirted hacking jacket with slanted pockets and ticket pocket is $375. Invented over 100 years ago, their famous Covert cloth coat with velvet collar, complete with traditional rows of stitching around the sleeve and hem, is $525, an excellent value. Like most Cordings merchandise, it is a classic and can be worn in style indefinitely.

For their 150th anniversary, Cordings commissioned the production of 150 meters of one of their special Scottish tweeds. An old gentleman came in and asked to have a shooting trouser made of it to match a jacket that he had bought there several years before. He was being inaugurated as the president of the Old Yorkshire Shooting Society and insisted on looking "smart" for the occasion.

Their third floor contains a Barbour shop featuring trousers with button flies (just the thing when you're out stalking, as it is always a bother to snag your zipper in the forest) and cotton pocketings instead of the less durable nylon. Cordings also specializes in jackets and rainwear made of Grenfell cloth. This material, named after Sir Walter Grenfell, the doctor-explorer, was originally made to protect him on his explorations of the Arctic. Since then it has been used whenever a high-performance, light cotton fabric was essential, including five Mount Everest expeditions and many Olympic ski competitions. Finally, another authentic vestige from English lore, Sherlock Holmes's tweed stalking cap—the one more associated with Basil Rathbone's impersonation of the character than the late and estimable Jeremy

Brett's recent rendition—can also be purchased here. Like Cordings, this cap is the genuine article.

———

CUTLER & GROSS
16 KNIGHTSBRIDGE GREEN
LONDON
TELEPHONE: 171 581 2250
HOURS: 9:30–6 MON.–SAT.

Glasses were once thought of as a rather regrettable medical necessity. In the last twenty-five years or so they've become an exciting fashion accessory, especially as seen at Cutler & Gross. The Knightsbridge shop, sequestered in a mews diagonally across from Harrods, was founded in 1969 by two university chums, Graham Cutler and Tony Gross, who graduated and became opticians with a vision. Instead of focusing on the eye or the headache, they viewed glasses as art objects. Tony was interested in fashion, Graham in design. So with the help of a traditional frame maker, they set up their own workshop, initially producing all the frames by hand.

There are more of them here than anywhere else, and if you don't see a frame you like, they'll make one to your specifications. Ready-mades cost $100 to $180. Custom—with absolutely proper lens size, bridge fit, nose pads, and arms—cost $300 and take eight weeks. The London *Times* called Cutler & Gross "the first to put serious fashion into glasses." And their customers, the fashion designers, put them on the runways.

But it's their sunglasses that have put them on the map. Architects and movie stars, editors and artists, and rock's royalty swiftly became devotees. The most popular styles are the Old Curator, the Corbusier, the Rajasthani, their signature wrap, and a small thirties tortoiseshell librarian look, harking back to the days when it would have been made of real tortoiseshell. The tints of their lenses can be eye-catching—fuchsia, smoky pink, and peppermint—or old-world dark green and gray.

Cutler & Gross has achieved international distinction for its sunglasses, which have been nominated for numerous fashion awards.

LONDON

Elton John, Mick Jagger, Madonna, and other celebrated devotees have been observed wearing them even after dark, and that is precisely the point. "Sunglasses can be tribal, like a mask," observes Tony Gross. "People wear them because they look good, not because the sun is shining."

W. & H. GIDDEN
15D CLIFFORD STREET
LONDON
TELEPHONE: 171 724 2788
FAX: 171 494 2388
HOURS: 9–6 MON.–FRI., 10–5 SAT.

From its turn-of-the-century riding aprons to its knitted brushed cotton hunt shirts with woven collar bands for attaching white piqué or silk riding stocks, W. & H. Gidden is the last of the traditional English saddlers. Having moved from its original turn-of-the-century Oxford Street residence to this quaint three-story Victorian town house, redolent of saddle wax and leather, the 190-year-old equestrian specialist carries the largest stock list of top-quality hunting and riding clothes in Great Britain.

This is the country's only remaining bespoke saddler. Its rich tradition of aristocratic patronage dates back to 1815 with the Duke of Wellington, whose defeat of Napoleon at Waterloo was accomplished astride a Gidden saddle. Today, it holds the royal warrant as saddler to Her Majesty Queen Elizabeth II and also acts as official saddler to the British equestrian team. With the finest vegetable-tanned, hand-finished leather products encircling its main parlor and a custom saddler in residence, the shop has all the familiarity of one's personal tack room, even down to an idiosyncratic rug—Master's green with red pinstripes—that would seem out of its element in any other setting.

With only one tailor still custom-making breeches in the United Kingdom—Bernard Weatherall, whose bespoke breeches sell for $1,200—this is the place to acquire the best ready-to-wear breech. It is made in Germany and retails here between $275 and $400. They also carry the English Husky nylon-quilted riding jackets, as well as

tweed hacking coats and such classic riding wearables as the cotton hunt shirts ($77.50). Among their many hand-tooled leather goods, their Whitney Boston bag—its thick melton wool striped yellow, red, and black and trimmed in a tan bridle hide—is easily the most paddock-chic piece of weekend luggage I've seen.

W. & H. Gidden epitomizes classic British style. Buy one of their products and you own the very best England has to offer. The company periodically issues its own house catalog, so you can now make purchases by post or phone and have them pony-expressed directly to your closet-cum-stall.

EDWARD GREEN
12/13 BURLINGTON ARCADE
LONDON
TELEPHONE: 171 499 6377
HOURS: 9–6 MON.–SAT.

As a teenager, whenever I observed an especially well-dressed man strolling down New York City's Madison Avenue, it was odds-on that he would be sporting a highly polished, dark-tan cap-toe shoe. After much investigation, I eventually ran down this turn-of-the-century shaped shoe at 346 Madison Avenue and learned that it was made by an English firm, Edward Green, under the name of Peale, a legendary custom shoe maker in London whose lasts and name had been acquired by Brooks Brothers.

Brooks no longer carries that shoe, but Edward Green lives on, handcrafting shoes from models that are frequently more than fifty years old. The genre of footwear produced by this legendary Northampton firm is essentially based on lasts and designs borrowed from or inspired by the great bespoke shoemakers of London, circa 1920. They have supplied the top end of the London ready-to-wear trade for over one hundred years.

There are over thirty styles carried in stock, with the most popular ones available in six widths from A to F (with most others offered in three). Among their most interesting models: the Hampstead slip-on, a cap-toe with side elastic gusset, and the Wildsmith hand-stitched house shoe, a slipper originally created for George V, who liked them

large to accommodate his thick shooting hose after a day in the field. Today's version is an unlined summer shoe in brown or black ($560). At prices starting at $500, they will make a stock special in twelve weeks. Proper correspondent golf shoes, in leather with red buck, cost $575 and require twelve weeks, but are not immune to inclement weather. Edward Green's elegant velvet slippers, at $265 with plain toe or $425 monogrammed, are less than half the price of bespoke slippers.

Seventy percent of the Edward Green shoe is made by hand, making it the only factory-produced shoe to strictly observe the same discipline of craftsmanship as English custom-made footwear. Sold at the most exclusive of the world's men's stores, this prized shodding is much like a Savile Row suit: It is the rare well-dressed man who doesn't own at least one pair.

HACKETT
137–138 SLOANE STREET
LONDON
TELEPHONE: 171 730 3331
FAX: 171 730 3525
HOURS: 9:30–6 MON.–SAT., TILL 7 WED.

Next to coming upon a secondhand bespoke dinner jacket or set of tails from one of Savile Row's finest, the hope of any style-conscious

public school lad was to discover the perfect aged and broken-in tweed hacking jacket. During its early days on New Kings Road, Hackett made its name selling just that—upper-crust castoffs from tails to bowlers. When the supply dwindled and sources for replenishment became scarce, they took to remaking anew these artifacts of the manor born.

OLD-BOY PATOIS: TWO-COLOR QUARTERED
DESIGN IN MOIRÉ SILK CUMMERBUND AND
BOW TIE SET.

Hackett makes the sort of clothing most foreigners expect to find when they come to London.

LONDON

England in general would look more like this aesthetic had the pea-cock revolution not turned things upside down. Actually, Hackett opened several shops on the more British side of the United States—its East Coast—but had to call it quits. Somehow, Americans—even the Ivy League tweed wearers—could not accustom themselves to sixteen-inch pegged-bottom fourteen-ounce corduroy trousers and flannel suits of equal weight for year-round wear. No, this is still the preserve of the very British, military trim fashion worn by the true-blue Tory.

With its gold-trimmed navy rugs, dark stained-wood floors, cream marble, and brass fixtures, the Hackett environs exude tradition and taste. There are a custom tailor and a barber on the premises, and a grooming package is available that includes a shave, haircut, mas-sage, and gentleman's facial. Their business clothes are cut in the skirted hacking style: three-buttoned, deep center vent with lapelled vest ($700–$800). It's a modern Huntsman of Savile Row at affordable prices. The Hackett chesterfields, paddock jackets, moleskin, or tunnel-top cord trousers are so veddy British, barely stopping short of being viewed as blue-blooded clichés.

This is also a great shop to find the most English of town clothes, such as their suede shoe models in a tassel loafer, three-eyelet tie, monk strap, or cap toe, all at $280. Their terrific idiosyn-cratic dinner accessories include moiré quartered and shaped cummerbunds ($75). Of course, Hackett carries the obligatory velvet smoking jacket with silk frogging in Bordeaux, bottle green, or navy ($600).

As modern renditions of the wardrobe favored by those in the elite circles of public schools, regiments, and clubs, these garments have a mannered spirit that clearly distinguishes them from the more "tarted-up" world of contemporary English menswear. No clothes made today try so rigorously to eschew fashion's fickle imprimatur. Hackett is the only London firm with the savvy and taste to revive the true classics of old England without making them appear either cos-tumey or retrospective.

LONDON

HOLLAND & HOLLAND
31–33 BRUTON STREET
LONDON
TELEPHONE: 171 499 4411
FAX: 171 499 4544
HOURS: 9:30–6 MON.–FRI.; 10–4 SAT.

For those who share a passion for adventure, from stalking stags in Scotland to tracking down larger game while on African safari, the new Holland & Holland emporium has overnight become the center of this universe. As London's most expensive and expansive retail showplace built in several decades, this modern men's club is not only open to the public, but it can equip, outfit, educate, and bespeak your pilgrimage to wherever the "banging" holds high promise.

Holland & Holland is the top rifle maker of the "London's Best" gun makers, while Purdey (also a "London's Best") is considered the superior shotgun maker. The term "London's Best" is rarely accorded. It means that no further expenditure of money or time could possibly improve the product's level of excellence.

Founded in 1835 and at this address since 1960, H & H was bought in 1989 by the Wertheimer family of France, owners of the House of Chanel. After acquiring the two town houses abutting either side of this landmark, they combined and renovated all three buildings. The result is a country lodge in a city setting which houses the poshest gun shop this side of Balmoral.

From head to toe, trigger to cartridge, Holland & Holland has it all, and more. And they don't just stick to their guns. They can tailor a hunting suit with breeks, waistcoat, and jacket of Scottish thornproof tweed ($1,600), make the most complex arrangements for your upcoming expedition, and do everything possible to make the sport accessible and exciting. For collateral reading material, there is also a complete library and bookstore of current and past works on the subject. Designers from Ralph Lauren to London's fashion provocateur, Vivienne Westwood, often saunter in to see what men who can spend $50,000 on a single rifle might be cloaked in while engaged in the sport of kings.

LONDON

H. Huntsman & Sons
11 Savile Row
London
Telephone: 171 734 7441
Fax: 171 287 2937
Hours: 9–1, 2–5:30 Mon.–Fri., 10–2 Sat.
(ready-to-wear only)

Huntsman has been at 11 Savile Row since 1919. The shop origi-
nally resided on Bond Street, the Row's predecessor as the center of
men's tailoring. The establishment's prestige as the preeminent
custom maker of riding and shooting clothes has carried over to their
town clothes, which share similar lines. Their signature silhouette
evolved from the hacking coat: close-fitting throughout the chest,
slightly waisted and flared. The jacket has a long, open look in the
front. They finish their single-breasted models with only one button
for fastening the waist. Detailing is kept simple; these are stiff,
unfussy clothes for the man with the military bearing of a sergeant-
major.

The craft and skill of Huntsman tailors, as well as the service
rendered to their customers, has remained virtually unchanged over
the years. A visit to Huntsman's nineteenth-century back rooms
reveals jacket makers in their shirtsleeves and waistcoats, stitching
industriously atop high cutting tables. Their garments are held
together by the same number of stitches as those made seventy-five
years ago.

This is also the Row's most expensive tailor. Prices start at
$3,000 for a two-piece suit and you can expect to wait two and a half
months for completion. These are clothes with a clear intention: to
build you up, stretch you out, and impose a shapely line through the
torso, waist, and hip. Constructed to last for decades, the firm's style
attracts men who are aware of fashion without being unduly influ-
enced by it.

Huntsman tweeds, woven from twenty-ounce cheviot wool in
their own exclusive patterns and colors, are obviously meant for the
outdoors, whether you are stalking in the highland or shooting on

LONDON

the estate. They no longer custom-make breeches, but they do make the sine qua non of hunting coats: cut like a tailcoat with a waist seam and special side seams for comfort in the saddle, lined in tattersall wool and trimmed under the vents to keep the horse's perspiration from staining its thirty-two-ounce scarlet shell. In Evelyn Waugh's *Brideshead Revisited*, the precocious Cordelia Flyte laments that her inebriate older brother Sebastian is in disgrace, having attended the morning's hunt clad in "a beastly rat-catcher's coat . . . like something out of Captain Morvin's Riding Academy." He would have upheld the family honor had he worn this exquisite coat from Huntsman. With its purchase, you acquire a garment steeped in heritage, which, like most of the apparel sold here, will probably outlive both horse and rider.

The service here is typically British; they overlook nothing. "We used to send all our suits to be cleaned in Scotland," says Brian Hall, Huntsman's managing director, "and we still do if a suit is badly soiled. Why? I don't think it has anything to do with the water, though that makes for a nice story; it's just that they are marvelous cleaners. We insist on pressing the suits ourselves, however. Bad pressing can ruin a new suit, whereas good pressing can rejuvenate an old one." He adds, "Many of our customers take our follow-up services seriously. We have one in Paris who comes over roughly once a month, bringing with him two large suitcases of clothes for cleaning and pressing; he takes back the batch he left behind on his previous visit."

When I think of the quintessentially English look, one descended directly from the riding coat–tailcoat sensibility, this is it. Hubert de Givenchy is one of their many longtime customers, and there are not too many men who wear clothes more elegantly than he. Like neighbor Anderson & Sheppard, Huntsman has its own house style, one that has successfully transcended both time and fashion. Therefore, if you are prepared to wear their cut, better also to defer to their judgment regarding its proper detailing as well. A clear house style makes the process much less stressful and more satisfying for both tailor and client, which is why this establishment has survived so splendidly, making clothes whose fit brings out the officer in every gentleman.

HERBERT JOHNSON
30 NEW BOND STREET
LONDON
TELEPHONE: 171 408 1174
FAX: 171 495 3655
HOURS: 10–6 MON.–FRI., 10–5 SAT.

The story recounts how one day the Prince of Wales was riding in Hyde Park when his top hat was whisked away by an unexpected gust and badly battered. Fortunately, young Herbert Johnson happened to be on hand. After recovering the topper for his future sovereign, he offered to repair the damage. The hat was restored to its former stateliness. Pleased by the handiwork, the prince told Johnson that if he set himself up in business, royal patronage was virtually assured. The suggestion was heeded and young Herbert quickly won fame as a purveyor of hats for all gentleman friends of the court.

The firm that proudly bears his name celebrated its centennial in 1989. Only four doors removed from its original location, Herbert Johnson's thriving wholesale and export business has made its name synonymous with fashionable, top-quality headgear throughout the world. The shop offers more than a hundred styles and is always up to satisfying that special, even fanciful, request. A solid gold top hat was commissioned by a Nigerian prince. A snow-white bowler was built for an Italian count. And a scarlet top hat whose band was resplendent with rhinestones was the caprice of an American impresario. During the 1930s, Johnson's pioneered the "Scarf Helmet," a long scarf of paisley cashmere, foulard, or linen attached to a head-hugging cap. It was designed for motoring, skiing, and other endeavors that involved wind-challenging movements.

Those with less extravagant tastes will find much to content themselves with, including a classic Panama hat from Ecuador. Italy's trademark Borsalino hat is available in the folding variety especially designed for traveling. Another folding hat, their trilby, has the added advantage of being waterproof.

Herbert Johnson and Lock & Company share the distinction of being the last remaining hatters in England. Only an establishment with Lock's rich heritage could make this one-hundred-plus-year-old

LONDON

firm seem like an upstart. As the younger of the two, Johnson offers designs that are more theatrical than old-world. With their narrow bands and wider brims, their fedoras and trilbys have greater expressiveness than most headgear. One can imagine Indiana Jones once again defying impossible odds in such a hat, and in fact he has: The famed Jones fedora was created for the films by this firm. Worn floppy, rakishly angled, insouciantly creased, or all of the above, this asterisk of male plumage provides even staid London town with a bit of dash and a hint of adventure.

JOHN LOBB LTD.
9 ST. JAMES'S STREET
LONDON
TELEPHONE: 171 930 3664/5
HOURS: 9–5:30 MON.–FRI., 9–4:30 SAT.

For centuries, St. James's Street has been the site of coffeehouses, gentlemen's clubs, and elegant outfitters, a Mecca for the noble and royal. The current John Lobb Ltd. at Number 9 stands in the shadow of the great gate tower of St. James's Palace, in the very same spot once occupied by Lord Byron's bachelor establishment.

PRIVILEGE ELEVATED TO AN ART FORM: AN EXAMPLE OF BRITISH PREEMINENCE IN GENTLEMEN'S LUXURY GOODS—A SPECIAL-ORDER MONOGRAMMED SHOE BAG.

The business was established in 1849 by a crippled farm boy from Cornwall who clearly knew something about feet. Since that time, four generations of Lobbs have insured that the art of cobbling as practiced here conforms to the highest standards. John Hunter Lobb, the founder's great-grandson, carries on this legacy with his partner, Mr. John White. Each of their shoes and boots is produced by a team of specialized artisans, all of whom endured long apprentice-

LONDON

ships before earning their exalted posts. Neither the dark depression of the thirties nor the German bombs of the Blitz (when Lobb's premises were hit six times) could ultimately destroy the durability of painstaking techniques passed down from one generation of craftsmen to another.

It is a time-honored process. First the customer's feet are measured by the fitter. His measurements, tracings, and notes go to the last-maker, who applies them to a solid block of maple, beech, or hornbeam, turning out a precisely contoured model of the customer's foot, outlines, indentations, protrusions, and all. Next it goes to the "clicker," who chooses and cuts the eight pieces of leather used in the upper part of each shoe, and the "closer," who cuts and stitches the upper to ensure its strength and durability.

Then the "maker" joins the upper to the sole—which is made of the best tanned Oak-Bark leather—and the layered, riveted heel. After the eyelets and inner soles have been added, the polisher has at it, bringing out an extraordinary patina. The finished product is perfect. Its toe shape is not square, not pointed, not round, but subtly beveled with a slight rise at the center. As Lobb describes it in relation to any other pair of shoes, it is "a Rembrandt compared with a penny print."

These craftsmen can make anything: riding boots, velvet slippers, dress pumps, button shoes, or cowboy boots. A first-time customer's initial order will take five to six months because the last must be carved. Subsequent purchases take two to three months. Calfskin shoes start at $1,800 per pair but if your taste runs to the more exotic crocodile, you can expect to pay twice that much. Shoe trees made from the same wood as your last are $300. They also make traveling shoe covers to protect these exquisite leather confections, wool felt bags trimmed with tassels with your initials embroidered if desired. When asked how long they had been producing these quirky little hands-at-home bits of the old empire, no one seemed to know. They have been a mainstay of the firm as far back as anyone could remember.

When you buy a Lobb product, you acquire footwear for the ages. "It's not uncommon for people to walk in here and have shoes repaired that are more than forty years old," says Mr. Lobb. Adds designer Hardy Amies, a Lobb habitué since 1938: "I buy one pair every two years and they can easily last twenty years if you look after them. That way, I have a bank of shoes that will last me until they are pointed heavenward."

LONDON

Lock & Company
6 St. James's Street
London
Telephone: 171 930 5849
Fax: 171 976 1908
Hours: 9–5:30 Mon.–Fri., 9:30–4 Sat.

Studying the facade of this legendary hatter from across St. James's, one immediately comprehends the historical resonance implied by the phrase "Made in England." It stands for pride, stability, and permanence, and is a throwback to a time when retailers believed a company's honor and reputation were staked on every item bearing its mark. Few establishments can convey so much in a first glance, but, then again, not many firms can trace their origins back to 1676.

Fewer still can boast a front door that has remained unchanged for nearly two hundred years. This antiquity is covered in pitch, the sticky tarlike waterproofing substance that was spread on the undercarriage of boats during the nineteenth century. So rare is this example of resilient English craftsmanship, it has been granted virtual landmark status. By order of successive prime ministers, this portal cannot be altered in any way.

The Lock logo is every bit as distinctive as its entrance. With its simple black script filling a white oval, this trademark is more a stamp of authenticity than a symbol of commerce. Its striking modesty has inspired other firms searching for a logo that connotes something more than selling. Ernst Dryden, the legendary designer of Knize in Vienna, was only one of the artists inspired by the Lock insignia.

Though Lock originally built its reputation creating custom hats for the aristocracy—the Duke of Wellington was loath to let anyone else make his tall hats and one of the firm's signature bowlers bears Anthony Eden's name—they no longer make true custom hats. However, they will trim the odd brim or change the occasional crown for regular patrons (at no charge). If your head is very round or long, they can have headgear made up for you.

Snap-brim hats are a Lock specialty, as are the softer felt hats such as Borsalinos and trilbys. Panama hats can be made to order for up to $700, or you can purchase one ready to go at $200. Their selec-

tion also includes homburgs ($160) in black, gray, and brown. Prince
Charles purchases his polo caps here.

Any vestige of the modern world would appear awkward in
this venerable preserve. No computers here, only handwritten
ledgers and discreet personal service. Until January 1993, Lock had
never even held a sale. When it finally relented, the event was
deemed so momentous it received television coverage throughout
the Continent and the store was besieged by hordes of customers
who were being introduced to Lock for the very first time. This phe-
nomenon greatly amused the proprietors. After nearly three hun-
dred years, they had assumed that everybody already knew Lock of
St. James's Street.

LONGMIRE
12 BURY STREET
LONDON
TELEPHONE: 171 839 5398
FAX: 171 930 1898
HOURS: 9:30–5 MON.–FRI.,
10–3 SAT. (NOVEMBER AND DECEMBER ONLY)

Should a man wish to wear his passion on his sleeve, Longmire can
easily accommodate him. This is the only store in the world whose
entire raison d'être and therefore stock are devoted to ornamenting
the male wrist. Longmire specializes in enameled and enameling cuff
links of various motifs. They carry an enormous range, over five hun-
dred different pairs of ready-mades starting at $500. However, their
real forte is making them to order. Starting at $600 for silver to
$2,500 for eighteen-karat gold, you can have cuff links custom-
enameled with the design of your choice—your company logo, a
handpainted rendering of the family pet, ancestral crest, anything.
Depending on the intricacy of the design, the completed product takes
six to ten weeks.

The firm has gained three royal warrants since its founding by
Paul Longmire in 1962. Ninety-eight percent of its merchandise is
exclusive to the store. Said by the *New York Times* to have "the world's
largest selection of dress sets and cuff links to be found," Longmire

LONDON

also keeps on hand at least one hundred pairs of hard-to-find antique cuff links.

Without a security commissionaire standing point near the door, entering this shop is like gaining access to some holy of holies. Two bullet-proof sliding doors protect the treasures within from any unwelcome visitors. Once inside, it's all turn-of-the-century with green walls, brass, antiques, and French jewelry cases. A tad self-important, perhaps, but if you are searching for something to dress that special sleeve, this jeweler can accommodate almost any whim, no matter how idiosyncratic or personal.

POULSEN & SKONE
NEW & LINGWOOD LTD.
53 JERMYN STREET
LONDON
TELEPHONE: 171 493 9621/499 5340
HOURS: 9–5:30 MON.–FRI., 10–5:30 SAT.

The shoe shop of Poulsen & Skone, located upstairs in the London store of Eton supplier New & Lingwood, is the marginal survivor of that company's 1992 acquisition by South African entrepreneur Anthony Spitz. The new owner's penchant for corporate downsizing and bean-counter's cost cutting has not only taken its toll on both of these retail establishments, it has led to the complete demise of Bowring & Arundel, the exquisite little furnishings shop that stood next to Anderson & Sheppard on Savile Row for nearly half a century. Bowring & Arundel is now shuttered, all the staff and artisans who produced Poulsen & Skone's bespoke footwear have fled to the sanctuary of G. J. Cleverley, and the older, highly trained members of the New &

WING-COLLAR PEDIGREE: THE BONA FIDES OF WING-COLLAR PERFECTION (STUD SET BY JAMES ROBINSON OF NEW YORK).

ARBITER ELEGANTARIAN OF FACIAL
FRAMES: TO-ATTACH WING COLLAR
AND TO-TIE BOW (STUD SET BY
TENDER BUTTONS OF NEW YORK).

Lingwood staff—many of them sartorial dons who never abandoned those shirts with separate white stiff collars—are gradually being supplanted by younger, less expensive, and less knowledgeable salespersons.

However, some classics of yesteryear still remain to keep a brave candle barely flickering. Upstairs, Poulsen & Skone still carries those corduroy Eton slippers that were first designed for the lads in 1865. They still carry some of the ready-to-wear shoes from the Cleverley era and, for the moment at least, these holders represent some of London's best RTW models. Poulsen & Skone's cap-toe suede lace-up, Peale butterfly-front slip-on, apron toe suede slip-on, and unlined chukka boot still retain their bespoke mien. Downstairs, New & Lingwood continues to stock a legitimate piqué-front dinner shirt and separate stiff collars to attach, as well as sized black-tie and white-tie to-tie bows.

It is the too-frequent destiny of many small family-owned English retail establishments to be gobbled up by foreigners initially smitten by their dusty pedigrees and the status they are deemed to convey. After this changing of the guard, reputations that took so long to establish are quickly trampled upon in a mad rush to the god of profit's altar. Most of the time, they either vanish or, as in the exceptional case of Swaine Adeney Brigg, are rescued from looming oblivion through a second, more providential acquisition. These standbys of English character and taste—New & Lingwood and Poulsen & Skone being just two of the more salient examples—deserve better.

S. J. PHILLIPS LTD.
139 NEW BOND STREET
LONDON
TELEPHONE: 171 629 6261
FAX: 171 495 6180
HOURS: 10–5 MON.–FRI.

There are undoubtedly better-known jewelers in London, but none who offer more rare, museum-quality, or swellegant antique men's cuff links than this Bond Street silversmith. Founded in 1869, S. J. Phillips typically carries no more than twenty-five pairs at a time, but among them are certainly a few the Duke of Windsor himself would have coveted. Their clients come from some of Europe's finest families, so many of these period pieces are acquired through estate sales and are being resold for the first time.

From a hallmarked 1907 pair with four enameled hunting scenes ($3,500) to a diamond-and-onyx set on platinum from Cartier, Paris, circa 1930 ($35,000), this cuff art could dress the hand of any monarch. For less princely hands, there are also nine- and eighteen-karat gold signet rings in several models with exceptional monogramming or plain oval cuff link sets made with the old-fashioned link apparatus in either silver or gold ($300–$1,200).

HENRY POOLE & COMPANY
15 SAVILE ROW
LONDON
TELEPHONE: 171 734 5985
FAX: 171 287 2161
HOURS: 9–5:15 MON.–FRI.

Savile Row, the London street named after the Earl of Burlington's wife, Dorothy Savile, in 1733, is the cradle of English bespoke tailoring. Its fame can be traced back to the founding in 1806 of Henry Poole & Company.

Tailor to Edward VII, Charles Dickens, Prince Otto von Bismarck, and William Randolph Hearst, Henry Poole was considered by London society to be the arbiter of gentlemen's raiment. As such, he

was immortalized by Benjamin Disraeli when he appeared as the thinly disguised Mr. Vigo in the former prime minister's last (and perhaps most readable) novel, *Endymion*. As rendered by Disraeli, this artisan was "the most fashionable tailor in London . . . consummate in his art, neither pretentious nor servile, but simple with becoming respect for himself and others."

Poole started the great tradition of English tailoring. By the early 1900s his was the largest establishment of its kind in the world, employing over three hundred tailors and cutters. He was also a man of immense creativity. Like all tailors, Poole was continually faced with the task of determining whether a patron had gained a few pounds since his last fitting—this was, after all, a London where the usual dinner could run to twelve or more courses. He saved himself and his clients no small embarrassment by building an elaborate leather-upholstered Chippendale-quality chair that discreetly hid within its innards a scale that quietly recorded its occupant's weight without the subject ever being broached. With this stroke of genius in place, a Winston Churchill or a J. P. Morgan could have the delicate matter disposed of while sitting back in comfort, sipping some of "Old Pooley's" excellent claret while puffing on a hand-rolled Havana.

Redevelopment forced Poole's from Savile Row in 1961, but it was able to return to its traditional home in 1982. The establishment is currently helmed by Mr. Angus Cundey, a fourth-generation cousin of the founder. With its staff of eighty—forty-six on the premises—Poole's is still Savile Row's largest tailoring firm. Its reputation is international. The Poole tailors make twice-yearly trips to select cities in the United States and its senior cutters frequently visit the Continent. A Poole two-piece suit starts at $2,000, blazers from $1,300.

Poole's house style falls somewhere between the casualness of Anderson & Sheppard and the close-fitting hacking jacket found at Huntsman. Compared to many of their neighboring colleagues, Poole's artisans are more willing to adapt to the customer's tastes. As Angus Cundey explains, "Tailoring here has always been a combination of the proposal by the tailor and the acceptance by the customer. It needs a melding of the two. Customers are advised by their tailors on a changing fashion—narrower lapels, for example—and usually accept

LONDON

small changes because they have seen them elsewhere. Savile Row changes only very gradually and quite deliberately."

Henry Poole placed great value on personal relationships. He was on terms with society's elite, including Dickens, Baron de Rothschild, the royal family, and most of his country's heads of state. His Italianate premises were a meeting place for the young bloods and swells of the era. Yet he lavished just as much attention on less celebrated clients. His tradition of fine service continues today. "Its generally true," says Angus Cundey, "that once a customer has come to us he remains with us for the rest of his life. In our business, the personal touch is everything."

JAMES PURDEY & SONS
57/58 SOUTH AUDLEY STREET
LONDON
TELEPHONE: 171 499 1801/5292
FAX: 171 355 3297
HOURS: 9–5 MON.–FRI.

James Purdey & Sons is the other of "London's Best" gun shops in the United Kingdom. Walking through its doors, you are immediately transported to the setting of some English explorer's adventure. You almost expect battered but intrepid Mr. Stanley to walk in and presume you are Doctor Livingstone. While its inventory of clothes is limited, what is here attains the same standard of excellence as its weapons. Its brodequin boot, a rubber ankle boot lined with leather, is stylish and utilitarian. Hand-knitted pure wool shooting stockings (in unusual patterns of thistles and checks) are sold complete with matching garters. An assortment of waxed clothing, including hats, overtrousers, jackets (lined with a quilted body warmer), and overskirts, is available. When it comes time to rewax these garments—a must, since allowing waxed cotton to dry out weakens the fabric—you can purchase a tin of clothing wax or ask the shop's craftsmen to accommodate you.

Shotguns are this shop's specialty. Its craftsmen will fit you for a weapon as meticulously as any Savile Row tailor would fit you for a suit. While the new Holland & Holland may upstage Purdey's in the wardrobe and gear department, Purdey's has all the imposing charm

LONDON

of a small castle. Stepping into it is like entering the gun room at Balmoral, except this evocative slice of English privilege is not only a lot closer, it is infinitely more accessible.

PAUL SMITH
40–44 FLORAL STREET
LONDON
TELEPHONE: 171 836 7828
FAX: 171 379 0241
HOURS: 10:30–6:30 MON.–FRI., TILL 7 THURS.; 10–6:30 SAT.

"British style is something the Americans have been stealing for years, the French have been nicking constantly, and the Italians just take and sell back to us," says television personality–fashion designer Jeff Banks. With virtually complete dominion over male fashion for more than two centuries, the crown's only claim to fame in original menswear thought comes from a designer who does not even make English clothes. Unless, of course, you consider eccentricity the defining characteristic of the *style anglais*. Like those merry pranksters who comprised Monty Python's Flying Circus, Paul Smith has removed the class from classic—at least the Lobb-Lock version of it—to create clothes that impart a sense of humor as well as history. His is a form of cultural anarchy that only the British can pull off.

I first encountered Paul's clothes in the late sixties at Mr. Howie, a store way down Fulham Road. Blending street fashion with Savile Row, these garments merrily sabotaged the accepted metaphors of class dressing through their improbable combinations such as chalk-striped suits with polyester floral shirts. Paul adds lowbrow touches to highbrow designs, employs tweeds in ways that would have made the Scottish crofters wince, and uses humor to pummel the mickey out of British priggery.

Paul's pioneering spirit brought him to Covent Garden in 1979—a market area once bustling, then abandoned, like Les Halles in Paris. He established headquarters in an old banana warehouse. Constructed in 1850, the building still retains its original wood-plank floors and beams. This architectural throwback provides an ideal setting for the thoroughly modern, vibrant apparel created by a man who transforms the incongruous into an art form. The Covent Garden frontier he first explored,

LONDON

like the then unfashionable lower Fifth Avenue where he opened his shop in New York City, became its city's hotbed of high-fashion retailing.

Today, there are four Paul Smith shops in London. His collection is carried by every hip fashion purveyor in cities throughout the globe. The fashion set flocks to his doors knowing there will always be an item whose mannered lunacy will qualify it as a conversation piece as well as a classic. Paul creates clothes that are high in quality, high in imagination, and highly entertaining. His socks have hands on them, his gray flannel vest has a red satin bottom trimmed in black fringe, and the only predictable thing about his neckwear is that it knots. Like Paul, his clothes possess a long-term point of view with a short fuse for complacency.

SWAINE ADENEY BRIGG & SONS
10 OLD BROAD STREET
LONDON
TELEPHONE: 171 409 7277
FAX: 171 629 3114
HOURS: 9:30–6 MON.–SAT.

"All men are equal," wrote E. M. Forster. "All men, that is, who possess umbrellas." There are two schools of thought about the brolly. One holds that as it is likely to be lost, little should be invested in it, while the other counters that like any personal accoutrement, it should be functional and attractive. Living as they do in a land of unforeseen drizzle, the English make a study of umbrellas. Anyone making a bumbershoot in this country must adhere to an exacting standard. Swaine Adeney Brigg, holder of royal warrants to successive English monarchs since 1750, produces the best umbrellas in the kingdom.

Their umbrellas are made from a single piece of wood. Exactly where others tend to snap and fall apart, it is solid and thick with runners, caps, and ferrules made of solid brass. The hand spring and top spring are nickel silver. Its nylon or silk cover—hand-cut, hand-sewn, and painstakingly hand-tied to each rib—opens to a domed shape for maximum protection. With prices starting at $195, the umbrellas are stocked in three lengths (25", 26", and 27") with a choice of crooks or handles such as Malacca, Polished Chestnut, or Whangee. Every handle bears the royal warrant engraved on a plated gold collar. If an appro-

QUINTESSENTIALLY ENGLISH: ELEGANT BUT
NOT OVERREFINED—A HOSPITABLY PROPOR-
TIONED AND DETAILED FOLDING WASH BAG,
HANDCRAFTED IN BRIDLE LEATHER WITH
BRITISH RACING GREEN WATERPROOF LINER.

priate combination is not on the premises, they can special-order one
and deliver it in eight to ten weeks.

Though classic brollies dominate, they make a few special
umbrellas of note. There is a traveling model whose tip and handle
unscrew to fit inside your luggage. Umbrellas with hidden compartments
allow you to conceal your pen, flask, or—for the Errol Flynns among
us—sword (the very thing for fending off that reckless bicycle-riding
messenger bearing down on you from across the street). They also carry
great eclectic handmade leather travel goods such as miniature traveling
jewelry boxes in pigskin, tie cases, and the best folding bridle-leather
dopp kit with dark green waterproof liner ($275).

Some years back, the firm was bought from the original family
by the Seaman's Trust, which apparently had no idea what to do with
it. A great English institution was left to slide into infirmity. Fortu-
nately, John de Bruyne, a graduate of Eton and Harvard, recognized
its specialness. He bought it and moved it from its Piccadilly address
(where it had been for over 250 years) to these larger premises on
Bond Street. This grand baronial town house, complete with Gothic
paneling and a central hearth, reflects the lifestyle of the firm's illus-
trious patrons from times past. Here, products made in limited quan-
tity continue to be imbued with a richness of suggestion and nuance.

LONDON

For this business, it is each product's distinctive personality that is paramount, something only the Europeans understand and build upon. Items of easy luxury, elegant but not overrefined, have been Brigg's history. And, once again, they are its future.

TURNBULL & ASSER
71–72 JERMYN STREET
LONDON
TELEPHONE: 171 930 0502/5
FAX: 171 930 9032
HOURS: 9–6 MON.–SAT.

Jermyn Street is for shirts what Savile Row is for suits. Wrapped around one of this historic thoroughfare's most prestigious corners is the double-barreled shirt shop of Messrs. Reginald Turnbull and Ernest Asser. Incorporated in 1885 and stationed here since 1904, T & A, as its devotees fondly refer to it, is renowned for its opulent window displays. The riot of so many bold stripes and colorful accessories will either make you salivate Gatsby-like or send you running for the nearest white shirt. Years ago, it was not uncommon for the upper-class Englishman to own more dress shirts than neckties. As he favored dark suits accompanied by school, club, or regimental ties, his selection of neckwear was limited, and the ties he did own were worn repeatedly. Therefore, only an interesting dress shirt offered him enough sartorial latitude to enliven his ensemble, which is why so many Jermyn Street shirtmakers came to prosper.

In the early sixties, with Michael Fish as its neckwear buyer, Turnbull helped usher in the peacock era with its brightly colored and patterned shirts, five-inch-wide Kipper tie (so named for Mr. Fish), and turtleneck dress shirt. It is always a joy to visit the store, attired in richly polished wood, thick wall-to-wall Persian carpets, magnificent hues coming at you from every angle. Whether it's the dress shirts, the neckwear, or the silk dressing gowns inspired by the stylish decadence of Noel Coward, the joint reeks of buttoned-up, dandified English eccentricity.

This West End institution has always understood the relationship between collar and face. Since the attached-collar day shirt became accepted form in London, all the royal males since Edward VII have

sported collars that were slightly more important in scale than those favored by the Continental or American. Shirt collars here are still higher in band and longer in point than others on Jermyn Street, the T & A look not varying much despite its maverick reputation. Ironically, with fashion returning to the classically designed dress shirt, collars are slowly returning to face-flattering proportions.

Walking a few steps down Bury Street, you arrive at T & A's clubbish Churchill Room, whose membership just happens to include every notable from the cuff-link-wearing world, past and present. There are sumptuous leather chairs and sofas, walls covered in faded green watered silk, a grandfather clock ticking the centuries away, and over eight hundred fabrics to hold a visitor spellbound. Custom-made shirts ($175–$350) take twelve weeks, with a minimum order of six. Bespoke neckties can be ready in a month. T & A will also make-to-measure boxer shorts, nightshirts, robes, and dressing gowns in an array of colors and fabrics ranging from the somber to the enthusiastic.

Finished with either their patented three-button cuff or turn-back French cuff, the Turnbull dress shirt is elegant enough to dress many a prince and does: Prince Charles has been a devoted customer since leaving university. Turnbull & Asser is more than London's most famous haberdasher. Like the Hermès print tie or Gucci slip-on, the Turnbull & Asser dress shirt is a recognizable status symbol conferring both suitability and style.

LONDON

LOS ANGELES

An Introduction

When the dust finally settles on the twentieth century to reveal the American man in his final phase of sartorial evolution, many would be surprised to discover that the Pacific Coast may have had a more profound impact on shaping its aesthetic than the European-influenced East Coast. As American society relaxes its expectations governing appropriate public attire for men, the erosion of its tradition-bound formality will continue. And no other part of the world can claim more responsibility for this development than Southern California, particularly the city of Los Angeles.

Many businesses have loosened their dress codes, and even those firms with the most stringent dress guidelines now have their "casual Fridays." This inclination toward casual male attire not only reflects changes in the corporate culture, but with the computer age has come a reevaluation of what constitutes appropriate business attire. Given the wonders of E-mail, fax machines, and conference calling, the modern male entrepreneur can, should he choose, conduct business from his bed. Therefore, the need for the suit-and-tie uniform that was once de rigueur in the corporate world has diminished.

Though this trend is a relatively recent phenomenon throughout most of the world, Southern California has, from its earliest days, pioneered a relaxed dressing ideology that reflected both its climate and distance from the established protocols of Eastern business attire. During Hollywood's formative years, its sun-drenched, outdoors persona became so distinguishable from those male fashions of either the East Coast or Europe, it came to be dubbed the California Look.

Prior to World War II, most of the large movie studios were run by European immigrants who expected their marquee males' dress to project an international flavor. As the early movie stars hobnobbed with kings and barons, polo players and playboys, their cinematic dress reflected this haut monde concept of style and fashion. Unless they were cast in a period piece, leading actors usually appeared on-

screen in their own wardrobe. This allowed audiences to see firsthand the incredibly stylish things England's Cary Grant could do to a chalk-stripe suit or the paces Fred Astaire might put his Savile Row tailcoat through. The larger-than-life appearances on the large screen of such Continentally clad men inspired millions of males to follow their lead.

When the War Production Board lifted its restrictions on garments whose design required an abundance of fabric, Southern California fashion became even more theatrical, colorful, and—like most things Californian—oversized. Early on, the California Look was identifiable by its touches of western detailing or tricky combinations of different fabrics within one garment. After the war it went even wilder and bigger with vividly colored, broad-shouldered, lapel-less sports coats, Hawaiian shirts worn outside deep-pleated, wide-cut trousers, and matching shirt-and-slacks ensembles. For dress-up, the Barrymore 4½"-long shirt collars or large-collared dress shirts done up with fat, Windsor-knotted neckties differentiated the West Coast's interpretation of the so-called "bold look" that became the fashion in the late 1940s. As the popularity of television grew, the California Look was beamed into cities and towns across America.

Though they had previously shared some similarities in men's fashion, West Coast and New York style completely parted company during this Ivy League era. Postwar movies introduced a succession of looks that influenced the fashion-conscious youth market including the beacher style, the bunkhouse fashion of the Hollywood cowboy, and the tough, motorcycle-rebel look of Brando and Dean. And as many of these on-screen fashions were being endorsed by the rest of the country's moviegoing public, Southern California continued to forge ahead with its alternative leisure ensembles for the Los Angeles business community. Visitors to this hotbed of liberated business attire came away with much to consider and some envy over the way Southern Californian men could deliberately dress down and still do deals.

Whereas today's Washington, D.C., is considered a one-company town with the federal government as its omnipresent employer, Los Angeles appears to be a land born out of the entertainment industry, with Beverly Hills as its capital. As most of the makers, marketers, and packagers of American pop culture either reside or work here, Holly-

LOS ANGELES

LOS ANGELES

wood's entertainment fashion tastes get exported along with the rest of their fantasies to a large, impressionable audience. Although shopping takes place all over the city, it centers in Beverly Hills, a hamlet of household names whose yearly income is over four times the national average.

Strolling down Rodeo Drive, its shrine to shopping as a form of momentary notoriety, one quickly understands that this area's principal charm resides in an obsession with facade and celebrity that is almost beyond parody. Everything about this limestone-and-marble stretch of conspicuous consumption resonates with associations that are quintessentially Hollywood. It looks like something you might come upon on some MGM soundstage. Rodeo's reputation as a rendezvous for movie stars charges the atmosphere with anticipation. You sense that even the locals as well as the tourists keep one eye trained for that cinematic luminary who just might be coming out the next door. The longer-established stores play upon this voyeurism by billboarding their walls with their high-profile clients' framed and autographed photographs.

Within walking distance of this mercantile dream factory, one discovers the full spectrum of twentieth-century taste in menswear. However, since this *ville*'s conscious personification of cinematic stardom and mind-boggling affluence is its chief tourist attraction, Beverly Hills style tends to rely heavily on the artifices of luxury to convey its message. Its trappings can seduce the parvenu or insecure of taste into believing that a garment will convey prestige and class only if it looks expensive. Despite its view of fashion through glitter-daubed eyes, Beverly Hills offers men a range of fashion, whether classic or contrived, whose quality is as fine as can be found anywhere in the world.

Starting on Rodeo with Ralph Lauren's tweed juggernaut, we move on past Giorgio Armani's colossus of modern quietude to the three B's of Beverly Hills braggadocio—Bijan, Battaglia, and Bernini. The sheen refracted from the collective gloss of their neckwear, shoes, and fabrics makes one appreciate the burghers' passion for sunglasses. Farther down the drive, Sulka, Fred Hayman, and the new Zegna shop offer some respite from all this ostentation. Carroll & Company has opened new headquarters two blocks east on North Canon Drive. On Wilshire Boulevard, Barneys, that interloper from the other coast,

has opened a magnificent new emporium laden with vendables of downtown Manhattan chic. Saks Fifth Avenue has also moved into elegant new digs just in time to keep its better-entrenched competitor, Neiman Marcus, from monopolizing the burg's upscale market with its broad selection of designer luxury togs. Some of the city's best shopping takes place in outlying districts that offer a freedom of fashion, riskier and less commercial than that found in its high-rent district.

Having preached the glories of sporty informality with an almost missionary zeal for over seventy-five years, Los Angeles has finally traded its blue jeans, T-shirts, and blazers for clothes equally comfortable yet far more stylish. With Mr. Armani's drapey languor in ascendancy, this city has assumed a position as the culture's arbiter of high-profile slouch. Even though the notoriously Caliphobic Woody Allen once quipped that L.A.'s only cultural contribution to the western world was its sanctioning of a right turn on a red light, the American man can thank this side of the Mississippi for making his business attire more off-the-cuff than on.

AMERICAN RAG
150 SOUTH LA BREA AVENUE
LOS ANGELES
TELEPHONE: (213) 935-3154
FAX: (213) 935-2238
HOURS: 10–10 MON.–SAT., 12–7 SUN.

"No one buys a complete coordinated outfit or a roomful of furniture anymore," says Mark Wertz, cocreator of American Rag. "They simply put things together as they find them." This is the guiding philosophy behind American Rag Compagnie, a compendium of five European-style specialty shops owned by Mark with his wife, Margot, and set along one city block on the east side of the boulevard.

During the early seventies, Mark opened stores called Salty Dog in several of Holland's major cities. He would buy closeouts of such items as America's bell-bottom jeans and then sell them to Europe's Woodstock generation. Featuring what he called twentieth-century classics, the stores became so successful he later sold them to a large Dutch company.

LOS ANGELES

In 1984, he started his U.S. business by taking over the old Gumps Department Store in San Francisco. One year later, he came to L.A. and gutted this two-story building, the former home of Acme Hardware. He gradually took over most of the block on this now-fashionable shopping street while it was still an out-of-the-way address. American Rag is the quintet's anchor store, featuring an unusual pastiche of antique fashions from Levi's and 1950s varsity jackets to current items from different designer collections such as Double RL, Diesel, Basco, and DKNY, which they mix with their timeless classics.

Fun, quirky, and very sixties, the incongruity of the shop's eclectic antifashion statements is its dominant theme. Here you can find worn Levi's ($50–$80), a used jean jacket ($150), or a second-hand Ralph Lauren polo shirt ($30). They carry London's Cutler & Gross eyewear, vintage tuxes for 90210 proms, and Woolrich jackets. The globe-trotting Wertzes spend as much as six months of every year in foreign lands handpicking the offbeat merchandise for their racks. Customers—who include rock stars, movie celebs, motion picture costume designers, and members of L.A.'s counterculture—dive into the spirit of the store by creating unusual combinations that express each wearer's individual perspective, aspirations, and sense of fantasy. Their "classidelic" approach to attire melds well with the Fred Segal mentality of off-road sportswear, attracting both the Rolls-Royce and the Schwinn bicycle crowds.

ANTO
268 NORTH BEVERLY DRIVE
LOS ANGELES
TELEPHONE: (310) 278-4500, 652-5870
FAX: (310) 278-0635
HOURS: 9–6 MON.–FRI., 9–5 SAT.

Although L.A. is not thought of as a shirt-and-tie kind of town, for those like Jay Leno who must wear a suit to work, or Ronald Reagan and Arnold Schwarzenegger, who cannot fit into a ready-to-wear one, this is where the celebrated come to be comfortably collared. Anto, a Lebanese shirtmaker who started his business in Beirut in 1946 before

settling here in the early 1950s, still creates each client's initial patterns. From 1953 to 1977, he supervised the production for one of Los Angeles's shirtmaking luminaries, Nat Wise, and in 1988, the two firms merged. Another well-known maker down Brighton way, Jack Varney, also recently downsized to add his distinguished list of Hollywood notables to what is becoming a virtual Anto monopoly.

The first order requires a six-shirt minimum; the shirts range in price from $165 to $185 with a five-dollar charge per hand-sewn initial which, like everything else, is done on the premises. The steps taken by the firm to guarantee a satisfactory fit are time-consuming but well considered. First they make a toile, or a basted try-on shirt, which can be executed as quickly as necessary. After that fitting, ten days of labor produces the first finished shirt, which you try on and then wash. If everything is in order, the remaining shirts can be ready in two to three weeks. Anto's customers can also take advantage of their laundry service, which features weekly home delivery for $3.50 per shirt.

Other than Dick Carroll's, I have yet to walk into an established Beverly Hills retail store that does not have its very own wall of fame crowded with pictures of Hollywood stars and starlets, all expressing their deepest appreciation and sincerest best wishes. Anto's luminaries are presented New York delicatessen–style, with the pictures crowded frame-to-frame. Manila envelopes containing the paper patterns for each honoree, their names Magic Markered in large letters for all to see, sit beneath the pictures. These curiosities are the high points of this large room's rather unremarkable decor. Two ceiling-high bins resting on opposite walls contain the firm's mammoth selection of shirtings, fifteen hundred flavors in all, from silk sport shirtings from the fifties to Italy's latest sea island cottons.

Like a Hong Kong custom tailor, Anto will make a shirt in any style the client requests. This seemingly open-minded approach can be a recipe for disappointment. This shop's pattern making is as top-notch as the quality of its fabrics. However, any shirtmaker who lacks a definite house style usually needs strong guidance in the form of, say, a Milanese dress shirt collar, if the end result is going to look high-class. Though Anto's shirts are sewn with a single needle, their wider side seams separate them from shirts made by Europe's master shirtmakers.

LOS ANGELES

Although Armani dresses his share of Oscar winners and nominees, Anto Sepetjian shirts more of them. If you want the Barrymore collar or other such vestiges from Hollywood's glamour days, this could be a treasure trove. However, during the past thirty years, Hollywood has produced few sartorial giants; the days when Ray Milland, Gary Cooper, Clark Gable, Joseph Cotten, and others lent this town its stylish tone are history. What you can still receive here is polite service, fine quality, and, should you really make it, your picture next to Sinatra or Brando.

—————

CARROLL & COMPANY
425 NORTH CANON DRIVE
BEVERLY HILLS
TELEPHONE: (310) 273-9060
FAX: (310) 273-7974
HOURS: 9:30–6 MON.–SAT.

Carroll & Company offers one of the few opportunities to view America's authentic gray flannel fashion before its total eclipse by the megabrand designer business. Other than New York City's Paul Stuart, Carroll's is the last private-label retailer to purvey upper-end English and American clothes of the soft-shoulder persuasion to the affluent traditionalist.

However, after forty-five years of standing point at one end of the *ville*'s legendary shopping boulevard, Rodeo Drive, and welcoming those descending from the hills to worship at its Mecca of the most, Dick Carroll is officially entering the era of the second generation. John Carroll, Dick's thirty-one-year-old son, is taking over the reins from Dad, having worked in the store since he was eleven. The store is also cutting its umbilical cord from Rodeo Drive and taking up residence two blocks east on North Canon Drive in a more contemporary setting with rotunda, modern architecture, and clean lines. John feels his generation is intimidated by Rodeo, and here he can attract a younger clientele to build upon as his father did.

Richard Carroll, a native New Yorker, worked in the publicity department of Warner Brothers when the studios strove to shape and manipulate the public's perception of their leading players' private

lives and habits. To that end, it paraded before the media a continual conga line of gorgeously attired actors who, in turn, influenced the dressing mores of the entire cinema-viewing world. Dick Carroll became one of that industry's leading haberdashers and expanded his operation as the town's community of relocated East Coasters grew. Ostentation is shunned here; not a single movie star's picture graces their walls, though they have clothed them all.

With the exceptions of those few established makers whose names appear on shingles around the store, Carroll & Company is the only label found here. Shoppers will find English satin-striped cotton pajamas ($95–$150) and velvet monogrammed slippers, as well as robes of similar pedigree. Europe's finest crafted, cashmere-lined leather blousons, elegant woven sport shirts, and velvetlike cotton pleated trousers, along with the obligatory V-neck cashmere or shetland crewneck sweaters are among the Carroll regulars. For tailored clothes, they offer their own special designs (starting at $495) as well as those hand-sewn by Hickey-Freeman, Oxxford, and Chester Barrie ($895–$1,750).

Carroll's will still be the meeting ground for the Gucci generation who like their collars buttoned down and their blazers trimmed in brass. Now they will be offered a few more Italian versions in that traditional approach. Carroll's is that bit of old Hollywood evocative of the Astaire era, when men knew how to dress and had someplace to dress up for. With Ralph Lauren's Rhinelander Mansion West ensconced over on Rodeo, and Giorgio Armani's affirmation of the future just a few yards beyond that, Madison Avenue never seemed so near and yet so far.

GIACOMO
732 NORTH LA CIENEGA BOULEVARD
LOS ANGELES
TELEPHONE: (310) 652-6393/6431
HOURS: 8–5 MON.–FRI., 8–1 SAT.

The size of this tailor's lilliputian outpost belies the celebrity of its cinematic clientele. Hollywood's new royalty—Schwarzenegger, Stallone, Katzenberg, and Spelling, and so on—have joined such members of

the old guard as Gene Barry, Jack Valenti, and Kirk Douglas as devotees. Jay Leno is the latest tinseltown aristo to trust himself to this tailor's expert hands.

Giacomo Trabalza has been plying his craft since 1964. After having spent his first fifteen years in this country apprenticing under a number of New York City's finest Fifth Avenue tailors, he migrated west to make his fortune. Four people assist him on suits that require two fittings and cost $2,200. He makes a classic silhouette that, while sensitive to trends in men's fashion, still reflects his Italian predisposition to a slimming line and structured form.

Though not a stylist on the order of New York, London, or Milan's finest, Giacomo creates clothing of unimpeachable quality and fine tailoring. Given the entertainment world's taste, as exhibited by the majority of those who try to fill this country's big and small screens, his work offers a step in the right direction.

SCOTT HILL

100 SOUTH ROBERTSON BOULEVARD
LOS ANGELES
TELEPHONE: (310) 777-1190
FAX: (310) 777-1199
HOURS: 11–6 MON.–SAT., 11–5 SUN.

A simple sign to the left of its front door says it all: SCOTT HILL—A MAN'S STORE. An unfussy cream stucco building with large windows framed in bottle green injects a breath of fresh air to this city of the elaborately garnished man. This 3,500-square-foot citadel of Northern Italian–inspired fashion is the brainchild of Mr. Hill, who, for eighteen years, bought menswear for Tarzania's Ron Ross, one of Southern California's most respected men's retailers. Situated a long drink of Evian from two of the city's toniest watering holes, the Ivy and Chaya's Brasserie, this store hit the boards running in 1994 and hasn't stopped to catch its breath yet.

Its decor, residential in feel, merges the old with the new. Birchwood walls, antique furnishings, and mobile fixtures that can reconfigure the hardwood floors from one week to the next provide Scott's soft-shouldered, artisan-crafted fashions with a familiar yet varied backdrop. Malo cashmere knitwear, Nicky neckwear from Milan, Luigi

Borelli dress shirts from Naples, hand-tailored suits from Isaia, plus finely edited morsels of Donna Karan, Armani, and Vestimenta are among the supporting scenery.

While Los Angeles retail has experienced a recent doldrums, this store continues to glide through its infancy in expansive style, no doubt attributable to those initiates who appreciate its modern tweed taste that mixes fashion basics with a twist of Italian tailored chic. Close in spirit to Boston's Louis, Scott Hill offers the City of Angels a definitive yet understated alternative to its current roster of dressing sensibilities. One of the few men in Hollywood to dress with authentic style, George Hamilton, was recently observed here putting together the on-set wardrobe for his current TV show. Given L.A.'s preoccupation with Mr. Armani's monotone drapings, this store will attract enthusiasts eager to step into similarly quiet fashions, except that these have colorings more Anglo than Latin.

MAXFIELD
8825 MELROSE AVENUE
LOS ANGELES
TELEPHONE: (310) 274-8800
FAX: (310) 657-8800
HOURS: 11–7 MON.–SAT.

If Los Angeles is poised to leap into the new millennium, Maxfield will probably already be there to greet it. This avant-garde gallery is a noted pit stop for Hollywood celebrities as well as anyone else who can afford to collect cutting-edge fashion as art. Maxfield's founder, Tommy Perse, and his partner and wife, Anne Marie, couldn't be more respectful of each designer's intention and point of view. Perhaps that is why this austere concrete bunker situated at the quiet end of Melrose Avenue ranks as one of the galaxy's most fascinating *haut*-material destinations.

After parking your vehicle in its manicured, white-lined black macadam stalls and traversing its stone patio guarded by several enormous concrete monkeys in Zen-like poses, you enter this windowless seven-thousand-square-foot monastery. Its quiet intensity whispers that all is focused on the mission at hand—to quickly connect the

LOS ANGELES

ARMANI AT HOME: CASHMERE
CARDIGAN AND SATEEN SHIRT—
ORNATE SIMPLICITY BY THE
SAVANT OF SLOUCH.

serious shopper with the trendiest couture-quality play clothes in as private and as service-sensitive an ambiance as possible.

Loyalists revel in Maxfield's spare, cerebral environs, the peripheries lit by aluminum industrial spots and the dark clothes suspended from steel racks. They come here expecting to find the rare and for twenty-five years they have rarely been disappointed. Tommy and Anne Marie spend six months of every year combing the fashion firmament for the edgiest wrappings around.

Black is the color of continuity here; Tommy pioneered black as the color of choice before anyone. Today he carries the crème de la crème of black wear from the likes of Matsuda, Armani, Yamamoto, Comme des Garçons, Dries Van Noten, and Prada. Though each designer's work is hung together as a collection, they are kept within arm's reach of one another so that customers can easily put together ensembles that capture the mood of the moment. Maxfield has long been dressing the elite members of the fashion-forward entertainment industry such as Quincy Jones, Gregory Hines, Tom Cruise, and the king of Hollywood hip, Jack Nicholson, who come here to be draped as lords of *noir moderne.*

As though he were organizing a presentation for a fine-art gallery, Tommy carefully considers each addition to his collection—such as last fall's four-button black fatigue corduroy slouch jacket or Armani's blackest of Black Label creations—usually with someone special in mind. These are not clothes for the dull of spirit or shallow of pocket; the price tags here can easily convert a quick shopping fix into a major spree. This is a couture patisserie where visitors do not come simply to look but to gorge themselves. For the high-stim epicurean who covets the offbeat and ethereal, Maxfield

has the stuff and the staff to give you a fashion high you'll not soon come down from.

———

FRED SEGAL
8100 MELROSE AVENUE
LOS ANGELES
TELEPHONE: (213) 651-4129
FAX: (213) 651-5238
HOURS: 10–7 MON.–SAT., 12–6 SUN.

Though California may have introduced Levi's miner's pants to the frontier, Fred Segal pioneered denim as fashion and jeans sportswear to the rest of America. Located here since 1960, this smorgasbord of sportswear has long been L.A.'s spot to shop. This emporium of fun and fashion employs 150, occupies thirty thousand square feet of Melrose Avenue real estate, and has a parking lot large enough to accommodate one hundred cars. *L'Uomo Vogue*, Italy's magazine of *haute mode*, just celebrated its owner, Ron Herman, and his twenty-five years at the helm of this famous store.

Pre-washed, sexy jeans were among the primary attractions that lured shoppers to dozens of Saint-Tropez shops during the 1960s. Lothar, Mic Mac, and the Bob Shop were doing things with denim that were undreamed of in the land of its invention. When Ron visited Europe in 1970, he saw it all happening, brought it back to America, and unzipped a whole new segment of leisure wear.

In 1976, Ron bought the business and now Fred Segal is his appreciative landlord. The store's willingness to take risks has certainly paid off as the younger, casual styles they propose continue to sell year in and year out. They showcase designers that other stores display only in a limited manner off in the corner. Prada, Gucci, Zegna, and Armani are all here, but Ron and Co. buy it their way as edgy, item-driven sportswear. Not forgetting their roots, the store still does an enormous jeans business. They sell more Double RL jeans here than any Ralph Lauren store. They also carry athletic, western, French, European, outdoors, and some vintage gear that can be worn in that L.A., in-your-face entertainment-industry style.

Walking into this store is like hopping on a merry-go-round; the excitement and energy are contagious. It always looks different, as they continually move things around. Just down the street from L.A.'s intimidating purveyor of haute celebrity chic, Maxfield, Fred Segal's music and welcome sign chart out different territory and another kind of Zeitgeist. It's obvious the employees here love what they do, since this is probably the coolest place to work for the young in fashion and youthful in spirit. And the fun all starts at the top with an owner who never stops getting a kick out of the new and the now.

JACK TAYLOR
341 NORTH CAMDEN DRIVE
BEVERLY HILLS
TELEPHONE: (310) 274-7276, (213) 272-9909
FAX: (213) 272-9900
HOURS: 9–6 MON.–FRI., 9–5 SAT.

Jack Taylor claims to be one of this country's oldest privately run top-end retail businesses. After having first worked in New York City for such firms as GGG's and Witty Brothers, the proprietor followed Mr. Greeley's advice in 1953 and opened his own shop in L.A. Since then, this seventy-eight-year-old Russian-born custom clothier is still going strong in the land of 90210. Mr. Taylor has more verve than most of his younger competitors. He is also more knowledgeable than any of them, having produced custom clothes for the famous, the affluent, and those aspiring to be both.

Mr. Taylor's tailored clothes are the real McCoy, made by hand in fine fabrics with no expense spared. He refers to his cut as "British-inspired," with narrow shoulders, shaped torso, slant pockets, and deep vents of the hacking-coat variety. However, as this is Hollywood rather than Hyde Park, much of his clothing's aesthetics must appeal to the status-conscious wearer. Its English pedigree is about as far from Savile Row as Beverly Hills is from Baghdad. Here, even the details of tailoring are worn as badges of one's bank balance. Hand stitches jump out at you, fish-mouth-shaped lapels or pocket flaps are enthusiastically rendered, while linings and buttons have enough noise to ensure the wearer's entrance will receive as much notice as his ego.

However, excusing the "glad to grab your attention" dimension that is apparently a required ingredient of the Beverly Hills look, Jack Taylor knows his stuff, which explains why he has managed to survive the rigors of Beverly Hills retail. Calling upon his many years of bespoke experience, Jack imbues his tailored ready-to-wear with perks. He chooses his own suiting fabrics and has them hand-tailored in Italy, which produces the jacket *sans* buttonholes and leaves the trousers uncut. This affords Jack the flexibility to fashion a final product according to the customer's needs and wishes. Should a client want his suit or his pants cut with western-style pockets or a button fly, Mr. Taylor's on-premises tailors can make them up quickly. These ready-made suits, their buttonholes hand-sewn and their trousers custom-fitted, start at $2,400.

A collection of what is probably the Rolls-Royce of sports-coat luxury—the Brioni tailored jacket ($3,000) in Harrison's of Scotland's millionaire cashmere—is stocked here. For those aficionados of old-world luxury, Mr. Taylor offers the original Coxmore vest, the paragon of sweater vests, in cashmere for $750. He has also commissioned one of Italy's fabled tie-makers, Laura Luchini, to hand-sew his own selected silks into self-tipped silk neckties ($110).

Cocooned in old Hollywood glamour—Dior-gray walls with cream trim, marble floors hushed with English rugs, and, recessed into the ceiling, an enormous chandelier given to the proprietor by an appreciative Saudi potentate—Jack Taylor continues as a one-man string quartet in an MTV world. Fortunately, this sartorial contrarian has listeners throughout the globe who know he knows and, for them, his knowledge still matters.

MILAN

An Introduction

With fashion as its leading export, Italy is unique among industrialized nations. Centuries of work for the pleasure of pleasure have generated an Italian fascination with appearance. Throughout the country, questions of style, charm, and elegance are debated with a religious fervor. It is barely a coincidence that Italy's leading businessman, Gianni Agnelli, is also widely regarded as the country's reigning sovereign of style, its own Duke of Windsor.

What Italy has accomplished for its classically oriented male during the past thirty years is a rewriting of the canons of bespoke English dress as originally established by the British aristocracy and perpetuated by the tailors, shirtmakers, and cobblers of London's West End. As the major Italian city closest to London and with its historical penchant for stylish sobriety, Milan offers the sophisticated shopper the most stylish raiments in classic menswear.

Stroll into the original Prada shop, sequestered beneath the palatial grandeur of Milan's turn-of-the-century glass-topped Galleria, and walk down the stairs. You will encounter a Benoit montage celebrating the splendor of Milanese life circa 1925. One side of this extraordinary work depicts a bustling pier crowded with the bedecked and bejeweled as they bid adieu to a departing luxury liner; the other captures a throng of elegant passengers, porters in tow, preparing to board the legendary Orient Express. Benoit's masterpiece is no mere homage to some bygone era. Milan is still a place of great luxury—it is Italy's second largest city and its economic pump—inhabited by so many well-dressed men that it is easy to imagine that everyone, including your taxi driver, might well be in the fashion business. Two interests dominate the town's center: banking and fashion.

Whereas Florence is a vibrant country town and Rome a breathing historical treasure, Milan's architecture, a forlorn victim of World War II carnage, can be rather cold and humorless. An exception

can be found in any one of the city's breathtaking courtyards, a delight that, unfortunately, tourists are rarely afforded. Milan's weather is as gray as its environs and the air frequently carries the hint of impending drizzle. However, this unrelenting drabness is relieved by the Milanese man's unique approach to adornment. Whether his bearing is natural or acquired, he carries it off with such aplomb that it seems a birthright.

Ironically, for a city that has spawned and is home to so many fashion designers, Milan would not be my first choice for the latest Armani or Gigli. Its designer stores carry virtually the same collections that are distributed in other cities around the world. As one of Italy's most well-respected men's designers recently lamented, one is sooner likely to see the latest fruits of Italian textile or fashion creativity in Osaka or Toronto as in conservative Milan. This is a shirt-and-tie town.

Surrounded by such sartorial convention, the Milanese man carries on the disciplines of taste and subtlety handed down from the English Regency's Beau Brummell while stamping it with his own indelible imprint. There is no mistaking the Milanese gentleman in his tweed jacket for either a university professor or a member of the landed gentry. He carries off a regimental tie with no Old Etonian intention taken. Resplendent in a chalk-stripe suit, he does not resemble some chief executive officer in the City of London, and he rarely wears the black shoes considered de rigueur in Downing Street. He sports his quilted riding jacket even when he isn't riding or being pummeled by rain.

This Milanese male understands the power of a well-cut suit of gray worsted. He appreciates the incremental richness afforded by a brown shoe and intuitively senses how brown suede carries him to the next level. The properly tied four-in-hand holds no mysteries for him; no one has to explain its correct relationship to the shirt collar. Bottle green is his navy blue, and no glove cover can dress his hand better than his precisely fitted shirt cuff. He embodies Italy's collective pursuit of the decorous. Anyone wishing to perceive the essence of classic dressing could do worse than visit Milan and study its natives.

MILAN

Al Bazar's name is derived more from its bustling ambiance and eye-catching presentation than its location. Unlike the traditional Middle Eastern bazaars, this classicist's preserve does not lie in close proximity to its city's crossroads of commerce. Highlighted by its green-and-gold awnings, the shop is situated on a tiny neighborhood street behind Italy's most important convention hall in a district that is home to some of Milan's most affluent citizens. You are more likely to find the local cognoscenti making purchases here than any tourists.

The store is a series of rooms that resemble closets overflowing with a farrago of eclectically displayed merchandise. Persian rugs, tossed on top of the English blue, green, and yellow tartan carpets snaking through the establishment, enhance its marketplace air. While Al Bazar projects a more impassioned and colorful mien than Milan's other temples of bottle-green classicism, it stays within the boundaries of refined tradition so appreciated here.

Lino Leluzzi, the store's owner, eschews signature lines in the belief that customers who purchase them will abandon a shop should he drop a particular favorite. His business is built around clothes tailored expressly for the store by Isaia and Sartoria Napoletana, as well as Guy Rover dress shirtings, and Italian handmade neckwear. Cashmere sweaters by Scotland's John Laing are another specialty here with a broad selection of dress shoes from English, American, and Italian makers. Al Bazar offers the traditional with an upbeat tweak of classical standbys, such as a dress shirt with a special spread buttondown collar, or a caramel-hued crocodile belt or yellow slicker rainwear from America's Bostonian. In-store tailors are on hand for last-minute alterations and they can whip up something made-to-measure in less than a month. Such service and dedication have attracted a loyal following. If many of its customers seem to be treated like old friends, it is because that is exactly what they are.

Giorgio Armani
Via Sant' Andrea 9
Milan
Telephone: 760003234
Fax: 760014926
Hours: 10–7:30 Mon.–Sat.

Enter the Temple of Tones. This shop's stoic, simple facade—a rectangle of black steel—is set back from one of Milan's smartest streets. Solitary mannequins, one male and the other female, greet you from each of the store's two cavernous windows. Both are swathed in the designer's latest understatements. Passing between them, you enter the shop through an oval corridor and are ushered into its main room. Here, silk-shaded lamps bathe the cream walls and bleached, grained cabinets in a reverential glow while taupe runners bring a hush to the anthracite-gray wood floors. Nothing bright, nothing ostentatious—not the sort of imperious castle one would expect for the king of modern menswear.

In less than twenty years, Giorgio Armani has so upended the sedate world of menswear that the fit and feel of all male apparel has had to adjust to this new reality. From the orthodox fitting rooms of London's Savile Row to the bedrooms of Hollywood movie stars, getting dressed just has not been the same since Mr. Armani cut the guts out of the tailored jacket. Just as Coco Chanel transformed the woman's suit jacket, Armani has liberated men from their unbending box of a business uniform and introduced a new era of casualness and comfort, a mood that will continue to define fashion well into the next century. His boldness has made him fashion's preeminent visionary, while his clothing's lack of contrivance constitutes the very essence of modern dressing.

Menswear, his first love, has provided the springboard for his international business. This twelve-year-old shop was his first and, being in his backyard, continues to offer his latest thinking on the direction of high fashion. In the brief history of men's designer fashion, Mr. Armani is the only one who has been able to yearly reconfigure the silhouette of his men's business suits and live to tell the tale. In evolving toward his current silhouette of elongated soft-shoulder fash-

MILAN

ions, Mr. Armani has condemned a considerable number of his prior, overly shouldered creations to lives of quiet obsolescence in the closets of his many admirers. Anyone intending to buy something of stylish longevity here must exercise some caution, since much of what makes avant-garde clothes exciting can be transitory. However, his tailored clothes are characteristically refreshing to wear and convert easily from uptown to downtown with the flick of a T-shirt.

Mr. Armani's sportswear is equally provocative and can offer a less intimidating introduction to the not-ready-for-prime-time Armani business slouch. I am particularly impressed by the attention he has recently lavished on some of the hallowed icons of traditional menswear—such as his rubber-soled lace-up buck shoe. Rescaling its shape and offering it in sophisticated slate colorings has transformed this previously outdated vestige of preppy wear into something modern yet enduring. His argyle sweater, an engineered union of the familiar with the brand-new, juxtaposes different textures of muffled shadings that jumble its Scottish origins. The Armani rendition of the ultimate sweater cliché, Dad's shawl-collared, letter cardigan sweater, is equally metamorphosed into the present. In vaporizing its bulk by using a softer yarn and stitch, oversizing its drapey fit while replacing its customary wops of English repp coloring with earth tones, he transforms a conventional design into a garment of contemporary chic.

Beyond the specific realm of clothing design, Mr. Armani has made profound contributions to the very essence of men's style. More than any other designer of our time, he has succeeded in redefining the boundaries of what was previously considered to be less than genuinely masculine attire. His look aspires to a kind of transcendent neutrality, enabling men to feel comfortable in clothes possessing drape and texture, attributes formerly associated more with female style than male. Mr. Armani treats the sacrosanct male suit shoulder like an haute-couturier might, proposing it as the defining social statement—strong and extended for the aggressive eighties, narrow and rounded for the introspective nineties.

But perhaps his most important contribution to twentieth-century male fashion, particularly its American incarnation, is his success at marketing subtlety on a mass scale. No other men's fashion concept has ever been sold in such large volume without being obvious in its design,

fit, color, or some combination thereof. Today it is Tommy Hilfiger color-block sportswear, Coogi's ornate sweaters, Nicole Miller's themed neckwear; in the eighties it was Hugo Boss's airplane-shouldered clothes and Alex Julian's multi-Colours sportswear; and in the seventies, Nik-Nik printed sport shirts and the Cardin hourglass silhouette elicited instant recognition.

That the king of modern menswear is responsible for men wearing clothing so understated in color and unadorned in design is one of modern male fashion's greatest ironies. Mr. Armani, perhaps without intention, has effectively decelerated the erosion of style and taste in menswear not only in high fashion's more rarefied firmaments but in its traditional grounds as well. For that alone, he is to be lauded and followed carefully.

BALLINI-STIVALERIA SAVOIA
VIA VINCENZO MONTI 44
MILAN
TELEPHONE: 463424
FAX: 33104406
HOURS: 9–12:30, 3–7 MON.–FRI.; 9–12:30 SAT.

It looks and smells like a tack room, and well it should. Ballini is Milan's prime purveyor of saddles, boots, and other polo paraphernalia. It is to polo what Brigatti is to golf. Founded in 1870 and located in this cosmopolitan setting since 1973, the shop is somewhat off the beaten bridle path.

Arturo Ballini, who is nearly seventy, owns this storied establishment. He sees that its shelves are stocked with the finest in German and English riding equipment. Since any respectable polo player's regalia would be incomplete without the proper belt, there are some unusually stylish examples here. For a

TEN-GOAL WAISTBAND DECORUM: YELLOW OR RED WEBBING TRIMMED IN ALLIGATOR FOR THE BREECHES OF ITALY'S POLO GENTRY.

MILAN

more rugged look, Ballini carries a hand-tooled plated-leather woven belt with a brass buckle ($60). Members of the blazer set can have their sartorial appetites sated with a solid red or yellow-webbed sport belt trimmed in dark-brown alligator.

Despite the attention lavished on a splendid array of equestrian accessories, this store's specialty remains its custom-made shoes ($1,000) and riding boots ($1,800) which take forty days to create. Backstage, behind the shoe display, is a profusion of boot and shoe lasts.

Ballini's clubby decor is a masculine harmony of dark wood and antique rugs gracing marble floors. A portrait of founding shoemaker Giuseppe Ballini, surrounded by an arrangement of bits and stirrups, looks out on his establishment from a wall of faded turquoise. This shrine to the store's venerated past is not without its touch of the au courant: a picture of Sylvester Stallone wearing his Ballini boots. His presence here is not incongruous. Mr. Stallone is part of a polo-playing tradition that stretches back to the days of Spencer Tracy and Gary Cooper. His inclusion in a place of honor—the film star's picture hangs just below Mr. Ballini's—demonstrates that the sport of kings is still the sport of latter-day Hollywood royalty.

M. BARDELLI
CORSO MAGENTA 13
MILAN
TELEPHONE: 86450734
FAX: 8053442
HOURS: 3–7:30 MON., 10–7:30 TUES.–SAT.

Bardelli is considered by most traditional retailers to be the finest menswear store in Italy. As such it serves as perpetual host to the world's upscale shopkeepers from Tokyo to Toronto. This store is an upper-crust stronghold where the conservative Milanese businessman can shop in familiar comfort for his newest gray suit. This is a honed, disciplined presentation with everything in its place and a place for everything these gentlemen might need to wear. Bardelli manages to offer its discriminating clientele the sartorial refuge of a Brooks Brothers while still titillating their cultivated taste buds.

MILAN

Bardelli started as a hat business during the nineteenth century. It has stood at this location, in an ancient neighborhood left over from Roman times, for the last fifty-one years and is definitely not on the tourist trail. When hats became unfashionable in the 1950s, Bardelli augmented its stock with ties and accessories. The arrival of Gianco Bardelli, the hatter's grandson, brought even greater innovation. Creative and curious, Gianco made a revolutionary contribution to Italian retailing when he moved the merchandise out of its cabinets and onto the floor so customers could actually touch it. This monumental act ushered in a new era in Milanese shopkeeping. It also earned his competitors' scorn. They sniffed that it was foolish to put clothing out where it could get soiled. Bardelli countered that he intended to sell the goods before they became soiled.

The store is laid out as a series of small, impeccably furnished rooms. On the ground floor, you will find English-style neckwear, beautiful hosiery, and gloves, as well as other accoutrements. A winding marble staircase leads the visitor up to a floor composed of room after room of conservative men's clothing of unequaled quality, unequaled refinement, and unequaled depth.

Displayed amidst a sea of dark green trim and gray flannel carpeting is a selection of the world's finest footwear, including such celebrated names as America's Alden and England's Edward Green. There are two separate rooms devoted to the store's private-label Druhmor knitwear in cashmere, lamb's wool, and shetland, and another room stacked high with alternative knitwear as well as an ample assemblage of urban casual wear. Ralph Lauren's sportswear was introduced to Italy here by Bardelli.

Most of the store's clothing—crafted from the finest worsted mills of Italy's Biella and England's Huddersfield—is made exclusively for the store. At any given time, there are four to five hundred three-button, side-vented suits tailored by Kiton and Brioni ($1,000–$1,700), as well as eight to nine hundred jackets ($500–$1,000). Bardelli is famous for its Venetian cloth suit whose reddish hue on the inside is visible, since it is made unlined (as is much of Italy's more sophisticated business clothing). From the hand-stitching of the open seams on its interior to the hand-finishing of the pocket welts on the outside, these garments eloquently demonstrate why Italy holds a monopoly on artisan-crafted, factory-produced tailored clothing.

MILAN

Starting in the 1950s, Milan began tinkering with the established canons of male elegance as practiced by the English aristocracy. Although many of those somewhat fossilized precepts still function as points of reference, the Milanese man's dressing style is a by-product of a broader vocabulary. Bardelli has always been one of the ancient tongue's most intelligent renovators, and, as such, continues to attract those men committed to expounding upon the masculine tradition within the boundaries of classical taste.

BIFFI

CORSO GENOVA 6

MILAN

TELEPHONE: 58111182

HOURS: 9:30–1, 3–7:30 MON.–SAT.

Biffi is Milan's only high-quality multilabel fashion store for men. While Milan provides a showcase for its country's top designer flagship stores such as Armani, Ferre, Versace, et al., most of the city's other emporiums of sophisticated swank are private-label affairs like Bardelli or Red and Blue. Biffi, like Browns of London or Charivari of New York, offers its collection as an amalgam of individual pieces from the world's most sophisticated designers, supplemented by items carried under its own label.

Biffi's current stable of designers includes England's Paul Smith, Belgium's Dries Van Noten, America's Donna Karan, and Italy's Romeo Gigli. Their knitwear is created for them by John Smedley of England.

Originally a woman's shop, Biffi was founded twenty-five years ago by two Milanese ladies named Rosy and Adele. They began carrying the important designer collections for women and added menswear ten years ago. This is urbanized fashion, displayed on eccentrically shaped glass tables, hung on gracile pipe racks, and in metal-trimmed black wood cases on wheels that whoosh noiselessly across the moss-colored flooring.

Sleek and stark, Biffi's moderne facade and high-tech interior provide a provocative backdrop for clothing that can be uptown or downtown. It is a must stop for those who want to glimpse fashion

through the eyes of an insider. Although all Italians consider their midday repast as obligatory as their morning cappuccino, Biffi forgoes this custom during Milan's fashion weeks, when it keeps its doors open for those fashionites desperate for an in-between-shows shopping fix.

BRIGATTI
Corso Venezia 15
Milan
Telephone: 76005552, 76000273
Fax: 780766
Hours: 3–7:30 Mon.; 10–1:30, 3–7:30 Tues.–Sat.

When was the last time you walked into a sporting goods store and were received by women dressed in navy pleated skirts, cashmere twin sets, Hermès-style scarves, and penny loafers? Only in Milan could such an environment not only exist but prosper. Dimly lit, paneled in dark wood, scented with leather and mothballs, Brigatti is a high-class pro shop that would convince the most skeptical of Milan's other-worldliness when it comes to matters of adornment. Even in their most athletic moments, aesthetics is not far from the Milanese soul.

Brigatti is a sartorial paradox, a mixture of Abercrombie & Fitch, Manhattan's formerly august sporting goods store, and Zabar's, that same city's uproarious emporium for gourmands. Towering cabinets already laden with merchandise have even more piled on top of them; a ladder is required to reach much of the wares. Golf is a specialty here, so there are authentic saddle-leather golf bags, wood head covers, contraptions for retrieving balls from water, English golf umbrellas, portable golf chairs, and putters galore. Those wishing to test that new club prior to purchase may retire to a special room with a net strung across it.

Other aspects of the sporting life are not ignored. There are separate rooms devoted to cross-country, fencing, basketball, rugby, tennis, and so on. The fishing and hunting department carries a vast collection of Barbour outerwear. More important, it has assembled authentically designed country outerwear in all its indigenous shadings of green from the sporting pockets of the Continent and England. The fishing trousers, walking coats, hunting coats, and all the Tyrolean

MILAN

hats and badges, feathers and medals—items usually found in an out-of-town rather than a downtown sporting store—are here.

These elements conspire to create the milieu of an extended Italian country club circa 1884. Brigatti offers an unhurried air and gracious service not unlike that found at the country estates many of its clientele repair to on weekends. It is a unique, century-old institution, a four-story cavalcade of gadgets and gear, as far from the world of Nike Town as Milan is from Chicago.

A. Caraceni
Via Fatebenefratelli 16
Milan
Telephone: 6551972
Fax: 29003374
Hours: 9–12:30, 3–7 Mon.–Fri.

Many of today's best-dressed men work in the European tailored clothing business. Even though they might sell textiles or finished clothes under various labels, their personal tastes can only be satisfied by the best. Michel Barnes, Luciano Barbera, and Sergio Loro Piana are men of exceptional personal style and, as such, share a passion for tailored clothing of the highest caliber. They also share a tailor: Mario Caraceni, nephew of the legendary Roman tailor and creator of the Italian soft suit, Domenico Caraceni. Although Mario, who began working here for his father in 1946, is not a tailor by training, his partner, Mario Pozzi, is. Together since 1967, they have turned out some of Italy's most beautiful examples of postwar tailoring art.

In the years following World War I, as Savile Row's famed Scholte, tailor to the Duke of Windsor, was inventing his London drape cut, Domenico Caraceni was working toward a similar objective in Rome: a less stiff, less imperious, more comfortable fit of clothes. The family craft has traveled well.

This soft-shouldered, soft-chested suit, whose feel Mario Caraceni likens to that of a fine linen handkerchief, represents tailoring of the first rank. All its seams, buttonholes, and belt loops are hand-sewn, as are the corners of its pockets, which are framed in tight semicircles of silk hand stitches so minuscule they are nearly invisible. Such partic-

ular finishing of the pocket corners is expected at this level of tailoring, just as handmade buttonholes are a hallmark of the custom-made Italian dress shirt. The Caraceni signature sleeve lining is a green-and-brown stripe on an ivory background. The house button is made of vegetable corozo in a shape particular to this store. Suits ($2,600) and jackets ($1,850) take two months and three fittings.

The shop resides in an office building. Its appearance is closer to that of a gracious salon than its well-worn forerunner in Rome. The deep-red carpets, high ceilings, Hepplewhite chairs, doorways framed in marble, and walls of white and peach have welcomed the most contentious of celebrities. What is produced here is spun from the vision of Rome's Signor Caraceni. Its pedigree is evident in the coat's expression and its same little boat-shaped breast pocket. This craft reflects its progenitor's standards. Nothing has changed; Domenico would approve.

With his death in 1940, a battle ensued. Various relatives immediately opened shops, each seeking to prove his right to carry on the great Caraceni tradition. Today the Milan phone book lists three tailors under the name Caraceni, including one claiming to be "the real Caraceni." However, Mario's shop is the clear choice of the cognoscenti. After visiting this establishment, the seemingly overwhelming problem of your delayed plane or the inopportune timing of that upcoming meeting in Munich mysteriously diminishes in significance, yielding to a more pressing priority—the date of your next fitting.

10 CORSO COMO
CORSO COMO 10
MILAN
TELEPHONE: 654831/2/3
HOURS: 3–7:30 MON.; 10–30–7:30 TUES.–SAT., TILL 9 WED.

When Romeo Gigli abandoned this curious space next to a garage, his former partner Carla Sozzani (sister of the editor-in-chief of Italian *Vogue*) made it her own. It can be entered from the street only through a driveway leading into a courtyard that it used to share with a Renault repair shop. Unexpected, outrageous, definitely un-Milan, this tony bazaar would seem more at home in New York's SoHo or

MILAN

London's Covent Garden. Connected to the pulse of Milan's "down-town" fashion world with its surrounding discos, restaurants, and bars, it is a place to see and experience.

Presentations by different artists and designers—e.g., house-wares, glassware, a bookstore, a button sewer—are incongruously jux-taposed with the former mechanic's world next door. This is high fashion in a performance art setting. Mobiles and curtain partitions dangle from lofty ceilings and a riot of goods are wittily displayed on snaky rods, straight pipes, S-shaped tables, cartoonish chairs, and any other available surface.

Poke around and you forage out work from new designers still unknown to all but a select few. Hip shoppers come here for simple, clean, inexpensive sportswear that is neither contrived nor precious. Eclectic and sophisticated, 10 Corso Como allows you to tap into an ever evolving thought process of design school fashion that is always moving forward and, occasionally, back. Pants are about $100, shirts $60 to $150. Antistatus, anticommercial, antimainstream, the shop's label captures it all: NO NAME.

DORIANI
VIA SANT' ANDREA 2
MILAN
TELEPHONE: 76008012
FAX: 760022627
HOURS: 3–7:30 MON., 10–7:30 TUES.–SAT.

Dark Persian area rugs, bottle-green carpets, rich satin-striped sofas, green-striped wallpaper, and lampshades striped in burgundy and hunter green help Doriani lend new dimension to the Milanese penchant for understatement. The store is a study in disciplined, reined-in taste. They will assemble a rich challis tie with a tweed jacket and similarly hued tattersall shirt, then highlight its subtlety in one of their windows with portraiture-like splendor.

Doriani is owned by the Sassi family, who at one time operated twenty-four stores throughout Italy. After their flagship store had resided in Corso Vittorio Galleria for twenty years, they moved it to one of Milan's most prestigious retail corners in the heart of the Golden Rectangle.

MILAN

Only a notch under the quality of Milan's trio con brio—Bardelli, Neglia, and Tincati—Doriani's merchandise is made exclusively for the store. Much of it is noteworthy. Their own square-toe shoes ($350) are some of the best-looking Italian-made brown shoes I know of.

The salespeople are purveyors of the Agnelli school of eclectic nonchalance. Watches are worn over shirt cuffs; button-down collars, though worn with neckties, are left undone; and jacket sleeve cuffs are left unbuttoned to intimate their tailor-made origins. Recently I saw a Lacoste-style knit shirt made with a button-down collar, which I can only surmise was created so that it could be worn just as Gianni Agnelli wears his Brooks Brothers oxford button-downs—unbuttoned. After trying to fully absorb this flaunting of the conspicuously inconspicuous, I usually retire to the Confretteria Cova next door to consider all this strenuous restraint over one of Milan's more delectable snacks.

ETRO
VIA MONTENAPOLEONE 5
MILAN
TELEPHONE: 76005049, 76022176
HOURS: 3–7 MON., 10–7 TUES.–SAT.

It has been nearly ten years since the Etro printed paisley canvas-and-leather bag first attracted the fashion world's notice. As the international traveler replaced his more recognizable Vuitton or Gucci bags with Etro's madder-colored signature design, this firm's reputation as a resource for stylish English-inspired merchandise spread.

Etro had its beginnings as a print house. Recently it expanded into manufacturing its own collection of finished merchandise and opened a series of glamorous emporiums on Europe's most prestigious shopping streets to house it all. As with their version of the paisley motif, which England's venerated silk printer David Evans popularized into a British icon, Etro is a transplanted melodrama of Anglophilia. The store appears to be an Italian homage to Ralph Lauren's Rhinelander mansion, cleaned up and polished to within an inch of its life.

MILAN

There is nothing quite like traversing the ground level's magnificently crafted parquet wood floor and ascending the exquisite staircase leading up to the men's floor with its mahogany banister, antique green-and-tan runner, and steps hand-polished to a high luster. Light fixtures from a British jewelry shop illuminate another room. In other areas on the floor, ties and various items are displayed around ornate silver cups on wide wood tables. More cups decorate the bookshelves, while framed photos stand on tables and mannequins pose in military regalia.

Among the proffered wearables rarely found in print design are shetland sweaters, castle-cozy paisley slippers ($120), and quilted wool challis riding jackets, similar to the English Husky, turned out with corduroy collars ($550). Like the aforementioned luggage, these clothes are part of the store's signature. Traditional unprinted items—clearly English in inspiration but unmistakably Italian in taste and color—include suits, sports jackets, ties, and shoes.

Etro exists in a dignified time warp. One is never certain if its ambiance is intended to recall the illustrious heritage of upper-class English life or simply represent the wishful thinking of one more Italian searching for the Harris tweed grail. Either way, its substantial taste enhances the world of Italian luxury.

DITTA GUENZATI
VIA MERCANTI 21
MILAN
TELEPHONE: 86460423
HOURS: 3:15–7:30 MON., 9:15–7:30 TUES.–SAT.

Though Italian male elegance, as manufactured and practiced in Italy, may have conquered the world, it has always displayed a certain innate deference to British style. Continuing this tradition, Ditta Guenzati stands proud and plaid. Established in 1700, the oldest store in Milan is everywhere resplendent in tartan, from its robes to its rugs. If they don't have it, it's not an authentic Scottish tartan. There are tartan vests, trousers, capes, ties, and fabrics ($35 a yard) rolled out on ancient wood tables. From these can be made jackets, school kilts,

or your wife's pleated skirt. Some of its other wares that break up the monotony of so much plaid include solid shetland sweaters, argyle hose, and paisley ties.

Imbued with character, the shop is owned by two gentlemen who purchased it in 1968. If the Scottish tartan, as an icon of English taste, survives, it is because—as Andy Warhol's pop celebration of the Campbell's soup can proved—the repetition of a single subject or concept can elevate its mundane character into a higher form of art.

LIBRERIA DI VIA DELLA SPIGA
VIA DELLA SPIGA 30
MILAN
TELEPHONE: 794222
HOURS: 3–7 MON., 10–7 TUES.–SAT.

This functionally decorated five-year-old store, owned by the publisher Garzanti, sits on Milan's most charming shopping street, the Via della Spiga. Here you will find a reasonable selection of illustrated books on Hollywood style-setters (among them Noel Coward, Cole Porter, and the incomparable Fred Astaire), hotels, interior design, travel, fashion art, and advertising. But I find its chief attraction to be its intriguing collection of fashion books—many printed in English—including a select group of limited editions from the United Kingdom that scarcely ever make their way to the States. For anyone interested in fine books about aesthetics and style, this store is a valuable resource.

G. LORENZI
VIA MONTENAPOLEONE AND VIA PIETRO
MILAN
TELEPHONE: 76022848
FAX: 76003390
HOURS: 3–7:30 MON.; 9–12:30, 3–7:30 TUES.–SAT.

Situated in the midst of the Montenapoleone shopping mecca, G. Lorenzi should place high on the itinerary of any international traveler. The shop first opened as a scissors and knife sharpener in 1929.

MILAN

On the wall of the store's tiny alcoved entrance is a bronze sculpture depicting a little man honing a knife. It serves as a reminder of the establishment's roots. From this humble origin, three generations of Lorenzis have gone on to build a business known the world over for its masterful products.

Cutlery is still the thing here, and its quality is unmatched anywhere. The varied, prestigious assortment of knives, razors, scissors, and other cutting instruments is augmented by a vast selection of unusual gadgetry. They will still sharpen and repair the articles sold here, from a trivial adjustment to a pocket razor blade, to helping one choose a collectible handmade knife.

The store's philosophy can be gleaned from its decor. The simple granite floors, nutwood cabinets with velvet-lined drawers, and oak displays speak of a dedication to harnessing natural materials and transforming them into something useful as well as beautiful. Its gadgets, knives, scissors, smoking implements, and other items combine elegant form with function. G. Lorenzi carries only those products made by craftsmen capable of working in special mediums such as chrome, brass, horn, and nickel. Anything of inferior quality would seem frivolous next to the deer horn brushes, silver flasks, buffalo horn knives, or marble-handled manicure kits. Even the Lorenzi business card is rendered in aluminum.

Among its more unusual but handy items is a plastic plug adapter designed to fit every conceivable outlet in the world. Finding a socket for your laptop during that next trip to Madagascar will no longer be a daunting chore. The seasoned itinerant will have a field day choosing from among an impressive array of travel Water Piks, jewelry cases, and smoking accoutrements in exotic woods and stones. And for the man who is not above a little pam-

GENTLEMAN'S CHROME TALCUM
POWDER DISPENSER.

PLUGGED-IN TRAVEL: THIS LEATHER-
CASED ELECTRICAL DEVICE CONVERTS
INTO A MULTITUDE OF PLUGS TO ENSURE
THE FLOW OF ELECTRICITY FROM ANY
COUNTRY'S OUTLETS.

pering, Lorenzi offers a specially shaped chrome container that
makes the dispensing of one's morning talcum powder another act of
stylish decorum.

———

MESSINA
VIA A. VOLTA 5
MILAN
TELEPHONE: 29002505
HOURS: CALL BEFORE YOU GO

The single faded antelope-colored cap-toe in the window says it all:
No frills, just the genuine article. Gaetano Messina, a former boxer and
a Sicilian shoemaker's son, is one of the last of a generation that
custom-cobbles shoes for the Italian nobleman. Yet, even after twenty-
one years here, his shop is still so little-known that it claims barely a
handful of clients outside of Italy.

Inside its lilliputian showroom, shoes and leathers are displayed
in an easy jumble. The house style is a squared-off toe—very
Milanese, very elegant and rather like the bespoke shoes of English
master George Cleverley when he was creating his magic at the leg-

MILAN

MILANESE CUSTOM BENCHMADES.

endary Tuczeks in London during the 1950s.

Since the little maestro speaks scant English, it is advisable to have in tow someone fluent in the native tongue. Everything is made on the premises. Eight months is required for the client's last to be created and, after that has been approved, another month to make the shoes. Additional pairs take only a month or so depending on the time of the year. Messina and his one assistant spend forty-five hours producing a single pair, for which he charges a reasonable $1,300. His customers often bring him their shoes to clean and polish and he transports them back in his homemade leather satchel like some journeyman cobbler of a previous century.

NEGLIA
CORSO VENEZIA 2
MILAN
TELEPHONE: 795231, 798187
HOURS: 9:30–1:30, 3–7:30 MON.–SAT.

Neglia is one of Milan's three high-quality suit-and-tie stores, a reputation it shares with Tincati and Bardelli. The store opened thirty years ago and carries the world's most respected brands: private-label Kiton and Brioni suits, Thurston suspenders, Briggs umbrellas, W. & H. Gidden luggage, Burberry coats, Polo sportswear, and the most comprehensive Brooks Brothers presentation in Milan. Its austere host, Neglia Vincenzo, is the son of the original owner, who was a tailor.

With great reserve, Neglia blends English ingredients with Northern Italian taste, marrying charcoal-gray worsteds with something bottle green. Downstairs, Neglia boasts the finest presentation of

MILAN

European footwear in Milan, a large sampling of Church, thirty-two styles of Edward Green ($475–$575), and an extensive collection of J. P. Tod's, maker of the brown suede sports shoe so favored by the Italian cognoscenti. Sportswear, suits, and topcoats can also be found downstairs. Ties, shirts, and furnishings are on the street floor; all of these are presented in a setting arranged with care and precision. Hanging lamps, ceiling spots, and brass fixtures placed directly atop the displays bathe the cream walls, blond-wood cases, and floors of marble and parquet with their reflective glow. As a result, the clothing and shoes are clearly illuminated without the usual shadows that attend indoor displays.

This is not a fashion store. Neglia is about disciplined classics assembled with new touches each year. If you can get to the Montenapoleone area only once, you will want to visit what is Milan's downtown equivalent to New York City's Paul Stuart.

RED AND BLUE
VIA MONTENAPOLEONE 8
MILAN
TELEPHONE: 76023392
HOURS: 3–7:30 MON.; 9:30–12:30, 3–7:30 TUES.–SAT.

This venerable little shop was established to sell the products manufactured by the Fedeli family—makers of Italy's finest classically styled knitwear. Originally, Grandfather Fedeli produced hats in a factory in Monza, but with the diminishing appeal of headwear it evolved into a knitwear manufacturer in 1934. Its elegant offspring, Red and Blue, became the quintessential haberdasher for the Milanese aristocracy. The shop derives its name from a color combination of

THE PRINCE OF THE RIVIERA: THE DUKE TOOK TO PAIRING HIS NAUTICAL TEES WITH LINEN SHORTS AND ESPADRILLES.

MILAN

regal lineage popularized by the peripatetic Duke of Windsor when he first sported his guard's two-color repp stripe tie while traveling abroad. The red symbolized the blood shed by those valiant soldiers who guarded crown and country; the blue was a tribute to royalty's blue-blooded lineage.

When it was founded in 1946, the family correctly sensed that Via Montenapoleone would become Milan's "via" of luxe. Their merchandise has helped set the standards of quality and taste for which this thoroughfare is so renowned. Entering this shop is like lifting the lid to a velvet-lined jewel case. Its splendor is accentuated by exquisite black-and-white marble floors refracting the light from its crystal chandeliers and mahogany paneling. Every drawer holds yet another exemplar of upper-crust Milanese taste.

Signor Mazzucchelli, the former manager who knew everyone and everything, is now retired. He's been succeeded by his protégé, Vittorio Vamoni, whose taste can be discerned in the exquisite design and placement of his initials on his meticulously trim, custom-made dress shirt. Unfortunately, Grandfather Fedeli recently passed away, or he would still be found welcoming customers and old friends alike.

Red and Blue carries the largest variety of colored socks in Milan: cotton lisle ($24) in sixty colors throughout the year—among them purple, pink, turquoise, red, and four distinct blues—as well as silk, wool, and cashmere hosiery in a broad range, and the most sophisticated selection of gloves. There are beautiful cashmere cardigans and shirts, linen polo shirts, silk pajamas, cashmere robes in twelve colors ($1,000) and classy silk scarves, neckwear, and pocket squares.

Periodically, its elegant old-world windows are aglow with hosiery, neckwear, printed silk scarves, shirtings, robes, and other wearables in its namesake's color scheme or other two-color tableau. Where else but in Europe could you see the staging of such lavishness accomplished with the simple combining of only two colors? Where else but in Italy's best-dressed city would such refinement be so expected?

Romeo Gigli
Corso Venezia 11
Milan
Telephone: 76000271
Hours: 3-7:30 Mon., 10-7:30 Tues.-Sat.

This is the home of one of Italy's most important menswear designers. Romeo Gigli's thoughtful, consistent point of view—one that couldn't be more thoroughly his own—commands the worldwide respect of his peers while expanding Italy's fashion lexicon for today's modernist.

His clothing reveals an innate sense of tailoring. Never bold, the shape—with its soft, sloping shoulders and straight lines with narrow-legged trousers—is often described as modern Brooks Brothers. It is the fabrics, such as seersucker velvet or washed tweed, that are untraditional and sensual. Gigli is carried around the globe in the most sophisticated fashion stores, yet nowhere is he exhibited as dramatically as here, the shop he designed.

Attached to a landmark building, the entrance (formerly a fruit stand!) is an independent structure of glass and bottle green decorated in an ever-changing motif that might feature arcane childlike scribblings, abstract depictions of flowers or Gigli's latest designs. With walls offering a panorama of hand-rubbed hues, the inner decor is vibrant and exciting. Steps of orange stone cut a pathway up through three floors, the topmost of which is for menswear. Merchandise is propped on pillows, hung on poles suspended from the ceiling, and tossed on Moroccan leather ottomans in shades that lend to the impression of a Byzantine bazaar gone metropolitan. The poles are high-tech, the lighting by the famed Fontana, and everywhere lurks a hint of Philippe Starck. It's an eclectic arrangement with a purpose: to give the viewer pause, make him work, and ultimately engage him.

Gigli has developed a following of fashionable, knowing men who appreciate the simplicity of Armani or the deconstructivist tailoring of Belgium's Dries Van Noten but refuse to be dressed head-to-toe by any one of them. There is a traditional reference and a decided irreverence to all his designs; a Gigli "classic" is not for any conventional businessman I know. Like some fine aperitifs, this is an acquired taste.

MILAN

Italian clothes tend to be more lavish than their function requires. No article of clothing elicits the Milanese obsession with quality and detail more than the skin-touching dress shirt. The set of the collar, the narrowness of the side seams, the positioning of the hand-embroidered initials, the button shape and placement, the fit of the cuff—there is so much to consider, so much that can go awry. Fortunately, Siniscalchi has long been tending to the Milanese passion for precision. The knowing dresser can't help but appreciate the way the sleeve is meticulously attached with tiny pleats in the cuff, the shoulders set in by hand, and each shirttail bearing the date when it was made.

The shop was started in 1948 by Vittorio Siniscalchi and is now under the direction of his son Alessandro, thirty-one, who speaks fluent English. Situated on the Via Gesù for fourteen years, it was ousted by the construction of the Four Seasons Hotel. In 1989, it moved to the third floor of this office building on the periphery of Milan's "golden rectangle." The decor, like the shirts, is elegant, spare, and lustrous. It's furnished in a Biedermeierish color scheme with black lacquer columns, fruitwood tables, highly polished floors, and a lot of glass. The stacks of two-ply shirtings from top Italian mills offset the room's starkness with their patterned luster.

At $275, the shirts are fairly priced, considering the cost includes a number of extras that you would be charged for elsewhere: an extra set of cuffs and surplus fabric to construct an extra collar, rather than an extra finished collar, which is useless if your neck size changes. The Siniscalchi shirt also offers a wide range of handmade monograms from simple initials to a coat of arms.

After the first measurements are taken, the first fitting is made in a toile, which precedes the finished sample shirt. Once the sample is approved, finished shirts appear in three weeks. Although they make any fit at the client's request, the genius of Italian shirtmaking is found in the garment's body-tracing lines with no excess fabric

MILAN

anywhere—from across the wearer's chest to the darts used to remove any excess fabric from the concave portion of the back. The armhole is fitted high under the arm and placed in by hand, leaving no visible stitching on the back yoke where it meets the shoulder's seam. Buttons are specially stitched so they do not appear mechanically attached.

All the crafting is done on the premises, which you will appreciate if you are awakened one night by the horrific thought that you forgot to remind them to leave enough room for your dress watch. You can rush to the shop in the morning, where you will no doubt be assured that your request had already been anticipated and seen to.

TELERIE SPADARI
VIA SPADARI 13
MILAN
TELEPHONE: 86460908
HOURS: 3–7:30 MON., 10–7 TUES.–SAT.

Cattaneo Giuseppina's shop doesn't dazzle the eye unless you are searching for Europe's finest shirting fabrics for a made-to-measure dress shirt. With over seven thousand meters of men's shirtings stacked floor to ceiling and strewn across large wood presentation tables, its warehouse ambiance becomes part of its charm.

Founded in 1946, the shop is a veritable festival of fabrics. They stock fifty different shades of solid blue and many fancies that will probably never be seen in today's ready-made shirt. Everywhere are royal oxfords, sea island cottons, and high-count cloths from the top Italian mills such as Testa, SIC/TESS, and Oltolina.

What's unique about this place is that walk-in customers get to see parts of the upcoming season's better shirting collections, a treat usually reserved only for those in the business. When this shop becomes better known, I have no doubt it will be visited by manufacturers who will buy its shirting lengths and send them to the Far East to have the fabric made up for half the price.

Located diagonally across from the seventeenth-century Gothic duomo, the shop is a reminiscence of the days when men took the time

MILAN

to select their fabrics and carry them in hand to their tailors or shirt-makers. Here in Milan, men still consider such expenditure of time a tradition worth preserving.

TINCATI
PIAZZA OBERDAN 2 OR VIA PIETRO VERI 1
MILAN
TELEPHONE: 76004924 OR 29409154
FAX: 76004928
HOURS: 3–7 MON., 10–7:30 TUES.–SAT.

As any student of Milanese male style knows, three shops—Tincati, Bardelli, and Neglia—comprise this city's university of higher sartorial learning. Unlike Milan's other two "colleges," Tincati's curriculum on the complexion and spirit of male adornment is less grounded

in the verities of the English prescript. This school enlivens mannered dressing as only Italy can.

No store better instructs its students on how autumn's understated blaze of colors—olives, mustards, rusts, ochres, and greens—can be tastefully reflected in a business ensemble. Tincati's windows are always resplendent with clothes combining colors so rich and unexpected, it boggles the mind how many novel ways they can accessorize the simplest blazer.

The firm's local alumni prefer Piazza Oberdan, its humble, original campus cum old-world Milanese tailor shop, to the newer, more polished outpost in the Monte-napoleone area. The Tincati house style is a soft-shoulder silhouette handmade for them

THE VERBIAGE OF PERMANENT
NECKWEAR FASHION:
SHEPPARD'S CHECKS, BARRISTER
STRIPES, AND POLKA-DOT
FOULARDS.

by Brioni, Kiton, or St. Andrews in some of Italy's and England's nattiest cloths. While this store has evolved its own cut of clothes, its fit aspires to the pliancy of the Savile Row tailor Anderson & Sheppard, anonymously pictured in its brochure.

MILAN

Tincati carries the classiest neotraditional neckwear anywhere, especially if you are a devotee of the Macclesfield–repp stripe taste so evocative of the Astaire era. Each tie comes with an elongated keeper. Its rear blade can be tucked through it and into the top of your trouser, leaving room for the front blade to swing horizontally in step with the movement of the torso. This seemingly minute yet deliberate stylistic gesture deftly illustrates the Italian facility for reworking an English concept of formality into something idiosyncratically stylish.

As the Tincati house cut ensures an ongoing proposal of elegance for all its wearers, the customer's attention is free to focus on what happens underneath and within its lines. Buying clothes becomes a seasonal exercise in enriching and refining within a given structure, forcing the wearer's expression of taste upward rather than outward into the hinterlands of temporal fashion. The Agnellis, Windsors, Coopers, and other paragons of male elegance always established the one silhouette that was most flattering to their physique and then built a dressing style from within it. On a good day, Tincati offers more educated treatises on this rare masculine art than any other store in Italy and perhaps all of Europe.

GIANNI VERSACE
11 VIA MONTENAPOLEONE
MILAN
TELEPHONE: 76008528/9
FAX: 76008647
HOURS: 3–7:30 MON., 10–7:30 TUES.–SAT.

Entering a Versace store always reminds me of my first encounter with New York City's Continental Baths in the late 1960s. I was immediately catapulted into a world unto its own, a den of the beguiling and the forbidden.

The typical—and that word has never been used more loosely—Versace setting is a palatial hothouse whose climes nourish all that is high tech, high gloss, and highly seductive. Mr. Versace's clothes are designed to demand attention, whether it be from women, men, or both.

This store is a monument to the designer's unique take on the objective of dress. There is nothing old-world about it. Its sleek, reflec-

MILAN

tive materials are the expressive tools for only the most modern of industrial architects. They contribute to a hard-edged orgy of grays from anthracite through coal, with stone floors and faux-snakeskin-covered metal chairs, all lent an air of the baroque by an army of marble male torsos scattered throughout the revelry.

Underneath all the glitter is undeniable substance. Amid gold lamé vests and pink leopard-printed sports jackets, one discovers items of couture quality and luxury. Versace's neo-Pucci silk sport shirt is practically a collectible, provided you can afford the $1,500 required to slide into it. As outrageous a price as that appears, as much silk is discarded in producing the shirt as is seen in the finished product. The shirt is constructed and engineered to present its large-scale printed design in perfect symmetry. Versace will make cashmere sweaters "too sexy for your body" by knitting in sinuously curved cables. I've also come across printed jeans, à la Lilly Pulitzer of the American fifties, that were really wonderful. Worn with a linen knit T-shirt and Gucci loafers, they are perfect slumming wear for the veranda of the Splendido at Capri, or at South Beach.

Versace clothes are not for the demure. They are brash, self-aware, and arrive bearing messages. They are also beautifully constructed in expensive fabrics that are sensuously shaped to hug, caress, and entice. This is the world of ornament as body covering, where surfaces are employed as instruments of allure. It is clothing in which to pursue or be pursued.

ERMENEGILDO ZEGNA
VIA PIETRO VERRI 3
MILAN
TELEPHONE: 795521, 795522
HOURS: 3–7 MON., 9:30–7 TUES.–SAT.; OPEN FOR LUNCH

Juxtaposed against the bustling shoppers' paradise that is the Via Montenapoleone, Zegna's first retail store shares a gray marble forum with Tincati. Behind its impressive glass facade looms a spare albeit dramatic interior. Floors of granite and wood parquet, a paneled stair-

case of gray stone steps, and a suspended mezzanine heighten an effect that would draw the envy of any Broadway set designer.

The well-respected Zegna family had long been known for its high-quality textiles; their introduction of ready-made apparel was part of their natural evolution. In the seventies, their suits were worn in the United States by men who were attracted to the square-shouldered, fitted silhouette popularized by Italian men. Today, the Zegnas are the custodians of the mountain in Biella where they manu-facture most of their textiles. It was here that they pioneered a high-performance fabric made from specially twisted yarns that minimizes the wrinkles from traveling (a process that was soon emulated by the other Biella mills). The actual clothing is made in family-owned facto-ries in Italy, Switzerland, and Spain.

As the stores proliferate throughout Europe and on Fifth Avenue, Zegna has become the world's fastest-growing designer business, gaining ever greater prominence as the on-the-go businessman becomes aware of its modern international style. The Zegna suit is available under two labels. The Sartoria ($1,200) is the more classic cut, though it has more attitude than either the Tincati or Bardelli suit. Zegna Soft ($700–$800) is more fashionable and made from less tra-ditional fabrics. Introduced several years ago, it was directed to the younger customer who is attracted to Armani fashions but wants something better tailored. Its rounder, broader shoulder creates a V effect from shoulder to waist—but if the fashion silhouette is long and tubular, you'll find that here as well.

Filling another void, their recently expanded sportswear collec-tion offers a sophisticated European style for men comfortable with their maturity and not obsessed with looking like something they are not. Their knitwear and sportswear have started to win the attention of those who want something a bit more classically European in spirit and quality than America's Tommy Hilfger or the Gap.

In his quest for fine, high-quality clothes with a hint of swank, the international businessman increasingly looks to Zegna. Neither cutting-edge like Armani nor conservative like America's Oxxford, Zegna represents a handsome middle ground. Theirs is modern clothing a man can wear with comfort in any boardroom, whether it be in Bangkok or Bahrain.

MONTREAL

AN INTRODUCTION

Montreal, after Paris, is the largest French-speaking city in the world. Although reputed to be more open to fashion and other sybaritic pleasures than Toronto, today Montreal's fashion point of view could neither be termed French nor fixed.

During the early seventies, when glamour, industry, and the English moved west to Toronto, the merchants who replaced them were Sephardic Jews, establishing themselves as this city's leading retail force. More impassioned than the English shopkeepers, they have encouraged Montreal to celebrate its colorful Mediterranean connection. But most of the retailers build upon trade from the outside, because most Montrealers don't, as a habit, dress like Continentals.

Montreal is an island located at the gateway to the continent in the Saint Lawrence River. It comprises little streets, many neighborhoods, much charm, and the tall mountain smack in its middle which gave it its name. Formerly Mont Réal when explorer Jacques Cartier climbed and christened it in 1541, today it is Mont Royal.

The city's language, culture, and politics continue to be dominated by the Franco-Anglo question. In the 1970s, Quebec language laws decreed that more French appear on signs and in schools. But English is still very much spoken, and this is a bilingual metropolis. The French inhabit the city's eastern side while the English hold court on its western flank, with the affluent living on opposite sides of Mont Royal, in Outremont and Westmount. Other languages are heard: Italians make up Montreal's largest ethnic community; there is a Chinatown, a large Jewish community so saltily immortalized by novelist Mordecai Richler, and areas established by the Greeks, Portuguese, Jamaicans, and Haitians. Cosmopolitan as the city is, it has no "downtown" area—although there is an exuberant underground world, linked by the Metro, that keeps Montreal's notorious winters at bay.

And then comes the sun, and lighter threads. Montrealers, and visitors to the city, need clothing for all seasons. Herewith, some suggestions on where to find them.

CORNEMUSE
1061 RUE LAURIER OUEST
MONTREAL
TELEPHONE: (514) 270-7701
HOURS: 9:30–6 MON.–FRI., 9:30–5 SAT.

Situated in the French Outremont district, which is somewhat reminiscent of a quaint Connecticut town, this neighborhood men's and women's boutique carries gifts and a few classics of international fare. The shop is eight years old, an offshoot of the Vaugeois family's older store in Quebec City. Thrust between gourmet shops, Cornemuse is fun to visit on a Saturday afternoon. It's a fine place to pick up sporty outerwear such as English Barbour fishing coats made of oilskin ($200–$400), Geiger's Austrian Tyrolean jackets made of boiled wool ($275–$550), and authentic Norwegian sweaters ($150–$225).

HENRY MARKS
1448 DRUMMOND STREET
MONTREAL
TELEPHONE: (514) 842-9801
HOURS: 9–6 MON.; 9–8 THURS., FRI.;
9–5 TUES., WED., SAT.

This is a store patronized by the Canadian who comes home, unhooks his garters, and puts on his plaid flannel robe and slippers—all of which are available here. This third-generation store claims to have changed little from the days prior to the English evacuation. It's Montreal's last vestige of conservative Anglo-American attire, however, without the authenticity of London's Savile Row or the flourish of New York City's Madison Avenue.

Glen Nobes's family bought the business from the Marks estate in the thirties. For forty years it resided in a well-known Montreal

MONTREAL

hotel before moving here in 1985. It's the only store in the world I've come across that still carries English suspenders (the British term for garters), which are intended to hold up their Pantarella English sock under the Coppley Apparel group's Cambridge clothing suit trousers. They also carry canvas-front, soft-shouldered clothes by Canada's Samuelsohn, and high-quality underwear from Europe by Hathaway's Eminence.

Henry Marks is a well-respected, old-world men's store established because it appealed to the English people who dominated Montreal life. Replete with cream carpets and wood tables, it remains a handsome refuge for today's most northern traditionalists.

RUSSELL'S
2175 RUE DE LA MONTAGNE
MONTREAL
TELEPHONE: (514) 844-8874
HOURS: 8-5 MON.-FRI., 8-3 SAT.

As a lone custom tailor, Russell Goldberg's career has elicited more publicity than most well-known high-fashion designers. This is not only because he is a most congenial promoter of his own work, but because he has tailored the province's corporate and political elite. His distinguished clientele ranges from Alexander Haig to Brian Mulroney, the former prime minister of Canada. On one wall there is a photograph of the prime minister with President Clinton, bearing the inscription, "I've recommended you to the President." Russell also travels, like the English Savile Row tailors, to show new fabric swatches and reassure clients in Ottawa, Toronto, New York, and Connecticut. When he's out of town his very proper associate, Roger Giroux, sees to your every wish.

What's special about Russell's is that he makes to order both dress shirts and tailored clothing right on the premises. Only then can he have complete control over the timing and quality of his finished product. His shop is set up like few others in North America. Twenty people work on the premises, so that in a matter of days a visitor could have a first fitting for a suit and dress shirt that will pretty much guar-

antee the intended result. Such immediate accommodations, in addition to making his trousers on site, are unusual. Only a few European tailors are able to do the same. Suits run $1,495 to $2,000; custom shirts are $150; a cashmere sports jacket is $2,000; and ties are $75 to $125. Russell's house style is an English-oriented cut. This well-groomed look is understated yet commanding.

Russell's occupies a limestone town house. Ascend its carpeted outside stairs, open its door, pass through a small, oak-paneled anteroom, turn right, and you are surrounded by fabrics, antiques, black lacquer tables, and Mr. Goldberg's impressive desk with its black alligator accoutrements. The chairs are covered in faux leopard; the black rugs are striped with red and tan. Russell's is a club. As such, its stewards will make dinner reservations or obtain theater tickets for you. This is old-world service delivered with old-world charm and élan.

2949-9035 Co.

3526 RUE SAINT-LAURENT

MONTREAL

TELEPHONE: (514) 849-9759

HOURS: 10–6 MON.–WED., 10–9 THURS.–FRI.,

10–5 SAT., 1–5 SUN.

This is Montreal's only "downtown" shop, not in the sense of its location but its fashion. Named for its charter number, it was started two years ago by Sandrina Bucci, who sells her collection to other stores in Canada. She carries hip sportswear—A.K.A. Gap—in dark colors. The decor is modern and deconstructivist, making a wood-and-concrete-and-aluminum backdrop for such unfussy clothes as jeans, oversize sweaters, Harvey Rothschild English knitwear ($100–$185), rugby-style tops ($75–$125), Palladium shoes ($120–$300), and other apparel of simple design. The only flourish comes from the classical music that infuses the high-tech air.

MONTREAL

MONTREAL

L'UOMO
1452 RUE PEEL
MONTREAL
TELEPHONE: (514) 844-1008
FAX: (514) 843-5527
HOURS: 9–6 MON.–WED., 9–9 THURS.–FRI.,
9–5 SAT.; OPEN SUNDAYS IN DECEMBER 11–5

L'Uomo is undoubtedly the single finest men's store in Canada, ranking among the top ten in North America. Its owners, Albert Cohen and Paul Teboul, are from Morocco and are passionate about fashion and quality. They insisted that Kiton, the great Neapolitan tailor, supply them with seven-fold ties, and Borelli, one of Italy's top shirt-makers, make them dress shirts under the Kiton name with special hand-sewn collars. Like the Blues Brothers, they're on a mission from above—except in their case, the mission is to convert the ill-clad. They believe in "service, service, service," and run L'Uomo like a private club that they open to the public.

SEVEN-FOLD ART: THE ULTIMATE IN
NECKWEAR CRAFT—A TIE MADE
ENTIRELY FROM SILK.

And the public comes, mostly from out of town, like Toronto, Vancouver, and the United States. The place is more hard-edge than lush, more Cardin of the seventies than Lauren of the nineties: A Euro-cold emporium done in grayish hues and black poles, with a huge marble bust that is used in catalogs and promotions to illustrate the store's manly image to such customers as Mick Jagger, Michael Jackson, Eric Clapton, Sugar Ray Leonard, Jean-Paul Belmondo, and Pierre Trudeau.

Having worked in the wholesale business, Albert and Paul saw a void in the market for an exclusive men's store. "Montreal had a lot of European haute couture boutiques catering to women but none for men," says the mustachioed Teboul. "And it had always been my dream to open a men's shop." It was not easy at first. The audience they had to attract comprised mostly "local businessmen whose idea of high fashion was a navy suit, black tie, and white shirt." What was worse, those local businessmen couldn't even pronounce their name. (Although that quickly changed. Today, there are at least seven stores in the area with "Uomo" on their awnings.)

They paved the way for Ermenegildo Zegna, Nino Cerruti, Gianni Versace, Giorgio Armani, and Valentino—all of whom can be seen smiling down from the walls, their signed blow-ups paying tributes to "the boys" for initiating them to the wilds of North America. They have also introduced Romeo Gigli, Claude Montana, Jean-Paul Gaultier, and Thierry Mugler, and are Kiton's exclusive Canadian account. John Lobb shoes are here, too, as well as Charvet shirts, Loro Piana silk-and-cashmere robes, and neckwear of the very best sort.

Today, L'Uomo is all its owners ever wanted it to be. "There is no question," Teboul crows, "we are *the* fashion establishment of European haute couture for men in Montreal."

NEW YORK CITY

AN INTRODUCTION

New York City offers more opportunities to view fashion in the making than any other city in the world. Whereas the advanced sartorial thinking of other metropolises is primarily displayed within their stores, Manhattan's is hung out daily, swirling to and fro in perpetual motion from its citizens' highly purposed pace. Whether it is the manicured swank of the Upper East Side, the regulation black of Avenue A, or the downscale affluence of Chelsea, it's all here in full view. As the world's foremost global village—with each neighborhood providing its own indigenous dress code—New York's dawn to after-dark street life is a parade of archetypes so diverse and original that its kaleidoscopic effect feeds on and then transmutes itself each day.

Reflecting the city's openly egalitarian culture, many come to this town to court importance, to create a place for themselves among the cultural and corporate elite. While trying to find their niche, newcomers often undergo a personal reinvention which is allowed to play itself out under the considerable anonymity afforded by this city's velocity and vastness. And part of this evolution usually entails an exploration of alternative dressing styles.

Much of what is shown seasonally on the New York runways is a freeze-frame of its citizens' experimental and eccentric dress, bubbled up from some scene acted out in any one of the city's innumerable mosh pits of activity. In addition to the show on its streets, even in this city's most mundane places, such as its public transport venues, examples of evolving style abound. On any given day, a Gotham bus or subway car can play host to such an unlikely assemblage of highly costumed males that you often wonder if you have not stepped into the middle of some Woody Allen casting call. Any typical rush-hour morning can find you sitting across from some homeboy-styled private school prince slouched next to a black-booted, tattooed crew-cut man in conversation with a boomer in Upper East Side pinstripes and

chesterfield. All three are doing their best to ignore the muffled noise emanating from the earphoned bicycle messenger resplendent in high-tech Day-Glo road warrior gear. It is this sartorial goulash and its random brilliance of personal expression that sets Gotham City apart from the rest.

New York City is still headquarters for prep togs, esoteric status footwear, and American-style sportswear from urban casual, athletic, or rugged country to downtown hip. You can still pay your respects down at 346 Madison and glimpse what remains of the chromosomal button-down contingent. With the shuttering of Tripler and Chipp and the sterilization of old J. Press, midtown's original gray flannel street looks a bit forlorn. Upscale prep has limousined itself up to Ralph Lauren at Seventy-second Street, while its less orthodox fashion off-shoots have scattered themselves in shops as dissimilar as lower Fifth Avenue's C.P. Company, Chelsea's Camouflage, the city's conglomeration of Gap and Banana Republic.

Achieving an internationally topical demeanor is still the rule of thumb at the city's most prestigious safeholds of upscale commerce with Saks, Barneys, Bergdorf Goodman, Sulka, and Paul Stuart all within a few traffic lights of each other. For alternative shodding of insider chic, one can choose from among Belgian Shoes, Diego Della Valle, J. M. Weston, Billy Martin's, Paul Stuart's Edward Green, and Ralph Lauren. Sporting goods from Scandinavian and Paragon represent the best assemblage of high -quality athletic wear and equipment to be found in any one city.

New York cannot match Paris's price-is-no-object luxury of wares; its polyglot society could never produce Milan's homogeneously honed sense of refinement; nor can it boast London's centuries-old network of bespoke artisans. What sets it apart from all other cities is the creative energies of its locals spilling out onto its streets. Within its bustle and freedom, a state of mind develops inviting the curious to join those already in pursuit of their own fashion persona.

NEW YORK CITY

NEW YORK CITY

BARNEYS NEW YORK
MADISON AVENUE AND 61ST STREET
NEW YORK
TELEPHONE: (212) 826-8900
HOURS: 10-8 MON.-FRI., 10-7 SAT., 12-6 SUN.

Barneys is this country's finest multistore specialty retailer for men. The first floor of its new $100 million Madison Avenue emporium houses the most complete assemblage of high-class haberdashery ever compiled in one setting. From hats to hosiery, gloves to slippers, no store does it any better. With its gallery-height ceilings, handsome plaid-carpeted floors, and a spaciousness reminiscent of a more gracious era, the room has quickly established itself as a venue for those international traditionalists in pursuit of classic design with consummate quality—and a selection that is vintage Barneys.

They can garnish all your limbs and then some. Starting at the top is headwear, imported from just the right places and makers: Lock's, Christy's, Borsalino, Worth & Worth, and, for summer, fifteen straw models made by hand or machine. Dressing the hand in order to stylishly doff these *chapeaux* are their hand-sewn gloves from suede to peccary, silk to cashmere-lined. Barneys' patterned hosiery is among the city's most interesting and comprehensive. Most neckwear aficionados acknowledge their neckwear presentation to be the most highbrow culling in the city. Among the designer labels is America's Garrick Anderson, a specialist in thirties-inspired upper-class taste whose cravats attract the most discerning of the town's bon vivants.

COSSETINGS FIT FOR A KING: LORO PIANA'S CASHMERE SLIPPERS TO MASSAGE AND GARNISH THE LESS ATTRACTIVE OUTPOSTS OF A MAN'S ANATOMY.

Barneys' private-label sportswear on the main floor is particularly well chosen, especially if you require such apparel on the mature and elegant side. Their sea island knits are "Allen Solly" worldly as are their sweaters and linen sport shirts. Their footwear represents a giant leap forward from what was available during the store's exclusively downtown tenure. There are

always some special models of bench-made or newly proportioned, updated classics to behold.

The store upstairs is also far from typical. Any merchant that cajoled Oxxford Clothiers, maker of the world's finest and formerly dullest tailored clothing (under new ownership, Oxxford is about to raise the taste of its appearance to the level of its unparalleled workmanship), into adopting more adventurous fabrics deserves everyone's respect. A visit here requires a shopper to maintain his focus lest he become overwhelmed with choices: historically Barneys' greatest strength and inherent weakness. The clothing floor presents a greater variety of shoulders, fabrics, silhouettes, and grades of tailoring than can be found in any other single store. And having pioneered the likes of Giorgio Armani and Europe's and Japan's avant-garde, as well as having been the first to house Donna Karan's downtown chic, the store is laden with high fashion edited with the sophistication of the industry's most knowledgeable eyes.

And how they are presented! Of course, their windows have always been acclaimed as provocative, eye-catching affairs, but other than Louis in Boston or Paul Stuart in New York, no other men's store lavishes more time, attention, and thought on dressing their displays. The store's arrangements do a real justice to its designer labels as well as its own private offerings. Even if you cannot afford what you see, just browsing can offer an invaluable education to anyone interested in the art of wearing clothes.

Barneys' fortunes are guided by the Pressman family, one of the last dynasties of American retailing. In today's highly competitive specialty retailing, the important players attempt to forge exclusive relationships with designers and manufacturers to create into special items and collections under the store's own label. Patriarch Fred Pressman has been doing that longer and more skillfully than anyone else in the menswear trade. "Retailing," he says, "is products and merchandise, not merchandising by ledger books, but from the feel of fabric and instinct." Sons Gene, Barneys' fashion visionary, and Robert, its financial expert, were the architects of the business's repositioning, which has culminated in the Madison Avenue store.

Building the largest new store in New York City since the Depression while trying to purvey citified Manhattan fashion to

selected corners of the country represents one of the largest gambles in the history of American tastemaking. With this expansion, the Pressmans are betting nothing less than Barneys' entire future that it can appeal to the currently sublimated instincts of taste particular to the country's richer, worldlier set, a level of style, they feel, that has nowhere to unearth itself in American malls or department stores.

The international community attracted to Barneys' downtown artsy and modern vision is delighted to see so much fashion assembled under one roof in the center of this metropolis. However, whether there are enough men with the desire and capital to embrace such cosmopolitan sophistication will be one of the industry's most-watched developments. This is one of the few retailers that profoundly appreciate the difference between good and bad taste. For that reason alone, if Barneys prospers, America's collective taste level will be the beneficiary.

BELGIAN SHOES
60 EAST 57TH STREET
NEW YORK
TELEPHONE: (212) 755-7372
FAX: (212) 755-7627
HOURS: 9:30–4 MON.–FRI.

While Henri Bendel was signing the final documents transferring the ownership of his famous Fifty-seventh Street emporium to its new owners, he overheard them remark that since Americans did not appreciate or understand quality, they would knock off much of their merchandise in Hong Kong and make a fortune. After accepting their check, Henri—who believed this country would always have a market for goods of superior workmanship—called his wife and declared they were going to open another shop.

Now in his mid-eighties, Henri Bendel lives on Sutton Place and visits the second of his retail shops for at least a few hours every day. He has always done things his own way. When the original Bendel's moved from Ninth Street and Fifth Avenue to Fifty-seventh Street during the 1930s, it was one of this crosstown artery's few

retail stores. In opening his new enterprise conceptualized around a single design, Mr. Bendel again contradicted conventional retail wisdom.

First made of felt and canvas and worn as a slipper by the Belgian peasantry, Mr. Bendel's Belgian shoe is carried only in his store and is produced exclusively by his partner in Bruges, the Flemish section of Flanders. The shop keeps in stock forty thousand pairs in various colors and models, selling about thirty thousand of them each year. Such a delicate handmade slipper is not made for hiking, but there is nothing more comfortable to wear inside or outside the house. They encourage customers to first wear the shoe and then send it back so the store can put a thin rubber protective layer over the leather sole for outdoor wear.

Despite the slipper's humble beginnings, Henri Bendel's rendition was aimed at the upper stratum of society. Initially embraced by the rich girls of the Foxcroft crowd, it became a fixture of the Lilly Pulitzer–Lacoste clique, broadening out beyond the social register, the latest copy of which just happens to sit on the table as you enter the shop. Today, many cosmopolitan men choose their black velvet evening slipper to finish their Donna Karan or Armani-style crepe tuxedos. If you can abide the wait, which can run up to a year, their faux-leopard slipper has no peer in esoteric, casual elegance. But for those who can't wait, their simple black, brown, or navy suede slipper can grace an outfit in monotone cachet with the same idiosyncratic style as monogrammed velvet custom-made slippers. They retail from $225 to $300.

THE CONSUMMATE CASUAL FOR THE ARROGANTLY STYLISH.

Like Gucci's Fifth Avenue shop, which in busier times used to close for lunch from 12 to 1 P.M., this store is no hostage to commerce either, shuttering itself on Saturdays and closing promptly at 4:00 P.M during the week. Although the cult following of this shoe is growing, it's still one of Manhattan's better-kept secrets. Only in this megamarket of style could such a fashion prosper while retaining so much insider status.

NEW YORK CITY

This legendary institution was founded in 1901, when Edwin Goodman and master tailor Herman Bergdorf forged an alliance to create stylish clothing for distinguished women. In 1928, the flourishing business moved into its present location in what was then a newly constructed building on the former site of the Cornelius Vanderbilt mansion. Overlooking Central Park and the renowned Pulitzer Fountain on Grand Army Plaza, the store was designed and decorated to resemble the homes of its affluent patrons.

Bergdorf Goodman Men moved out of the Fifty-seventh Street side of the predominantly women's fashion store in 1990 and reopened as a separate shop directly across the street. Touting itself as "the ultimate store for gentlemen," the men's store was conceived to cater to those knowing, well-traveled dressers who were accustomed to the best hotels, restaurants, and resorts. Employing its sister establishment's original credo of cosseting its upscale customers in familiar trappings, Bergdorf Goodman Men is a sumptuously appointed mix of shop and club. With vaulted ceilings, two-story rotunda, and gray cloth walls, the ambiance is posh yet tempered. Greeters, after first welcoming you at either entrance, will accompany you through the store if such is your need. The store's scale, neither overwhelming nor claustrophobic, allows easy access to its elegant merchandise presentations.

Anchored by the English haberdasher Turnbull and Asser and the French *chemisier* Charvet, the alcoved main floor features its very classy private-label neckwear, the dress shirtings of Borelli, and the classic sportswear knits of makers such as England's John Smedley and Italy's Malo Tricot. Accompanying all these high-end wearables is Bergdorf's own private-label stock of better-quality dress shirtings, furnishings, and sportswear.

The second floor reflects the store's overall sartorial predisposition toward the classically tuned approach—those who tread that fine

line between fashion and tradition. Here are suitings from the likes of Kiton, Brioni, St. Andrews, Oxxford, and Hickey-Freeman as well as the city's most complete presentation of Italy's classiest classicist, Luciano Barbera.

Upstairs on the third level is a marble-floored boulevard of international designers, presented in separate, carpeted shops. From Giorgio Armani's Black Label and Ferre Couture to Gucci, Prada, and Hollywood's Richard Tyler, the lineup changes with the vicissitudes of fashion. There is also a To Boot shoe boutique and the 745 Cafe which is the closest a Manhattanite can come to lunching in a Westchester country club without boarding Metro North.

Bergdorf Men is one of New York's most tasteful settings for the man wishing to select business clothes from a cross section of the world's leading labels. Their in-house tailoring has always reflected the parent store's early heritage and the staff is courteous and knowledgeable. Housed in one of the world's preeminent retail locations, this monument to privilege would have made founding father Herman Bergdorf very proud.

BILLY MARTIN'S WESTERN CLASSICS
812 MADISON AVENUE
NEW YORK
TELEPHONE: (212) 861-3100
HOURS: 10–7 MON.–FRI., 10:30–6 SAT., 12–5 SUN.

This roundup of cowboy luxury was founded by the late Billy Martin, baseball legend and former New York Yankees manager. Outposted here since 1978 and later joined by the likes of Giorgio Armani and Gianni Versace, Billy Martin's is one of the reasons upper Madison Avenue has become the Faubourg-Saint-Honoré of New York City. With Martin's death in 1993, the shop was bought by his agent, Doug Newton, who keeps Billy's spirit alive by stocking the kind of sophisticated cowboy classics loved by the gunslinging second baseman and his often celebrated clientele such as Bruce Willis, Eric Clapton, Arnold Schwarzenegger, Bruce Springsteen, the Taylors Liz and James, and Alec Baldwin. The top hands as well as the tenderfooted have

NEW YORK CITY

NEW YORK CITY

flocked to this store in such vast numbers, it was expanded in 1993 to nearly three times its original size.

At Billy Martin's, you can't see the walls for the merchandise. You may have to prowl about to uncover that "must have" collectible, but it's an investment of time that will rarely go unrewarded. They have everything here that a true western wear connoisseur could possibly crave. Since most waist ornamentation would look out of place with such hopalong footwear and apparel, the shop features over five hundred museum-quality belt buckles, mostly handmade and one-of-a-kind, in three widths (¾", 1", 1½"). With prices ranging from $195 to $10,000, many of these artworks are fashioned out of sterling silver or gold offset with precious stones and are appropriately exhibited in antique French display cases.

Although they carry a cornucopia of frontier items, boots are their real specialty, from calfskin ($395) to lizard ($595) to alligator ($3,200) and everything in between. If your taste veers toward rarer hides, such as ostrich or hippo skin, saddle up here. These shoddings come in a wide array of designs, all of them commissioned especially by the store from the finest boot makers in Texas. Though you can find the occasional sophisticated yet workmanlike pair that would be just right for a dust-up at the O.K. Corral, most of these boots are evocative enough to appeal to the dude in everyone. Some of their designs border on the audacious, much like the Judie Buie boot of yesteryear. Whatever your taste, the store's attentive staff will assist your hunt for the correct heel or perfect toe and, if your needs require, they can custom-make a pair in four to six weeks.

Carrying on the Martin legacy, this store continues to celebrate the creativity of cowboy-inspired wear. More than mere boots or frontier apparel, these are authentic renditions of folk art enhanced by an infusion of elegance and originality. The vision they represent is often bold and singularly American. This is High Noon on Upper Madison.

Brooks Brothers
346 Madison Avenue
New York
Telephone: (212) 682-8800
Hours: 8–6:30 Mon.–Sat., till 7:30 Thurs.; 2–5 Sun.

In 1977, while researching my first book, I asked the president of Brooks Brothers for permission to interview the firm's longest-employed salesman. When I introduced myself to Mr. Mancini, who by then had given his employer fifty-four years of faithful service, he said quizzically, "Flusser," paused a beat, and then asked, "Are you Will Flusser's son?" Before I could respond that I was his nephew, he brightened and said, "No, you must be Nate's kid." After I demurred that Nate was my other uncle, this exchange, all thirty seconds of it, concluded with the beaming Mr. Mancini declaring, "Of course, you're Marty's child. I should have known." From the University Shop on up, I have been a Brooks habitué for close to forty years. I even have a picture of my father, taken in 1906, sporting the Brooks button-down he wore almost every day of his life until his designer son convinced him to move on to spread-collar shirts.

I don't consider it boasting to state that there is probably no one currently employed by this world-famous institution who is more familiar than I with the merchandise it offered back in its heyday. My earliest visits to Brooks were like those of a divinity student arriving at the altar of Saint Peter's in Rome. Once through its Forty-fourth Street portals, you stood at the birthplace of a vestmental tradition that has become part of Americana. On its cavernous, wood-planked main floor, the oak tables, this sanctuary's pews, were stacked with folded suit coats laid out in neat rows like napkins, a setting that evoked the firm's early days as a dry-goods store down at Catherine and Cherry Streets.

Standing in this venerated domain, imbibing all its possibilities, one was faced with a major decision—which way to turn first. Moving right, toward the Madison Avenue side, brought you face-to-face with a regalia of Brooks perennials, all the stuff Madison Avenue lore was built upon—double-breasted English covert chesterfields with matching fawn velvet collars, yellow tattersall waistcoats, or smoking jackets in navy serge with burgundy trim. To the left, the shoe depart-

NEW YORK CITY

ment beckoned. Once a Brooks aficionado, you could not even consider anyone else's shoes. Their antique-shaped, tobacco-toned, hand-lasted English cap-toe was the ultimate in Brahmin shodding. Brooks's famous hand-sewn tassel loafer in just the correct shade of brown was the benchmark by which you judged all other tasseled slip-ons. Their original, red-soled, true white buck—made where else but England—and, of course, their baby calf opera pump were objets d'art for the well-heeled.

Straight ahead, the hosiery department presented a panorama of ankle decor that had no peer on or off these shores, then or now. One could always find sized Scottish bird's-eye and hand-framed argyle sport socks in cashmerelike color mixes only the land of heather and bagpipes could produce. Come the Christmas season, hand-knitted wool fireplace stockings from Mary of Sweden would arrive in extraordinary cottage-born color combinations such as turquoise with loden green and mustard. For dress, their selection of sized French lisle or wool hand-clocked hose in short, over-the-calf, or garter length stretched on forever.

To most outsiders, Brooks was a stronghold of conservatism and dry style, but to those of the gray-flannel life who frequented country clubs or other Ivy League settings, Brooks was also one of the primary wellsprings for the preps' "king of the hill" party clothes. Around the horn-rimmed set's many private playgrounds, the stylish button-downers would engage in a form of sartorial one-upmanship that brought wild dollops of golf course color or tartan-inspired outrageousness into classic ensembles that made insiders smile while outsiders winced. This blue-blooded, *mano a mano* parlor fray was practiced up and down the Eastern seaboard and at no other place were you more likely to see it rolled out for public consumption than here, at "trad" central.

Brooks had its own dress code: no Windsor knots worn in this establishment. What better place to learn about pattern-on-pattern dressing or how to inject color into an outfit? You couldn't help but notice numerous displays demonstrating how to correctly mate a striped tie with a striped shirt or a tattersall shirt with a herringboned tweed jacket and club tie. It was not aberrational to spot some young prep sporting maize corduroys, blue-striped oxford button-down, repp

tie, tweed jacket, brightly colored socks, and tasseled loafers. Pink and peach oxford button-downs were accessorized in combinations that made the whole look masculine and handsome. Nobody popularized it more than the king of gestural elegance, Mr. Fred Astaire. Watching his on-screen alter ego personalize it by pinning its collar, rolling back the button cuff, or duding it up with a dressy Macclesfield tie and double-breasted chalk-stripe suit, you saw this song-and-dance man single-handedly transform this archetype garment into a legend.

And the clothes weren't the only legends on hand. There were the audacious personalities like English Ernie who, in his Savile Row suits and stiff separate-white-collared Jermyn Street dress shirt, scurried about the place talking like he owned it. For a wide-eyed teenage boy who loved clothes this was tradition come to life, sartorial theater where the admission was free. All you had to do was walk in and pay attention.

However, beginning in the sixties, men's fashion experienced some rather unfriendly, unbuttoned decades leaving Brooks's buttondowners searching for a way to simultaneously protect yet expand their elitist franchise. Much like the Savile Row of post–World War II England, Brooks was unable to reach back into its vast archives of design to capitalize on its rich heritage while moving forward. One of the flagrant examples of the firm's inability to grasp what they had at their fingertips was their so-called fun shirt, so aptly named for its witty amalgam of different stripes or plaids juxtaposed on different parts of a button-down shirt. This concept inspired so many copies that, by 1990, America's Tommy Hilfiger and his French counterpart, Façonnable's Albert Goldberg, had built enormous sportswear businesses based on its very simple yet limitless design applications.

Pressured by the demands of successive owners for growth and profits, the Brooks of 346 Madison Avenue, godfather of American style, will be grandfather of one hundred stores by the end of this century. Their suits are mere shadows of their once unimpeachable canvas-front originals, with 60 percent of them retailing for $400 or less. They no longer carry footwear possessing the same hand-sewn stature as Edward Green. Their opera pumps and white bucks are now extinct. The hosiery—one size fits all and all of it forgettable—is as devoid of any style as that carried by other mass merchandisers. For

NEW YORK CITY

the moment, the original collared button-downs in white and blue still stand watch, as do the pajamas and boxer shorts. The only product carried in the store that has actually improved is their top-of-the-line Golden Fleece suit ($895), now hand-tailored in Brooklyn by Martin Greenfield.

As I walk through those hallowed doorways from the Madison Avenue of the recently departed Tripler, Chipp, and J. Press of old, the sandalwood aroma of old Number 44 arouses pleasant recollections. I greet the floor's last keeper of the flame, veteran salesman Tommy Davis, who like English Ernie wears his suits bespoke from England and his shirts custom-made. When I ask how all is going, he just smiles sadly and says, "You know how it is." I nod back to indicate that, alas, I do indeed.

CAMOUFLAGE
141 EIGHTH AVENUE
NEW YORK
TELEPHONE: (212) 741-9118
HOURS: 12–7 MON.–FRI., 11–6 SAT., 1–5 SUN.

This is a mom-and-pop neighborhood fashion store, mom and pop being Norman Usiak and Gene Chase, the neighborhood being Chelsea, and the fashion being almost anything that evokes a certain kind of American Gestalt. Work wear, Army-Navy wear, clothes from the fifties, western wear, antique clothes, bowling shoes, and Brooks Brothers redux—all of it and more has been thrown together in what has been the defining mosh pit of downtown men's style for almost two decades.

Since 1976 everyone who is or was anyone has popped in to say hello and see what the boys were up to. What they often found was a bohemian, nonfashion, eclectic mix of street savvy and design wear from fatigues to tailored clothing. As fashion provocateurs and purveyors of their own brand of "in" wear, Norman and Gene have always mixed high with low, fashion with antifashion, Jeffrey Banks multicolored sweaters with Pacific Uniform chinos, or a New Republic tweed jacket with Converse sneakers. Camouflage is where you will see a Jhane Barnes jacquard shirt over a hip Hanes-type T-shirt or a

Pendleton shirt combined with a cap from the fifties and Joseph Abboud brushed cotton jeans. Among other things, Norman and Gene pride themselves on championing new American designers and romancing vintage American designs.

Stone-gray with electric fans throughout, this store is like a hip diner whose habitués will travel out of the way just to be tended to by its caring owners. Twenty years of embracing this country's old and new design is a testament to Gene and Norman's courage and persevering support of American fashion. Camouflage has never been mainstream in neighborhood, spirit, or merchandise and that's exactly what makes this avant-garde contrarian so rebelliously attractive.

DAVID CENCI
801 MADISON AVENUE
NEW YORK
TELEPHONE: (212) 628-5910
FAX: (212) 439-1650
HOURS: 10:30–6:30 MON.–SAT., TILL 7:30 THURS.

Started in Rome by David's grandfather as a shirt and pajama shop some seventy years ago, the business now has two more branches, one in Milan and this one in Manhattan. The upper Madison Avenue retreat, which stretches up through three floors, was renovated and expanded in 1992. Warm and woodsy with marble tabletops throughout, it's a handsome example of Italian reserve. Accessories, neckwear, and shoes dominate the first floor. The second is for suits and sports clothes. Overcoats and formal wear are on the third floor.

David Cenci caters to the New Yorker who liked the Zegna suit in its 1970s incarnation, before its shoulders broadened, its fit relaxed, and its trousers became fuller and deeper-pleated. Their Italian-made business suits start at $1,000, go up to $2,300 for cashmere, and come either in double- or single-vent. For the man who likes conservative clothes that fit close to the body and are single-vented—the preference of most older Americans—this is the spot.

The store has a collection of urbane sportswear for the man who wears it for shopping or traveling rather than on the playing field. Their sophisticated outerwear, reflective of a taste seen more in Italy

than here, includes a quilted leather Husky riding jacket ($700) and suede cameraman's vests ($350). You will also find some elegant lisle knitwear in solid or striped round-neck or collared versions starting at $85 as well as selected items from Avoncelli, one of Italy's superb knitwear makers, from $135 to $175.

Since 1982, David Cenci has set out to clothe the forgotten middle-aged man of means who first became enamored of the fitted Italian fashions in the early seventies. As this customer grew older and more well-to-do, his conservative tastes continued to embrace this body-conscious, higher-quality Roman style. With the proliferation of the high-fashion designer business at the top end and the basics of the Gap at the low end, he found it difficult to find such leisure wear. David Cenci is one of the few New York City retailers to target this overlooked niche and service the forgotten man of mature tastes and *bella figura*.

CHARIVARI
18 WEST 57TH STREET
NEW YORK
TELEPHONE: (212) 333-4040
HOURS: 11–7 MON.–FRI., 10–6 SAT., 12–6 SUN.

If New York City is the fashion capital of the world and Charivari is New York City's most avant-garde store, then in the tautology of fashion-speak, Charivari must be the most fashion-forward store in the world. What most retailers regard as frosting, Charivari regularly stocks in more depth and range than any of its competitors. With three of its four stores concentrating on the narrow tier of high-styled menswear, two Coty Awards for innovative merchandising, and twenty-five years as Gotham's *enfant terrible* of specialty retailing, Charivari can justifiably claim that it is no longer on the cutting edge, it is the cutting edge.

Company president Jon Weiser, son of Charivari's founder, Selma Weiser, began working here in 1971 while studying film at New York University. Four years later, his sister Barbara, who had been working full-time for her Ph.D. at Columbia University, joined her

mother and brother. Jon, who started the men's business, shrugs off any notion that the firm set off to be self-consciously audacious by declaring, "We never set out to break any rules because we didn't know there were any rules to break." Beginning in its humble upper Broadway store as a hip Paul Stuart for the bohemian West Side, the business became progressively fashion-driven and designer-labeled.

Charivari has always demonstrated a certain prescience; it pioneered Armani and the Italians as well as the Japanese designers Issey Miyake, Yohji Yamamoto, and Matsuda. The store's French name translated in English means "uproar," and that indeed is what this store can stir with its risk-taking approach to fashion and its independence of thought. While they may share a designer collection with another store, what they buy of the collection is usually more provocative than their larger retail counterparts. Accordingly, Charivari is shopped by international buyers as much for their personal wardrobes as to explore what this cerebral fashion family has on its mind.

Jon believes that, unlike the eighties, there is less happening in high fashion, so he beefed up his mix with his own private-label merchandise, which now comprises 20 to 30 percent of the total business. The first such label, Sans Tambours ni Trompettes (which, loosely translated, means "without fanfare") has captured the spirit of the time perfectly by offering the trendiest minimalist basics at comparably affordable prices. If you are searching for just the right dark brown long-sleeved T-shirt, you are more likely to find it here than anywhere else.

East Coasters are told to look toward the west to find the future; Charivari, as the West Side's resident fashion provocateur, looked east. With the opening of its sleeker, more nineties-refined Charivari Madison on Seventy-eighth Street, the family has inched away from the eighties high-tech decor of their Fifty-seventh Street flagship. A visit there finds Belgian designers such as Dries Van Noten, maker of some of men's fashion's most beautiful modern classics, in current ascendancy.

L.A.'s Maxfield, San Francisco's Wilkes Bashford, and Chicago's Ultimo all share Charivari's fashion-first sensibility and some of the same well-traveled clientele. But New York City, more than any other town, is a polyglot of cultural archetypes bent on the process of reinventing themselves. With its eccentric West Side roots, no store tracks

NEW YORK CITY

NEW YORK CITY

the wanderings of Gotham's street-conscious, fashionable minds better than Charivari.

Charivari has two other New York branches at 1001 Madison Avenue (telephone: 650-0078) and 257 Columbus Avenue (787-7272) which both sell menswear.

CHEO
30 EAST 60TH STREET
NEW YORK
TELEPHONE: (212) 980-9838
HOURS: 10–6 MON.–SAT.

Noel Coward always held that "work was more fun than fun." Cheo Park agrees. He will never be well-to-do or enjoy much leisure time, and will probably continue working until he can no longer hold a needle. But he will have fulfilled a boyhood dream: to have earned a living as the most respected of men's garment makers, a Savile Row tailor.

Though born into a family of tailors, Cheo was encouraged by his father to become an engineer. But the son wanted to emulate his older brothers, provided he did so on his own terms. He had to be taught by the best. The word for suit in Cheo's native Japanese is *sebiro*, a take on Savile Row—and if that was where the craft of tailoring cloth was born and perfected, that was where Cheo wanted to learn his trade. He migrated to London, taking one course at its famous Tailor & Cutter School, and receiving a more extensive education when he apprenticed for three years with a de facto Savile Row tailor.

Upon finishing this internship, he packed up his Japanese work ethic with his newly acquired bespoke skills and came to America to ply his craft. Cheo spent ten years working out of a shop on upper Lexington Avenue before moving to this midtown address in 1990. Entering his understated den of a showroom, one finds a faded Persian rug, worn pine floors, brass lamps, English props in predictable disarray, with a Scottish plaid sports jacket casually draped over a wood form. In a few moments, Cheo, his warm eyes sparkling from behind

tortoiseshell spectacles, emerges from his back workroom to greet his guest. He and two or three helpers make everything on the premises, just like the lads back in the old country. His suits require several fittings, take about six weeks and start at $2,000.

Cheo is an exponent of the soft-drape style of cut favored by the Savile Row tailor Anderson & Sheppard. His version is tailored with knowledgeable and stylish detailing. The clothes are well-made; I know of no other Oriental tailor whose garments so authentically reflect Anglo-American sensibilities.

Two pictures hang on the wall of his showroom. One is of the Duke of Windsor, whose tailor, Scholte, was an early inspiration to Park. The other depicts Cheo as a student in London, wearing a raincoat and beaming with pride. The street sign over his shoulder tells you he is standing on the corner of his beloved Savile Row. He has the look of a man who has followed his heart, and his work reflects this youthful joie de vivre.

C.P. COMPANY
175 FIFTH AVENUE
NEW YORK
TELEPHONE: (212) 260-1990
HOURS: 11–7 MON.–SAT., TILL 8 THURS.; 12–5 SUN.

It's pretty unusual for an Italian fashion company to have its only retail outlet in Manhattan. But then everything about C.P. Company is "off-road." It was founded by designer Massimo Osti as a clothing collection inspired by the Italian male's mythic love of the race car. As he says in his passionate tome devoted to the famous Italian car race the Mille Miglia (Thousand Miles), "A car, like a man's clothes, established his identity, not just his social status. It was a portrait of his taste and style of life." The C.P., in this case, stands for Chester Perry, an Italian cartoon character who races cars.

Housed in the Flatiron Building—a fabulous New York City landmark so named for its resemblance to a turn-of-the-century flatiron—the C.P. Company has restored the entire inside of what had for thirty-five years been home to the Astra Cigar business. Now the inte-

rior is as remarkable as its historic exterior. An Italian architect from Turin converted the space into a "road race through time" with a space-age stainless steel racetrack guardrail on one side opposite a montage of wood arranged to create the impression of an ascending mountainside.

Idling among these race car trappings sit C.P.'s high-tech "trad" fashions. Marrying functionality and aesthetics with casualness and fantasy, the designs use fabrics of the future cut in classic shapes and constructed to take advantage of the cloth's industrial strength. They carry jackets with goggles built into the hood and watch windows built into the sleeve, a jacket favored by some of the Mille Miglia contestants. Their version of the Montgomery coat is a hip duffle coat, oversized and unlined at $425. For warmer temperatures, they make dust coats, jeans, and different tops out of a specially woven linen. The clothes are not inexpensive, but are well made with a selection of France's Paraboot to balance off the whole aerodynamic aesthetic.

Massimo Osti is no longer at the wheel, the company having been bought by the Italian manufacturer GFT and then removed from its corporate aegis by GFT's president, Carlo Rivetti, who now owns it privately. Romeo Gigli does some of the design work, as do other stylists of a similar caliber. However, the concept still reflects its founder's fascination with bodies, both vehicular and textile. Poised at the crossroads of Manhattan's latest fashion district, C.P. Company is the perfect pit stop to get your sportswear retooled and style pumped up.

DIEGO DELLA VALLE
41 EAST 57TH STREET
NEW YORK
TELEPHONE: (212) 644-5945
FAX: (212) 420-8516
HOURS: 10–6 MON.–SAT.

One drizzly day, five years or so ago, I was sauntering down Milan's cobblestone streets, wishing that my custom-made George Cleverley English walking shoes were less inclined to soak through at the mere sight of a rain-splattered street. I recall thinking how wonderful it would be to find footwear that was stylish and water-repellent while

providing bedroom slipper comfort. Assuming that an analogue of such mutually exclusive concepts was unlikely ever to see the light of day unless I created a pair myself, I continued my reverie until I happened upon a shop at the end of the street. In its window was a shoe that resembled an Italian hiking version of the American Clark desert boot circa the fifties—nice toe, dark brown suede, dark rubber sole. I wandered in for a closer look, tried them on and . . . presto! They were so comfortable my Cleverleys have been in repose ever since.

J. P. Tod's shoes, like the green English Husky quilted riding jacket they are often worn with, are now a fixture of every well-dressed Northern Italian man's wardrobe. From September to April, on any given rainy day in Milan, you would think no one owned any other footwear. As to be expected, Gianni Agnelli was one of their earliest enthusiasts. The shoe, handmade of water-resistant shades of medium to dark-brown suede with various soles for different seasons, has a casual sophistication. It feels like a sneaker, yet has the scale of a shoe that was meant to be worn with bulky corduroys or woolly flannels. As with other brown suede shoddings, whatever is worn atop them ends up looking richer and more refined for the pairing.

The J. P. Tod's collection descends from the original Diego Della Valle 133 pebbled driving shoe, which was and still is handcrafted by artisan shoemakers in the Marche region of central Italy. Three generations of cobbling have made this firm one of the world's five largest shoe manufacturers. The demand for these shoes has grown so greatly that each store that carries them—and they are a standby in most of Europe's better specialty stores—do so in limited supply. Fortunately for Americans, the shoe is carried in the States at prices that are often less than those found on the other side of the Atlantic. The collection ranges in price from $175 to $250.

The J. P. Tod's shoe is one example of the sueding of men's footwear in the nineties. Nothing makes a man look more worldly than the correct brown shoe, and if it happens to be dark brown suede, it is an automatic gradation up on the proverbial scale of style. Due to their break with more traditional, shiny-surfaced footwear, suede shoes tend to be misunderstood by men who are unfamiliar with English fashion. In 1924, at the International Polo Matches held in Meadowbrook, Long Island, the Duke of Windsor first introduced the

NEW YORK CITY

brown buckskin shoe to America. Since then it has been the choice of the cognoscenti here and abroad. However, now that the Italians have become converts, leave it to them, in this case Diego Della Valle, to modernize its look and function without sacrificing any of its aesthetic authority or sartorial correctness.

William Fioravanti
45 West 57th Street
New York
Telephone: (212) 355-1540
Hours: 9–6 Mon.–Sat. (Saturday by appointment only)

You don't have to travel to Rome to acquire a fine custom-made fitted suit. This shop on New York's Fifty-seventh Street is as far as you need to go. Since 1951, in a showroom that looks as if it might have been transplanted from the Via Veneto, Bill Fioravanti has been producing superbly tailored suits and overcoats for many of this country's most important financial and corporate executives.

Behind his Italianate showroom, with its gilded baroque furniture, gold tooled-leather walls, and Tiffany-style lamps, twenty-one tailors, five pantmakers, and one vestmaker are hard at work. Such a large staff permits Fioravanti to complete a suit in two weeks, if necessary, although the normal time is three months. However long it takes to create, each suit will be pieced together by hand with linings of pure silk.

As the operator of this country's most successful tailoring operation, Bill Fioravanti is one of the few craftsmen to have grown well-to-do from this labor-intensive, person-to-person business. He started making clothes for those Americans who wanted the slim-lined shouldered Italian look of the 1950s and early 1960s. With only slight modifications, he has continued to make this style of garment right throughout the drapey, deconstructed era of today. This is not a natural-shouldered, casually soft suit for the English worldling. It is closely related to the Romanesque Brioni cut with its uncluttered lines, squarish pitched shoulder, clean chest, suppressed waist, and narrow sleeves. Starting at $3,950, this silhouette demands both attention and deep pockets.

Like those survivors on Savile Row, the Fioravanti house style is not intended for everyone. Bill's success comes from sticking with what he believed in and letting his customers judge the results. These suits have an edge to them that clearly reveals their Southern Italian lineage as well as their custom-tailored quality. For men who continue to favor such body-sculpting, hand-tailored luxury, this is the ultimate in self-appointed power dressing.

ALAN FLUSSER CUSTOM SHOP
SAKS FIFTH AVENUE
NEW YORK
TELEPHONE: (212) 888-7100
HOURS: 10–6:30 MON.–SAT.

Overlooking the scenic splendor of Rockefeller Center's ice-skating rink in winter and pastoral gardens in summer, the Alan Flusser Custom Shop affords shoppers one of the city's most breathtaking views. The blue-domed, tortoiseshell-hued oval room—ensconced on the Fifth Avenue side of Saks's newly refurbished sixth floor—provides an elegant backdrop for Mr. Flusser's custom designs. Beckoning from either side of the shop's entrance are two enormous Swiss PKZ illustrations from the 1920s, each depicting a distinguished gentleman attired in the stylish dress of his era, a suggestion of what can be found inside.

"Since it costs no more to make the clothes right than wrong, we like to think we can steer men in the proper direction," says the firm's frightfully opinionated proprietor, Alan Flusser (you think this is easy!). "We try to teach a man how to wear a navy suit, white shirt, blue-and-white tie, white handkerchief, dark socks, and shoes perfectly, for him. Those are the building blocks, which, as easy as it

HANDROLLED LINEN BREAST POCKET RIGGING FOR THE SARTORIAL LITERATI.

NEW YORK CITY

sounds, few men can do well. After that it's off to the races." (Boy, does this guy love to talk!)

Alan Flusser has been studying how to dress well since childhood, when he would watch his father dress up in his Fred Astaire best. After thirty years of having his own clothes custom-made, three books on menswear, a few awards, his own ready-to-wear business, and ten years in the custom business, Mr. Flusser feels qualified to pontificate on his favorite subject. And since his successful custom tailoring for Michael Douglas's Oscar-winning portrayal of Gordon Gekko in the film *Wall Street*, many have come to study with him.

The Flusser house style starts with a slightly sloped yet tailored soft shoulder, discretionary waist suppression, and a comfortable but closely fit hip, either vented on the side or not at all. The trouser is cut to be worn on the natural waist and pleated full enough so that the transition from the jacket bottom to the trouser thigh proceeds smoothly down to its tapered cuffed bottom. From its basted try-on derived from each customer's individualized paper pattern to its hand-sewn buttonholes—made by the only tailor Frank Sinatra would permit to do his when he patronized Dunhill tailors—the Flusser suit is scrutinized more by the knowing staff than by their patrons. Prices begin at $1,495 and average $1,895; suits take six to eight weeks for completion.

While most tailors primarily depend on swatch books to present the majority of their selections, things are a bit different here. Each season, special designs are created in limited quantity exclusively for the shop. In addition to these, Mr. Flusser's frequent visits to the leading European mills enables him to offer clothes handmade from fabrics as divergent as a modern Armani-like high-twist crepe worsted cloth to a thirties-style hand-loomed shetland sports-coating. From heat-resistant reverse-twist English frescos and Italy's silklike 150s worsted for spring to worsted cashmere suitings for fall, Mr. Flusser has on hand more unusual cloths than any other custom tailor in the world.

Complementing the tailored clothes are the shop's own true custom, rather than made-to-measure, dress shirts. With high-count, narrow width, two-ply cottons from Europe's finest mills and shirt collars designed for each individual's face instead of some everyman's fashion, these single-needle affairs cost $275 and take ten days for the

sample shirt and another three weeks to finish. The ready-to-wear shirts are made from custom fabrics with hand-cut cotton-lined collars, single-needle construction, and pearl buttons. Ranging in price from $135 to $175, they represent one of the city's best values in luxury dress, and there is always the odd horizontally striped shirt to satisfy even the most ardent Anglophile. The shop stocks French linen and silk foulard hand-rolled pocket squares, patterned French wool, cotton or silk dress hosiery and specially designed, hand-finished English braces. The four-in-hand collection is refreshing not only because it includes some seven-fold neckties, but because its old/new, London/Milan dressiness separates itself from most of the city's top-drawer neck decor.

And to tickle the fancy of those world-class shoppers who feel they either own or have seen just about everything the universe of fastidious luxury has to offer, the shop always has on hand a few surprise items: handmade sueded cotton khakis, unlined zephyr-weight cashmere travel coats, reversible forty-ounce madder silk hand-fringed scarves, crepe linen Corbusier jackets, or three-piece, hand-crafted crocodile dress belts with covered buckle and specially cast brass side joiners. With Fred, Ella, Bing, and Tony warming up the room, the Alan Flusser Custom Shop aspires to function as a sartorial refuge, where men seeking permanent aesthetic solutions as a basis for their own dressing styles can do so in privacy and comfort, free from commercial pressure and the bias of off-the-rack fashion.

H. HERZFELD
507 MADISON AVENUE
NEW YORK
TELEPHONE: (212) 753-6756
HOURS: 9-6 MON.-SAT.

Most American and European small furnishings shops began as purveyors of Anglo taste for the upper-crust male. Ever since Madison Avenue's Tripler became a casualty of the eighties' leveraged retail wars and the Blocks of Dunhill Tailors retired, H. Herzfeld carries on as the sole survivor of this city's made-in-England era. This business

NEW YORK CITY

has its roots in the German firm founded by Alex Herzfeld in 1880, which thrived until the Herzfeld family immigrated to South America during World War II. The founder's son, Herman, and grandson, Wolfgang, opened this New York establishment in 1949. Wolfgang was at its helm until his retirement in 1986 when the mantle was passed to his son-in-law, Jonathan Cline.

Still located at its original address, H. Herzfeld offers a peaceful respite from the frantic pace of midtown's Madison Avenue. Traditional wood flooring, double-height cathedral ceilings, and English brass chandeliers combine to give its front room a gracious parlor warmth, one that assures you the attentive staff is prepared to listen and serve. They can still discuss quality in the context of how it used to be. This establishment offers edited selections of prestigious European makers such as underwear by Switzerland's Zimmerli, hosiery from England's Pantarella, and Bond Street headwear from Christie and Lock ($145–$225). You will also find sea island cotton or merino wool John Smedley knit shirts ($125–$145) plus their own fine dress shirts constructed from English and Swiss cottons and starting at $175. They carry everything from hats to shoes, all directed at the established gentleman who is mature enough to have developed his own fashion perspective. Theirs is the customer who appreciates quality and expects his purchases to service him over the long haul, just as the Herzfeld firm has been doing since its founding.

ALEXANDER KABBAZ
903 MADISON AVENUE
NEW YORK
TELEPHONE: (212) 861-7700
FAX: (212) 861-2897
HOURS: 7–7 MON.–FRI., 10–6 SAT. (CLOSED IN AUGUST)

Alex Kabbaz maintains that his custom shirts are the most expensive money can buy—and at $300 to $400 per torso covering, they are certainly in contention. He can make a sample shirt in one day, fit it on the second, and either refine it or, if necessary, make it over completely by the third. Then he tosses it away. Constructing the final product by employing an inordinately high number of stitches per square inch,

calibrating the measurements to within an eighth of an inch on all the seams, and then attaching the buttons by hand certainly qualifies its workmanship as top drawer. That the only fabrics he will use are European, two-ply, and woven in the more costly narrow widths (which can be accomplished only on older, slower looms) earns the finished package the designation "deluxe" in anyone's language.

It would not be overstating the case to suggest that Alex is passionate about his work. Born into a family of textile designers and artists, he was partly raised by his grandmother, who grew up in Paris during the 1930s. She had the good fortune to be befriended by two of America's leading art patrons, Gerald and Sara Murphy, heirs to the Mark Cross business and intimates of F. Scott Fitzgerald and Picasso. Acting as her benefactors, they provided her with passage on the SS *Normandie* to New York City where she worked for Sulka as a shirting designer.

Alex began his tutelage under one of New York City's master shirtmakers, Fred Calcagno, who for forty-two years saw to the shirting needs of the Rockefellers and Onassis at Pec & Co. on Fifty-seventh Street. Leaving there, Alex bought the Poster Shirt Company thereby inheriting the patterns of all their illustrious clients. He later merged his business with Pec & Co. after Fred Calcagno retired. While most shirtmakers worth their salt might have two hundred or so bolts of different fabrics on hand, Alex has amassed over three thousand. Having absorbed the stocks from two of this city's oldest custom firms, a portion of his inventory comprises rare voiles and broadcloths that will never be produced again.

In 1990, Alex decided to relocate to an area as close to the center of his regular customers' Upper East Side neighborhood as possible. Sitting on upper Madison Avenue, Alex can open at 7 A.M. to accommodate the early type A Wall Streeters, as well as those like the author Tom Wolfe who enjoys taking a midday stretch to check on the status of his latest tab-collar composition. At times, this former graduate engineer's enthusiasm for invention can send him beyond the boundaries of high-class taste, but when he is held in check, his shirts are everything their price might suggest. As they are all made entirely on the premises, Alex can turn out his little miracles as fast as you can button them, provided you are up to the costs. Anyone accustomed to having his whims fulfilled, no matter what, will not leave here disappointed.

LEONARD LOGSDAIL
510 MADISON AVENUE
NEW YORK
TELEPHONE: (212) 752-5030
HOURS: 9–5:30 MON.–FRI.; SATURDAY BY APPOINTMENT ONLY

Leonard Logsdail is a quite approachable Savile Row tailor. Not only does his self-deprecating humor make him less stuffy than many of his English colleagues, but he actually holds court on this side of the Atlantic. Having spent three months of every year of the last decade attending to his American clientele, he finally decided to settle here, marrying an American and becoming a commuter from Connecticut.

His tailoring process is unusual if not unique in the States. Leonard fits his clients, cuts the paper pattern, then faxes the order to London where his partner, Brian Burstow, does most of the actual tailoring. Within a month, the basted suit is sent to New York for a fitting, then returned to London for completion. This entire process takes eight to ten weeks and costs upwards of $2,500.

The Burstow and Logsdail suit is a fairly typical Savile Row affair, ranking on the stiffness scale midway between the military severity of the Huntsman cut and the sportswear softness of an Anderson & Sheppard. Its silhouette is narrow, with a defined waist and padded torso in the best tradition of British clothing. However, one thing that distinguishes it from its stateside competitors is that unmistakable Savile Row detailing, its carefully matched buttonhole thread that allows the buttonholes to vanish into the fabric's ground, along with the button color, and elegantly sewn buttonholes.

Few American tailors have ever been able to capture the spirit of the true Savile Row suit. Not only is its fit a combination of subtlety and structure, but the culture dictating its finishing has been the arbiter of high-class tailoring taste for as long as anyone can remember. For men who like their tailoring British, yet do not travel to London frequently, the Burstow-Logsdail connection permits the age-old craft of the bespoke tailor to travel across the Atlantic without incident. This unusual alliance of artisanship and cutting-edge technology has strengthened Savile Row's foothold on these shores, an arrangement that delights Leonard as much as his clientele.

LORO PIANA
46 EAST 61ST STREET
NEW YORK
TELEPHONE: (212) 980-7961
FAX: (212) 980-7962
HOURS: 10-6 MON.-SAT., TILL 7:30 THURS.

This cozy little ground-floor retail shop is the latest addition to New York's growing world of Milanese taste. Belonging to one of Italy's premier textile families, this town house, whose upstairs serves as its American corporate headquarters, has been beautifully refurbished by the Loro Piana brothers. With its gray-flannel carpets, dimly lit rich saddle-leather-colored walls, tortoiseshell-appointed fireplace and clubby ambiance, this dwelling exudes a refinement that immediately declares its Northern Italian extraction.

Throughout much of the world, Loro Piana is synonymous with the fine cashmere and other luxury cloths that are produced in their state-of-the-art factory in Biella, Italy. Their production methods are so sophisticated, the Chinese government trades them raw material in exchange for technical expertise. Following the Zegna lead, Loro Piana has recently branched out into finished products which utilize their own fabrics. This store also carries beautiful knitwear, handmade cashmere/silk and pure silk neckwear, and features fine made-to-measure dress shirts by Borelli, the Neapolitan shirtmaker. An array of their cashmere sports jacketings and worsted fabrics are on display and can be tailored to your specifications.

Over the years, the Loro Piana name will become as recognizable in the United States as it is almost everywhere else. The family has bought and completely modernized a venerable New England mill that now produces fabrics of a quality previously found only in Italy. Almost everything they touch, from this town house down to their wonderful cashmere slippers, reflects their penchant for commerce based on an updating of old-world taste and style.

NEW YORK CITY

MILLER HARNESS COMPANY
117 East 24th Street
New York
Telephone: (212) 673-1400
Fax: (212) 473-0128
Hours: 10–6 Mon.–Sat., till 7 Thurs.

During the 1930s, when the carriage trade finally surrendered to the automobile, three family businesses—Knoud's, Kauffman's, and Miller's—survived the transition with varying degrees of success. Knoud moved up to a Madison Avenue address before ultimately expiring in the 1980s, Kauffman's remained as a single-store, family-run business but was forced out of its historic premises, and recently closed shop, while Miller's thrived and expanded into a global enterprise with over one thousand dealers selling its wares throughout the world.

The firm began life as a harness maker in 1912 on Twenty-third Street, the era's undisputed hub of the draft horse community. The draft horse was that beast of burden which, either alone or as part of a team of equines, pulled the carts and carriages driven by the teamsters. Gradually, Miller's concentrated on providing sports clothes for those men who wanted to appear stylish during their equestrian pursuits. In 1950, their introduction of the first stretch breech catapulted the store into its present position as the leading purveyor of riding gear and wear in the world. Before this particular innovation, the breech would ride up the ankle, leaving the exposed patch of limb to be rubbed raw against the stirrup's leather cover. Miller's has gone on to hold several patents on fabrics they have invented such as Airflow, a moisture-wicking cloth used for a saddle pad.

An auction barn once functioned across the way from the shop, the same auction barn that previously housed Kauffman's. Men would go there to buy their horses, then cross the street to have them rigged at Miller's. The auction barn no longer stands, but Miller's still outfits most of the privately kept horses in New York, as well as many of the thoroughbreds across the country. The owners of these fine animals buy Miller equipment through the company's catalog or from specially approved stores that carry the Miller merchandise. Miller's also outfits the United States equestrian team.

This is a real tack shop, not some sports store with a riding theme. You won't find any western wear or hunting and fishing gear here. The store carries 99 percent of what's in its catalog, but many additional items are made exclusively for Miller's and can only be purchased here. Favorites include a show-rider breech at $139, tweed hacking jackets from Canada at $450, and Barathea melton pinques with wool tattersall lining at $695. The selection is so broad and its quality so superior, it has made Miller's the largest wholesale distributor of English equestrian clothes in the world, including that blessed island where the hacking jacket was born.

MORGENTHAL-FREDERICS
New York
685 Madison Avenue
Telephone: (212) 838-3090
944 Madison Avenue
Telephone: (212) 744-9444
Hours: 10–6 Mon.–Sat.

In an environment out of *Architectural Digest*, this firm offers optical fashion at its most aesthetic. Viewing eyewear as an accessory that can alter your image or persona more than your clothing, these two stores try to take the medicinal out of the eyeglass-buying experience. Designed like antique pharmacies with open apothecary cabinets as displays, their Shaker-inspired interiors and white-smocked assistants make talk of nosepads and glare guards seem positively routine.

The Frederics Optician Store, which was founded in the mid-twenties, was purchased in 1986 by Richard Morgenthal, an artist who was also a trained optician. When he took over the 685 Madison Avenue shop, he joined his name to the renowned Frederics nomenclature. Since then, he has forged a business much like London's Cutler & Gross, who are as interested in their eyewear's form as its function. Over seventeen hundred frames, from Oliver Peoples and Matsuda to its own Morgenthal collection, grace the Morgenthal-Frederics shelves. Frames average between $200 and $400 and cover the full gamut of eyewear decor, from vintage designs and plastic and wooden moderne to faux tortoiseshell. Though eyeglasses were once

NEW YORK CITY

thought of as a social liability ("Men seldom make passes/At girl's who wear glasses"), at Morgenthal-Frederics, looking good never looked so good.

<center>

NEW REPUBLIC

93 SPRING STREET

NEW YORK

TELEPHONE: (212) 219-3005

HOURS: 12–7 MON.–SAT., 12–6 SUN.;

CLOSED JULY AND AUGUST

</center>

The New Republic store is the brainchild of the city's most Beaton-esque toff, designer/retailer Tom Oatman. A Spring Street pioneer, New Republic first opened across the street in 1983 and relocated here three years later. The store has contributed mightily to SoHo's mystique as a neighborhood of the edgy and hip. Tom has been hoarding clothes since he first became enamored of fashion as a teenager. His loft-sized apartment is packed with the one-of-a-kind vintage models that serve as the starting point for each season's collection. These new wearables are inspired by designs from decades as disparate as the Roaring Twenties and the Rocking Seventies.

REGIMENTAL IRREVERENCE: ETON SCHOOLBOY SCARVES FROM ENGLAND'S MOST VENERATED SUPPLIER RECOLORED FOR THOSE UNMATRICULATED CLOAKS OF THE DOWNTOWN SET.

The clothes are not thrift wear, nor do they possess the kitsch often associated with the secondhand. As modern interpretations of bygone menswear, now removed from their original context, they continue to elicit respect as fashion that was and still is unmistakably American. That New Republic wholesales to such wellsprings of *la mode* as Neiman Marcus and Barneys attests to these garments' present-day appeal.

You will find here a genre of dressing sensibility that has no peer or competition even in this vast supermarket of a fashion city. This is as original a vision of highbrow English eccentric dress as you are likely to find anywhere. For example, you might come upon a four-button black-watch tartan hacking jacket at $495, or a pair of English velvet slippers embroidered with skull and crossbones, symbolic of the valiant, star-crossed Light Brigade, at $165. Every spring Tom takes the train from London up to Cambridge to visit the only remaining maker of schoolboy scarves and has them made up in his own quirky, noncollegiate color combinations. He has carried English John Smedley long-sleeve wool shirts in offbeat colors since the store's inception, at the surprising below-market price of $140. For spring, you might find an unconstructed bleeding madras soft-shouldered jacket with an authentic hooked single vent for $495 or zip-front jackets reminiscent of the fifties, with contrast solid backs and sleeves and patterned fronts à la Ricky Ricardo, a possible mate for the striped, high-backed trousers of the suspenders-wearing era. There are antique sunglasses, old-looking new shoes, hand-loomed Scottish argyles, and Fair Isle knitted skullcaps, all presented in prewar cabinets and display cases of the department-store deco style.

Apart from cutting your teeth twenty years ago in Brooks Brothers, or studying *Esquire, Apparel Arts,* or *Adam* magazines from the pre–World War II era, collecting antique clothing is about as instructive a form of design education as one can receive. Tom Oatman is the author of a highly respected book on labels, which, like old clothes, provide a looking glass into the popular culture of their time. His unusual design background has enabled him to transform a childhood fascination into a thriving enterprise and given him the perspective to make clothes that will transcend the time in which they were created. I'm sure if Tom could have any wish for his clothes, other than a broad commercial success, it is that they would end up being recycled as vintage clothes in the twenty-first century.

PARAGON SPORTING GOODS
867 BROADWAY
NEW YORK
TELEPHONE: (212) 255-8036
HOURS: 10–8 MON.–SAT., 11–6:30 SUN.

In a culture divided by extraordinary ethnic diversity, one thing unites this metropolis like nothing else: sports. Ask any candid newsman and he will privately admit that the sports pages drive his paper's circulation. No other city in the world plays host to more professional athletes and their followers than this cosmopolitan complex. Whether you are a Knicks, Yankees, Mets, or Rangers fan, a jogger or marathoner, attend the U.S. Open or participate in the Gay Games, belong to the local country club or pound paddleballs against the wall in the nearby public park, New York City is the United Nations of sports. And this demanding city's paragon of sports retailing is this appropriately named eighty-six-year-old, third-generation family-run store, located in the hub of newly fashionable lower Fifth Avenue.

Paragon Sporting Goods offers the latest in sports paraphernalia and attire, covering fifty different kinds of equipment from bocce to wet suits. The theme here is universality; its directory is printed in six languages. Celebrities and suburbanites, Europeans and South Americans, the athletic and the wanna-bes, the hip and the hip-hop all wait their turn to haul away part of the dream. And the fact that athletic wear has become fashionable for young and old makes Paragon even more of a happening.

Three full floors of this loft building are devoted to showing merchandise, much of it discounted to prices that cannot be matched in other parts of the country. The remaining five floors house the establishment's deep inventory. Paragon's selection of apparel is extensive; its walls of athletic shoes divided by sport and gender, awesome. Given the wide variety of sports franchises that call the New York area home, one shouldn't be surprised that the store's range of team merchandise is also all-encompassing. Europeans stop here to buy just the right street-cool team jersey for their children. In the backpacking department are garments and gear made in the latest high-tech fabrics and high-function design. They have the largest selection of hiking boots in

the city and you can even pick up a pair of wellies here, just in time for your next trip to the moors.

Whereas other international cities may engage New York in some friendly fashion competition, when it comes to athletic wear, the best any rival can hope for is second place. The contest is hardly even fair, since it is held in the sports capital of a country that invented the World Series, the Super Bowl, the Masters, and the NBA. This is clearly the case where the Big Apple has the home court advantage, and Paragon is the city's big "ref" of playground duds.

POLO SPORT
888 MADISON AVENUE
NEW YORK
TELEPHONE: (212) 434-8000
FAX: (212) 434-8088
HOURS: 10–6 MON.–SAT., TILL 8 THURS.

Not everyone can afford to park their yacht-cum-flagship virtually at the curb of their very own mansion, smack in the middle of Manhattan Island. Ralph Lauren can. Across the street from his old-world, baronial fantasy of mahogany and tartan is Mr. Lauren's newest world, Polo Sport. At a time when classic white for tennis is considered old-fashioned and fluorescent pastels sully the naturalness of mountain ski slopes, Ralph has tossed his topper of high-bred taste into the slogan-ridden universe of urban warrior active wear. Combining his state-of-the-art trademarked synthetics in sleek shapes and functional designs with refashioned vintage outdoor sporting looks, this twanger of tradition is once again pioneering new fashion terra firma. His two-floor, ten-thousand-square-foot store wraps its imposing windows as sports tableaus around the southern

FACTORY- OR ARTISAN-KNIT, RALPH LAUREN MAKES THE SMARTEST SPORT SOCKS.

NEW YORK CITY

corner of Seventy-second Street's prestigious residential thorough-fare.

Entering Polo Sport is, indeed, like climbing aboard a grand yacht. With its teakwood-stained cherrywood flooring, white lacquered walls, bits of brass, and crisp, clean lines, all that's missing is the salt-water spume. There is a gigantic scull suspended from the ceiling and canoes and kayaks hang on the walls. Each room in the bilevel habitat represents a different sport and lifestyle. One-quarter of the space is occupied by a Double RL boutique. In contrast with the rest of the store's spare, airy ambiance, this countrified outpost is crammed with faded jeans, weathered bombers, and vintage-looking merchandise. A double-height central atrium is made cozy by the couches and working fireplace in the sunken seating area on its main floor.

With aspirational American lifestyles and fashion frequently crossing paths today, the Polo Sport constituency will extend way beyond those professional sports enthusiasts and serious high-tech rock climbers who are already devotees. Modern dressing has become a mixed bag of ski jackets with jodhpurs and cool synthetics with warm tweeds. Urban sports who will probably never vacation on a dude ranch or summer in the Adirondacks will no doubt pull their four-wheel drives curbside and help Ralph inject some taste into the trappings Americans currently wear while consummating their love affair with this country's great outdoors.

RALPH LAUREN AT 72ND STREET
867 MADISON AVENUE
NEW YORK
TELEPHONE: (212) 606-2100
HOURS: 10-8 MON.-FRI., 10-7 SAT.

Welcome to the tradition that Ralph helped save. This mansion was formerly home to one of America's best-dressed men, William Rhinelander Stewart III. His valet, in a rash breach of manservant eti-quette, once revealed that he would always see to it that his gen-tleman's larger bills were pressed crisp in preparation for the following day's service. Today, this august dwelling is again home to another of

this country's famous tastemakers, Ralph Lauren. No tour of Gotham's sanctuaries of male adornment would be complete without a visit to this shrine of transplanted Anglophilia. In creating a showcase for his fantasy lifestyle, Mr. Lauren not only upstaged the fountainhead of American fashion on Forty-fourth and Madison, he figuratively and literally moved it uptown. Today Mr. Lauren's limestone homage to the stylish plenitude of the past stands as this country's most compelling evidence that the traditional disciplines of taste have lost none of their relevance in matters concerning modern male dress and style.

Passing through its doors, one is greeted by a rush of atmosphere thick with bywords. Had Dickens been a dandy, a house in one of his novels would look not unlike this. Every inch of floor and wall surface is covered with talismans proclaiming the unassailable verities of the tried, true, and bluestocking tastes of eras gone by. The floor guide over the elevators reminds one of early Brooks Brothers. Ascending its baronial staircase, one can imagine having just dined at the Edwardian Grill Room of London's Connaught Hotel and retiring upstairs to bed. The store's haphazardly ordered presentation captures the easy elegance of Ralph's beloved St. James's cobbler, John Lobb. Like Ralph's best clothes, this environment will only gain character with a little wear and tear.

This crown jewel of the Polo empire is the culmination of Ralph's pioneering concept of aspirational selling. He understood before anyone else that in order to sell upscale men's clothing or products based on a romanticized notion of life, environment was as important as content. This glamorous melodrama provides a setting where one can be stylishly seduced. Browsing here is like visiting the home of a British peer, except virtually everything in this joint is for sale.

And what's worth buying is always considerable. Ralph's English shoe selection always features four or five "old boy" elegant benchmade models. His sportier shoddings, whether his espadrilles à la Saint-Tropez, his boat shoes, or his off-mountain footgear, are tops. There are sportswear pieces inspired by *Apparel Arts* of the 1930s, and undoubtedly the best designer hosiery, dress or sport, to be found anywhere. Like a Mario Buatta room, it takes a while to sort through the activity of the whole, but when you invest the time, you will find

much of it designed and made well enough to one day end up in a vintage clothing store, a destiny that would certainly delight this designer.

From Timberland to the Gap, Façonnable to Tommy Hilfiger, Ralph Lauren has popularized American design on such a grand scale that he enabled others to create businesses based on his extraordinary vision. Some feel he took what was indigenously British and simply repackaged it for the colonies' consumption, a sentiment as far from the truth as root beer is from beer. One visit to London during the past several decades would have clearly illustrated that, while much of what inspired the Lauren vision was certainly English flavored, it was also obvious that the natives hadn't a clue what to do with it. When Ralph focuses his energy and imagination on creating clothes that some might term derivative, his version not only ends up improving upon the original, but broadens its appeal as well.

Recognizing that the Brothers Brooks had lost its momentum during the early sixties, Ralph envisioned the next step and how to get

THE CALF OPERA PUMP: THE LAST
VESTIGE OF MASCULINE COURT
DRESS AND LONG-STANDING
SYMBOL OF ARISTOCRATIC TASTE IN
BLACK-TIE FOOTWEAR PRESERVED BY
AMERICA'S FIRST TOFF OF
TRADITION.

there. He reconfigured the Ivy League's self-limiting parameters of taste and quality, and marketed his designs around lifestyle themes. In stimulating so much worldwide emulation, he not only ensured the survival of what Brooks originally stood for, he also catapulted American fashion into worldwide prominence.

But perhaps Ralph's greatest legacy will be found not in any single design or particular credo of fashion but rather in the attitude and spirit necessary to wear clothes well. No menswear designer has invested more time or money teaching men how to make their appearance seem upper crust yet their own. He has single-handedly elevated the taste of an entire generation. From advertisements featuring Ralph "clothed-down" in denim and flannel or "clothed-up" in chalk stripe

and satin to his media campaigns showcasing his Polo models swathed in all measure of rumpled glamour, Mr. Lauren's message has consistently taken the high road of restraint and subtlety to make its quiet point: that fashion differs from style and that stylish clothes are only such if you know how to wear them. And one thing is for sure, not many men know how to better than Ralph.

Mr. Lauren has supplanted Brooks Brothers as the arbiter and protector of the herringbone faith. His restoration of the Rhinelander mansion parallels his resurrection of traditional American fashion. Ralph Lauren has saved both with a classiness that would have made Mr. Stewart and his valet feel right at home.

JAMES ROBINSON
480 PARK AVENUE
NEW YORK
TELEPHONE: (212) 752-6166
HOURS: 10-5 MON.-SAT.

Along with the gemless wedding band, the wristwatch, and possibly the quietly costly tortoiseshell-enameled pen in pocket, cuff links are among the few sanctioned outlets for the male embellishing urge. When Edward Munves's personal collection of antique cuff links outstripped even his ability to enjoy them, he turned a private passion into another reason for shoppers to visit his family's august establishment. Glowing with subdued elegance, James Robinson is one of this city's choice addresses for those men wishing to consider a serious investment in the art that can grace their shirt cuffs.

This tenth-generation firm displays its many examples of finely crafted cuff jewelry with an almost old-world propriety. Theirs is a gracious space of tall ceilings above dark green carpeting where glass-topped mahogany cases sparkle in concert with the lustrous wares contained within. As you enter the shop, to your right is the private little corner reserved for men's accessories. After your initial perusal of the cuff links under glass, they will, if requested, take out three black rectangular leather boxes, one for enamel links, a second for gold, and a third for stones. These range in price from $1,200 to

NEW YORK CITY

$5,000. If you require something that will anoint your dinner clothes with a bit of history, their antique dress sets are arranged in two additional boxes. And in the adjoining velvet-lined glass showcase are their beautiful gold or platinum watch chains ranging from $2,500 up to $6,000.

The golden period of jewelry design flourished from the late nineteenth century through the 1930s. After World War II, handcrafting was replaced by mechanized, automated production with the sacrifice of individuality for volume. To be accepted into the Robinson collection, each pair must attract Mr. Munves's discriminating eye, be crafted and hallmarked at a specific level of quality—and have two finished sides. He does not like to see the link's superstructure exposed by the wave of an arm, an idea I wholly subscribe to. With 100 to 150 pairs fulfilling those criteria, it's not hard to understand why stylish businessmen or their wives have adopted Mr. Munves's passion as their own.

SAKS FIFTH AVENUE
611 FIFTH AVENUE
NEW YORK
TELEPHONE: (212) 753-4000
HOURS: 10–6:30 MON.–SAT., TILL 8 THURS.; 12–6 SUN.

If New York City is the international fashion firmament's capital, and Fiftieth and Fifth is arguably the town's central crossroads, Saks Fifth Avenue sits at the heart of the universe of worldly high style. Facing Rockefeller Plaza and bordered by the country's most famous religious monument, Saint Patrick's Cathedral, if Saks does not occupy the most prestigious parcel of mercantile real estate in the world, I'd be hard pressed to point to another. Anyone who has ever visited the city around Christmastime and taken in the store's gingerbread and Santa Claus windows or walked onto its evergreen-ceilinged main floor realizes that this famous institution represents the very core of American tradition and affluence.

Saks started out to be exactly what it is—a large, upscale, high-fashion specialty store. It was the dream of Horace Saks and Bernard

NEW YORK CITY

Gimbel, both of whom operated retail stores on Thirty-fourth Street at Herald Square in the early 1900s. The combined financial clout of their two families allowed them to purchase a site on upper Fifth Avenue, which was then primarily an elegant residential district. Saks Fifth Avenue opened for business on September 15, 1924.

While the name said Saks, the driving force who would ultimately make the store a legend was named Gimbel. With the untimely death of Horace Saks in 1926, Adam Gimbel, a cousin of Bernard's who had acted as Horace's assistant, assumed the SFA presidency. Only thirty years old and an architect by education, he displayed a unique flair for the retail business. To attract the affluent in greater numbers, he remodeled the store in the sophisticated Art Moderne style he had admired during the Paris Exhibition of 1925. Mr. Gimbel wanted Saks to have the feel and appearance of a sumptuous home brimming with elegant, exciting merchandise. He hired buyers to scour the earth for the finest goods money could buy while concentrating on suppliers who would guarantee exclusivity to Saks.

The quality and tone set by Adam Gimbel endured throughout the decades. Its relatively recent acquisition by Investcorp, the introduction of a new management team, and a renovation of the entire store have kept Saks Fifth Avenue in the vanguard of fashion retailers. However, after Mr. Gimbel retired, the men's business languished somewhat under a series of store managements. Fortunately for Saks's male clientele, Adam Gimbel's spiritual successor has emerged in the person of Philip B. Miller.

Following in the footsteps of this country's two titans of specialty retailing, Adam Gimbel and Stanley Marcus, Phil Miller is a man of great personal taste and integrity. Perhaps he is not quite cut from the same renaissance cloth as Mr. Gimbel, who spoke several languages, read two books a week, and was a renowned sportsman. However, like Adam Gimbel, Phil Miller takes a personal responsibility and pride in guiding the public's taste upward while keeping an eye on the bottom line.

Mr. Miller cut his retailing teeth as a merchandise manager at Bloomingdale's and went on to become chairman of Lord & Taylor. In 1977 he was named president of Neiman Marcus. Six years later,

he left that firm to become chairman and CEO of Chicago's Marshall Field's, positions he held until he joined Saks in 1992. No other top executive in American retailing can equal his wealth of experience in specialty retailing or his particular expertise and enthusiasm for menswear. With his assumption of the Saks chairmanship, the store's recent expansion has especially rewarded those gentlemen seeking Saks's impeccable image of upscale taste. Heeding Adam Gimbel's policy of providing men with the same level of quality and service it offers to women, Saks now has double the space to do it in.

Dress furnishings are the chief beneficiaries of the additional footage on the main floor. Men's sportswear has now taken over the second floor, and the newly renovated sixth floor accommodates the enlarged collections of updated traditional, European, and designer men's clothing.

Surrounding himself with a cadre of talented fashion executives and buyers, Phil Miller is systematically returning the firm's men's business to the luster it enjoyed during the Adam Gimbel era. The main floor has added the furnishings of Loro Piana, Sulka, and Luciano Barbera. The second

ALTERNATIVE BLACK-TIE: BLACK-AND-WHITE-CHECKED, PLEATED-FRONT GINGHAM DINNER SHIRT AND WOVEN PAISLEY TO-TIE BUTTERFLY BOW BY ALAN FLUSSER.

floor is now bookended by the country's most impressive in-store Ralph Lauren shop on one side with high-end golf and sporting clothes on the other. Men's shoes have expanded their home in the sixth-floor tower and added collections like J. Weston, J. P. Tod's, Gucci, and Paraboot. The men's floor, which probably sells more high-quality tailored clothing than any other single floor in the world, now features the hand stitches of Brioni, Oxxford, Chester Barrie, and Ralph Lauren's Purple Label, as well as the tailored fashions of Zegna, Versace Couture, Joseph Abboud, and this country's largest Giorgio

Armani men's business. The store offers the Alan Flusser clothing collection as a New York City exclusive as well as housing major shops by Calvin Klein, Donna Karan, and Hugo Boss. Within a price range from $750 to $1,500, Saks offers the most varied array of men's suitings in the city.

Perhaps the most dramatic feature of the sixth floor's remodeling are the windows that overlook Fifth Avenue and Rockefeller Center. Partly influenced by the adjacent Art Deco Rockefeller Center and Radio

SOLES OF COMFORT BY
J. P. TOD'S: MARRYING
METROPOLITAN CASUALNESS WITH
MILANESE TECHNOLOGY.

City Music Hall as well as the designs of the French traditionalist of Art Deco, Jacques Ruhlmann, the store's Fifth Avenue Club, without question, offers Gotham's most dazzling setting for corporate or personal shopping. There are bilingual associates to help tourists visiting Saks feel right at home. The corner space's ceiling-height windows create the impression that you are suspended in midair among Manhattan's most glorious monuments. And topping off all this Saks diversity is the nattily attired chairman's inspiration, the Alan Flusser Custom Shop, ensconced in an oval room overlooking Fifth Avenue.

From top to bottom, Saks Fifth Avenue offers one of the most exciting all-inclusive, self-contained shopping experiences in the world. In 1986, Adam Gimbel's testament to American entrepreneurship was accorded landmark status. With its carriage-trade reins having passed into the hands of America's preeminent retail tastemaker, this world-class institution seems destined to lead retailing during the twenty-first century just as definitively as it did in the twentieth.

NEW YORK CITY

SCANDINAVIAN SKI SHOP
40 WEST 57TH STREET
NEW YORK
TELEPHONE: (212) 757-8524
HOURS: 10–7:30 MON.–FRI., TILL 8:30 THURS.; 11–6 SUN.

This forty-six-year-old establishment is one of the country's premier ski retailers. They are the only shop in the city that devotes 365 days of the year to purveying nothing but ski stuff. They sell equipment to the South Americans in summer (the Southern Hemisphere's winter) and the rest of the world during the other three seasons.

When I was younger and a more dedicated skier, Sig Buchmeier's was the place to get the top skiing equipment and togs. After Buchmeier's was absorbed into this store, the name was changed, but not the merchandise. This is Alpine Central. From Bogner to Head, no store offers better provisions or technical advice than these knowledgeable folks. Upstairs houses the clothes, downstairs is where you will find the rentals and a team to help organize your ski trip, while the main floor concentrates on equipment. For the past six years, they have offered a direct mail catalog, so you don't have to go to midtown Manhattan to be plugged into the latest downslope technology or ski fashion.

PAUL STUART
MADISON AVENUE AT 45TH STREET
NEW YORK
TELEPHONE: (212) 682-0320
FAX: (212) 697-3117
HOURS: 8–6 MON.–FRI., TILL 7 THURS.; 9–6 SAT.

During the sixties, the savvy, soft-shouldered set would buy their three-pieces at Brooks Brothers and then quietly sneak next door to buy their furnishings at Paul Stuart. There, a shopper could divert attention from 346's undertailored sacks with a more interesting necktie or adventuresome dress shirt. Although you traded that herringbone authenticity for the more offbeat, it did get better notice from your dance partner.

Founded by Ralph Ostrove, who named the store after his son, Paul Stuart opened its Ivy League doors on East Forty-fifth Street in 1938. In 1965, Ostrove's movie-star handsome son-in-law, Cliff Grodd, was named president. This appointment marked the commencement of a new era. Grodd believed Americans needed an alternative to the overtly stylish menswear from Europe and the repetitious predictability of the Ivy League look. He introduced merchandise that was less collegiate and the distinctive style that is now known as the Paul Stuart look began to emerge. The phrase "updated traditional," like the shaped two-button suit, originated right here. Being located next door to the very tradition they were updating, Paul Stuart set out to create a reason for the dyed-in-the-wool traditionalist to change his colors.

Paul Stuart's private-label fashion commands the respect and attention of its worldwide peers. If a man requires a conservatively styled, better-quality, soft-shoulder, single- or double-breasted business suit in short, regular, mid-tall, or long, Paul Stuart has

more of them than any other retailer in the country, starting from $775 for its domestic make, up through its top-end, Italian-tailored imports ranging from $1,430 to $1,900. For the dapper English enthusiast, Paul Stuart is probably New York City's only credible source for off-the-peg side-vented clothing.

In addition to their natty tailored clothing, the store always has on hand a range of classy sweaters, well-designed rugged outerwear, and attractive hosiery. Some unusual shoe models, bench-made in England by Edward Green, are always worth keeping an eye peeled for as

NECKWEAR FOR NONCONFORMISTS: PRINTED BOWS FOR THE GENTLEMAN WHO LIKES TO TIE HIS OWN.

well. And no store affords the bow-tie buff equal opportunity to express his extroverted style more than this establishment. Unlike other retailers, Paul Stuart designs the vast majority of the merchan-

WORLD-CLASS ANKLE AESTHETICS:
HANDSOME PATTERNED HOSE
MAKE THE TRANSITION FROM
SHOE TO TROUSER BOTH SEAMLESS
AND STYLISH.

dise it sells, and it is this talent for product development that has perpetuated its individuality.

Since this store sells one look, its own, it is easier to educate the sales staff on the tastefully acceptable variations on its theme, especially when that theme is an ongoing one. Even the random customer, as long as he is of the soft-shoulder persuasion, is likely to receive better advice here than elsewhere. Paul Stuart excels at helping the less secure dresser put outfits together so that he feels confident his wardrobe will be appropriate for any occasion.

With its impressive record for consistency of vision and place in the American fashion constellation, Paul Stuart has also contributed to the intellectual diet of its literate *New York Times* clientele. The firm's eloquently written advertisements on the essence of style and taste expanded the sartorial horizons of all who took the time to absorb them. And their windows, winners of numerous citations and awards, are always a joy to behold as they bear witness to the store's swank art and Dickensian humor.

Paul Stuart has not only managed to freshen the tradition of dress fathered long ago by the Brooks family, it has lived by the values and disciplines upon which those traditions were founded. While other upscale retailers try to seduce new customers with such glamour gimmicks as portable telephones, shoe shines, and concierge service, Paul Stuart continues to attract business the old-fashioned way—they work for it. As Cliff Grodd says, "We open at eight A.M., that's our free shoe shine."

NEW YORK CITY

SULKA
301 PARK AVENUE
NEW YORK
TELEPHONE: (212) 980-5226
HOURS: 9–6 MON.–FRI., 10–5 SAT.

In menswear, the term "furnishings" evolved from the notion that a well-chosen cravat or shirting was required to furnish the space left open at the neck when the revers of a man's tunic were first folded back. No name in American retailing is identified with endowing that cynosure of a man's business ensemble with more luxury than Sulka. This firm has been producing its meticulously tailored shirts, distinctive silk neckwear, robes, and pajamas for over one hundred years. One of the first retailers to move north from Lower Manhattan in the 1930s, Sulka's Fifth Avenue Georgian bastion, with its sixteen-foot ceilings and hand-carved walnut sliding doors, was a treasure trove of men's merchandise unrivaled in sumptuousness anywhere in the city. By the time it had relocated to these Park Avenue digs, being a Sulka customer put everyone on notice that you had arrived.

Amos Sulka, a salesman from Johnstown, Pennsylvania, formed A. Sulka and Company on New York's lower Broadway in 1895. He and partner Leon Wormser, a shirt-cutter from Alsace-Lorraine, accoutered policemen, firemen, and the butlers from influential families with uniforms of superior quality. Soon their employers, including such well-dressed luminaries as John Jacob Astor, also became clients. In a precedent-setting move, this New York–based company opened a Paris branch in 1911; a London store was added in 1924. As its business prospered, Sulka started an uptown excursion that eventually brought it to its current location.

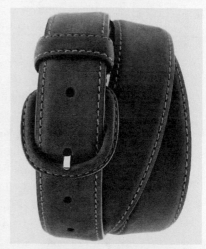

ONE OF THIS HABERDASHER'S PLETHORA OF URBANE WAIST WRAPS: TOBACCO-TONED SUEDE BELT CONSPICUOUS FOR BOTH ITS WORKMANSHIP AND RICHNESS.

NEW YORK CITY

The last family member sold his stock in 1975 and the company floundered under a number of different owners until it was rescued by Vendome in 1989. This prominent European holding company— Piaget, Cartier, Dunhill, Mont Blanc, and Baumier and Mercier are among its well-known acquisitions—hired Neal J. Fox, one of America's premier quality retailers, to transform their battered jewel into the Tiffany's of menswear.

Besides its New York, London, and Paris stores, Sulka also has outposts in San Francisco, Beverly Hills, and Chicago. The interior designs of all six establishments have been made uniform to project the same timeless and handsome look. Their decor is reminiscent of the Biedermeier style, with a series of colonnades combining limestone and marble lined with warm cherrywood paneling and furniture accented with ebony trims. Special broadloom area rugs lend the stores a warm, clubby feel.

Sulka is still the tops in quality for custom shirts ($200–$350) which take six weeks; in a nod to their superior service of yesteryear, they will accommodate their customers by hand-laundering dress shirts for $7. Their silk dressing gowns ($1,250–$1,700) are made individually by hand in their own workrooms in New York City and are the kind of stuff Noel Coward might have lounged in while trading badinage with Gertrude Lawrence in productions such as *The Vortex*. Sulka's famed silk neckwear, hand-sewn, double-lined, silk-tipped, and stitched in a diamond design in the neckband for reinforcement, are all of top-drawer quality, as are their belts, handkerchiefs, and hosiery. While it's difficult to come upon sportswear genteel enough for stylish comportment in places such as Portofino or the Riviera, here the casual clothes more than measure up.

Ten years ago, Sulka's fate could hardly have appeared bleaker. It seemed probable that the esteemed Sulka reputation, like that of other high-class retailers from the hansom cab age, would be dragged downmarket, razing in no time what had taken decades to erect. Today, run by men who understand quality and the investment required to build a luxury brand, Sulka's fortunes have dramatically improved. Like France's Charvet or England's Turnbull and Asser, Sulka continues to serve as an international benchmark for quality and classic style. Their customers are assured access to superior mer-

chandise that ranks in the same class as Europe's higher-quality furnishings. Nothing could be more encouraging for those familiar with Sulka's illustrious past than watching one of the States' few remaining brand names of international distinction prepare to make its second hundred years even better than its first.

ROBERT TALBOTT
680 MADISON AVENUE
NEW YORK
TELEPHONE: (212) 751-1200
FAX: (212) 751-1442
HOURS: 10–6 MON.–SAT.

Ensconced in the shadow of Barneys on Madison Avenue is this pristine ray of California sunshine. Its interior is bright and upbeat, trimmed in English sycamore quarter-sewn blonde wood with taupe-and-ivory harlequin-patterned wall-to-wall carpeting. The firm's handsome, handsewn products—there are over fifteen hundred dress shirts and five thousand neckties—provide the light-hued rectangular room's colorful focus.

The firm's neckties range in price from $65 to $105, then jump to $150 for samples of its seven-fold neckwear art. The single-needle dress shirts retail between $100 and $150. Robert Talbott's look is dressy; its taste ranges from the updated traditional to the Euro-classic. A company-owned shop, its prices represent good value. Talbott's refreshing, clean ambiance manages to impart an intimacy that makes the purchase of a dress shirt and coordinating accessories virtually stress-free.

TENDER BUTTONS
143 EAST 62ND STREET
NEW YORK
TELEPHONE: (212) 758-7004
HOURS: 11–6 MON.–FRI., 11–5:30 SAT.

If you are in the market for that special button, there is really no other store in the world to consider except Tender Buttons. Everyone who is anyone in the design or fashion business either shops here or

NEW YORK CITY

NEW YORK CITY

visits simply for inspiration. In New York City's eclectic shopping universe, this is considered Mecca for those obsessed with the perfect detail. Bill Cosby purchases the buttons for his cardigans here, Ali MacGraw comes in to add any buttons in the shape of Scotties to her collection, and Kermit the Frog, like Greta Garbo before him, found the perfect trench coat buttons on these shelves.

With its exquisite cache of hidden treasures awaiting discovery, Tender Buttons more resembles your grandmother's attic than a button store. Meticulously framed panels of precious antique buttons are displayed along the walls, well-worn tables sit in the center, and an infinite array of buttons neatly arranged in boxes are stacked from floor to ceiling along one wall. How many buttons comprise the store's inventory? "We have no idea," says Millicent Safro, co-owner of the store with Diana Epstein, "I once counted one shelf of buttons and it took two weeks."

The genesis of this establishment was accidental. In 1964, Epstein and Safro discovered that the tumbledown Upper East Side store where they used to purchase buttons was no more. They bought the establishment's supply of buttons and then rented the shop to house them. Shortly after, they turned the collection into a business, naming it "Tender Buttons" after an obscure book of poetry by Gertrude Stein. The shop became a forum where the owners could make a typically sixties statement: that of elevating something seemingly insignificant into an art form. Today, the two are acknowledged experts in a highly specialized field. In addition to having authored a definitive book on the history of buttons, they have organized button exhibitions at the Smithsonian Institution in Washington, D.C., and at the Gallery at the Ginza in Tokyo.

Men who shop here can choose from an array of six hundred styles of blazer buttons, including a superb collection of antique livery or real English men's sets. One can find here the genuine English horn buttons and the German-made, dressy melamine buttons that some Savile Row tailors use on their suitings. They also have a great selection of rare antique cuff links, dress sets, and other odd gentleman's jewelry. As Millicent Safro explains, "What I love about buttons is that each one is a tiny evocative event. They celebrate historical incidents, serve as a microcosm of the culture from which they arise, and reflect the aesthetic sensibilities of their time."

Tinkers' Catalog
Telephone: (800) 565-8465
Fax: (904) 565-1620

SOUTHAMPTON CHEAP CHIC:
ELASTICIZED COTTON PULL-
ONS WORN FOR THE BEACH
OR BLACK-TIE.

In the WASP outskirts of Long Island's Southampton community, one Bellport mother, Carla Beerman, started a children's business for the sons and daughters of the turtle-embroidered and sockless Ivy Leaguers visiting for the summer. Making elastic waistband pull-on bottoms out of brushed cotton fabrics printed with cabbage roses or other decorating motifs tamed by high society, she attracted the interest of the grown-ups and her business blossomed.

Two catalogs are produced each year. The men's pants cost $40 to $60 and take two weeks for delivery. These "trou" can be thrown in a washer and dryer and virtually lived in. The paneled madras, mixed tartans, or fruit pants are all the more chic because, like pajama bottoms, they are cheap and beyond comfortable.

Vincent & Edgar
972 Lexington Avenue
New York
Telephone: (212) 753-3461
Hours: 10–6 Mon.–Fri.

Arriving at this modest Upper East Side shop, you will immediately discover why the only true custom cobbler left in Manhattan is a

NEW YORK CITY

thirty-eight-year-old Russian maverick by the name of Roman Vaingauz. Custom cobbling is not glamorous; it requires long labor as well as skill of the highest order. Roman not only does authentic custom work, he makes the shoe almost completely by himself. The last is carved in his basement on this artisan's pride and joy, a hundred-year-old German apparatus, while the rest of the shoe is made in his tiny shop's back room. He toils ten to twelve hours every day to turn out two pairs every week. Each pair requires forty hours of labor—the hand-sewn uppers alone take three and a half hours—and are stitched by Roman with a surgeon's skill. The most he can afford to charge for a basic shoe without pricing himself out of the market is $1,200, a veritable bargain considering the sheer quantity of work involved. When he presents his creation to its new owner, it's difficult to tell who is the prouder.

Roman's father and grandfather were shoemakers in Russia when Russian calf was the leather of cobbling legend. After moving here, Roman worked for the storied Fifth Avenue shoemaker Vincent & Edgar during that firm's final year. Upon their retirement, he assumed the helm of the business and moved to these humbler quarters.

Despite his Slavic accent, he can articulate the advantages of custom footwear over ready-made better than most of his colleagues because he has dismantled and reassembled every fine ready-to-wear shoe known to man. He charges two hundred dollars to resole a shoe. His basic premise is that whether the renowned Edward Green handmakes your shoe one at time or Florsheim mass-produces it, your foot still needs to fit the shoe's last and not the other way around. And fitting into a ready-to-wear last that can properly support the wearer's particular foot is almost impossible unless you happen to have a perfectly shaped foot, which, according to Roman, few do.

This cobbler claims to be learning constantly and he finds great pleasure in being so young for a craft that is nearly extinct. Looking at him in his jeans and sport shirt, surrounded by his shop's tattered decor, you will be surprised by his sophisticated eye as well as his familiarity with the styling and detailing of higher-class European shoemaking. If you are prepared to accept the normal ten-to-twelve-week wait, you will be rewarded with footwear that is as authentically bespoke as it is designed in the best tradition of London's West End.

E. Vogel
19 Howard Street
New York
Telephone: (212) 925-2460
Hours: 8–4:30 Mon.–Fri., 9–2 Sat.

This firm makes some of the best riding boots in the world. It supplies boots for members of the United States Olympic equestrian team, for distinguished European and Asian tack shops, and for countless numbers of nonequestrian shoppers. Unlike most European models, which tend to run heavier and fit larger, this show boot is appealing for its height, lightness, and snug fit. The Vogel boot has a sole that, like its upper, is more flexible and affords the rider a more sensitive contact with the horse, while its longer length protects him from being pinched by the saddle pad.

As genuine, dyed-in-the-saddle horse people (they run their own horse and trade shows), the Vogels know it all. Everything they sell is bench-made on the premises. Their workshop, its air redolent of shoe leather, is still located in its original Manhattan venue, a narrow, three-story building that dates back to 1872. With its old sign in the shape of a riding boot hanging out front, it has the feel of a Nottingham cobbler. Boots are the specialty here—they make well over two thousand pairs annually—so don't be distracted by their shoes, which represent a somewhat less sophisticated offering.

Boots start at $350 (for a calf paddock boot) and, once measurements have been recorded, take ten to sixteen weeks (depending on how busy they are) for the finished product. For showing, dressing, and eventing, the firm recommends French calf leather for its softness, suppleness, and fine grain. More important, the hide "shines up" to a greater luster than domestic leathers. Numerous other styles are available including Field, Newmarket, and Wellington. Their Hunt boot was first made with a loose-fitting top that could be pulled up over the knee whenever one went trampling through the brier. Today it is close fitting and comes with a cuff, but you have to "make your colors" before you are permitted to attach it. And the Vogels, with their impeccable horse sense, can teach you the proper etiquette and protocol required to attain them.

NEW YORK CITY

J. M. WESTON NEW YORK, INC.
42 EAST 57TH STREET
NEW YORK
TELEPHONE: (212) 308-5655
FAX: (212) 308-2710
HOURS: 10–6 MON.–SAT. (IN SUMMER, 11–5 SAT.)

The only shoemakers still crafting authentic hand-sewn, welt-constructed ready-to-wear footwear are on the other side of the Atlantic—England's Edward Green and Weston in Limoges, France. Weston is the only one of the two to have a freestanding store in the United States.

Celebrated in France and especially in Paris, where they have five shops, Weston began as a custom riding-boot maker and took to manufacturing handmade gentlemen's street shoes around the turn of the century. This elegant French *bottier*, which opened in the fall of 1986, sits across from the Four Seasons Hotel as a handsome addition to Gotham's most luxurious cross street.

Upon entering J. M. Weston, one is immediately captivated by its decidedly low-key, craftsmanlike attention to detail and appointments. With its paneled walls, beige carpeting, and tan-and-cream moldings, you might think you have stepped inside one of the firm's hand-lined leather creations. The store originally showcased their model shoes under glass, a presentation that smacked of too much French hauteur for the colonies' taste. Today, these samples rest on custom-made mahogany tables set conveniently at eye level like fine jewelry, so customers can readily imbibe their subtle shadings and handcrafted character.

Like Paris's John Lobb Custom, many of the Weston styles are based on the larger proportioned French country shoe. When broader-shouldered, fuller-cut clothing first caught hold, it was their black demi-chasse lace-up that provided men with one of the few high-quality shoes capable of balancing the new fuller-scaled fashions. Many who had previously thought of Weston only as a traditional shoemaker (which it certainly is) were delighted to discover that several of their vintage models could be mated with the new clothing silhouettes, imparting a frisson of class and downtown chic. One of the shoes they do best, along with John Lobb, is a sophisticated penny

loafer from which all vestige of high school has been removed. They carry it in many colors, widths, and skins from suede to crocodile, at prices from $395 to $1,500.

As Weston makes their shoes one at a time, you can, for a 15 percent surcharge and ten-week wait, order anything you want, a reassuring thought for the man who requires a size 8 for his left foot while the right takes an 8½. They have a large variety of shapes and soles to interchange, enabling them to create your demi-custom shoe at a ready-to-wear price.

Weston offers a wide range of fashionable casual shoes that convert from an uptown to downtown mien with a simple change of hosiery. With Europe's only self-contained shop housing such variety and made-to-measure capability, Weston surely has a leg up on its European counterparts.

WORTH & WORTH
331 MADISON AVENUE
NEW YORK
TELEPHONE: (212) 867-6058
HOURS: 9–6 MON.–FRI., 10–5 SAT.

Fine headwear is a bit like fine cigars. Both are holdovers from yesteryear. Neither product appeals to a large cross section of men, but what clientele they do attract tend to be discriminating and demanding. Satisfy such opinionated tastes and you have created a customer for the long haul. Since 1922, Worth & Worth has been doing just that and doing it better than any of their competitors—a statement easily substantiated, as they are the lone hatter to survive the lidless and longhaired years of the post-Kennedy era.

During that time when custom dictated the covering of a man's head and other purveyors were selling hats for a buck or two, Worth & Worth were selling theirs for $6 and up. Almost a bespoke hatter back then, they were determined to separate themselves from the minions and make only the best hats available. They did, developing a carriage trade comprising the socially correct and the criminally incorrect, from Lodges to Lucianos.

NEW YORK CITY

NEW YORK CITY

In 1959, the original owner John Margolis sold the business to a man who supplied linings to the headwear trade. Around 1975, Harry Rosenholtz, a customer, offered to buy the business. The owner agreed with one stipulation: Harry had to serve a one-year apprenticeship in the store before the transaction would be made final. He not only fell in love with the business, he developed an even greater affection for the owner's daughter. Harry ended up wedded to both, relationships that continue happily to this day.

At the time he first became involved with Worth & Worth, it had become a large wholesaler of mediocre headwear. Beginning in the early 1980s, Harry redirected the business back to its upscale clientele, once again employing the established production methods and legendary quality that had gradually disappeared as the demand for fine headwear similarly diminished with each decade. Today, Worth & Worth's credo reflects their commitment to uncompromised quality: if they cannot make it like they know it should be made, they will not put their label on it.

The Worth & Worth fedora is now handmade in Italy's second-oldest hat factory. Its shadings are made exclusively for them in the finest rabbit or beaver available. The hat is aged for six months in a humid storage room, enabling the felt to congeal and tighten, thus producing a lighter, more malleable hat. And just like in the old days, it can be touched into the desired shape without the use of steam.

Each year, Harry makes two pilgrimages to Ecuador to commission the rarest of Montecristos. Less than a hundred weavers make this headwear, from straw that is grown and woven only in one area of Ecuador. He carries them in eight different shapes and in various commercial qualities ($395 to $800). However, for the privilege of purveying an art that predates the Spanish settlers, he is willing to wait the eight months it takes to make the ultimate, and at $2,000 to $5,000 per Panama, so is his waiting list of international aficionados who covet these summer asterisks of rarefied comfort and style.

Along with his less formal fedoras ($100–$200) and an array of sports caps is a collection of dress hats including homburgs ($185) and bowlers ($250). All of the salespeople who work in the thirty-five-year-old Madison Avenue shop (or the recently opened, larger branch in Chicago) have a minimum of two years of hat-blocking experience.

They can discern various qualities of felt blindfolded, and are conversant in the history of headwear. After first considering the shape of your face and the distance between midbrow and the bottom of your chin, they can recommend a correctly proportioned hat for any customer. If they cannot fit you properly from among their various brim, width, and crown combinations, they will whip up a custom fedora in three months for $350 to $500. As is to be expected from a business born of a prior time, Worth & Worth is a merchant of stylish protection and a conduit of sartorial lore.

NEW YORK CITY

PARIS

An Introduction

If I had to choose only one city in which to buy all my clothes, I would choose Paris. This may seem surprising, as Paris boasts no internationally influential designer of men's fashion, lacks any historically significant male shopping bastion on the order of London's West End, contains not a single colossus of upscale menswear such as New York City's Saks Fifth Avenue or Barneys, and cannot claim to have more individually well-dressed men than Milan.

However, no other city can match Paris's all-encompassing assemblage of the world's best-designed and finest-made wearables. From Levi's to Lobb, Texas to the Tyrol, all the international classics of male habiliment—"classic" being a designation of the highest order in this extremely judgmental country—are represented here. Whether offered in their original form or revised with that inimitable Gallic *goût*, their diversity has made Paris the world's gourmet supermarket for all things sartorially stylish.

And no one displays clothes as appealingly as the French. Even when the most ordinary clothing is presented through the discriminating eye of the French retailer, it assumes an unmistakable chic. Taking an evening stroll down one of the *ville*'s "boulevards of luxe" such as rue du Faubourg-Saint-Honoré or avenue Montaigne, one finds shop windows lit in spectacular declaration of the fashions being proposed within. This is a treat capable of eliciting respectful awe from even those least enamored of French hauteur. Paris's breathtaking beauty and innate flair for the visual underscore the national government's preoccupation with the city as a symbol of France's illustrious culture. The last two administrations have spent more money preserving and enhancing its aesthetics than all the previous postwar French governments combined.

Paris has also played a significant historical role in the European male's sartorial education. Upon a royal visit of Queen Victoria in 1886, the Paris courtiers, bedecked in their silks and jewels, became enchanted by the "poverty *de luxe*" of the English aristocracy's coun-

PARIS

trified tailored woolens. As the philosopher and confessed Anglophile André Maurois observed, "There is something affected and deliberate about the very casualness of shaggy fabrics in which a Continental dresses whereas the English know how to be truly casually casual and therefore elegant." Ever quick to recognize genuine style even if it was not of their own making, France became the first European nation to adopt the *style anglais.*

A new international era of men's fashion commenced with England leading the way and the rest of Europe doing their best to catch up. Savile Row became its epicenter as Continentals flocked to London to put themselves in the hands of the Row's master tailors. With the French view of dress as an instrument of class and privilege, Paris easily assumed the role of England's most ardent disciple. The city's equidistant proximity to all the European capitals made it a fashion hub where gentlemen could augment their new English wardrobe and pick up Paris's latest version of the Bond Street style.

Between the two world wars, many of the globe's greatest craftsmen and designers set up shop to cash in on Paris's bustling international trade while legitimizing—in the eyes of their countrymen back home—their bona fides as authorities in English fashion. Two of Italy's most renowned tailors, Caraceni and Cifonelli, opened up affiliates there. Vienna's elegant Knize soon followed. New York City's *chemisier* to the then nouveau riche, Sulka, became the first American firm to establish a Parisian outpost. From across the channel came St. James's bespoke bootmaker John Lobb and Jermyn Street's Hildetch & Key. The influx of talent and taste just kept coming. Whereas a man voyaged to London if he was intent on acquiring something uniquely British, or made Rome a port of call when wishing to purchase lightweight wearables of virtuosic workmanship, he came to Paris to see how the French infused designs from beyond its borders with a certain élan that transformed the original into something even more luxurious.

France has never been known for having a definable men's look. However, the French silhouette has always been more body-conscious and elongating in the torso than its European or American counterpart. This partially explains how one of France's own (although Pierre Cardin was born in Italy) revolutionized men's tailored clothing in the 1970s with his signature hourglass silhouette. However, French fashion—

PARIS

at least that which has evolved since the close of World War II—has largely been an amalgam of elements and influences from other countries, particularly England and America.

Today, Paris remains the melting pot of upper-class fashion. It is not unusual to see a Parisian on *le weekend* sporting his Levi's 501 jeans, brown suede Weston slip-ons, Charvet-style dress shirt open at the neck under an English tweed jacket, Italian quilted riding coat, English scarf, and New York Yankees baseball cap. Hermès, Charvet, Gelot, and Motsch, world-renowned names of historical import, continue to compete with Mettez's tyrolean wear, Old England's British updates, and Loft's bubbled-up street basics for the international man's attention and francs.

With four famous firms vying for the attention of the bench-made shoe aficionado, Paris reigns supreme as the undisputed center of hand-lasted, ready-to-shod footwear. The city's selection of sophisticated urbanized sportswear surpasses even New York City's. At least five Parisian stores sell their sport shirts with the famous Brothers' long button-down collar. It seems only the French instinctively understand how that collar's particular roll transforms the entire shirt into something intangibly smart. Paris's fickle weather ensures that a plethora of high-class headgear, umbrellas, gloves, and scarves is always available, as well as an international aggregation of outerwear that reflects its turf-tough origins.

France is still a class-driven society. For over three hundred years, it was the world's richest nation, with a sybaritic court that reflected the Napoleonic zeal for redesigning everything from entire cities to the legs of chairs. I have rarely seen the French revise a design from another land without adding to its inherent style. While they did not invent the jean, they certainly remade it into something fashionable and chic. Weston removed the collegiate from the American penny loafer, transforming it into an object of persuasive sophistication. Hermès unbridled the English riding coat and made it elegant. And Loft, the Parisian Gap, removed the workwear from the American T-shirt, improving its design, quality, and fit without the encumbrance of a stiffer tariff.

The Parisians are perhaps a touch arrogant and chauvinistic. Their role as guardians of aristocratic taste and style may be self-appointed. However, in the realm of menswear, I for one am content to let them have their day in court while exercising my due diligence out in the stores.

ARNYS
14 RUE DE SÈVRES
PARIS
TELEPHONE: 45 48 76 99
FAX: 45 48 84 72
HOURS: 10–1, 2–7:30 MON.; 10–7:30 TUES.–SAT.

Fifty years ago in the Paris of Gertrude Stein and Picasso, this store provided a refuge for a certain kind of intellectual toff. It was (and still is) for the bohemian dandy or boulevardier—such as the late Gide, Cocteau, Le Corbusier, and even the rough-hewn Hemingway—who preferred his fashion left-wing in expression, but Tory in quality. When not engaged in fevered polemics or the modern arts, members of this heady group indulged themselves in flights of masculine fancy that could be worn on the eccentric side of the road. They found their sartorial muse at Arnys.

Owners Michel and Jean Grimbert are the grandsons of a Russian immigrant tailor who came to Paris in 1901 and then in 1933 founded this establishment—one of France's first ready-to-wear boutiques. At that time, Paris was a city of custom tailors and low-end shops. The store flourished from the moment it opened its doors, but was forced to close during the Second World War. Its reopening was nearly as welcome as the Allied victory.

Today, everything is made exclusively for the store, from their specially lined and numbered print silk ties to their own fish-mouth-shaped notches on the lapels of their single-breasted jackets. You could search through the inventory of any store in Europe without finding a better hand-finished suede vest, with horn buttons, knitted back, and silk lining at $650. Among their most elaborate presentations is the Corbusier jacket (which was first made for the man some forty years ago). It's a sport coat fashioned like an artist's smock with a mandarin collar and four pockets and made in seasonal fabrics: for fall, loden ($950) or fawn corduroy lined with flannel ($895); for spring, stone-washed black or navy cotton ($795). The jacket offers a stylish alternative to the conventional sport jacket, particularly if you don't mind being perceived as a bit of a dilettante.

PARIS

Arnys sportswear is so well made and costly that one imagines the only sport you can wear it for is shopping. Their knockabout chambray-style sport shirt is a simple affair of lustrous dark-blue, pima end-on-end cotton with long point collar held down by hand-finished loops and hand-sewn pearl buttons placed under the collar à la Armani. A collegiate blouson trimmed at the waist and collar with striped ribbing may seem pricey at $650; however, it is made with Belseta, a microfiber so fine, 90,000 meters of it weighs only one gram.

ONE STORE THAT COULD BE JUDGED BY ITS COVER: AN EXCEPTIONAL CANVAS SUIT CARRIER SYBARITIC ENOUGH FOR EVEN THE MOST DANDIFIED OF PARISIAN BOULEVARDIERS.

Upstairs is where the very soul of this men's haute couturier really resides. Arnys specializes in making vestments based on the models worn by the original settlers of this area of the Left Bank, the landed gentry of eighteenth-century France. These clothes are some of the most original and well-designed men's *vêtements* in menswear. They are a cross between the English Edwardian and the French gentleman farmer with a soupçon of Count d'Orsay's dandy thrown in. Their baronial tweed cloak ($1,400) is designed as a long sleeveless vest with an attached cape that sumptuously drapes the shoulders. Another wrap of ancient design is a topcoat with special hammer shoulder in whipcord or tweed ($2,000).

The establishment also custom-tailors proper suits and dress shirts. The suits start at $4,000 while their bespoke shirts start at $450—costly to be sure, but they will fit them *sans* charge for the rest of your life. And Arnys makes them to last that long. This is probably the most expensive menswear store in the world, quintessentially French in its unabashed celebration of the eccentrically epicurean in male adornment.

Au Petit Matelot
27 avenue de la Grande-Armée
Paris
Telephone: 45 00 15 51
Hours: 10–7 Mon.–Sat.

Mentioned by Balzac in his *Lectures on Paris* in 1837 and rewarded by French president Jacques Chirac with the Gold Medal of Paris for being one of the oldest stores in Europe, Au Petit Matelot is the Abercrombie & Fitch of France. Not as august a dwelling as its history might suggest, this establishment has a worn boat-planking facade, which attests to its role as France's original outfitter for the sea. Two authentic turn-of-the-century signs attest to this establishment's vintage while proclaiming its artisans as "Clothing Specialists for the Hunt, Voyage, Automobile, and Yachting." If that is a boast, it is certainly no idle one.

The store has added to the navy pea coat ($250), which it invented, such classics as the English Gloverall duffle coat (which it was the first to import); walking coats by Barbour and its more colorful competitor, Henri Lloyd; loden coats (for which the cloth is bought in Austria and sent to Germany for making); olive green riding jackets; and yachting reefer coats with matching trousers. Here, too, is the most extensive collection of jockey silks in Europe. Their colors in all their particular combinations have been designated and registered by the Horsemen's Association; one of the store's silk designs is displayed in New York's Museum of Modern Art.

Not only do you see a lot of outerwear here, you see much of it in green. In this part of the world, green in its various hues symbolizes everything that separates the newly rich from the patrician, the tastes of the immigrant from that of the gentry. For a European, green is rich in aristocratic imagery. For the English there is the British racing green of their Jaguars and Aston Martins or the Edwardian green of the Connaught Hotel's grill room, Asprey's carpet, or Harrods' awnings and shopping bags. To an Italian, bottle green is his navy blue. And to the French it is the color of nobility and breeding that marks the wearer as a man who can afford to take his leisure in the country. Green is not only the color of status for classic outerwear, but nothing provides better camouflage for the nobleman enjoying the pleasures of venery on his estate.

PARIS

Originally designed to accommodate specific functions and movements in the field or forest, little of Matelot's wearables have been modernized in the interests of fashion. Garments retain their original cloth as well as original character, and they are a welcome throwback to a time when clothes were bought to be handed down from one sport to another.

BERLUTI
26 RUE MARBEUF
PARIS
TELEPHONE: 43 59 51 10
HOURS: 10–7 MON.–SAT.

This elegant *bottier* is situated in the heart of Paris's "Golden Triangle." It sits diagonally across the street from this city's most famous tailor, Cifonelli, with whom it shares many customers. Some of these are older gentlemen looking for finely crafted shoes with a conservative style. Some are businessmen from India, Africa, and the Orient for whom the store adapts its shoes. And some are, or have been, Arnold Schwarzenegger, Sargent Shriver, Alain Delon, and Jean-Paul Belmondo.

The fifty-year-old shop, wrapped in a weathered facade of caramel-colored wood, was designed by M. Berluti to resemble a nineteenth-century house. With its beige carpets, cream walls, polished wood cabinets, and leather chairs attended by aged standing cigar and cigarette ashtrays, it more resembles a gentlemen's sitting room than a bootmaker's premises. The shoes are arrayed on several curved marble counters. While their styles are not as English in feel as Lobb, each is a beautiful confection of slightly fuller-proportioned models. Below them, on the bare marble floor, stand the boots. Generous swatches of leather hides, cascading to the floor, are also on display.

Berluti is committed to the proper fit. At the risk of losing a sale, they will readily inform a customer if the style he has requested is contrary to what his foot requires. The store might discourage him from buying a slip-on if his arch is not appropriately shaped to secure it on his foot and will graciously explain why. During the 1960s, Berluti

became the first *par mesure* shoemaker to introduce a collection of ready-to-wear footwear in Paris. At $500 to $1,000, it's a great way to own a custom-looking shoe without paying a custom-made price.

All the individually crafted shoes are made on the premises. First comes a trial shoe, with a sole made of special Sardinian wood. After the customer tries it for several months, Berluti opens the shoe to judge the foot's distribution of weight before creating a final product. These take four to six months and cost $2,500.

Aside from their exemplary workmanship, the savoir faire of the Berluti craft is found in their ability to exact just the right highs and lows of shading from the shoe leather. Once finished, the shoes are polished with contrasting colors—green or red highlights are painstakingly rubbed into black, for example—to create reflections and shadows and, ultimately, a patina much like a fine piece of Chippendale. If, as Kennedy Fraser suggests in her book *The Fashionable Mind*, clothing is the furniture of the mind made visible, Berluti can craft some masterful cabrioles.

CHARLES BOSQUET
13 RUE MARBEUF
PARIS
TELEPHONE: 47 20 56 59
HOURS: 9:30–7 MON.–SAT.

In 1969, Michel Barnes introduced a new concept to Paris retailing. Opening his first store—simply called Barnes—he filled it with swatches and fabrics and offered to make individual clothes for each customer. This proposition combined the best elements of the custom and ready-made worlds. It enabled the Paris man to buy something different: well-priced individually tailored clothes that could be delivered in less time and with less fuss than those custom-made. They also fitted better and looked more personal than anything that could be bought off the rack.

Today, Monsieur Barnes operates five such stores, his customers awestruck by the choice of eight hundred fabrics brought directly from Europe's top mills, such as Moxons, Loro Piana, and Carlo Barbera. The

PARIS

CASUAL CONTINENTAL CHIC: GOSSAMER-THIN
CASHMERE-AND-SILK NECK DECOR FROM
DRAKES OF LONDON. ONLY THE EUROPEANS
SEEM TO SPORT THESE SANS AFFECTATION.

clothes, which are based on models that Michel designs and stocks in each shop, are manufactured by a small factory in northern Italy. He delivers the suit in under two weeks at a cost of $800 to $850.

Michel's business instincts tend to be as impeccable as his taste. Recently, he concluded that his more sophisticated customers were ready for a change. As one of Paris's most stylishly attired bons vivants, Michel has always admired the casual elegance of Fred Astaire. Having evolved his store's silhouette from its square-shouldered look of the typical French suit of the 1970s and 1980s into a softer shoulder look, his new lighter constructed cut more resembles his own personal approach to dress. With English-flavored furnishings to help define this new mood and Paris's most tastefully evocative windows for the traditional coat-and-tie man, the Barnes stores have once again reasserted themselves as the training ground for the contemporary French businessman ready to take the next step up the sartorial ladder of style.

CERRUTI
3 PLACE DE LA MADELEINE
PARIS
TELEPHONE: 42 65 68 72
HOURS: 10–7 MON.–SAT.

Just off the Faubourg-Saint-Honoré, on a lovely corner that looks out on the majestic Madeleine Church, this store continues to be an obligatory stop for those who want to see what's happening in modern men's fashion. The charismatic Nino Cerruti took over his family's well-

established Italian textile business in 1950, when he was a mere nineteen. In 1967, he opened this establishment as his new international headquarters.

Upstairs, his tailored clothing floor provided one of the earliest settings for sophisticated Euro-clothing. It has always been the place to study the latest silhouettes in his sophisticated Italian-designed textiles. Sportswear and furnishings are on the main floor. There are always great sportswear items, such as Nino's buttery soft leather pieces in the latest color or shape. His sweaters and outerwear are consistently top-notch.

Over the years, Nino has become celebrated for his visionary approach to men's fashion. He is a devotee of soft materials and an unstructured cut that allows maximum comfort and easy body movement. "More than a clothing style," he says, "it truly is a lifestyle." It is a lifestyle often coveted by the rich and famous. Nino has become a prolific designer to the stars, providing the clothes for such films as *Bonnie and Clyde, Pretty Woman, Basic Instinct,* and many others.

A new custom couture shop has just opened in the store's lower level. SALON SUR MESURE, says the discreet sign at the top of the stairs. Downstairs, he designs clothes in accord with his guiding philosophy: to make urban wear more casual, and casual wear more dressy. In an adjacent workroom, Nino has installed eight people to hand-tailor the new, drapier fabrics of Biella into his signature slouchy dresswear. Suits cost $2,500 to $4,000, and require the two or three fittings that are so much a part of the custom process. Decorated in creamy tones with parchment walls and sycamore floors covered with an eye-catching contemporary rug of Nino's design, it is modern enough to almost obscure the garments' traditional origins. It is not surprising to see Signor Cerruti injecting a bit of freshness into the age-old craft of custom tailoring. Nino has always relied on the past to help guide him toward the future.

PARIS

CHARVET
28 PLACE VENDÔME
PARIS
TELEPHONE: 42 60 30 70
HOURS: 9:45–6:30 MON.–SAT.

Charvet offers more reasons to have shirts custom-made than any other shirtmaker in the world. Take its carpeted elevator to the second floor. Stepping out you will think you died and went to shirting heaven. Gatsby would have expired from overstimulation—"bolts and bolts of fabrics, piled to head height and taking up an area as big as a millionaire's billiard room," as the writer Peter Mayle has observed. There are over fifty different whites, and more stripes, checks, plaids, silks, and linens than one could ever imagine existed. What an intoxicating way to encourage one to acquire more shirts than originally intended. And with what generosity they are presented. This is not a place that asks you to visualize a finished shirt from a four-inch-square swatch. Here, the bolt is rolled out and displayed in full measure, giving you ample opportunity to see how the fabric hangs and decide if its color and pattern flatter you.

Maison Charvet, *chemisier extraordinaire*, is located in a distinguished bank building flanking one end of Paris's most empire-elegant square, place Vendôme. Although its ground floor is filled with Louis XVI furniture and Oriental rugs, and crystal chandeliers hang in each of the five windows, its cold formality is cheered by a dazzling array of colored and patterned silk in the guise of neckties and bows suspended hodgepodge around the room's circumference, with squares and scarves piled high on every square inch of the tabletops scattered about the floor.

This firm was founded in 1838 by Charles Charvet at a time when gentlemen did not go to their shirtmakers, their shirtmakers went to them. A maverick, Charvet changed all that. He also pioneered the then astounding notion of attaching the collar and cuffs to the shirt. After his death, Maison Charvet remained a family business operating in much the same manner as it always had. Very little was displayed; a customer was shown only what he requested. In most cases, this was something fairly conservative. The typical Charvet shirt was sold in white, blue, cream, or a subtle stripe.

Then, in 1963, family strife divided loyalties and Charvet was put up for sale. To prevent its falling into foreign hands, Charvet client Charles de Gaulle urged Denis Colban, a supplier of shirting fabrics to the establishment, to find a French buyer. Colban, who during his years of service to the shop had never entered it through anything but the tradesman's door, came up with a novel buyer: himself.

Things began to change as soon as he assumed the business's helm. The shift, subtle at first though it would prove seismic later, became apparent when Baron de Rothschild visited the store and asked to see some shirt swatches. One of those proffered was an elegant pink that immediately stood out when surrounded by so many sober tones. Questioned about its presence, Colban, following the long-established Charvet custom, responded that pink was not for the Baron. To which Rothschild responded, "If it's not for me, who is it for?" Some time later, Nelson Rockefeller requested some shirt swatches be sent to New York. Colban, much to the horror of the Charvet workers, included along with the predictable blues, whites, and creams some bold stripes and unusual colors. Of course the order came back with the rousing new colors chosen.

From that point on, Colban changed the Charvet perspective as well as its formerly passive relationship with the customer. He relished the *chasse* to please the unpleasable and was adamant in his commitment to accommodating any taste or quirk. These sentiments are echoed by his son, Jean-Claude, and daughter, Anne-Marie, who, since their father's death in 1995, carry forward his legacy.

The legendary Charvet shirt is produced in its own factory at Saint Gaultier, some two hours outside of Paris. Only one woman works on each shirt at a time, whether custom or ready-to-wear, and she does everything except sew on the buttonholes and iron. The buttons are made of thick Oriental mother-of-pearl that cannot help but make one feel special. A custom shirt costs $280 to $350, depending on the fabric, with one fitting required for completion in thirty days. A less time-consuming alternative, more convenient for foreigners, is the demi-measure: The body of your shirt is cut to an existing pattern, and its sleeves and collar are made to measure. This takes only three weeks, with no fittings necessary.

PARIS

From head to foot, the merchandise here is breathtaking in its depth and diversity. There are soft fedoras in fifteen colors ($250), silk sweaters in thirty colors ($600), silk T-shirts with sleeves ($125) and without ($80), knitted silk briefs ($85), silk underwear tops ($125), and incredible custom silk pajamas ($1,200). Charvet's shoes are packed in bags of its own shirting fabrics ($350).

Charvet is unique today not merely because of its magnificent wares or long tradition, but also because of the philosophy first espoused by Father Colban and instilled in his children. "Customers don't come to us to save money," he would say about more than one special order, "they come to get precisely what they want—and that is exactly what I intend to give them."

For most of the 1920s and 1930s, five French *chemisiers* were universally acknowledged as the world's finest men's furnishing stores—Poirier, Seelio, Seymour, Bouvin, and Charvet. Only Charvet survives, and it is probably better today than it was then. "Charvet is profoundly faithful to the soul of France," proclaims one devoted customer. That customer, Jean-Louis Dumas, is the owner of Hermès. And here, the customer is always right.

CIFONELLI
31 RUE MARBEUF
PARIS
TELEPHONE: 42 25 38 84
HOURS: 9–12:30, 2–7 MON.–FRI.; 9–12:30 SAT.

Cifonelli is one of the most famous names in the history of Italian tailoring. Like the equally renowned Caraceni, he came here from Rome during Paris's heyday between the wars. Unlike Caraceni, he stayed after the war was over. Today, no other tailor can boast a higher profile. Cifonelli caters to the city's aristocracy as well as a select group of internationals and celebrities present—such as Omar Sharif, Paul Anka, Jean-Claude Killy, Karl Lagerfeld—and past, like Darryl Zanuck, Orson Welles, Porfirio Rubirosa, and Josephine Baker (who created a sensation and a whole new fashion when she first suited up in her Cifonelli-made tails). Having a suit made here is like joining an

elite club with dues set accordingly—$3,800, three fittings, and a six-week initiation period.

Founded in 1926 by Arturo Cifonelli, the firm is now run by his son, Adriano, who took over after his father's death in 1972. One arrives at his shop after passing through a courtyard and ascending a grand marble staircase to the first floor. There you will be greeted by what is, given the company's history and business, a surprisingly modern setting: lustrous black ceilings, lacquered champagne walls, brown-and-beige patterned carpet, and Empire chandeliers. It is sleek, strong, and masculine.

So too is the Cifonelli suit. What distinguishes it is the treatment given the shoulders. Fitted with expert precision, the sleeve head is rounded in a way that immediately declares its hand-rendered pedigree. The armhole is cut high, affording a man a longer look as well as a wide range of motion. The jacket stays put on the shoulder no matter how much the arms move. It offers a definite line, with the roundness of the sleeve head muting the suit's potential sharpness.

With shoulders and chest that build a man up, this is the ultimate French power suit. Its silhouette shows off the wearer, imparting a regal carriage. It is a structure that allows a man to appear confident and strong while walking amidst this city's other statues of sculpted virility.

———

DANIEL CREMIEUX
6 BOULEVARD MALESHERBES
PARIS
TELEPHONE: 42 66 54 50
FAX: 42 66 27 78
HOURS: 11–7 MON.–SAT.

For those who perused French fashion during the seventies, Daniel Cremieux's shop was one of the primary reasons Saint-Tropez became a must stop for casual wear. For many, it still is. Daniel's store in Paris, run to perfection by his stylish wife, Jeanne, is a source of American-inspired sportswear that is regularly shopped by retailers, manufacturers, and insiders in search of design innovation.

PARISIAN BON TON: TWO ICONS OF AMERICANA—THE STARS AND STRIPES AND BROOKS BROTHERS BUTTON-DOWN.

Daniel is more experimental than his French colleagues. He has fun with his clothing, infusing it with vitality and wit. His sport shirts ($90), striking Francophile rugby shirts ($100), hand-knit sweaters ($150–$300), and terrific red-white-and-blue flag shirts are a kind of tongue-in-chic Brooks Brothers. They're displayed in a college shop atmosphere you'd imagine uncovering in France during the fifties: lots of light wood, brass, old sporting sculptures, and framed menswear scenes from yesteryear.

Whether using unassuming twists or bold strokes, Daniel forces us to view traditional apparel from his fun-loving vantage point. A visit here is always refreshing. The store and its wares are engaging and leave you feeling just a little bit merrier than when you arrived.

CRIMSON
8 RUE MARBEUF
PARIS
TELEPHONE: 47 20 44 24
HOURS: 10–7 MON.–SAT.

This charming outpost is the fantasy of Cecily Barnes. It looks like a college-town shop in Cambridge, England, and Cecily, who is English, can usually be found on the premises attired in Her Majesty's best: blazer, tartan skirt, and gillies.

The shop is named for one of Ms. Barnes's favorite colors; its crimson-lacquered facade is bookmarked between two enormous banners painted crimson and gold. These provide a colorful diversion on

an otherwise pedestrian street. Not surprisingly, the interior is furnished with tartan-covered wood tables, Persian rugs, deer heads, tartan pillows, and Cecily's vivid wares stacked on open shelves.

Crimson specializes in English and Scottish-made knitwear classics such as fine-gauge Smedley wool knit shirts ($130), two-ply Scottish cashmeres ($450), and lamb's wool crew necks and V-necks ($140). This store is one of Paris's best for fine-gauge hosiery, offering an extensive range in cotton lisle and wool hose ($30). There are also great patterned hose such as bird's-eye wool over-the-calf sports socks ($30). Americans have been known to think nothing of ordering several dozen assorted, right over the phone. All the hosiery comes in a vast array of rich, unusual colors that you would never see back on the other side of the Channel. Which explains why Cecily Barnes is in Paris.

A. CRISTIANI
2 RUE DE LA PAIX
PARIS
TELEPHONE: 42 61 12 34
HOURS: 9–12:30, 2–6 MON.–FRI.;
SATURDAY BY APPOINTMENT ONLY

This is one of Paris's last great tailoring institutions. It borders on the elegant place Vendôme, whose center is dominated by a statue of Napoleon Bonaparte. That landmark inspired the Cristiani logo: a pair of scissors affixed to the Colonne d'Austerlitz with the Little Corporal perched at its top. To further reflect the grandeur of its environs, the showroom-atelier was designed in the Empire style by the famed decorator Jansen. Hung discreetly on its walls are photographs of some of the firm's notable clients: Maurice Chevalier, Gene Kelly, Gary Cooper, Louis Jourdan, and Marcello Mastroianni.

The two tailoring Cristiani brothers, energetic and spry, like to finish each other's sentences. They remind me of the tailoring pair in the Sylvester Stallone comedy *Oscar*. In his book *Unto My Sons*, Gay Talese traced the life and career of their father, who came to Paris from Italy in 1911 and founded this firm in 1929.

The Cristiani suit is somewhat seventies French architectural: narrow shoulders, a clean chest, and closely fitted waist, with straight-

PARIS

hanging trousers. Where it differs significantly is in the detail work. The lapel buttonhole is cut on a horizontal line rather than slanted—a somewhat peculiar detail that Cristiani insists does a better job of securing the rosettes and ribbons that are so much a part of their prestigious clientele's dress. All the buttonholes are made by hand, with a different stitch used for those on the sleeve. In patterned and striped suits, the collar is attached in such a manner that the stripe or pattern continues without interruption. If a vest is purchased, the material can be cut on the bias so that no interruption of pattern or striping occurs here either. An interior pocket that buttons closed has a special compartment for carrying a pen or pencil. Cristiani's own imported silk is used for the linings.

Every portion of the garment is sewn and pieced together by hand. A Cristiani suit usually takes three to four weeks (although rushed visitors can be accommodated in eight days) and costs $3,000. How many fittings do they make? As many as you need. "We have a Brazilian diplomat who loves fittings," I was told. "We support him with patience because he is so elegant."

This establishment is more than just bricks and mortar, fabrics and furnishings. It is a living, breathing testament to the life of the Cristiani brothers, an extension of their shared passion for the tailor's culture and tradition. Only these old-world romantics could carry on such a business today. After their retirement, the Cristiani name may continue in business, but never in spirit.

FAÇONNABLE
9 RUE DU FAUBOURG-SAINT-HONORÉ
PARIS
TELEPHONE: 47 42 72 60
HOURS: 10–7 MON.–SAT.

The French love their tradition spiced with an American energy but grounded by an English pedigree. This is prep headquarters, French style. Although Façonnable's designer and owner, Albert Goldberg, was enamored of America's Brooks Brothers and England's Savile Row long before the worldwide ascendancy of Ralph Lauren, his success has closely paralleled the Polo evolution.

PARIS

Goldberg's father, a Jewish tailor from Poland, opened his store in Nice in 1950. In 1972, after some trips abroad, Albert opened his own Ivy League–inspired sportswear store down the Côte d'Azur in Saint-Tropez. Its success engendered a worldwide business. Façonnable now has twenty stores in France and its merchandise is carried exclusively by Nordstrom in America and Mitsui in Japan. The popularity of the collection in the United States recently prompted Albert to open his first overseas retail store right smack in the middle of New York City's Fifth Avenue. In 1984, he set up his European flagship store in Paris's rue Royale. Nine years later, Albert moved to this new, enlarged, multilevel structure.

Each of this store's rooms is designed differently, with elements borrowed from France, England, and America. The result is an arresting mélange of areas decorated in the spirit of their merchandise: a chamber with a coco mat trimmed in dark green for sportswear; Oregon pine walls and a rustic wood floor for outerwear; Persian rugs, herringbone floors, posh seating sofas, and English antiques for tailored clothing. Downstairs, you will find vacation clothes all year round: Bermudas, polo shirts, cotton sweaters, and colored boat shoes. This is also an excellent source for canvas-front, side-vented, natural-shoulder blazers with the obligatory brass buttons ($650).

As a bastion of button-down fashion for the Parisian blazer set, Façonnable represents yet another example of the Gallic knack for appropriating a formulaic aesthetic from beyond its shores and adding just enough joie de vivre to make it into something that the irrepressibly self-assured French can then claim as their own.

GASTINE RENETTE
39 AVENUE FRANKLIN D. ROOSEVELT
PARIS
TELEPHONE: 43 59 77 74
HOURS: 10–7 TUES.–SAT.

Gastine Renette, France's most renowned gunsmith, is famed throughout the world for its dueling pistols. Named after its two founding partners, Louis Gastine and Albert Renette, the history of this legendary

PARIS

French institution is intimately linked to the transition of the Champs-Élysées from an eighteenth-century preserve of outdoor walks and bucolic amusements to a residential district with mansions inhabited by Paris's most noble and elegant families. Few businesses existed in this district when Gastine Renette first opened its doors in 1812. However, other establishments gradually closed in around the gunsmith, eventually creating Paris's center of fashion, luxury, and prestige—the "Golden Triangle" of avenue Montaigne, avenue Franklin D. Roosevelt, and le Rond-Point des Champs-Élysées.

Offering a breath of country air to urban denizens, the Champs-Élysées was a serene place, a perfect setting for introspection or romance. But its calm was occasionally disrupted by the roar of gunfire. Duels were fought by hot-blooded men with cool hands in the nearby groves of the Bois de Boulogne. A maker and retailer of fine pistols could not ask for a more ideal situation. For over a century, not a single duel between aristocrats took place in this city without both combatants first visiting this cannoneer near the Rond-Point. They came here either to buy or rent a new set of pistols for the occasion or to receive instruction in the art of monomachy in one of the firm's shooting galleries.

DOUBLE-LENGTH AND DOUBLE-STRENGTH TRAVEL PARKA: LIGHT-WEIGHT LAYER OF HIGH-TECH PROTECTION THAT WATERPROOFS FROM HEAD TO TOE AND FOLDS UP INTO A FRACTION OF ITSELF.

Appointed supplier to Napoleon III after the formation of the Second Empire, Mr. Renette was one of the few people authorized to enter and leave the palace carrying guns. The firm became known among the gentry of nearly every country for manufacturing some of the most exquisite hunting rifles to ever down a grouse. Business flourished until the Germans stormed into Paris during World War II. When the Nazis forbade the sale of all weapons (they correctly assumed they would end up in the hands of the French Resistance), the store was transformed into a bicycle shop. After the war, the gunmaking activities were resumed in earnest.

Gastine Renette was bought in 1989 by Guene, a supplier of leather products to such prestigious firms as Dior, Cartier, and Baccarat since the turn of the century. As one of Paris's most evocatively French stores, its Gothic chapel houses the history of dueling weaponry craft, expressing the rich glory and culture of the mother country. Its original shooting galleries have been turned into an extended shop, but there is still a fifty-meter shooting room downstairs—for pistols only. This is like London's Holland & Holland, except with a Gallic flair—great banging-about boots, shooting clothes made in loden or Harris tweed, French country waterproofed shoes and headwear as well as leather products of field utility and suburban chic. Sold side by side with modern guns produced in the legendary Gastine Renette workshop, both recall a time when affairs of honor were not only matters of life and death but protocol and good form.

GELOT
15 RUE DU FAUBOURG-SAINT-HONORÉ
PARIS
TELEPHONE: 44 71 31 61
HOURS: 10–7 MON.–SAT.

When Edward VII forgot his hat on a trip to Paris in 1905, Monsieur Gelot saved the day and covered the royal head. As a result, he was the first Frenchman to receive a royal warrant from a king of England. Much about Gelot has changed since then. The establishment ceased producing silk top hats some ten years ago, and hare has replaced the now-endangered beaver as a primary source of felt. The original male hatmakers retired and were replaced by two women milliners. The business has even moved. Once ensconced in premises on the rue de la Paix that were positively redolent of character, it is now tucked away on the bright but antiseptic fifth floor of the new Lanvin flagship store.

But don't despair. Though changes have altered Gelot, it can still make the most of what your heart might desire for your head. The shop's current customers include such luminaries as Donald Sutherland and Anthony Quinn. Recently they had to doff their chapeaux in

PARIS

memory of their old friend and longtime customer François Mitter-
rand. Fedoras can be made in an infinite number of shapes from one
hundred different shades of Italian and English felt. They are pro-
duced on the premises in two to ten days, depending on the season,
and average $350, although an authentic Panama, fashioned from
straw produced by farmers in that country, costs $600.

Gelot is the world's last bulwark for custom-made chapeaux.
Anyone who covets personalized headwear should partake of this last
opportunity before the made-to-measure hat goes the way of the
endangered beaver.

HERMÈS
24 RUE DU FAUBOURG-SAINT-HONORÉ
PARIS
TELEPHONE: 40 17 47 17
HOURS: 10–6:30 TUES.–FRI.;
10–1, 2:15–6:30 MON., SAT.

If I had to spend part of my last Saturday afternoon in any store in
the world, the choice would be easy: Hermès. For anyone who views
being in the presence of the ultimate in luxury and taste as a spiritual
experience, this is the Vatican. Merchandise in this store is so rarefied,
you might be persuaded that Hermès is seeking to remind everyone
that the mere act of shopping here elevates the customer to a new tier
of privilege. Such Continental extrava-
gance is virtually unknown outside
of France, comparable only
to Asprey's of London.

Their menswear is cre-
ated without any consideration as
to its cost. The tariff will be whatever
it takes to make the best. And where
the designs are not obligated to bow to
commercial self-aggrandizement in the
form of a logo or signature but-
ton, the firm makes some of the
classiest raiment known to man.

BREAST-POCKET ÉLAN:
HERMÈS'S PEERLESS POCKET
SQUARES OFFER SILKEN APLOMB.

Hermès is also able to sell menswear in color combinations so sophisticated that not only would they be marked down elsewhere, they would probably have to be given away. Their extensive and diverse palette—with its greens from loden to bottle, its blues from baby to teal, and its mustards from Gulden's to Dijon—are an education to the beholder's eye. I am forever intrigued that, no matter how many times I return, each visit uncovers more examples of such highbrow taste.

No one produces a more expensively made pocket square ($85) than this firm. Its design is composed of at least ten colors that shade and shadow each other, producing a depth and richness usually found only in paintings. They are hand-rolled on the reverse side; when they're put in your pocket and folded, the points of the underside come to the front. If you are still not convinced that this is material luxury most people have yet to even dream about, mosey over to the belt counter for some waistline insurance. Don't dawdle over the ones on view. Ask instead for the leather-bound book with its fifty or so hides to choose among, such as cream ostrich, yellow bridle leather, or perhaps an olive alligator priced from $600 to $6,000. There is usually some wonderful outerwear here, such as the Hermès version of the English rubberized riding jacket in moss green or some other gentrified color. It is lined in their own orange tattersall wool check and topped with an off-hued brown corduroy collar. Upstairs, a shopping adventure in itself, you will find the most elegant tie bars in silver ($130–$400) or gold ($450–$1,500).

Only in France could you find something that is as outrageously tasteful as it is outrageously expensive. Such a combination is more rare than most people would believe. While it does not happen frequently, it happens more at Hermès than any store I know.

HONEST
37 RUE MARBEUF
PARIS
TELEPHONE: 42 25 87 27
FAX: 42 56 44 19
HOURS: 10–7 MON.–SAT.

This is not only one of Europe's finest sportswear stores, it is also Paris's best-kept secret. One might blame its name for its relative

PARIS

anonymity. Suggesting some gossip-driven magazine or the flash-of-the-week fragrance, it certainly earns my nomination for the most suspiciously off-putting appellation ever assumed by a men's store of such taste and intelligence.

Rue Marbeuf is the center for the French TV and film industry; the CBS offices are just upstairs. As a result, Hervé Lavise, the store's owner, buyer, and chief salesman, literally carries clothes for the fashion-savvy art director type: just the right T-shirt, the best unconstructed blazer, the latest suede walking shoe, or the best chambray work shirt. Pants are an Honest specialty. Fine trousers in gabardine, flannel, or khaki are always on hand. All the selections are understated and well edited. How else could the store so successfully exist in the "Golden Triangle" for almost twenty years?

Last season, Honest featured its own jacket based on the Corbusier model in a corded velvet—the zenith of deconstructivist luxury—and a charcoal-gray long-sleeved cotton-and-cashmere T-shirt, the fashion equivalent of the businessman's white shirt. Last spring, he carried a wonderfully designed natural-shouldered linen sports jacket that Brooks Brothers might have appreciated thirty years ago.

Bringing a touch of the Left Bank to the Right, the presentation here is unpretentious; the clothes are the decor. While not astronomically expensive, this merchandise reflects the style and knowing sensibility that again confirm Paris's predominant position as the city for sophisticated urban sportswear.

ISLAND
PLACE DES VICTOIRES
PARIS
TELEPHONE: 42 61 77 77
HOURS: 10–7 MON.–SAT.

This is Europe's most studied sportswear resource for the neotraditionalist. Of all the Ralph Lauren descendants, none has more wit or savvy than Island. Owner Loic Berthet sells his faux Americana to stores in Europe and Fred Segal in Los Angeles.

PARIS

While Island opened in 1976, its reference is the summer of '54—a romanticized vision of Maine. The store's interior, designed by Guillaume Truyoen with a decidedly New England flavor, has a country-house rug, old brass fixtures, vintage photographs of people by the sea, worn issues of *Field & Stream*, clip-on aluminum fog lamps, nautical clocks, fish hooks, old trunks, a wall telephone, and a gigantic rope coiled on the burnished vinyl floor under a table. A model dirigible floats above a display of slacks.

Most of the store's clothes are faded, stone-washed, sand-scrubbed, or bleached for that lived-in feel. They include great knit shirts, brushed-cotton button-downs, patch madras ties, hand-knit flag-design cable sweaters, washed chambray shirts, and button-fly plain-front soft khakis—among the best khakis sold in Paris. The prices range from $50 to $80 for knit polos, $75 to $100 for woven sport shirts, and $80 to $165 for trousers.

All the sport shirts feature only one shirt collar—you guessed it, the "Brothers" button-down. Berthet makes even plaid flannel shirts exciting with his new fabrications and great colors. His merchandise has a kicked-back, almost deferential air to it. As inviting and familiar as an old friend, it wants you to take it off the hook and relax with it at home, preferably in front of a hearth with a snifter of brandy.

HOBBS
45 RUE PIERRE-CHARRON
PARIS
TELEPHONE: 47 20 83 22
HOURS: 10–7 MON.–SAT.

Where would you go to find a one-of-a-kind design done in Scotland's finest two-ply cashmere, such as a reversible two-color sweatshirt, a jogging suit in marled athletic gray, or an all-over Tex-Mex design in a crew neck? Here, at Hobbs.

With its name inscribed in large gold letters against a striking facade of Fabergé blue, and situated atop an intersection looking down upon the grand couture shops on avenue Montaigne, this shop strikes the attitude of an amused Lord Fauntleroy considering the folly

PARIS

of his less-well-born neighbors. When owner Patrick Lifshitz, who formerly sold advertising for a magazine group, decided to pursue his true love, clothes, he decided to specialize. And specialize he does. His witty one-of-a-kind hand-knit intarsia cashmere sweaters inspired by cartoon characters, flags, or contemporary graphics are the darlings of affluent Parisians seeking a gift for that well-to-do someone who thinks he has everything.

This small, twelve-year-old shop is very woody, very Scottish in feeling. The sweaters come in limited depth and one size, to be worn oversized by ladies or casually full by men. Patrick's current offerings include such pinup icons as Fred Astaire, the Queen of Hearts, and Paddington the bear in crew neck pullovers ($750). Pure cashmere socks are available in twenty colors at $80.

Hobbs is a little slice of Parisian indulgence where one will find the ultimate gift in knitwear's ultimate yarn. With hands stretched 'cross the channel—the sweaters here are designed in France but made in Scotland—Hobbs serves up cashmere like nobody else.

MARCEL LASSANCE
17 RUE DU VIEUX-COLOMBIER
PARIS
TELEPHONE: 45 48 29 28
FAX: 45 44 96 83
HOURS: 10–7 MON.–SAT.

Marcel Lassance has been designing for the Who's Who of Paris for over twenty years. His fashion sense appeals to the slightly hipper Frenchman who prefers his classics on the more modern side. A pioneer of the brand of unstudied casualness that comprises so much of today's dressing idiom, Lassance takes a soupçon of Brooks Brothers and a pinch of fashion, mixes in his boulevard sensibility, and creates an elegantly haphazard pastiche of informality and style.

The inaugural Marcel Lassance shop opened in 1973. This larger one was established three years later and was one of the first to herald the Left Bank's arrival as a fashion arena. It was conceived as a large, unpretentious dressing room for men who like clothes but don't

like shopping for them. Coco matting lends the room informality and the customers—such as Gerard Depardieu, Jeff Goldblum, Johnny Halliday, Claude Chabrol, Costa-Gavras, and Claude Lelouche—sit around in cushy chairs and take their time. They are a devoted bunch, as is the staff. Philippe Vasseur, the manager, has run the shop since its inception.

Sports jackets range from $500 to $600, sports shirts are $80 to $125, and knitwear runs from $75 to $145. Marcel was a purveyor of unconstructed jackets years before Armani, and an early advocate of the Smedley-style knit collared shirt, worn buttoned up as the first layer under a vest or soft jacket. Marcel Lassance's strength is soft dressing, with fashion that is both sophisticated and self-effacing— much like Marcel himself.

JOHN LOBB

51 RUE FRANÇOIS-1ᴱᴿ
PARIS
TELEPHONE: 45 61 02 55
HOURS: 10–7:30 MON.–SAT.

Having been exposed to upper-class taste since his early upbringing, the Parisian male may be uniquely qualified to appreciate the aesthetic merits of bench-made shoes. Between the firms of John Lobb, Berluti, Edward Green, and J. M. Weston, Paris is the undisputed capital of hand-stitched, bespoke-inspired footwear. A shoe must possess an almost seminal character if it is to command this city's attention and respect. Such is the footwear sold at John Lobb.

Hermès bought John Lobb Paris, a subsidiary of the British custom shoemaker, in 1976 and moved it into the Faubourg-Saint-Honoré store. As the shop's custom offerings won it an international reputation for unmatched quality, Hermès began to consider the question of ready-to-wear. They wanted to produce and sell ready-to-wear shoes that would, in their way, achieve the same hallowed status as their *sur mesure* footwear.

Such luxury can not be rushed. Management understood that it would have to invest time while possibly deferring profits if it was to

PARIS

apply the Hermès standards to its ready-to-wear footwear. As a result, the firm planned its entry into the men's shoe market in the manner of a corporation plotting a long-range takeover strategy. First, they dispatched Mr. Dickinson, the éminence grise of their custom shoemaking, to England to oversee the development of the lasts. Dickinson instructed the craftsmen in how he wanted the shoe patterns cut. He insisted the stitching threads be of a particular size and color, and made sure the punching and finishing be done to his specifications. They then test-marketed a limited collection of models out of the Hermès store in Paris.

In 1990, Hermès opened this as its first freestanding shoe store. Four years later the firm further ensured the superiority and longevity of their product's workmanship by purchasing the Edward Green factory in Northampton, England's finest shoemaking facility. Today, Lobb makes the world's finest-designed and -crafted men's shoes.

Thirty-five models comprise its collection (with five or six new ones introduced each year) including a penny loafer that is so masterfully designed, it is probably the classiest ready-made shoe in the world. They even produce a lace-up cap-toe model in black suede, a shoe that from other firms often looks too close to Hollywood and Vine—not here. In an unusual nod to high fashion, there is even a Lobb rendering of the Doc Marten, although you would kick yourself if you were to splash oil or gasoline on them.

Shoes range from $550 to $650 and look so authentically bespoke that even a custom shoemaker would be hard-pressed to discern the difference without examining them off the foot. As with other products in the Hermès stable, these shoes were lavished over until they attained consistency with the firm's lofty tradition. The shapes of the shoes; the quality of the leather, cut from the same parts of the skins as in custom shoes; and the finishing—the soles and uppers hand-rubbed with polishes of different colors to obtain that bespoke lustre . . . this is as close to the custom-cobbled as a man can get without crossing the Rubicon into the millionaire's realm of Lobb Custom.

John Lobb Custom (in Hermès)
24 rue du Faubourg-Saint-Honoré
Paris
Telephone: 42 65 24 45
Fax: 40 17 47 09
Hours: 10–6:30 Tues.–Fri.;
10–1, 2:15–6:30 Mon., Sat.

The people at Lobb enjoy telling a story about this world-renowned shoemaker. It concerns Basil Zaharoff, the famous Allied agent and armaments provider of World War I. Zaharoff loved Lobb shoes and kept dozens of pairs in his Paris home. With death imminent, he requested that Lobb start yet another pair. He knew he would die before he could ever wear them, but he cherished Lobb shoes so much he just wanted to know they were in the works. Lobb customers are devoted; they tend to be fanatic about their shoes and establish life-long relationships with the firm, with good reason. This is the top custom shoemaker in the world.

The original John Lobb was established in London in 1829. With the opening of its Paris branch in 1901, Lobb benefited from the superior craftsmanship offered by the French. In many ways the Parisian shop would achieve an even higher standard than its estimable British brother. The subsidiary's acquisition by Hermès in 1976 has only heightened its commitment to excellence.

Housed in a separate home, on the side street abutting its august big brother's dwelling, the John Lobb Custom takes orders and measurements here. Its workroom, a scant ten minutes away, is outfitted to comfortably produce some four hundred pairs of cobbled art annually. They begin by making a leather fitting shoe with a cork heel, in which the customer is asked to walk about for several weeks. Then, once it is opened and the impressions are noted, everything is set in motion. A pair of shoes requires forty to fifty hours to make, takes six months for new customers, three months for old, and costs $2,000 to $3,000. The process is not unique, but the results certainly are.

They will make anything from tap slippers to golf shoes—and theirs is the ultimate in luxurious links wear, a true two-tone spectator ($2,800) whose white material is authentic buck with special soles and

PARIS

spikes, a far cry from the devolved plastic golf shoes of today. Among the other chefs d'oeuvre: incredible velvet monogrammed slippers ($2,000 plus $200 for the monogram); tapestry slippers using your own needlepoint ($2,000); or a Norwegian-style mountain shoe with a stitch as precise as any surgeon's ($2,000). Their shoe trees resemble wood sculptures and, at $300, cost more than most fine shoes. However, their most important treasure is the over forty years of old-world models and various examples of leather finishes that enrich and guide the selection process.

Given the venerable history of John Lobb and the standards of Hermès, Lobb Paris cuts no corners nor spares any expense to turn out the world's most expressively made shoe. In the United Kingdom, gun makers whose products are deemed to be beyond improvement are accorded the designation as a London's "Best." It is a rare honor, one that, were it awarded to shoemakers, would rest comfortably here.

LOFT
12 RUE DU FAUBOURG-SAINT-HONORÉ
PARIS
TELEPHONE: 42 74 44 02
FAX: 42 74 26 51
HOURS: 10–7 MON.–SAT., ALSO 10–5 SELECT SUNDAYS
DURING PV AND SEHM COLLECTIONS

Provocatively plunked down between the exquisite Hermès and the elaborate Gucci on Paris's premier "boulevard of luxe" is this shocking concoction of Patrick Freche. The French can glamorize anything: denim in the seventies, Polo in the eighties, and the Gap in the nineties. Opening an industrial-chic warehouse in Les Halles or on the boulevard Saint-Germain would not be surprising. Here, it is.

As a concept shop, Loft could not be more atypical. This is because Freche and his wife spent fifteen years in the French men's designer business. They learned that even the haute Parisian will wait until the expensive designer clothes are marked down at the end of a season and even then expect the same high quality and service at reduced prices. The couple also undertook some rather unorthodox research, such as parking themselves at the entrances to Paris's major

textile or RTW shows and noting the colors worn by the first fifty passersby. The result: Their shop offers its latest designs in black, navy, charcoal, and cream, or color combinations thereof, season after season. What a way to ensure the return of their customers, if those are the colors worn by the majority of fashion people then, now, and, in all probability, deep into the twenty-first century.

Loft opened in September 1988. More than a store, the Freches set out to create a label, a look, an ethic. Theirs is a thoughtfully considered concept of significant, long-range com-

PREPACKAGED AND PRESHRUNK PANACHE: THREE SHADES OF FASHION PERENNIALS IN MARLED GRAY.

mercial possibilities. Bohemian and stylish, intellectual and yet irresistibly simple, it is uniquely French. They make only what they feel will give intrinsic value for the prices they must charge and resist producing anything they do not believe in wholeheartedly.

And what they believe in is street-chic workwear for the Doc Martens/Prada throng, presented in a warehouse setting that announces you've arrived at the source, no middleman. The shop even has a girl knitting and some sewing machinery set up downstairs to underscore its feel of a factory outlet. Everything comes with special graphics in khaki-colored bags, kraft-paper brown boxes, or ecru sacks that are minimalist and marvelous. The shapes are spare, the fabrics modern, and the wares deconstructively finished. Without a doubt, theirs are the best-designed knitted T-shirts in Europe. Loft stays open on Sundays during Paris fashion weeks. Its owners are on hand carefully observing what the avant-garde is wearing, hoping it will inspire their next grouping of fashion basics for those who like their fashion far from basic.

PARIS

Maison Agry
14 rue de Castiglione
Paris
Telephone: 42 60 65 10
Fax: 42 60 48 92
Hours: 9–6:30 Mon.–Fri., 11–6 Sat.

Residing under one of Paris's stately covered promenades between the Tuileries and place Vendôme, Maison Agry has been the engraver to the French aristocracy since 1825. In a world of instant patina, this establishment can transport you and your family back to medieval times, when a coat of arms carried the same resonance as today's surname. No longer do you need to wear someone else's label or logo. The artisans at Agry will help you create your family insignia. It will then be registered, lest you achieve sudden celebrity and outsiders seek to claim a familial obligation.

This tiny sanctuary of patrician genealogy is a three-floor *boîte* decorated in the style of Charles X in rich Canadian maple, with touches of dark green and a winding wood staircase. Little leather-padded wood chairs creak as you sit to examine the archives and ponder ideas to illustrate your lineage. Wood shields, tiny drawers full of samples, and old books of heraldic designs are all within a coat-of-arms' reach.

The shop has been at this address since its founding in 1825 by the family Agry, who still own it. Today it is the distinguished Philippe Warnet who presides, guiding you through the engraving and design process from mold-making (after you've approved the design) to presentation (six weeks later). The engraved escutcheon costs $1,150. To apply it to your blazer costs $12 for each brass button and $160 for gold. Expensive to be sure, but there will be no others like them in recorded civilization and they will look of the manor born. Custom-made signet rings with crest are $2,200, while engraved cuff links offer innumerable possibilities.

Maison Agry is that rare place where one can witness France's particular role in developing *le goût raffiné* for the rest of the world. Even if the name on your earliest forebear's tombstone is not of such

lineage to qualify for peerage, it is still not too late to commemorate a family tradition in the form of a crest, in preparation for some future generation's knighthood.

———

MASSARO
2 RUE DE LA PAIX
PARIS
TELEPHONE: 42 61 00 29
HOURS: 9–5 MON.–SAT. (CALL FIRST)

Upon entering this veritable toy shop with its jumble of footwear spread all over the carpet, I am immediately reminded of Fred Astaire dancing with a slew of shoes in *The Barkleys of Broadway*. It's as if the scene were over, Fred has departed, and the shoes have just stopped to catch their breath.

More than two hundred models in different lasts and leathers are in evidence, strewn about every inch of surface available in this three-room atelier overlooking the venerable rue de la Paix. Most of the models are for women, as the firm has been making custom shoes to mate with couturier dresses for sixty-five of its eighty-five years. Only the past twenty have been spent attending to the more conventional demands of the male foot. Being relatively new on the scene, the men's shoes by Massaro have a lighter, springier look than the typical Continental bespoke renderings.

If you crave something with an odd buckle, an offbeat color, or in an eccentric style, Massaro—still going strong at eighty-five—will happily oblige. Since the store has always carried so many shoes in uncommon colors and shapes for people like Barbara Hutton, a past client who reveled in the store's diverse offerings, there are plenty of interesting fabrics and ornaments on hand to surfeit those foot-covering fanciers with even the most theatrical of tastes.

PARIS

If you can't get to Salzburg or Vienna and you appreciate folkloric wear for its inherent style, you will adore Mettez. This is the Parisian home of the Tyrol.

Mettez was started by the Frances family in 1847, when *la toile Mettez* was the canvas used by French farmers to cover their animals and hay wagons. Soon they were producing hunting clothes, workwear, and canvas tops for automobiles. During both world wars, Mettez supplied the military with millions of meters of its canvas. With the end of the war boom, business declined. In 1962, Alain Frances finally closed the door on one tradition while opening the door to another. He introduced the world of loden and its accoutrements into Paris's already extensive mix of international classics. When he moved to this new location in 1986, he completed the transition by covering his floors in loden-like flannel and his walls in Derby tweed.

A store devoted to selling so many shades of green could never prosper removed from a culture where it is identified with the sporting lives of French noblemen, English monarchs, and the aristocracy of the Alpine. Mettez is brimming over with merchandise infused with the spirit of the Tyrol, from paisley ties and other neckwear decorated with animals and hunting scenes to Tyrolean hats, Briggs umbrellas done in Tyrolean colored stripes, slippers of boiled wool, loden capes and vests, Viyella shirts in Austrian colors, and argyle hosiery to match.

Alain, like most educated Frenchmen, appreciates tradition. The making of loden cloth is a process of boiling wool that dates back to Egyptian times. Unlike the French folkloric costume, which is worn only on special holidays, Tyrolean wear—like the clothes of the American West—is living folk wear. As a dash of chintz can do for an elegant decor, a bit of loden in a man's ensemble can go a long way. Sporting something Tyrolean seldom fails to identify its wearer as a pure-bred Continental.

MOTSCH

42 AVENUE GEORGE-V
PARIS
TELEPHONE: 47 23 79 22
HOURS: 10–1, 2:15–6:30 MON.;
10–6:30 TUES.–FRI.; 10–1, 2:15–6:30 SAT.

Given this city's capricious weather, it is hardly recherché to see a Parisian with chapeau on head or brolly in hand even on the brightest afternoon. Chances are the headwear comes from Motsch, especially if the wearer is male and over fifty. Founded in 1887, this is one of the mythical names in French *chapellerie*. The store's vintage ads from 1930s issues of *Adam* magazine (the French equivalent of the early *Esquire*) are as exquisite as their products.

This was one of Paris's most beautiful shops, comparable to Lobb of St. James's Street, London, until Hermès bought it in 1990. It is one of the few businesses to actually lose its grandeur after being brought into the Hermès fold. In an attempt to salvage a foundering business, the new owner cleaved the shop in two, compromising its charm. If you enter the wrong door, you risk being assaulted by the throngs buying their silk scarves. Fortunately, a slice was spared so that the older clients—who for the better part of this century have come from Italy and England to have hats reblocked, repaired, or made to their specifications—will at least be able to recognize some vestige of its storied past.

Motsch is still home of the beret ($50), as well as ten styles of tweed caps, some made from Hermès fabrics ($125), the Sherlock Holmes flapped cap ($95), Panamas, Tyroleans, fedoras, and so on. Despite the structural renovations, the shop's facade, with its decoratively carved wood panels wrapping around the corner, retains all its former magnificence. However, that interior, where a world of hats once waited in a spacious hush of brown-and-cream mosaic floors, wood cabinets, and deep drawers, is now decidedly cramped. From across the street, you can still sense this great French institution's heritage, but I'm afraid the third-generation M. Motsch, now in his seventies, may very well be feeling that he retired a bit prematurely.

PARIS

OLD ENGLAND
12 BOULEVARD DES CAPUCINES
PARIS
TELEPHONE: 47 42 81 99
FAX: 47 42 39 30
HOURS: 9:30–6:30 MON.–SAT. (CLOSED MON. 12:30–2)

Every time I walk into this Paris institution—something I do with each visit to this city—I always imagine that Ralph Lauren would have loved to have had this as his Parisian outpost. When a visit by Queen Victoria created an interest in products from across the channel, Old England responded with goods of Anglo-Saxon inspiration adapted to the European continent. It's as close as Paris gets to America's Brooks Brothers of yesteryear.

Established in 1867, Europe's largest specialty store is much like an American department store of the nineteenth century, when such structures were considered cathedrals of commerce. The curved glass facade, with its huge windows embracing an imposing corner at the boulevard des Capucines and the rue Scribe, is a historical landmark; the three floors within are appropriately grand. Faux-marble ceilings, tufted leather sofas, and enormous Cuban mahogany-and-glass show-cases from the 1920s grace the bridle-leather-colored vinyl main floor which is home to men's clothing. A grand staircase of sculpted oak—so glorious it alone is worth the price of admission—leads downstairs

PATRICIAN GROOMING FOR THE JET SET:
BEAVER TRAVEL SHAVING BRUSH IN BRASS
SELF-CONTAINER.

to men's sportswear, outerwear, and footwear, and upstairs to women's and children's clothes.

After Harrods, Old England is the second largest purchaser of cashmere in Europe. The store carries the best selection of eccentric old-world sport headwear, such as golfing berets of Scottish tartan with pompoms, hunting caps, Tyrolean hats, and, of course, the French beret in universal colors. Their glove collection, probably the most extensive in Paris, including sublime suede gloves in loden green and peccary dress gloves in colors from light beige to dark gray. If you are searching for an umbrella to contend with this city's notoriously sudden showers, Old England carries an impressive inventory. The golf brollies by Briggs come with straight handles to slip into the golf bag or crooked ones for walking. There are also country robes of plaid flannel or checked lamb's wool with piping, circa 1930 ($650), flannel smoking jackets ($650), country jackets by Barbour, and great shoes from Paraboot to Edward Green, Alden, and J. P. Tod's.

This sanctuary of British style has been in the Henriquet family since 1867. Walking through its grand exposition, you immediately understand the Gallic fascination with all things *anglais*. It is one of Paris's most famous stores, so celebrated even the cabdrivers know it by name which, fortunately for those tourists who are not facile in the native tongue, sounds much the same in French as it does in English.

RHODES & BROUSSE
14 RUE DE CASTIGLIONE
PARIS
TELEPHONE: 42 60 86 27
HOURS: 9:30–1, 2–6:30 MON.–SAT.

Much the same as when it first opened seventy years ago, Rhodes & Brousse is the only Paris shirtmaker from the golden epoch of Adolphe Menjou, Maurice Chevalier, and Douglas Fairbanks to still reside at its original address. French boulevardiers could stroll in without giving a thought to the city's inconstant weather, as it is situated under one of Paris's landmark promenades.

PARIS

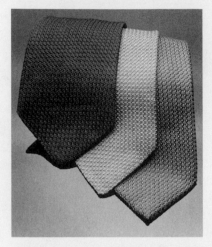

THE CONNOISSEUR'S CHOICE FOR
SUMMER SOLIDS: CUSTOM-MADE
SILK GRENADINES.

From the windows framed in walnut to the light oak vitrines and Persian rugs within, this store is like an antique leather-bound album of cherished memories. It is patronized by an older clientele who prize their conservative custom shirts. Famous for their specially designed bottoms, each shirt continues to be carefully gusseted on each side seam and still cut and sewn on the premises, just as in the days when Paris had no peer in shirtmaking. They continue to stock the elegant sized lisle hose created by the acclaimed French hosiery maker Boileau, as well as hand-rolled linen handkerchiefs with special border trims and the obligatory English Smedley knit shirts.

Rhodes & Brousse buys silk and assembles it into neckties just as it always has. If a client wants a tie made in the width he is accustomed to wear, or a grenadine tie made longer, with or without silk tippings, M. Brousse will oblige. Wearing a white apron over his blue-striped dress shirt, gray flannels, brown grenadine tie, and cashmere cardigan, he can often be found attending to customers, many of whom belong to France's oldest families.

This store remains a constant in an ever-evolving world. Charvet has moved into much grander digs. Sulka has been redecorated into faux-Biedermeier homogeneity. Paris's other holdout, the once extraordinary Hildetch & Key, has been humbled into commercial subservience by its English owners. But Rhodes & Brousse carries on, resolutely immune to change for the sake of profit. Some would call it sleepy; I call it genteel and irrepressibly French.

PARIS

VICTOIRE HOMMES
10–12 RUE COLONEL DRIANT
PARIS
TELEPHONE: 42 97 44 87
HOURS: 10–7 MON.–SAT.

One of the reasons Paris is the sportswear capital of Europe is that it gives birth to such hip establishments as the new Victoire men's store. This shop is owned by the family that runs the successful Victoire women's shop on place des Victoires. Under the Hartford label, the family has manufactured shirts for Hermès, Hemisphere, and Marcel Lassance and still makes one of its country's best shirts.

Fronted by three large wraparound windows decorated with rust awnings and wood blinds, Victoire Hommes speaks the tongue of L.L. Bean and Brooks Brothers graced by an indigenous French accent. Interesting vests; great woven sports shirts in washed buffalo-check, stripes, or takeoffs on the Brooks Brothers "fun shirt" styled with the original Brooks button-down collar; and terrific pants are displayed atop big pine tables. Wood plank floors and enlarged illustrations from the 1930s bring a nostalgic feel to this simple setting.

If you prefer your sportswear American in spirit but European in taste and quality, this is a store to visit. It's creative though not expensive and on the hit list of all the American and Japanese sportswear manufacturers. One often wonders what the European fashion community would do without authentic American sportswear to inspire it. I guess as long as they keep improving upon our American classics, we will continue to encourage them by being among their most loyal customers.

ROME

AN INTRODUCTION

As the first European city to be
visited by Americans after the war, Rome introduced the rest of the
world to Italian fashion. In 1953, a collection of Roman tailors staged
the country's first men's fashion show in Florence. Inspired by Raphael
and Michelangelo, they sculpted men with tapered waists, snug shirts,
and brilliant colors. The Roman stroll became a swagger, the swagger
a strut, and the peacock revolution was born.

With the rise of the Italian movie industry, Rome as seen through
the eyes of De Sica, Rossellini, Visconti, Antonioni, and Fellini,
attracted America's cinematic royalty. Cooper, Fairbanks, Power,
Menjou, and the like returned home bearing custom-made jackets and
silk pajamas, wearing fabulous shirts and shoulders, and sharing the
message that ancient Rome was, in fact, ahead of its time.

Italy's dazzling southern sun sparked brighter colors and lighter
fabrics—gabardine suits, zephyr-weight dress shirts in voile and
batiste. The baked cobblestones necessitated lightweight footwear in
fine, pliable baby leathers with lower lines and trimmed soles whose
slipper-like scale separated them from the heavier Bond Street brogue.
The preening of Roman style was a far cry from the sobriety one saw
on Savile Row, which continued to maintain its haughty hold on tradi-
tional men's taste.

The Continental look peaked between 1958 and 1963, around
the same time Carnaby Street was making its own antiestablishment
statements in London. Clothes that were designed to be slimming and
sexy—Cardin hourglass suits, fitted dress shirts, low-rise trousers, and
denim bell-bottoms—continued to shape menswear into the seventies.
However, toward the middle of that decade, the fitted fashion that
Rome had become so identified with began to lose its appeal. When
the city's influential cadre of tailors stubbornly refused to change the
silhouette they had so successfully pioneered, the Eternal City was left
in fashion's wake. Roman style stalled.

Today, the city is in a sartorial time warp, ranking third on the country's fashion scale behind Milan and Florence. In the world of custom clothes, the locals' style is not that much different than where it picked up forty or fifty years ago, with the Roman cut considered "quick" by English, American, and even Milanese standards. But, when it comes to quality, Rome can still produce some of the most superbly tailored men's clothing in the world. The workmanship that goes into a Battistoni shirt, a Caraceni suit, or a pair of Serafini silk shorts is as exquisite as the best that Paris, London, or Vienna has to offer.

The Roman man is inspired by the grandeur that surrounds him, and he dresses in response to it. The four-hundred-year-old apricot buildings, heroic columns, and mighty marble gods are not a backdrop; they are a complement. Walking in their midst, he wants to be visible but not showy. The well-dressed Roman retains an abiding interest in fashion, and still spends a disproportionate amount of money on his attire while setting aside plenty of time to properly attend to the details of classical elegance. His love of clothing is legendary. "Rome is the most seductive place in the world," Federico Fellini said after immortalizing it in *La Dolce Vita*, *Roma*, and other films. "I can't work in a foreign environment. I must know what kind of shoes a character wears, or in which shop in Rome he would buy them. Here, I know the labels in his clothes."

ANGELO
Via Bissolati, 34
Rome
Telephone: 4741796, 4884092
Fax: 4883101
Hours: 3:30–7:30 Mon.;
9:30–1, 3:30–7:30 Tues.–Sat.

As the former manager of Brioni, the late Angelo Vitucci had flair, finesse, and enough of a following to open his own shop in 1963. Rome was afire then, and where better to enjoy the blaze than around the corner from Brioni itself, a watering hole on every tourist's amble from the neoclassical Grand Hotel down to Elizabeth Taylor's Excel-

ROME

sior on the Via Veneto? From this choice spot, Angelo's attained instant success. He negotiated licenses in England, the United States, and Japan. His roster of celebrity clients included the likes of Frank Sinatra, Tony Curtis, Telly Savalas, and the shah of Iran. Today the store garbs the royal Fayad family, the sheik of Kuwait, and other dressers from the Middle East who are small and who like his slim, fitted, hand-styled look.

Angelo's widow and two former partners manage the business. Its staff and shop are smaller than before, but the firm's inherent sense of style remains intact. In contrast to the old-world workmanship so revered here, the decor is modern and glamorous. You will encounter accessories on the ground floor before ascending the winding lacquered staircase, accented by framed Spy prints, to the splendor above. Here, among camel rugs, black Breuer chairs, and chrome spotlights, is the custom-made clothing tailored like soft armor with firmness and structure. Compared to the Brioni house style, Angelo's shoulders are slightly wider and more sloped, but as resolutely self-conscious.

Fourteen tailors and three cutters in an offstage workroom create six to seven hundred suits a year. The fabrics, from the finest houses, include some unusual silks and cashmeres. The stitching and detail are meticulous. (Some of the shop's ready-to-wear suits are also made here, although most are made to Angelo's specifications in a nearby factory.) In another workroom, five ladies turn out custom shirts, with initials and handmade buttonholes, for $150 to $225. The suits range from $1,800 to $2,500 and usually take three to four weeks. But the shop takes pride in catering to foreigners and its accommodating craftsmen can, when pressed, turn out most men's wardrobe needs in a week.

BATTISTONI
Via Condotti, 61A
Rome
Telephone: 6786241
Fax: 6794187
Hours: 3:30–7:30 Mon.;
9:30–1:30, 3:30–7:30 Tues.–Sat.

As if passing through an enchanted decompression chamber, you walk under an archway and through a courtyard, under a second archway and through yet another courtyard before arriving at this red-winged legend of Roman shirtmaking. Here, in small wood-paneled rooms with marble floors, you stand shoulder-to-shoulder with haberdashing history.

The estimable Guglielmo Battistoni opened his shop in 1946 and acquired immediate glory, attracting so many limelit artists and writers that it became more salon than showroom. Gossip and social tidings mingled in the rarefied air with the discussion of sleeve measurements and tie silks. Chaplin touched elbows with Borghese, Steinbeck with Rossellini, Rock Hudson with Gianni Agnelli, Cole Porter with pret-a-porter.

Battistoni is one of the very few post–World War II Italians to have the royal warrant boasting "By Appointment to H.M. the King." The shirts here are renowned for their exquisite finishing, essential for those who still appreciate the art of their impeccable, torso-revealing fit. Side seams are infinitesimally narrow, armholes high. With no pockets or puckers, they fit like a glove (which may explain why the photo of a perfect pigskin glove appears on the opening page of the small red booklet Battistoni published years ago in four languages).

Every shirt is completely handmade, with distinctive mother-of-pearl buttons to slide through the handmade buttonholes. It takes one fitting and three weeks to complete (although, with a push, it can probably be done in one), costs $210, and comes with an extra collar and cuff. This is truly a masterpiece of shirtmaking. As Battistoni boasted in his little book, "Fashion and simplicity are one thing here. The cutting is perfection and although free of fancy it is never monotonous or sophisticated but always convincing."

ROME

With the devitalization of *la dolce vita* and a garish Foot Locker juxtaposed against the Via Condotti's hallowed eighteenth-century Caffè Greco, Battistoni carries on. Son Gianni and daughter Simonetta see to it that the late father of Italian shirtmaking's legacy not only survives but continues to be worthy of its reputation.

Brioni
Via Barberini, 79
Rome
Telephone: 484517, 485855
Fax: 485510
Hours: 3:30–7:30 Mon.;
9:30–1:30, 3:30–7:30 Tues.–Sat.

Brioni, an island off the coast of Yugoslavia, is where the rich go for vacation. Brioni, the luxurious emporium perched high on the Via Barberini near the Grand Hotel, is where they go shopping. Founded by master tailor Nazareno Fonticolo and fashion coordinator Gaetano Savini in 1945, this was one of the first stops for postwar Americans seeking refuge from Brooks Brothers bags. Here they found square, pitched Roman shoulders, tapered waists, and clothes so sculpted they seemed painted on.

When the end of the Second World War was declared, Savini declared an end to wartime drabness. His proclamation that men no longer needed to look like bookends for brightly dressed women became the rallying credo for Italian men's fashion. Out came the furs and brocades, the mohairs and lightweight wools, the raw silks in lime green, bubblegum pink, and yolk yellow. During the fifties and sixties, Brioni's clients became the ambassadors of the Continental look while making his clothing a status symbol. One of the first to stage a male fashion show, Brioni introduced bold fabrics in bright colors.

The flash has mellowed a bit, but the high profile remains. Yesteryear's clients included Douglas Fairbanks and Adolphe Menjou. Today, they are the deep-pocketed dandies from the Middle East and Far East as well as Donald Trump, who buys his $3,000 ready-made Brionis right smack in the middle of Manhattan.

ROME

Brioni has the most impressive shop in Rome. It is a limestone building with enormous windows, framed in a rounded-wood molding with inlaid chrome, which gives it grandeur and authority. The idea is reiterated inside, where Louis XV furniture stands on green marble beneath Venetian light fixtures. Accessories are on the main floor. Then it's up a few short flights of white marble stairs to the custom parlor with its Venetian chandelier in the shape of a Viking boat and its floor of brown-and-gray marble. Customers cannot help but preen here. Big wood tables present some one thousand suiting fabrics from the traditional to the sharp, the sublime to the shiny.

The fitting rooms, off a mirrored corridor, are decorated with old Brioni sketches and illustrations, fabric swatches, and photos of Brioni-clad actors, presidents, and socialites. Suits cost about $2,200 and usually take a week but can, under pressure, be ready in three days.

The four to five hundred custom suits turned out by Brioni each year are made much as they were when the firm was founded. Just beyond the fitting rooms, you can still see the tailors, as much a part of the display as the fabrics they sew. Sitting at tall tables under natural light, each at his particular task on his own particular chair or stool, they wear shirts, ties, and cable-knit V-necks and look just as they did when they were apprentices to their fathers forty years ago in this very same room. Now fifty years young, the Brioni name is recognized around the world for its superb tailoring, Roman manhood, and southern Italian craftsmanship.

CARACENI
Via Campania, 61B
Rome
Telephone: 42882594
Hours: 3:30–7:30 Mon.; 9–1, 2:30–7:30 Tues.–Fri.

Just as Battistoni was the father of Italian shirtmaking, Domenico Caraceni was the father of Italian tailoring. A modernist in the twenties, he introduced the soft suit to a structured society. Now it is his nephews, Tommy and Giulo Caraceni, who keep up the good work. He

ROME

taught them to cut and his art is their legacy. They are like two maître d's who are also chefs. They take the order (in English, which is a blessing), then go to the back to prepare it.

What is endearing about this shop is that it's not beautiful. But it is historical, just like the ancient walls it faces at the edge of the Villa Borghese. Caraceni began here in 1922 and little has changed since then. It's as if they knew you were coming but didn't bother to set the table: old brown carpet, worn green-velvet chairs, a clutter of swatches tossed unself-consciously about. On one wall, a sea of blue fabrics; on

another, a fog of gray. No marble, no chandeliers, nothing fancy; just the real thing.

Having a suit made here by the fifty-odd people involved in its creation, from buttonholes to vest, is special. It's an opportunity to learn the essence of style and elegance without the distractions of pretentious luxury. It's why the exalted have been here and back: the Rothschilds, Bulgaris, Gary Cooper, Zubin Mehta, Clark Gable, Henry Fonda, Charles Aznavour, and Gianni Agnelli (who invariably swathes his famously unbuttoned Brooks Brothers button-down under his softly tailored Caraceni worsteds).

TAILORING AS ART: DOMENICO CARACENI'S FAMOUS BOAT-SHAPED WELT POCKET FLOATS ON THE UNDULATING SURFACE OF THE JACKET'S CHEST.

A triumph of grace and harmony, the Caraceni suit costs $1,850. The shop turns out one thousand suits annually, and the design, the nephews claim, hasn't changed at all since 1922. Suits take a month to make, though they can be ready in a week. Characteristic of every suit claiming to be a genuine Caraceni is the unique shape of its curved breast welt pocket, which resembles a little boat in that it rocks, floats, and undulates with the movement of your arm and upper chest. This very visible detail bespeaks the genius of the innovative craftsman who single-handedly changed the direction of Italian tailoring.

Until World War II, Caraceni shops flourished in Paris and Milan. But the Parisian shop is no more, and while Milan supports

ROME

three offshoots, only one makes clothes on a par with the original shop in Rome. Everything here, even the pair of custom-made corduroy trousers that will toil for years with the old boy in his garden and probably outliving him, is extraordinary and instructive.

MASSIMO DATTI
Via Bocca di Leone, 89
Rome
Telephone: 6789942
Hours: 3:30–7:30 Mon.; 9–1, 3:30–7:30 Tues.–Sat.

Datti is so hidden away on a side street, it might as well be in Milan. Fortunately it is in Rome because for those visiting here, it's the only store to offer fashion with a more northern Italian sophistication to it. Started in 1900 as a tailor shop by grandfather Datti, today's show-place is owned by his son and grandson. It is appointed in light green rugs, blond wood cabinets, presentation tables finished in a marbleized tortoiseshell. The chairs are upholstered in the same burgundy-and-hunter-green paisley as the sofa.

The front room offers beautiful button-down sport shirts in brushed checks and herringbones ($90–$130), dress shirts, repp ties, Drummond sweaters from England, Etro printed pocket handkerchiefs, and printed paisley slippers. Datti's taste reflects an English persuasion, but the jacketings and accessories are a harvest of colors from a Milanese palette: mustard, gold, olive, sienna. Such colors deserve the stylish blue shirts, gray flannels, and brown suede shoes with which they are worn.

Walk back to the tailored clothing that occupies two rooms in the rear. Welcoming you are the firm's tweed jackets ($400–$500) and camel hair raglan-shoulder topcoats hand-stitched on all the correct seams ($650). And here, too, are the slope-shouldered, three-buttoned, side-vented suits (hand made by St. Andrews) that are the shop's real lure. With their northern Italian sensibility, they offer a different stylistic look for Rome. If this is your only stop in Italy, Datti can help you graduate from Roman flourish to Milanese refinement.

ROME

GATTO
VIA SALANDRA, 34
ROME
TELEPHONE: 4741450
HOURS: 3:30–7:30 MON.;
9–1, 3:30–7:30 TUES.–FRI.; 9:30–1 SAT.

Signor Gatto died in 1993, but his modest shop and superior shoe-manship were left in good hands. His heirs still attend to the well-heeled monarchs, moguls, magnates, and fine Roman families of old. And they still keep his humble shop in a small apartment within a modest building and do no advertising. Gatto's reputation is based on superb styling and meticulous detailing. They are what they always were; the prices, of course, are not. The first pair of shoes cost $1,500 and takes four to five months; the second ($1,200) takes two to three. Gatto is still considered one of the country's premier shoemakers.

MICOCCI
LARGO FONTANELLA BORGHESE, 78
ROME
TELEPHONE: 6896645
HOURS: 3:30–7:30 MON.; 9–1, 3:30–7:30 TUES.–SAT.

Tucked away into a suburban piazza at the end of the Via Condotti beyond most tourists' ken, Micocci is where the locals go. A visitor might stumble upon it, but only if he got lost en route from the Piazza di Spagna to the Piazza Navona. It is well worth the stumble, however. Here are Braemar sweaters and Schiatti leather vests and Micocci's custom shirts ($140), silk robes ($240), and silk pajamas ($220), for half the price of such things at Battistoni, Sulka, or Charvet. And in a matter of a few days, you can become one of its custom-shirted enthusiasts.

Signor Micocci, a jolly chap, speaks fine English. He'll go to any effort to find just the right piping to match the handmade initials on your pajama pocket. The shop was established in 1932 by his mother and has been staffed ever since by serious women in white lab coats.

ROMAN WORKMANSHIP AT ITS MOST
METICULOUS: HAND-EMBROIDERED AND PIPED
SILK LOUNGING PAJAMAS.

They silently appear to take your measurements, then quietly disappear into the back room to make patterns with the same meticulousness that might have been conferred on manicured nails in a bygone era. Unprepossessing as it is, Micocci has served Gary Cooper, Orson Welles, Sophia Loren, and Carlo Ponti, which is no surprise, and Michael Jackson, which is.

———

OLD BOND STREET
VIA GREGORIANA, 47
ROME
TELEPHONE: 6784305
HOURS: 3:30–7:30 MON.; 9–1, 3:30–7:30 TUES.–SAT.

Entering Old Bond Street, you are plunked down amid trappings with a definably tartan accent. Whimsically out of place for the past forty years, this is one of the last Roman shops influenced by English style from the glory days when the Duke of Windsor reigned sartorially. Signor DeRitis Marcello, the founder's son, will greet you in his charming anteroom with its English rugs, pine cabinets, vaulted ceilings, red-and-blue-tartan Queen Anne armchairs (so determinedly blanket-covered that the fringe remains), and tables of an old-world

ROME

mustardy green more likely to be seen on a vintage Rolls or Bentley. You will find accessories here such as an impressive array of linen handkerchiefs, some sporting a golf bag motif in gray, blue, pink, and yellow ($17), as well as a unique collection of cotton lisle hosiery with a fifties design, available in fifteen colors.

Then he will escort you down the little hallway, through velvet drapes of faded gold, to the back room and the exquisite shirting fabrics that certify Old Bond Street as old and high-class. Casually strewn on the table and cupboard shelf are Swiss voiles and high-count cottons, Italian broadcloths, and—if you are lucky enough to arrive before the supply is depleted and is never seen again—a collection of twenty-to-thirty-year-old silks originally intended for pajamas. The shirts, which start at $165, are handmade, including the buttonholes and monograms, and take a month. This tribute to Jermyn Street on the Via Gregoriana maintains Rome's connection with its imperial past.

CARLO PALAZZI
VIA BORGOGNONA, 7E
ROME
TELEPHONE: 6789143, 6791508
HOURS: 3:30–7:30 MON.; 9–1, 3:30–7:30 TUES.–SAT.

When all roads led to Rome, in the throbbing, Fellini-flavored sixties, they led to Palazzi. The Roman fever has subsided, but this nevertheless remains a landmark in the history of Italian men's fashion. His clients were and are kings and queens, socialites, writers, actors, artists, and directors of all nations. Carlo has also left his mark in men's fashion in film, designing the wardrobes for movies such as *La Cage aux Folles*.

The shop occupies the seventeenth-century home of the Marchesa Marconi (whose husband invented the radio). The interior is a streamlined homage to glass, marble, and iron. Beneath the building's original frothy ceilings, a Charles X armoire and two chests, retaining their exquisite marquetry, coexist alongside huge modern sculptures by Beverly Pepper and Arnaldo Pomodoro.

ROME

Always appreciative of the classics, Carlo was the first to propose a man's full-length fur coat, and was an early enthusiast of oversize cloth topcoats. His dress shirts were a virtual feast: When he offered brown or blue, he would open an armoire to display forty shades of brown or blue from dark to light. This is the best place in Rome, and perhaps the world, for custom-made sport shirts of cotton, linen, silk, and cotton-and-linen ($180–$300). The quality is excellent, and the variety, which includes geometric prints à la Hermès and Gucci, is dazzling. If you're heavy or small and can't find smart sport shirts your size, they'll make them for you here. The cost is not outrageous, about what you would pay for equivalent ready-made, high-quality Italian sport shirts exported to the United States or Far East—approximately $250–$300.

Palazzi classics include the short blouson jacket in an array of seasonal fabrics (from $250 for cotton or linen to $600 for cashmere), favored by clients from Japan and the Middle East, and a luxe cashmere jogging suit ($1,000), worn less for jogging than for lazing about in one's poorly heated country home. Unless it is late summer, which he spends at the Palazzo Palazzi on Capri, the irresistible Carlo will probably be on hand to chat up any luminaries and assist you with your choices.

<div align="center">

——

SERAFINI
VIA CONDOTTI, 62
ROME
TELEPHONE: 6780949
HOURS: 3:30–7:30 MON.; 9–1, 3:30–7:30 TUES.–SAT.

</div>

If you were to see an elderly Roman couple strolling arm in arm down the Via Condotti, she with her tweed suit and alligator bag, he in his thirty-year-old bespoke gray flannel suit and crumpled English fedora, you could almost bet they were en route to chat with Roberto Serafini.

English is hardly spoken in his hundred-year-old shop, yet this is where the English look was introduced to Rome. The British Empire reigned supreme at the time of the shop's founding and Serafini

ROME

THE FERRARI OF DRIVING GLOVES: THE
ITALIAN MALE LOOKS UPON HIS CAR AS AN
EXTENSION OF HIS TASTE AND LIFESTYLE.

brought the monarch's class to the Italian aristocracy. Serafini was the first to ennoble this charming street and establish it as a world-renowned bazaar. His tweeds would attract silver, leather, and jewels; his reputation would draw prestigious merchants such as Gucci, Hermès, and Bulgari.

Today, Serafini is no longer "fashionable," but it is still supported by the smart traditionalists it has long served, those who like the feeling of upper-class apparel. An exquisite presentation of Anglified accessories is displayed in the windows and only there. Simply ask for what you seek—a beautiful pair of knitted silk briefs ($65; $18 in fine cotton), driving gloves of chamois-colored pigskin designed so that the knuckles fit ($130), pigskin gloves lined in cashmere ($160), gray suede evening gloves finished with a pearl button ($145), a tendril-thin black silk umbrella cut from a single piece of wood ($250)—and it will be reverentially withdrawn from a walnut cabinet. If you wish to inspect your selection, you may want to turn toward the doorway. The one elegant, turn-of-the-century light fixture is twelve feet above you and lighting is almost nonexistent. For that reason, it is probably best to visit the store on a bright day.

SAN FRANCISCO

AN INTRODUCTION

San Francisco is a city of enormous character and presence. Prior to the turn of the century, it set the standards for America west of the Mississippi. Culturally and economically, its influence was felt as far north as Alaska, as far east as the Rockies, and as far south and west as ambition could carry its frontier capitalists. From its wild gold rush beginnings to its, in some ways, even wilder spawning of the antiestablishment generation a century later, San Francisco has been a microcosm of this country's colorful past, cramming more lifetimes into its relatively brief history than most cities three or four times its age.

Today, the city's largest industry is tourism, with very few visitors to this cultural confluence not forming some sentimental attachment to this former "Queen of the West." Nestled between mountains, country, and sea, it's a place both neophyte travelers and European sophisticates enjoy exploring. Though it has its helping of eye-popping architecture and spectacular vistas, San Francisco's compact and walkable downtown areas are humanized by their patches of leftover Victorian scale and charm.

Among all American cities, San Francisco is the least insular and most open-minded. While much of its shipping and manufacturing has disappeared, this is still a West Coast bastion of progressive idealism, the city of the Sierra Club, the gay rights movement, free speech, holistic health, lowered anxieties, and raised consciousness. It is the birthplace of the United Nations as well as Jonestown. With a stock exchange second in size only to New York City's, San Francisco's financial district is still one of this country's primary centers of commerce. Its restaurants are at the forefront of culinary innovation and, in Berkeley, it can boast the most exciting city of intellectuals in the West. The downtown shopping district ranks number two in sales among American cities. Six major department stores call it home while some of the world's most recognized shingles can be spotted hanging above its side streets.

SAN FRANCISCO

With a climate that is conducive to the layering of clothes, San Francisco has a reputation for stylish attire. Temperatures range from 45 to 75 degrees throughout the year, while the fog and the bracing sea breeze cool off even the warmest summer evening. One can really dress up in the morning and remain fresh throughout the day. San Francisco is the home of the all-year-round-weight suit. Leather jackets and sweaters are also popular out here, as it is the rare evening that some type of overgarment is not required.

San Francisco style epitomizes the "do your own thing" dialect of its polyglot society. Its fashion is not nearly as aggressive as New York's but, though somewhat more conservative, it is every bit as free-thinking and exploratory. San Francisco's acceptance of alternative lifestyles has made its gay community a relevant force in the city and freed its members to publicly cultivate their tastes and styles in a manner infrequently seen in other towns. As a result, European designers count on this city for an enthusiastic reception, since gay men are generally more sensitive to the latest nuances of fashion.

The greening of Silicon Valley—and in this case we are referring to the color of money—has recently sparked an influx of men into the high end of San Francisco retail. Twenty years ago, this community was widely known for its renegade dress-down office ethic. However, the latest crop of high-tech millionaires created by leveraged buyouts and public offerings now finds itself conducting business in the boardrooms of the world's international financial capitals. Forced to abandon their Peter Pan cocoon of high-school fashion, these boomers need clothes that reflect their new affluence and corporate reach.

Today, Saks Fifth Avenue, Neiman Marcus, and Nordstrom, those rambling multitiered shopping meccas, all have portals near Union Square, the heart of San Francisco's retail district. Wilkes Bashford, this city's Louis, Boston, is a must-see. For the more mature consumer, there are the formidable digs of Bullock & Jones and Sulka, while Gump's, Eddie Bauer, and Cable Car offer a glimpse of old San Francisco. Also high on any itinerary should be a visit to Buttondown in the Presidio, a chic neighborhood where you can window-shop till you drop and enjoy a quiet, epicurean meal as a restorative.

The city where Tony Bennett left his heart offers a preponder-
ance of nothing amidst a feast of everything. Its diverse neighbor-
hoods make it a delight for shopper and browser. Around Union
Square, one finds big-city bustle with bright lights, rich scents, and
seductive music. The flower vendors who occupy its busy corners
merely add one more splash of color to the vivid environs. Whereas
the new wealth and influence of Los Angeles attracts more media
glare, San Francisco's Victorian stature, with its Nob Hill elitism,
magical panoramas, and wondrous cable cars, makes it as unforget-
table a city as Venice. "There are just three big cities in the United
States that are story cities," observed the novelist Frank Norris, "New
York, of course, New Orleans, and, the best of the lot, San Francisco."
And with so many stories to tell, this town is an omnibus of American
fashion.

BULLOCK & JONES
340 POST STREET
SAN FRANCISCO
TELEPHONE: (415) 392-4243
FAX: (415) 986-6039
HOURS: 9:30-6 MON.-FRI., 9:30-5:30 SAT.

Bullock & Jones is one of this city's oldest privately owned retail
firms. Started in 1853 as a tailoring establishment, it also sold cash-
mere and other luxury sundries to those Americans who were lured to
the West by the Gold Rush. The founders, confident that more than a
few of the newly mined nuggets would trickle down into their coffers,
moved out here from Boston. Since then, the store has changed hands
five or six times.

Its present owner, the appropriately named Sidney Goodwill
from Montreal, learned his trade while running the menswear division
of Holt Renfrew, Canada's Bergdorf Goodman, as a leased operation.
When Carter Hawley Hale bought the chain they appointed Goodwill
as head of its men's business. In 1978, having had his fill of corporate
life, Mr. Goodwill left and bought this institution. Rather than expand
his operations by opening additional stores, he took what was then a
fairly novel approach to building his volume: direct mail. Today more

people know the Bullock & Jones name through its highly successful mail order business than from actually visiting the store. With over eight million catalogs mailed each year, this operation represents the world's largest high-end men's home-shopping service.

The three-story Victorian fixture of San Francisco retail is perched atop Union Square, the city's cultural crossroads. Its black-awninged portiere juts out onto the sidewalk, encircling in display those who pass through the store's main entrance. In a gracious space reminiscent of this country's most eminent prewar specialty stores, the first floor's front area presents furnishings and sportswear, while the rear showcases an extensive footwear selection.

Nowhere in the city will you find a more picturesque ambiance in which to consider off-the-peg or made-to-measure tailoring than on Bullock & Jones's newly refurbished second floor. Walking across its hand-plugged oak-plank floors, past its grand piano, and into its carpeted front room, you are immediately drawn to the floor-to-ceiling windows that afford a mouth-watering panorama of San Francisco's lush central common.

Bullock & Jones shares the same American, soft-shouldered roots as New York's Paul Stuart and L.A.'s Carroll & Company. However, Mr. Goodwill has been gradually steering the store's "older man" sensibility toward a taste that is better described as Euro-classic. Lively presentations of Zegna and Brioni now appear alongside updated renditions of Oxxford and Hickey-Freeman. The store still sells a lot of boldly striped, white-collar dress shirts and English woven neckwear for the Jermyn Street aficionado, but they have spiced the mix with the Italian tastes of Zegna's neckwear and dress shirtings as well as their own spirited private-label furnishings. With its catalog as a resource for so many items, shoppers depend on Bullock & Jones to present a broader range of men's merchandise than other single-store businesses. It is undeniably San Francisco's specialist in conservative fashion for the mature traveler.

BUTTONDOWN
3415 Sacramento Street
San Francisco
Telephone: (415) 563-1311
Fax: (415) 563-6715
Hours: 10–6 Mon.–Sat.

No collar style conjures up a warmer, fuzzier feeling within the hearts of the less emotive gender than this store's moniker. This former launderers' building is cleaned up and carpeted, while its white stucco walls are decorated with artifacts of a boyish yesteryear. Old radios, luggage, and bicycles from the 1950s provide a backdrop for urban sportswear with a buttoned-down coziness. It's an ambiance with merchandise of fireplace familiarity, capable of soothing even the most battered workday warrior.

All this civility sprang from the vision of the store's owner, Michael Sabrino, who one day decided this little stretch of "Upper Madison Avenue on the Pacific" was perfect for his high-quality, understated, stylish European weekend togs. Buttondown has attracted considerable publicity as one of San Francisco's finest fashion outposts, and its fame has spread far beyond its Presidio Heights environs.

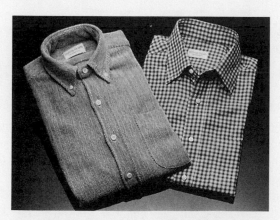

POLO COLLAR DOGMA: THE DÉGAGÉ
CLASSINESS OF THE BUTTON-DOWN COLLAR IS
FORFEITED IF IT DOES NOT POSSESS ENOUGH
LENGTH TO ROLL OVER AND PLAY CASUAL.

Formerly home to local merchants and decorator shops, this affluent San Francisco neighborhood has since become one of the city's choicest shopping locales.

The men who call this precinct of privilege home have grown up around quality and taste and are quick to recognize it. They come across a lot of it here. Buttondown carries great sweaters from Europe's top knitters such as Drumohr and Malo Tricot. Their hand-knit sweaters ($285–$1,200) and great sport trousers ($165–$285) complement a sophisticated collection of sport shirts that some choose to sport in the dégagé manner now so popular in Italy—unbuttoned. The European breeding of Peter Hadley, Luciano Barbera, Henry Cotton, and the Biella Collection lends Buttondown's outerwear a force and gentility rarely seen on these shores.

Michael Sabrino's little outpost of sportswear enchantment exudes the kind of serendipity foreigners hope to discover when visiting a city of such contradictory tastes. Somewhat off the Union Square track, an excursion to this section of San Francisco will charm anyone, particularly the man desirous of adding even more taste to his sportswear wardrobe, an unavoidable eventuality at Buttondown.

CABLE CAR CLOTHIERS
246 SUTTER STREET
SAN FRANCISCO
TELEPHONE: (415) 397-4740
FAX: (415) 614-8998
HOURS: 9:30–5:30 MON.–SAT.

Much like its namesake, this is the type of store that gives San Francisco its irresistible allure. Step through its doors and you step back in time—way back. Cable Car Clothiers is an anomaly in an age where museums or old photo albums are often the only medium able to connect one with his roots.

Founded by Charles Pivnick in 1946 and located on Post Street for over thirty years, Cable Car Clothiers moved to this location in 1991. It is San Francisco's most famous supplier of British goods. With over 70 percent of its merchandise produced by the Queen's minions, this is the world of Polo before Ralph Lauren got his expert hands on

ENGLISH SHIRTSLEEVE RETAINERS:
THEIR CHARM RESIDES IN THEIR
VERY ANACHRONISM.

it. Anointed with tartan-upholstered high-back chairs, mahogany cases with gold block lettering identifying their contents, brass fixtures, worn Persian rugs, and old Spry prints, Cable Car reeks of all the musty tradition worthy of a genuine, soft-shouldered Ivy League bastion.

Here the motto is "You are only as good as what you deliver," and the goods delivered here are the real deal. You can find three-button authenticity as it is still tailored by Southwick and Canada's Samuelsohn. Royal Yacht lotions and Kent of London brush sets presented in their turn-of-the-century wooden cases sit aside navy or burgundy polka-dot arm garters ($28). Genuine English club neckties ($48), boxer shorts, pajamas, Scottish tartan blankets, repp bow ties—it's all here, presented just as it was in the raccoon coat days of Langrocks of Princeton or Whites of New Haven. Fortunately, while the store upholds and celebrates that past, it has cast its eye toward the future. The merchant in Mr. Pivnick cautioned him that "high tradition" alone would not sustain his enterprise. In 1969, he initiated a direct-mail business. With over two million catalogs distributed yearly, Cable Car's fragile franchise has been obviously buttressed by Charles's foresight.

With the retirement of the Press family, the demise of the Chipps' senior Winston, and the commercialization of Brooks, Charles is the Sir Lancelot of the herringbone grail. Walking into his store is like climbing into Mr. Wells's time machine. It is a tribute to

SAN FRANCISCO

the hat-wearing era when tradition and tailoring dictated the season's fashions. Cable Car evokes a nostalgia for those post–baby boomers who, upon entering, are reminded just how different the world has become.

––––––

M.A.C.
1543 Grant Avenue
San Francisco
Telephone: (415) 837-0615
Hours: 11–7 Mon.–Sat., 12–5 Sun.

The acronym stands for modern, appealing clothing, and that is exactly what this quirky little fashion boutique has to offer. Situated in a little back-alley street that is also home to a number of other avant-garde shops, art galleries, and cafes, this fifteen-year-old business is a family affair. One of two stores to pioneer alternative fashion in San Francisco, it is run by Jeri Ospital and her two children, Ben, who directs the men's operation, and Chris, who helps her mother run the women's shop.

Here, both the medium and its merchandise convey an antichic message. The shop is done in the industrial, Ban-Lon kitsch style of the fifties with a nod toward today's environmental correctness—the tables are reused plywood, its lights recycled Tupperware, and its girders, as well as the rest of its foundation, have been played down to project its proletariat leanings.

From its inception, M.A.C. has featured the forward fashion of England's Katherine Hamnett, John Barlett, Gene Meyer, and New York's New Republic. They sell dress-up sportswear and hip business suits. A stop here will put you in touch with such latest trends in runway fashion as John Barlett's pink, purple, or lime-green-colored Hush Puppy retreads of 1950s fame. Ben's friendly chat and astute fashion advice have made M.A.C. a familiar hangout for those edgy San Francisco downtowners who find themselves lost among the Union Square bourgeoisie.

NORDSTROM
865 MARKET STREET
SAN FRANCISCO
TELEPHONE: (415) 243-8500
HOURS: 9:30–9 MON.–SAT., 11–7 SUN.

This is the department store of choice for the conservative man willing to pay full price for his business attire. With an inventory of over four thousand suits and service that defies the large-store stereotype, Nordstrom can easily convert the random purchaser into a regular.

The family-owned and family-run Seattle-based retailer, which started four generations ago by selling shoes to that city's early European settlers, picked up some seminal lessons in the art of customer relations that have informed its now legendary consumer-driven service. There is even a recently published book, *Nordstrom's Way*, that explains the firm's unique salesperson-empowering approach to building a business.

Opened in 1988, the Market Street store is the principal tenant in the San Francisco Centre, a vertical mall that boasts the country's first semispiral escalator that snakes its way up the eight-story walls to a dome that opens to the sky. Handsomely appointed in a mélange of carpeted, wooded, and brass-fixtured Early American traditional, this does not resemble your typical department store. The men's tailored clothing presentation, with its staff of sixteen, is formidable by any large-store standard. For prices ranging from $395 to $1,600, Nordstrom can suit up the modern traditionalist whether his tastes run from the conservative center vent to the sexier look of the European ventless models. As part of their moderate range of suitings, which includes such names as H. Freeman and Joseph Abboud, they also carry Canada's soft-shoulder maker Samuelsohn and enjoy an exclusive relationship with the French designer Façonnable. Recently they added to their top end the Zegna collection, which they can special-order along with their American standby, Hickey-Freeman.

Men come to Nordstrom to buy business clothes because of its comfortable environment, deep inventory, and stated mission of doing

anything possible to please the customer. Their salespeople are the highest paid in the retail industry. Knowing the store will support any decision they make, they are encouraged to interact with the clientele as creative problem solvers. Nordstrom's management is promoted from the selling floor, so the value of top-shelf customer service permeates the entire business.

For a man who is style-conscious but not fashion-driven, Nordstrom's overwhelming respect for its clients' time makes it easy to buy serious clothes. Their large staff, trained by the Nordstrom book, puts a human face on the usually depersonalized department store experience without compromising service or selection.

—————

WILKES BASHFORD
375 SUTTER STREET
SAN FRANCISCO
TELEPHONE: (415) 986-4380
FAX: (415) 956-3772
HOURS: 10–6 MON.–SAT., TILL 8 THURS.

Wilkes Bashford, the store, is one of America's enduring treasures of couture fashions; Wilkes Bashford, the man, is one of this country's most celebrated merchants of elite men's style. Acceptance into his fold not only conveys cachet to the designer or manufacturer, it can also spoil them forever. Few retailers can match this consummate professional when it comes to marketing and purveying fine merchandise. For thirty years, Wilkes and his team have stood at the forefront of the men's fashion revolution, giving customers and retailers an opportunity to see how it can and should be done.

Many San Franciscans describe Wilkes as "the man who made Sutter Street." With his legendary fashion extravaganzas promenading down this thoroughfare or around town in a variety of toney venues, Wilkes Bashford let San Francisco know which designer was in town and what he was selling. His profile is as high as that of any of the city's politicians, many of whom he dresses. Exclusivity and individuality have always been the keys to his store's success. Wilkes was also an early proponent of helping the customer create an ensemble from the store's extensive offerings. He believed the

consumer was not getting his money's worth unless he could do this effortlessly, a philosophy which has won his store an international following. As with Louis, Boston, half of his customers are from out of town, with many making excursions from L.A. for no other reason than to shop here.

In 1986, this eight-level embassy of high style opened directly across the street from its original location. You can immediately sense the Bashford touch the moment you enter this understated yet exciting world. The dapper proprietor collaborated closely with his architect so that each floor acts as a mood-setting backdrop for its fashions while simultaneously articulating the lifestyle of the Wilkes Bashford clientele. With everything in its place and a place for everything, the store is easy to shop. You can start on the ground floor and proceed upstairs, or take the elevator to the fifth floor and work your way down. Whichever route you choose, there is a bar on each floor ready to serve the libation of your choice.

The store's designer fifth floor is open and spare, with the trompe l'oeil effect of the suspended garments producing an air of Eastern restraint. Cutting-edge cloaks from Romeo Gigli, Katherine Hamnett, Richard Tyler, Gaultier, Issey Miyake, and Donna Karan are carried here. The first, third, and fourth floors, with their French limestone flooring and colorings from the Italian countryside, project the feel of a European landscape. This is where you will discover suitings for the boardroom, sports clothes for the yacht, or classic sportswear for the businessman, as well as the store's own Black Label menswear. Europe's classiest dress shirts, by Italy's Borrelli and France's Charvet, are staples and you can always find lots of rich, sophisticated neckwear to drape around their collars. The dress-up tailoring comes from the needles of Brioni, Kiton, and Zegna. With the average suit selling for $1,600, the models tend toward the classic. Accessories and shoes from Europe, including the handmade footwear of Paris's Weston, are all within easy reach.

These five floors (the second level carries elegant women's wear and accessories), as impressive as they are, do not represent the ultimate Wilkes Bashford experience. For that, you need only call ahead to secure an appointment for the Private Couture Salon on the seventh floor, where you can savor the same privileges as a Harrison Ford or a

SAN FRANCISCO

SAN FRANCISCO

Tommy Tune. This private fitting room, where the store can be laid at your feet, could pass for an elegant suite at the Ritz.

The proprietor's passion and singularity of purpose have been the prime ingredients of his longevity. Wilkes Bashford feels that "quality is the only true economy," and if you agree with that sentiment, you can understand how the store that bears his name has become a byword for the best in American fashion and retail.

TOKYO

Tokyo is a city of contradiction in a land of paradox. Though steeped in a ritualistic code of tradition-bound behavior, it stands on the cutting edge of the future. The city's mottled architectural landscape, featuring glass and concrete boxes alongside tiled-roof restaurants, reflects its haphazard melding of East and West. Tokyo's inhabitants are also a part of an amalgam of extremes that combines a fierce work ethic with a hedonistic character. Its New Age lifestyle is continually bumping heads with its custom-tied past. Out of all this conflict, Tokyo's multifaceted fashions for men have been forged.

If there were an award given for the world's most fashion-conscious city, Tokyo would be a formidable contender. Japan's citizens enjoy an affluence rarely seen anywhere else. In this town where 10 percent of the country's population occupies less than 1 percent of its land, space comes at a premium. Even though the average Tokyoite's income is 20 percent higher than the rest of the nation's, few young people can afford to buy an apartment here, much less a house, so their disposable income finds its way into the marketplace. Their free spending has elevated shopping in Tokyo to an art form, with the merchant acting as the country's vendor of culture.

Prior to World War II, most of Japan's imported men's clothing came from England, which shaped this nation's entire frame of reference for Western dress. Even today, the Japanese word for suit is *sebiro*, their Janglish for London's famed street of tailors, Savile Row. Japan first became acquainted with American fashion after World War II when members of the U.S. occupying forces would wander about the country in their off-duty attire. It was not until the 1960s that Japan's fascination with things American, particularly the blue-blooded, button-down styles of Brooks Brothers, led to a process of assimilation and re-creation that eventually begat a significant portion of its present menswear business. Van, a company

started by an entrepreneurial visionary named Ishizu, introduced the Ivy League look to this Eastern culture and has been its leading proponent ever since.

Today, Japanese menswear is segmented into several groupings, with "trad" representing a major piece of its enormous market. Brooks Brothers and Ralph Lauren have long had successful businesses here, while Paul Stuart and J. Press have even greater presence and influence in Japan than they do back home. And the recent arrival of J. Crew and Tommy Hilfiger's popularly priced sportswear has signaled the start of a new round of American influence.

Though European fashion is well represented here, not even the swami of high style, Giorgio Armani, has been as successful as American-imaged menswear. Mediterranean taste has always appeared too wrapped up in sex appeal to find much acceptance in a culture already insecure about its national physique. The Japanese are more comfortable with fuller-cut clothes that project verities more classic than visceral.

Besides its upper-class roots, another dimension of the English-American attraction for the Japanese is its suggestion that it can teach you something about dressing properly. Oriental culture places a high value on education; university professors rank behind only cabinet members and prefectural governors in occupational prestige. Before anything new can gain a foothold here, it must be grasped intellectually. During the 1980s, in a country approximately the size of California, the island of Japan supported two men's magazines devoted exclusively to scholarly elucidations of Western style. By depicting the dress-up habits of the public school lads at Oxford and Cambridge as well as their Ivy League cousins at Princeton and Yale, each periodical became a syllabus of Japan's evolving trad ethic.

Juxtaposed against this adaptation of upper-class Western dress is the culture's Eastern approach to form and line, as exemplified in the kimono. During the early 1980s, Japan's Rei Kawakubo for Comme des Garçons, Issey Miyake, Matsuda, and others gained recognition abroad before becoming important forces at home. They injected a disciplined simplicity and cool minimalism into the international fashion vocabulary. They've staked out their avant-garde terri-

TOKYO

tory, and their clothes are appreciated by the antifashion cosmopolitan who, like some collector of fine art, integrates individual pieces into his wardrobe each season.

Retail in present-day Tokyo is dominated by the behemoth department store complexes that are self-contained universes selling everything from food to fashion. The most impressive of these is a survivor of the war, Mitsukoshi's original downstore store in Nihonbashi. Outside, two enormous lions, exact copies of the stately creature that holds domain over London's Trafalgar Square, greet throngs of shoppers. Inside, a fifty-foot-tall bejeweled Buddha sits majestically in the center of its six-tiered atrium's cavernous main floor.

Upscale consumerism reaches its apex in the Ginza, Japan's Fifth Avenue. All of the major department stores such as Isetan and Takashimaya have their monuments to conspicuous consumption here. Like most downtown shopping areas, the Ginza tends to attract the older out-of-towner or foreigner. For those who seek less predictable fashion, there are the smart boutiques of Harajuku, Aoyama, and Omotesando, where the youth parade and purchase.

With the country experiencing the first economic downturn in its postwar life, few new stores have opened. While Barneys—owned by Isetan—offers what is by far the city's most sophisticated assemblage of international business fashion, there are four or five specialty retailers worth visiting. Of course, unless you are a size 40 or smaller, the selection for Westerners is rather limited. Beams in Harajuku is a must, and from there the rest can almost be taken in on foot.

As the Japanese have become a nation of merchants, their capital has become the world's largest market. Between its department megalopolises and labyrinthine specialty stores, their massive consumption of menswear stimulates the creation and manufacture of clothes everywhere. In a country known for its trade surpluses, Japan runs a fashion deficit, importing much more fashion than it exports. Yet Tokyo, with its large-scale consumerism, is more responsible for the global explosion of designer menswear than those cities like Paris, Milan, London, or New York that actually create it. It is just one more example of this culture's many ironies.

TOKYO

BEAMS

2F NOIR HARATUKU BOULEVARD

3-24-7 JINGUMAE

SHIBUYA, TOKYO

TELEPHONE: 3470-3948

HOURS: 11-8 MON.-SAT.

(CLOSED ON THIRD WEDNESDAY OF EVERY MONTH)

Just as Japan, having first been taught to build cars by America, eventually surpassed its teacher as the world's automotive leader, this store has proven to be an apt pupil of menswear, more successful than its Western mentors would have ever conceived. Beams is Tokyo's most renowned men's specialist and proof-positive of Japan's arrival on the world's fashion stage. No other Tokyo retailer more typifies this country's advancement and sophistication in men's fashion.

Beams was started in the seventies by Mr. Shitara, the son of a man who imported American menswear icons such as Levi's and Weejuns. He has taken his father's concept and expanded it into a twenty-six-store, $100 million retail empire. This address is its original stomping ground and one of the primary reasons Harajuku became one of Tokyo's first fashion centers. As with most recent Japanese retail ventures, its decor is American inspired, combining fifties modern with New England Ivy. The rough-hewn wood plank floors and wooden cabinets and tables on its ground level impart the feeling of a Vermont country store.

It is packed with urban casual wear whose diversity of design sensibilities transcends that of even the largest department stores. Seventy percent of the ground floor's merchandise is designed by Beams. All the Tokyo street trends are represented here in one form or another, from hip argyle vests and workwear-chic outerwear to club Bohemian chenille turtlenecks. Jogging alongside this fast-

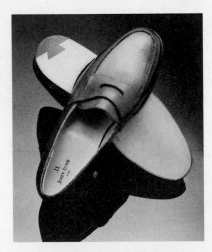

A SLIP-ON WITH HAUTEUR:
HERMÈS'S INCOMPARABLE LOPEZ
PENNY LOAFER.

TOKYO

paced gear is an assemblage of the world's savviest, most eclectic foot fashions: Nike athletic shoes, Tyrolean slippers, Clark's latest non-desert boot, and rock-and-roll, pointed-toe brothel creepers. Augmenting all of this serendipitous fashion are accessories for those parts of the body not already covered, such as the head, waist, ankles, eyes, and neck. And it's all sold on a floor so jumping you can hardly distinguish the customers from the salesclerks.

Ascending the store's winding glass stairwell, you leave behind Beams' fast-paced Gap machinations and enter its highbrow world of international design and artisan-crafted fashion. In a gallery setting, you will find an amalgam of men's clothing accessories whose relationship to each other is simply that they sate Mr. Shitara's passion for heady wearables. The diverse selections transcend the boundaries of any single archetype or mind-set of fashion. A $3,000 cashmere sports jacket by Neapolitan Italy's Kiton hangs next to a nylon-and-plastic vest by one of Tokyo's as-yet-undiscovereds. London's master shoemaker George Cleverley's square-toed slip-ons sit beside Albert Thurston's hand-finished white catgut braces, which share the same tabletop with a hand-tooled Mexican belt. Richard James of Savile Row hangs next to Romeo Gigli and John Lobb's exquisite penny loafer is neighbor to an Elvis Presley Nashville shoe—however, not in blue suede.

Beams' overview of international men's fashion is staggering. The tastes here embrace the street and the salon, the androgynous and the macho, the high-tech and the hand-tailored. The presentation is so provocatively cerebral, it defies comparison to any other store in the Far East and, perhaps, anywhere else. For the true connoisseur of world-class fashion, Beams is one major reason to visit Tokyo.

LLOYDS

5–18–4 MINAMI
AOYAMA, TOKYO
TELEPHONE: 3409-9335
HOURS: 11–8 MON.–SUN.
3–3–8 GINZA
GINZA, TOKYO
TELEPHONE: 3561-8047
HOURS: 12–9 MON.–SUN.

No single object captures English taste more than a well-worn and well-maintained bench-made leather shoe. Hold it up to the light and observe how its leather has gained texture and depth of color with age. In keeping with Japan's fascination with all things royal, upper-class in taste, and, in this case, British, this reverential throwback to old English boot-making calls itself by one of the most Anglo of names: Lloyds. The shop was started by a Mr. Toyota as an antique furniture store in 1972. He and his partner kept some of their display cabinets and eventually transformed the shop into a miniature John Lobb.

Just as antiquities develop character with age, Lloyds' hand-sewn leather products also benefit from the passage of time. With their English cabinets, brass-nailed, leather-covered foot benches, and well-trod Persian rugs, each branch of Lloyds maintains the atmosphere of an Oxford-on-Thames cobbler's shop, despite residing in the midst of one of Tokyo's bustling, glittering shopping areas.

With the exception of their Prince Albert velvet slippers, all of Lloyds' shoes are made in Northampton, England, at Crockett & Jones. Lloyds stocks around thirty styles of their own design in only E widths—the usual fit for the wider-footed Japanese—in sizes from 6 to 9. They can special-order any of their models if your foot does not fall within that range. The stores carry some stylish English welt shoes such as a semi-brogue oxford cap-toe, a ribbon-tasseled loafer, and a two-toned V-tip Derby summer shoe. These shoes cost between $380 and $580, with special orders taking six to eight weeks.

Recently, they added a complete line of bridle leather cases and luggage also hand made in England. Their briefcases, ranging in price from $450 to $1,000, are exactly the sort of distinguished models one

TOKYO

would expect British financiers to tote to the City. As with many Japanese renditions of anything Anglo, this store might strike some native Londoners as more caricature than homage, but it clearly demonstrates the owner's reverence for timeless products from a country that, like Japan, still has a place for pageantry and royalty. For those universityites desiring a proper finish below their tweeds and flannels, no place outside of London could offer more charm and nostalgia for the Empire than Lloyds.

OYSTER
2–18 MINAMIAOYAMA 3 CHOME
MINATO, TOKYO
TELEPHONE: 3478-1918
HOURS: 11–8 MON.–SUN.

This miniature, epicurean morsel of Tokyo menswear is particularly appetizing. It is the only privately owned store in Tokyo without any other branches. Oyster has quietly gone about its business for the last seventeen years while the now *en vogue* area of Aoyama has grown up around it.

Its owner, Mr. Kawate, an early enthusiast of American design, first stocked his shelves with the updated Brooks Brothers perspectives of Ralph Lauren, Alan Flusser, Jeffrey Banks, and Alexander Julian. His original model for the store's merchandise mix was New York City's Chelsea clothier of urban hip, Camouflage. Like many other establishments, Oyster first used the idiom of American style to define its fashion point of view and then traded up to those higher quality European renditions that offered their eighties twist on the Land of Liberty's freethinking sportswear tradition.

Set up like a kitchen with its cash register and tray of accessories forming a center serving island, Oyster's delectables hang within easy perusal and grasp. Hip tweeds from Northern Italy are always on the menu, as are selected bits from the Biella Collection, C.P. Company outerwear, Milan's Guy Rover sport shirts, Crockett & Jones shoes, and J. P. Tod's suedes. Zanella trousers are an exclusive of the house, as no other store in Tokyo serves them. You will also find a little Zegna,

TOKYO

some Naples tailored clothing, Italian-made patterned hosiery, and a sprinkling of other European haberdashery.

Opening up its door is like coming upon a string of pearls within a single oyster. Not only is what's inside a delightful surprise, but as its little oyster-shaped welcome rug states, "It's an oyster with a special sauce."

SHIPS
1–11–1 JINNAN
SHIBUYA, TOKYO
TELEPHONE: 3496-0487
HOURS: 11–8 MON.–SAT.

This twenty-year-old business opened its flagship here in 1986. Owned by Mr. Miura, yet another devotee of the high school and college fashions from America's 1950s, he originally imported whatever youth classics he could get his hands on, such as jeans, button-downs, and white bucks.

The store was christened Ships because its merchandise had to be boated in from abroad and many of its early fashions had a nautical theme. Located on a little side street, the two-floor shop has large chrome columns and a gray marbleized front that provide a modern exterior that counterpoints the traditionally designed threads inside. The ground floor features sportswear, but it is upstairs, where their tailored clothing and furnishings are on display, that this store really navigates.

Dress shirts have always been a Ships specialty, and their Milanese-influenced spread collar fashion is among the city's best. Made with a single needle construction in two-ply cottons, their dark blue oxfords and Montenapoleone-striped dress shirts lead the way. Recently they further bolstered their dress shirt franchise by adding a selection of Italy's finest, hand-sewn by Luigi Borelli ($225–$350).

Their tailored clothing has a singular sophistication. While respecting the suit's American soft-shouldered roots, Ships has moved its silhouette forward, embracing the updated Brooks Brothers sensibility of the French designer Marcel Lassance, whose fashions they

TOKYO

carry. Their longer, three-button model comes with rounded shoulders and small side vents, finishing over its narrow pegged and cuffed trouser. Made in Italy, it retails from $1,000 to $1,500. When paired with either their French Weston penny loafers, English Crockett and Jones lace-up, or American Paraboot, and accessorized by their spread-collar, upper-crust British neckwear, the look is smart and the next step up the trad ladder.

UNITED ARROWS
6-13-6 CHOME
SHIBUYA, TOKYO
TELEPHONE: 3797-9791
FAX: 3797-9797
HOURS: 12-8 MON.-SUN.

Founded in 1989, this stylish store is the creation of Mr. Shigematsu, former partner of Mr. Shitara, the founder of Beams. This is the first of four stores in Tokyo, with another six located outside of the city. They carry women's clothing on the first floor, men's on the second. The taste here is upscale Beams but without that store's street savvy. It aspires to appeal to the customer who would patronize Paris's Hermès or New York's Bergdorf Goodman. With its white-on-white walls and ceilings, pine display cases, and herringbone-patterned floors, United Arrows is pared-back, clean, and modern. Its merchandise provides all the color and texture a store could ever need.

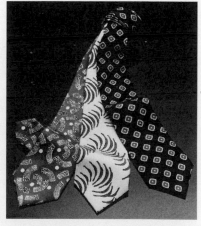

Members of Tokyo's toggle-coat-and-khakis set looking for upscale togs of European quality have made United Arrows the sportswear purveyor of choice. They carry offbeat classics and an imaginative collection of sportswear tops and

THE ELEGANTES OF GARRICK ANDERSON: LARGE SPACED ABSTRACTS BECAME KNOWN AS "CHARVETS" AFTER THE FAMOUS PARISIAN CHEMISIER WHO POPULARIZED THEM IN THE 1920S. NO ONE MAKES THE OLD MORE STYLISHLY NEW THAN THIS AMERICAN DESIGNER.

TOKYO

accessories. Recognized as one of the most credible new retailers in this city, United Arrows is slowly expanding its carriage-trade following.

The store name comes from an old Japanese fable in which a samurai father teaches his sons the value of strength through unity. With its founder's focused, unifying vision of offering merchandise that appeals to a specific genre of shopper, United Arrows should continue to advance in step with the affluent Tokyoite.

TORONTO

AN INTRODUCTION

Established by a French king, long dominated by the English, Toronto is an exciting mélange of cultures doing many kinds of business. For years it was an unthreatening second to the more culturally visible, French-accented Montreal. Then, during the 1970s, several major corporations, stock market, and real estate people decided it was the place of the future. They came in, and Toronto took off. It became the fastest-growing city in North America and, commercially, the seventh most important city in the world.

Situated only twenty miles from the U.S.-Canadian border, Toronto is inevitably affected by what happens in the United States. Clean, green, and orderly, it is known as Toronto the Good. This can be seen in its enviable subway system, love of theater and art, and reverence for its history. For every gleaming New City Hall, there is an Old City Hall; for every SkyDome, there is a Flatiron. Toronto's architecture embraces both the past and the future, the traditional and the hard-edged.

So, interestingly, does its menswear—although it still leans a bit toward the conservative. This is due partly to its British heritage, the Old Guard bringing with it a proclivity for pinstripes and Burberry raincoats. Torontoans are proud but defensive, a bit inclined to explain themselves and a bit in awe of New York fashion. Certainly they are more cautious than their confreres in Montreal. If a Toronto man were wearing a navy blazer, its blue would be more black, while in Montreal, its cast would be more purple.

Having overtaken Montreal as Canada's financial, corporate, and publishing center, Toronto's citizens are necessarily well-traveled. They jet regularly to New York and Europe. Foreigners come here, to swirl through Toronto from its Underground City to the Ontario Science Center to the soaring CN Tower. This is a city of tremendous ethnic diversity that touches the palate as well as the ear—from Little Athens to Little Italy to Chinatown—in over four thousand restaurants.

TORONTO

And it is a congregation of many residential neighborhoods, from quaint Cabbagetown to old-money Rosedale to chic Yorkville, its most fashionable shopping area. In a city that suffers such a long, harsh winter (well into April), a man needs a varied wardrobe. And Bloor Street, Toronto's Rodeo Drive, serves him well.

GIORGIO COUTURE
111 BLOOR STREET WEST
TORONTO
TELEPHONE: (416) 944-2600
FAX: (416) 944-2191
HOURS: 10–6 MON.–WED., SAT.; 10–8 THURS., FRI.

Owner George Elian is shrewd, charming, and knowledgeable. He dresses impeccably and has a definite feel for where he wants his business to go. George, who learned his trade at Holt Renfrew, opened his first shop in 1976, then opened and closed ten others.

Elian claims there is nothing like his store anywhere else in North America. Designed by Ezio Riva, who did the Ferre boutiques around the world, its high-tech ambiance is architecturally spare, with plenty of sleek, modern, metal surfaces. George has some specific ideas of what people look for when they're strolling along Bloor Street. If they walk in here, he wants to transport them far away from Toronto's classic side toward his futuristic conception, even if it more resembles Mars than Milan. This is Elian's vision of modern Italian fashion; however, his is the Versace version, not the Bardelli.

Giorgio Couture represents the fast track of Toronto taste. Juxtaposed to the decor's hard-edge silver, Ferre brightly colored sports jackets are illuminated, while the sportswear by Thierry Mugler, Dolce & Gabbana, and Moschino become easily highlighted. For those of less galactic tastes there are lightweight Loro Piana black cashmere raglan-sleeve topcoats ($1,500), handmade and shouldered Forrall suits, and some good-looking leather briefcases and luggage. As with Versace's glitzy-stroked fantasy, Giorgio Couture will either immediately grab or repel the curious, but it will definitely not bore them.

HOLT RENFREW
50 BLOOR STREET WEST
TORONTO
TELEPHONE: (416) 922-2333
HOURS: 10-6 MON.-WED., SAT.; 10-8 THURS., FRI.

Founded as a furrier in 1837, Holt Renfrew sold beaver and other indigenous skins to the monarchs of Europe. Those early royal connections established the firm's prestige while anchoring its initial expansion across Canada and into upscale fashion. After languishing in the hands of one of America's behemoth retail conglomerates, the store was reclaimed in 1987 by a prominent Canadian family whose business interests included Fortnum and Mason in London and Brown and Thomas in Dublin.

Hillary and Galen Weston bought Holt Renfrew planning to remake it into the Bergdorf Goodman of Canada. In 1991, they hired Joel Rath as president, a respected American retailer who studied at the knees of America's legendary carriage-trade merchants, Adam Gimbel of Saks Fifth Avenue and Stanley Marcus of Neiman Marcus. With the substantial resources, initiative, and taste of the two Westons behind him, Mr. Rath began to restore the firm to its original position as the country's preeminent luxury specialty store.

Today, there are twelve Holt Renfrew stores throughout Canada, but this is headquarters. Renovation was undertaken by Naomi Leif, store decorator to the stars. The main floor was totally redone, and the menswear presentation was expanded into a sumptuous downstairs space. There are now individual Calvin Klein and Donna Karan shops, the avant edgings of Matsuda, Gaultier, and Gigli, an exciting jeans room with a whimsically painted floor, a full-scale barber shop, and plenty of suits by Canali, Armani, Gieves & Hawkes, and Etro. Its main floor offers Turnbull and Asser, European luggage from Etro, Prada, and Tannen Crolla, and extensive outerwear furnishings with gloves in no less than thirty-five styles. Holt Renfrew also publishes a glossy quarterly, *Point of View*, which is sent to 175,000 customers. Like the store, it introduces its readers to worldly elegance and international style.

Whatever Holt Renfrew carries is either exclusive to the store, or the country's most complete presentation of that designer or label. Cou-

TORONTO

pling the Westons' financial strength and aesthetic sensibility with Joel Rath's retail expertise, the team has positioned Holt Renfrew to take its place as Canada's leading purveyor of upscale fashion and luxury.

———

MARC LAURENT
151 BLOOR STREET WEST
TORONTO
TELEPHONE: (416) 928-9124
FAX: (416) 928-0039
HOURS: 10–6 MON.–WED., SAT.;
10–8 THURS., FRI.; 12–5 SUN.

One day, Harry Bendayan was having lunch with a friend when he decided to open a men's store. He'd come to Toronto from Morocco at nineteen, and felt that shopping here was antiquated and inadequate, still mired in the predictable English mode. He opened Marc Laurent in 1980, and today it is Toronto's most well-recognized fashion store. In one way, it reminds me of Marcel Lassance's shop in Paris. Both are understated but knowing. Harry sells more merchandise of a subtle taste than anyone else in Toronto.

Having just expanded again, the store has moved across the street from its prior address. His last renovation in 1986—a sleek spread of granite, marble, and metal—was featured in several of Toronto's architecture magazines. I'm sure this one will be just as celebrated.

Harry's style is a casual chic. The clothes are tweedy, but without even a whiff of uptight English propriety. Bendayan introduced the tailored clothes of Nino Cerruti 1881 to Toronto. He carries an extensive array of Cerruti sports jackets in cashmere fancies and solids ($795–$1,000). He also features Armani, knitwear by Girombelli (the company that also makes Byblos, Montana, and

POISED BETWEEN CLASSIC TAILORING AND MODERN LANGUOR: CERRUTI'S THREE-BUTTON CASHMERE SPORTS JACKET IN FAWN HOUNDSTOOTH.

TORONTO

Versace). The colors are sophisticated, the shapes modern. There are washed-linen jeans in various hues, cashmere sweaters in seasonal shades, an amazingly luxurious washed-denim shirt that has the character of denim but feels like silk ($200). These are clothes for a guy who needs them for weekend traveling as well as for work.

Marc Laurent aims for the less showy, more fashion-secure man. It's a mix of clothes you'd expect to find in Paris or New York. At any given time, you'll discover something that can be effortlessly integrated into the wardrobe of the discerningly stylish man. Fortunately for Torontoans, at Marc Laurent, you don't have to leave town to look as if you had.

NICOLAS
86 BLOOR STREET ON BELLAIR
TORONTO
TELEPHONE: (416) 966-2064
FAX: (416) 966-2067
HOURS: 10–6 MON.–WED., SAT.; 10–8 THURS., FRI.

This is an aspiring Marc Laurent (which is around the block), and no surprise, since Nicolas Kalatzis used to work there. After nine years with Laurent, he developed enough of a following to open his own business in 1992. Nicolas is very charming, and always on hand. His one-hundred-square-foot shop is a rather functional space with cement floors, flecked Australian blond-lace wood, and glass. There is one changing room and an office in the back.

Nicolas specializes in Italian fashion merchandise, from Italian knitwear to Vestimenta, Romeo Gigli, and his own private-label high-fashion suits ($750–1,300). He features hip knitwear such as oversized, Smedley-type collared knit pullover shirts and cardigans ($275). Aware of Toronto's influx of Asian customers, he conscientiously carries clothing in smaller sizes (a lot of 34s and 36s). Nicolas has carved its own niche, more aggressive than Marc Laurent, less flashy than Giorgio Couture. With Toronto's appetite for international style on the rise, Nicolas is another place setting on this city's constantly expanding table of fashion.

TORONTO

PERRY'S
131 BLOOR STREET WEST
TORONTO
TELEPHONE: (416) 923-7397
FAX: (416) 923-8384
HOURS: 10–6 MON.–SAT.

When Perry Dellio opened his store in 1962, he said he wanted it to look as if it had been here forever, and that's just how it appears. Unlike the neighboring temples of glass and stone, Perry's envelops you in a hush of mahogany and teak, rugs and crystal chandeliers. Walking in here, you are immediately transported back to the pre-designer era. This is Toronto's preserve for the more mature tradition-alist. It reminds me of the late Tripler in New York City.

Perry's offerings are displayed in a series of oval rooms. Nothing here is inappropriate, trendy, or high fashion. Shirts and accessories are in the first room, outerwear and leather in the next. The third is for tailored clothes, which include suits by Samuelsohn ($535–$650)—Canada's last maker of canvas-front, natural-shoulder suits—and a less expensive label made locally. Custom-made clothes are in the back room, where longtime customers Pierre Trudeau and Oscar Peterson might be found. Custom suits are $850 to $1,000 and come with jacquard woven linings. If you're in Toronto and want something that looks familiar yet smartly fresh, Perry's is your bet.

HARRY ROSEN
82 BLOOR STREET WEST
TORONTO
TELEPHONE: (416) 972-0556
FAX: (416) 972-0564
HOURS: 10–7 MON.–WED.; 10–9 THURS., FRI.; 10–6 SAT.

Harry Rosen, Canada's preeminent mens clothier, founded his business as this country's first important purveyor of American traditional fashion. Today, he enjoys the respect and reputation as one of North America's leading menswear savants. In spite of having cautiously enlarged its spectrum of tastes to include Italian fashion in both tai-

lored clothing and sportswear, the Harry Rosen business continues to retain much of its soft-shouldered roots. His stores are microcosms of international contemporary fashion, shopped by American and European retailers in pursuit of his latest thinking, much of which Harry is happy to share.

In 1954, while starting his own business with his brother, Harry began his education in the ways of menswear. With twenty-two Harry Rosen stores across Canada, he is in a position to influence the sartorial habits of many. He seizes every opportunity through his advertising and brochures to educate those who will listen to his gospel on the subtleties of stylish individuality in men's dress. As with another retailer, New York's Paul Stuart, out of whose book he has taken more than one page, Harry's commentary is always wise, thoughtful, and captivatingly presented. This accessible, charming dynamo is frequently found on the retail floor, eagerly explaining the heritage of traditional menswear as well as some of the incomprehensibles of contemporary fashion.

This flagship store opened in 1987. It is an emporium of dress-up taste for men who need to wear tailored clothing for business. Furnishings and sportswear are on the main floor. The designer shops are upstairs, while the European classic, updated traditional, and made-to-measure clothing are downstairs. With suitings ranging from Brioni, Zegna, Corneliani, and their private label, J. P. Tilford and Sedgwick by Coppley Apparel, to Armani and Hugo Boss, the selection here is diverse and impressive. While eschewing the traditional purity of Paul Stuart on the conservative end and the edgy chic of Barneys on the advanced side, Rosen's menswear represents an accurate cross section of upper-end Canadian taste.

More than any other retailer in Canada, Harry Rosen is responsible for shaping much of the country's collective fashion consciousness. And in a country whose population is spread out over vast expanses of land, it is his passion and vision for the business at hand that has helped bring this northern expanse's appreciation for quality and better business apparel up to international speed.

TORONTO

VIENNA

AN INTRODUCTION

Duraing the nineteenth century,
Vienna was considered the Savile Row of Eastern Europe. By the close
of World War I, the Austro-Hungarian Empire was dismantled, and
Vienna had relinquished its cherished position as the seat of sovereign
authority. Two world wars have dissipated the atmosphere of everyday
luxury that once reigned there. The Budapest shoemakers and leg-
endary tailors from Prague have just about vanished as well. Yet, the
spiritual, and in some cases, actual, offspring of the fin-de-siècle arti-
sans seem determined to extend the city's tradition of imperial work-
manship and craft.

This is the city that gave birth to the first designer concept in
menswear—more than fifty years ago Knize developed a line of men's
toiletries and the famous Knize Ten cologne as well as a look, a logo,
and a legend—that spawned the designer megabusiness of today. It is
not, however, a "designer" city; you wouldn't come here to buy
Armani or Paul Smith. The unmistakable influence of Tyrolean wear
on American sportswear, as depicted every Christmas in the old illus-
trations by Leslie Saalburg in *Esquire* and *Apparel Arts*, immortalized
Austria while making the Tyrolean hat a prerequisite on every college
campus, and Tyrolean attire a fashion statement on every important
ski slope. Tyrolean wear is still significant there. Like Western wear in
the States, it is living folk art.

The very name Vienna evokes lush music and romance—
Beethoven, Mozart, Haydn, Mahler, the waltz, and Anton Karas's
zither from *The Third Man*—but Vienna also has a tradition of serious
style. Classic tailors and shopkeepers are still patronized by the sons
and grandsons of their original customers.

Most of Vienna's numerous eighteenth- and nineteenth-century
buildings have been preserved, attesting to a brilliant architectural
past that few cities can boast. It offers the great *strasses* where one can
still imagine horse-drawn carriages carrying the nobility to their assig-

nations. Western Europeans and Orientals are here in swarms, but oddly enough Americans have yet to discover it. The cobblestone backstreets are filled with charming little shops. Like Rome, it is wonderfully walkable. Like Venice, every inch of it is magically suffused with history. Like Paris, it remains one of the most elegant spots on earth.

Venice offers a bridge to the past—a glorious conflux of armor and arias, cafes and cathedrals, *Tafelspitz* at the Sacher Hotel and pastry at Demels, Hapsburg and haberdashery. No matter how many leather jackets are worn over loud plaid shirts, no matter how much new money appears in light colors, heavy fabrics, and garish combinations, there's not a thing anyone could do that would make this place look modern. With the fall of the Iron Curtain, Vienna may at long last regain its traditional role as the fashion hub of Central Europe.

W. F. ADLMULLER
KARTNERSTRASSE
VIENNA
TEL: 512 66 50
FAX: 513 99 74
HOURS: 9:30–6 MON.–FRI., 8:30–1 SAT.
(8:30–5 FIRST SATURDAY OF THE MONTH)

Situated near the Opera House, this was the showplace of the great Fred Adlmuller, cook-turned-couturier. Not formally trained, but stylishly ingenious, he created magnificent gowns for the royal families in the audience as well as the divas onstage, taught design at the local academy, put on fashion shows of men's and women's clothes twice a year, and gathered a grand following. The professor died in 1990, but a book describes his place in haute couture and Viennese society.

Two years ago, the shop was redone with simple elegance: light stone floors, red carpets and Persian throw rugs, and fixtures of black and Viennese brass. It brings to mind a modern version of Hermès and even carries a selection from that storied firm.

Being on the Kartnerstrasse, the shop windows are designed with a heavy Germanic hand more to attract tourists than to display the

VIENNA

THE ARISTOCRAT OF HAPSBURGIAN NIGHTWEAR:
PIMA COTTON PAJAMAS TAILORED WITH
THE UNSPARING DETAIL OF OLD-WORLD
CUSTOM CLOTHES.

merchandise in them. Overwrought and flashy, they scarcely suggest the history of the store or some of the sophisticated wearables found within. These include Versace print shirts ($400–$1,700); Hermès print shirts ($1,200) and scarves ($230), as well as coats, suits, and neckwear; Loro Piana polka-dot cashmere robes ($2,500); Lemmameyer alpaca sleeveless V-neck sweaters and cardigans ($425), once considered the height of elegance on the golf course due to their light weight and bell-shaped sleeves. Although the size range is limited, there are Chester Barrie suits from England, as well as Brioni, Zegna, Cerruti, and coats from Aquascutum. For a sense of life in the glory days, you need only slip on a pair of Adlmuller's old-world pajamas—available in ten shades of Egyptian cotton with contrasting piping, pearl-button fly, front waistband panel, pleated front, and a back in the shape of an English brace trouser.

Today, the shop is something of an omnium gatherum. You wouldn't come here for high fashion, but it's a chance to admire a potpourri of Europe's sumptuousness from the subtle to the flamboyant.

CHRISTL

STALLBURGGASSE 4

VIENNA

TELEPHONE: 533 10 61

HOURS: 9–6 MON.–FRI., 8:30–1 SAT.

(9–5 FIRST SATURDAY OF THE MONTH)

With its green-and-white-striped awning and its sign of creamy letters on chocolate brown, this looks, from the outside, like a candy shop. Here, the goodies are gloves. In its two front windows, each model is displayed with a reference number. Once inside, however, the feeling is of a bursary, with the valuables tucked safely away in brass-handled drawers stacked floor to ceiling. This interior is a mere 150 square feet, leaving no room to showcase the gloves that are available in every color, skin, and texture; you have to ask for what you want. Although the shop is famed for supplying gloves to Vienna's Spanish Riding School, what you probably want are gloves for driving or hiking, for strolling the *Strasse* on Sunday afternoon, or attending in tails the annual Opera Ball, all of which are made exclusively for the store right in Vienna.

ZUM JOCKEY-CLUB

TEGETHOFFSTRASSE 7

VIENNA

TELEPHONE 512 59 11

HOURS: 8–6 MON.–FRI., 8–1 FIRST SATURDAY OF THE MONTH

Tucked behind the Opera House near the Sacher Hotel since 1913 is this rendezvous for the older Viennese gentleman who still fancies his clothing, including his undergarments, made to order. Named for the old jockey club across the street that was bombed during World War II, Zum Jockey-Club is currently run by Robert Ruzicka, a fourth-generation descendant of the founder. The salonlike interior is pleasantly timeworn with dark rugs, Italian light fixtures, and drawn red velvet curtains in the changing room.

As with many small shops, the merchandise is generously displayed in the windows and preserved in glass vitrines within. Ask and

VIENNA

you will be shown the splendid English robes of silk foulard ($400) or Viyella tattersall ($175), as well as Swiss handkerchiefs ($20–30). They also make made-to-order dressing gowns of silk foulard ($350) or wool ($200), and beautiful English tartans ($225) that take three weeks for delivery. Of course, Jockey-Club also makes evening shirts for those black-tie dinners at the Von Trapps.

They are accustomed to satisfying the eccentric whims of Hapsburgian families. On my last visit, they were filling a request from one of their baronial regulars for boxer shorts with a double crossover design in back and special loops for his noble braces, a typically indulgent way of ensuring that the shorts remain at the desired height ($125). It's that kind of place.

———

WILHELM JUNGMANN & NEFFE
ALBERTINAPLATZ 3
VIENNA
TELEPHONE: 512 18 75
HOURS: 9:30–6 MON.–FRI., 9:30–1 SAT.
(9:30–6 FIRST SATURDAY OF THE MONTH)

Gone are the ballgowns and officers' uniforms once made here for the Imperial courts of Italy and Austria. Perhaps the emperors and officers have moved on, but their presence is still felt. Attached to the illustrious Sacher Hotel and dating back to 1876, this store has regally carved thirty-foot ceilings and a frescoed blue dome. Royal crests woven in velvet adorn the high walls, and two Venetian-style Hapsburg chairs covered in silk velvet brocade stand guard.

Today's needs are of a different sort, but thanks to the abundance of local Viennese gentlemen still inclined to have their clothes made to order, Jungmann & Neffe has survived by becoming specialists in woolstuffs. Since 1942, it's been owned by the Suchy family. For more than fifty years, the store has been selling fabrics from the finest mills in Europe, especially England. Here, for the elegant Viennese en route to the office or the Opera House, are 2,000 topcoat, suit, and trouser fabrics ($28–$85 a yard); the cashmere and cashmere-and-silk sport jacketings are particularly eye-catching. Accompanying the English fabrics are accessories such as English ties (some 2,000 of

them, including many bows), scarves, and Briggs umbrellas. With the
eloquent aura of an extraordinary time hovering over its aged shelves,
grand presentation tables, and carved cashier's booth, this is a living
museum. Even if you are not predisposed toward things custom made,
Jungmann & Neffe offers an opportunity to try on the grandeur of
what was once the Hapsburg civilization.

KNIZE
GRABEN 13
VIENNA
TELEPHONE: 512 21 19
HOURS: 9:30–6 MON.–FRI., 9:30–12:30 SAT.
(9:30–5 FIRST SATURDAY OF THE MONTH)

There is no one who has ever fancied himself a dresser who hasn't
passed through this firm's portals. Attesting to this fact are photos,
postcards, and letters from legendary customers such as George Solti,
Maurice Chevalier, and Adolphe Menjou as well as those currently on
the slopes at Saint Moritz. A debonair visiting this city without paying
his respects to this architectural landmark of menswear history would
be tantamount to a painter visiting Moscow and ignoring the Her-
mitage. Other than Caraceni and a few firms on Savile Row, this is one
of the world's giants of authentic old-world tailoring.

Knize was established in 1858 by a Czech family of tailors who
provided riding clothes for Austria's Empress Elizabeth, among other
notables. Around 1880, Albert Wolff, a banker, bought into the firm,
bringing financial backing as well as his ingenious wife, Gisela. When
Wolff died in 1902, Gisela and her son maintained the family interest
in the firm. They also set about making history.

Mrs. Wolff hired maverick architect Adolfe Loos to design a
sleek new shopfront and interior. His modern blend of glass, mirrors,
and black marble—a stunning example of the Yugenstile—still
stands, as does his curved staircase of blond cherry. She then entrusted
Knize's corporate identity and aesthetic sensibility to the extraordi-
narily versatile designer Ernst Dryden (né Deutsch) known for his lith-
ographs, logos, ads, book covers, posters, stage sets, and, later, fashion
designs for the haut monde as well as Hollywood. For Knize, he cre-

VIENNA

ated a most un-Viennese logo (clear lettering on a white oval), the legendary Knize Ten cologne, and a line of men's toiletries named Polo Ten, inspired by the upper-crust British game. ("It was Gucci before Gucci and Polo before Ralph Lauren," wrote Anthony Lipmann in his 1989 biography of Dryden). Loos and Dryden are as responsible for Knize's special niche in menswear history as are any of the firm's extraordinary tailors.

Ascending Loos's famous staircase is a memorable experience; it's like climbing a sumptuous stairway on a great ocean liner. And it is in this way that the Who's Who of men's fashion have made their entrance for nearly a century. The steps themselves, originally carpeted in white linen, are now painted the green of the Vienna woods.

Upstairs, the first floor is carpeted in another green—a green unlike any other, as special as Vatican purple—which intimates that this is a venue of distinction. Here, among the dark cabinets and showcases, are mahogany tables strewn with bolts of old English fabrics and a big leather-bound book containing quarter-yard samples of elegant dress shirtings. Although Knize carries ready-made suits from such top European makers as Brioni, Barrie, and D'Avenza, one should focus on its three-button, side-vented, soft-shouldered house style. All great tailors have a *style de la maison;* Knize's is the 1920s diplomat look—for the Anthony Edens of Austro-Hungary or the Hapsburg banker who would have been comfortable shopping at Brooks Brothers forty-five years ago.

From belt loops to buttonholes, a Knize suit exudes the detail of magnificent handiwork. A cousin to Anderson & Sheppard of London's Savile Row and Rome's Caraceni, it is definitely its own breed. No one else makes a coat with such a rounded-off shape. While it's not Victorian, it is definitely old-money. The vest, which has handmade tabs to keep its rear straps in place, is cut in two pieces and has a waistline much like a proper tailcoat. A tab beneath the vest attaches to the waistband button of the trouser to prevent the vest from riding up. Suits are $3,000 and worth every schilling. They take six weeks and require at least two fittings.

Of equal interest are the custom-made shirts ($260–$300) with their specially shaped buttons. The store also carries rare hand-woven Thomas Adie shetland sport jacketings, hats by Borsalino and Lock, its

VIENNA

own silk-lined ties made in two widths—is there any other store that offers the same ties in two different shapes?—and, of course, tails, which Knize still makes for the Viennese grand balls.

At one point prior to World War II, Knize had shops in all of Europe's most important travel spots, from Baden-Baden to Paris, as well as stores making custom clothing in Palm Beach and New York City. With the collaboration of Adolfe Loos, Ernst Dryden, and Gisela Wolff, Knize became the first "designer" name in international menswear. No study of the history of modern male elegance could ever be complete without closely examining this firm's particular role in defining style for the pre-war international traveler.

MAX KOWALSKY
GOLDSHMIEDGASSE 7A
VIENNA
TELEPHONE: 533 09 77
HOURS: 9:30–7:30 MON.–FRI., 9:30–1 SAT.

Max Kowalsky is Hapsburgian homage to the Ivy League. With its bottle green carpeting, cream walls, Biedermeierish wood cabinets, and fifties post-college sensibility, this is a store with tradition, though not one that is particularly Viennese. Although punctuated by such preppy props as a vintage golf bag and Yale banner, it is more private-school-international than simply retro-American.

Georg and Edi Koaretho opened the shop in 1985, determined to purvey their Anglo-American goods to a more sophisticated crowd than their father had ever envisioned when he began his small suburban shop some thirty years ago. Moving away from the formality of made-to-order, while respectful of tradition and classical taste, they filled the shop with modern, high-quality, international basics: Levi's 501s and Polo chinos, Herbert Johnson hats and Barbour fisherman jackets, Smedley cotton lisle and merino wool knit shirts in hip colors, and Timberlands and Tods and Alden tassel loafers.

Shopping here is like reading a classic. It's instructional, timeless, and a pleasure you can revisit, again and again.

VIENNA

LODEN-PLANKL
MICHAELERPLATZ 6
VIENNA
TELEPHONE: 533 80 32
FAX: 535 49 20
HOURS: 9–6 MON.–FRI., 9–1 SAT.
(9–5 FIRST SATURDAY OF THE MONTH)

Welcome to Tyrolean Central. If you appreciate American Western wear for its function-inspired design and understand the collectability of a fifties-style H Bar C shirt or a great hand-tooled roping boot, this is a place to savor. Instead of being born on the plains or the great frontier, the styles here were born in the mountains of the Tyrol but designed and made to take a beating much like the clothes that were worn by the tamers of the American West.

At the same address since 1830—on a splendid square with the Renaissance Michaelerkirche, the neo-Baroque Palais Herberstein, and a controversially modern building designed by architect Adolfe Loos— the store is an institution. Rickard Plankl took it over in 1880 and is undoubtedly the visionary responsible for the store's well-deserved fame. Tyrolean wear, like its American Western equivalent, is decorative but functional. It's authentic, not kitsch, designed to be worn and worked in, and to endure. This is as good as it gets.

Especially recommended: their own boiled-wool hunting coat whose undersleeve unbuttons to provide additional fullness for shooting ($420), a hunting coat by Salka ($400), a shooting cape ($325), Tyrolean hat, knit slipper socks with leather soles, and side-tying Austrian walking shoes. But the best treat is that they make to order Tyrolean togs, which are not only gorgeous and authentic but made to last a lifetime.

If you have the time and inclination, you can consult with Gert John, the fourth-generation owner, and he'll help you make up a special twenties-inspired loden jacket or vest that you can pass on to your grandson, since it will last at least that long without falling out of style. He has the fabrics, trims, horn or metal buttons, accessories, leather patches, brushes, and feathers. He has the old sketches and vintage books filled with old designs. He has the stone floors, big

oaken tables, and enough different shades of loden green for the greening of America, Austria, and everywhere else.

To mate a great Tyrolean jacket with Armani wide-wale corduroys, an English Smedley knit shirt, and J. P. Tod's desert boot is to be well versed, well dressed, and, well, different.

GEORG MATERNA
MAHLERSTRASSE 5
VIENNA
TELEPHONE: 512 41 65
HOURS: 8–12:30, 2–6 MON.–FRI.; 8–12 SAT.

This is the only store in the world that makes what I'd call custom stock specials. There are bespoke shoes and ready-made shoes, both of which Georg Materna does exquisitely, but these are something else. If you see a custom shoe whose style you admire, the shop will make you that model in one of their ready-made lasts, so you need not go to the expense of having your personal last made. If, for example, you're an 8½C in one of Materna's ready-made shoes (of which there are some twenty styles in three widths), and you like the black monk strap, cap-toe custom model, but you want it in brown suede with a crepe sole, they'll make it for you. . . . Not for the $1,000 of a custom-made shoe but at $500 or $600. You can choose from such leathers as ostrich, crocodile, box calf, and Scotch grain, and from a variety of soles—crepe, a Goodyear sports sole, rubber diagonal, and so on. They also make some Tyrolean models that are unique to the locale and to the modern world of bespoke shoemaking.

Combining those rugged soles with artisan-shaped uppers yields a modern shodding suffused with old world cache. Its Budapest toe box is higher and rounder than

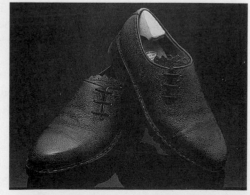

TYROLEAN TRADITION MADE-TO-ORDER:
SIDE-TYING COUNTRY WALKING SHOE.

VIENNA

the English or French silhouette, a proportion in accord with the fuller cut of today's clothes. It is no surprise that Materna consistently wins gold medals at the annual International Shoemakers Contest.

Bela Nagy, legendary shoemaker to the king of Bulgaria—and the father of Austrian shoemaking—established the business in 1927. In 1973, Georg Materna and his son, who had long supplied Mr. Nagy with fine leathers, bought the firm and moved it here, to a

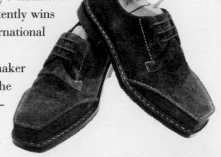

Thirties-style chestnut suede Alpine mountain shoe.

quiet location behind the Bristol Hotel. With its stucco walls, vaulted stucco ceiling, cream silk Austrian shades, rustic tiled floors covered in green rugs, Alpine country chairs covered in brocade, and beautiful wood showcases, it is an ambiance unlikely to have been experienced by anyone who hasn't toured Eastern Europe.

If you're an aficionado of fine, eclectic, town- or country-styled footwear, this shop is reason enough to visit Vienna.

Oberwalder & Co.
Karninerestrasse 39
Vienna
Telephone: 512 28 41
Hours: 9–8 Mon.–Fri., 9–1 Sat.
(9–5 first Saturday of the month)

This is headquarters. Literally. But if you don't know about it, you will probably miss it. Merely walking by the windows of this formerly august establishment, you'd never have a clue that lurking downstairs, below the souvenir figurines, tourist trinkets, and other airport paraphernalia on the ground floor, is Europe's largest selection of hats.

This shop's unwieldy presentation is sadly indicative of the state of headwear in the modern world. Nonetheless, persevere and you will find the original homburg. It may also be your last chance to touch a silk collapsible top hat ($385), which is virtually unavailable any-

where else since the demíse of Habig, the venerable institution that
hatted the Hapsburg aristocracy for over a century. You will see stacks
of Stetsons, columns of Borsalinos and boaters, and mountains of
Tyroleans. The Tyrolean hat, mated with a tweed jacket and long
loden coat with an inverted pleat, was a fashion rage on fifties cam-
puses, and it became fashionable again in Europe and the United
States during the early eighties. There isn't a man over fifty in Vienna
who isn't still wearing some version of this folksy hat—from the
authentic, with heavy silk cord and feather, to the citified. Ober-
walder's is where to find every one of them.

<div align="center">

LUDWIG REITER

WIEDNER HAUPTSTRASSE 41

VIENNA

TELEPHONE: 505 82 58

HOURS: 9:30–6:30 MON.–FRI., 9–1 SAT.

(10–5 FRST SATURDAY OF THE MONTH)

</div>

Five minutes outside downtown Vienna is the retail shop of the
aspiring Edward Green of Austria. It is on a corner in a narrow 1820s
building. Shoes are displayed on brick ledges jutting out from light
brick walls—which nearly reach to the vaulted stucco ceilings—as
well as on tables and about the floor. Despite the unexpected presence
of a beautiful grand piano, the feeling here is more factory than salon.
And the actual factory is just next door.

The Reiter shoe, with its high, round toe, is an Austrian variation
on the classic English business shoe. There are fifty styles in three to four
widths to choose from. The factory turns out only one hundred pairs a
day (some of which are sold in fine stores throughout Europe and Japan),
so they are well designed, well constructed, and traditionally detailed.

Shoemaking has been the family trade since 1917. After World
War I, the founding shoemaker's son was dispatched to observe cobblers
and craftsmen throughout the world. On returning, he introduced the
stitching machine and other sophisticated techniques to Austrian factory
shoe production. However, business declined disastrously over the years,
and in 1984, the firm was rescued from bankruptcy by the current (and
fourth-generation) owner Till Reiter. The willowy, bespectacled, violin-

VIENNA

playing Till is in charge, although his father is usually somewhere about (if he's not taking his two young granddaughters shoe-shopping or terrifying Vienna's salesmen by his surprise inspections—he has been known to tear shoes apart when he suspects plastic in a sole).

Thanks to Till's enterprising spirit, many of the shoes on display are the Goodyear-welted thirties and forties styles from the firm's glory days, to which he has added a modern last. Best-sellers are the classics, such as brogues and derbies, and a Norwegian shoe with rubber soles (which can, in fact, be added to any shoe). Reiter will make single pairs, which is rare indeed because this is not a custom shop: These are bench-made shoes. They take four to six weeks and cost about $310.

SALTMAYER
NEUER MARKT 6
VIENNA
TELEPHONE: 512 21 81
HOURS: 9–6 MON.–FRI., 9–12 SAT.

This small family-run bookstore has been at the same address since 1848, and might well have served such locals as Gustav Mahler, Anton Bruckner, and the good Dr. Freud. These days, it specializes in books on fashion, including some wonderful obscurities printed in Britain and Italy that you don't find elsewhere, as well as photography, the military, transportation, dolls, toys, and jazz. With its navy tile floor and big wood balcony it's a delightfully edifying refuge.

RUDOLF SHEER & SOHNE
BRAUNERSTRASSE 4
VIENNA
TELEPHONE: 533 80 84
HOURS: 8–6 MON.–FRI.; SATURDAY BY APPOINTMENT

If you could go to John Lobb and meet John, or to Caraceni and meet Domenico, it would be like dropping in on the elegant Herr Sheer. This is no ordinary septuagenarian shoe salesman. Decked out in a white

lab coat, it's clear he sees himself as more of a doctor than a shoe-maker. He has his theories. Believing that, as with snowflakes or fin-gerprints, no two people have exactly the same foot, he maintains that the shoe should help the foot support the body. As we age, our feet enlarge, necessitating a roomier shoe, and Mr. Sheer maintains that since the foot changes every two years, shoes should be properly updated so that the foot can be properly supported. He also believes shoes should bear the character of the man who wears them and they should fit the face as well as the feet of their owner.

This last of the grand shoemakers (since the passing of London's George Cleverley) stands twelve hours a day inspecting each shoe as it evolves. His workroom annually produces 200 to 250 pairs—after first making a trial shoe, which takes six months.

Opening the door to his shop, you enter what is nothing more than a dimly lit, rather dusty old house, giving you the distinct sense that you have just entered the antechamber of an old museum. The furniture is Thonet, the rug is old, green, and seedy. On the left, there is a large, beautiful wood-and-glass case filled with various styles of the exquisite shoes he has produced over the years. Around the walls, hung from the ceiling, are the faded royal warrants and tarnished carved crests of those emperors who have been his clients. Walking up a creaking wood staircase, you brush aside the velvet curtain, which keeps the heat from escaping downstairs. When you are ready to be fitted, Mr. Sheer personally examines your foot while you sit comfort-ably in a velvet chair in a relaxed, parlorlike setting.

Just as stopping at the Connaught Hotel is as close as an outsider might come to momentarily tasting the life of an English aristocrat, getting measured for a pair of shoes at this establishment makes you feel the way a nobleman might have in a bygone era. But even if you never buy a pair of shoes here, you will find it nourishing simply imbibing the ambience, which transports you back to another century and which may or may not make it to the next.